I

ENUNCIATION,

OR THE PLACE OF FILM

FILM AND CULTURE

Film and Culture
A series of Columbia University Press

EDITED BY JOHN BELTON

For the list of titles in this series see page 249.

IMPERSONAL ENUNCIATION, OR THE PLACE OF FILM

CHRISTIAN METZ

TRANSLATED WITH AN INTRODUCTION BY CORMAC DEANE
AFTERWORD BY DANA POLAN

Columbia University Press
New York

Publishers Since 1893
New York Chichester, West Sussex
cup.columbia.edu
Copyright © 1991 KLINCKSIECK
English translation copyright © 2016 Columbia University Press
All rights reserved

Cet ouvrage, publié dans le cadre d'un programme d'aide à la publication béné-
ficie du soutien du Ministère des Affaires étrangères et du Service Culturel de
l'Ambassade de France aux Etats-Unis.
This work, published as part of a program of aid for publication, received sup-
port from the French Ministry of Foreign Affairs and the Cultural Services of
the French Embassy in the United States.

Library of Congress Cataloging-in-Publication Data

Metz, Christian.
 [Énonciation impersonnelle, ou, Le site du film. English]
 Impersonal enunciation, or the place of film / Christian Metz ; translated by
Cormac Deane ; afterword by Dana Polan.
 pages cm — (Film and culture)
 Includes bibliographical references and index.
 ISBN 978-0-231-17366-7 (cloth : alk. paper) — ISBN 978-0-231-17367-4 (pbk. :
alk. paper) — ISBN 978-0-231-54064-3 (e-book)
 1. Motion pictures—History and criticism. 2. Narration (Rhetoric). I.
Deane, Cormac, translator. II. Polan, Dana. III. Title. IV. Title: Place of
film.

PN1995.M44813 2015
749.4301—dc23 2015021152

Columbia University Press books are printed on permanent and durable acid-
free paper.
This book is printed on paper with recycled content.
Printed in the United States of America

c 10 9 8 7 6 5 4 3 2 1
p 10 9 8 7 6 5 4 3 2 1

Jacket design by Archie Ferguson

References to websites (URLs) were accurate at the time of writing. Neither the
author nor Columbia University Press is responsible for URLs that may have
expired or changed since the manuscript was prepared.

CONTENTS

PART III: A WALK IN THE CLOUDS
(TAKING THEORETICAL FLIGHT)

ACKNOWLEDGMENTS

I am grateful to the following people, who in various ways helped me to translate this book: Seamus Deane, François-Christophe Crozat, Charlotte Austin, Nicole Ives-Allison, and a number of nameless contributors to the French-English forum at wordreference.com.

Support, encouragement, comments, and words of advice on bringing this book to completion and to publication were all gratefully received over the last few years from Warren Buckland, Phil Rosen, Dana Polan, Raymond Bellour, Frank Kessler, Selim Krichane, Costas Douzinas, David Lloyd, and Breandán Mac Suibhne. Thanks to William Guynn, whom I have never met but whose book *Writing History in Film* (New York: Routledge, 2006) first led me to *Énonciation impersonnelle*. I would also like to convey my thanks to Margrit Tröhler, Guido Kirsten, and Julia Zutavern, who welcomed me to take part in the excellent colloquium on Christian Metz that took place at the University of Zurich in June 2013.

This translation was completed during a year of postdoctoral research at the Department of Film Studies, Trinity College Dublin, which was funded by the Irish Research Council. My mentor during that period, Ruth Barton, gave welcome support and encouragement along the way. My thanks also to the staff at Trinity College Library, who provided great help, too, in particular Paul Doyle; Marie-Pierre Ciric at Les Belles Lettres; Jess Coleman at Curtis Brown; and Kathryn Schell and Jennifer Crewe at Columbia University Press.

Others with whom I have worked and from whom I have received great support in recent years include Paula Gilligan, Tony McKiver, Aidan Delaney, Patrick Crogan, and all of my friends at the (still unnamed) Reading Group.

Family and friends deserve ongoing thanks, book or no book, for helping me keep on keeping on. Without them this book could not have reached its conclusion.

Gabhaim buíochas croí leo go léir, agus buíochas faoi leith daoibhse, Norah agus Mobhi, as gach rud a rinne sibh le dornán blianta anuas.

TRANSLATOR'S INTRODUCTION

CORMAC DEANE

> We reason of these things with later reason
> And we make of what we see, what we see clearly
> And have seen, a place dependent on ourselves.
>
> —Wallace Stevens, *Notes Toward a Supreme Fiction*
> (Section 3, IV)

If you have been reading Metz, you will know that the application of concepts from semiotics and linguistics to the study of film is his major contribution to screen theory. This volume, *Impersonal Enunciation, or the Place of Film*, is part of that enterprise. As such, the insights that he offers arise as much from the failure of the semiology of language to formulate a film semiology as from his demonstration that such a project "works." More unexpected, however, is the way that Metz in this work breaks open a latent fissure in the semiotic project's attitude toward subjectivity, abandoning the quest for processes that lead to subject-formation and embracing instead nonsubjective, *impersonal*, even cybernetic logic at the heart of the cinema-machine. But I write in the knowledge that Metz has been steadily disappearing from view in anglophone screen studies roughly since the year of his death, 1993, and that the number of people who confidently regard themselves as readers of Metz is really quite small now. For readers old and new, then, this introduction describes the lines of continuity that run through Metzian analysis from the early 1960s to the fruition of his final film research in this, his final work, in 1991; and for both cohorts of readers I will attempt to describe what is new and worth reading in Metz, in this book and elsewhere, and to explain how his work has become lost in the shifts and drifts of film theory in recent decades. Ultimately, I will suggest how *Impersonal Enunciation* can be read in relation to the modes of

thinking about screens—such as media ontology, media archaeology, and phenomenology—that are popular today.

Metz's focus on enunciation dates from November 1986, when he initiated a seminar on the subject at the École des hautes études en sciences sociales in Paris. As a research agenda, the premise was simple: how to employ the concept of enunciation as a way of trying to identify the *place* from which a film utters itself. What ensues goes right to the heart of the phenomenological conundrums of screen discourse: Who or what is speaking, from where and to whom? Do films speak; do they make statements? On what grounds? What does the cinematic apparatus consist of; what is included by that concept and what excluded? What traces of humanness are to be found in its technology? How does the meaning of a film depend on the type of viewer who is watching? What does it mean to ask these questions at different moments in the history of film and of other screen media?

These are evergreen problematics, ones that have become more important when exploring the ways that screen media have changed in the years since the early 1990s. *Impersonal Enunciation* therefore anticipates the fundamental theoretical issues that challenge us when we discuss multimedia, interactivity, networks, media archaeology, and the resultant shifting ground underneath concepts such as subjectivity, machine intelligence, ideology, and the status of the apparatus. There is a strong sense here that Metz is talking about something new that is coming in media, something that exceeds merely film and television, something to do with the proliferation of screens and frames. Hence his interest in this book in interactive media, VCR technology, inlaying video images, split screens, handheld camerawork, Steadicam, promotional making-of TV films that accompany blockbusters, the growing taste for displaying film technology inside films, the aesthetics of surveillance, music video, the saturation of the media landscape with advertising, and so on.

The experience of reading these comments is tantalizing, as this book suggests that Metz would have been a close observer of the proliferation of screens and frames that has indeed occurred in the intervening decades, during which an array of new screen-based technologies have established themselves and in the process utterly changed the field of screen studies: personal computers, DVDs and other digital formats, digital cameras (moving and still image), digital editing, CCTV, robotics, drones, global positioning satellites, the Internet, file sharing, digital social networking, recordable television, streaming media, and mobile

information technology, all taking shape in a context of the conglom-
eration of media and military ownership. The point here is not to offer
reasons why we should read this book after more than twenty years of
developments but rather to say that we should read it precisely *because*
of everything that has happened in that time. The questions concern-
ing the avowedly technological aspects of screen narratives that Metz
poses are important because they were the first attempts to understand
a media environment that had not existed before. In other words, this
work does not merely have retrospective relevance, but it has a prospec-
tive timeliness.

One valuable contribution of this book is its demonstration of the his-
toricity of screen developments that we are too often tempted to regard
as new. Metz's enormous depth and breadth of knowledge, on display
here as nowhere else in his writings, enable him to make connections
across the space and time of screen history in highly original ways. The
section on secondary screens, to take just one example, ends with a dis-
cussion of Robert Altman's political drama *Secret Honor* (1985), but Metz
also identifies a secondary screen in the 1920 German horror film *The
Golem*, the 1931 French antiwar film *Wooden Crosses*, the 1945 Franco-
Spanish war film *Days of Hope*, the 1973 American thriller *Sisters*, the
1979 American science fiction-horror film *Alien*, and the 1980 Canadian
experimental film *Presents*. As we might expect of a French film critic
of his generation, there are frequent references to moments in the films
of Jean Renoir, Max Ophüls, Julien Duvivier, and Marcel Carné, as there
are also to films by John Ford, Alfred Hitchcock, and John Huston, but
the range of references extends in surprising directions, to include Rob-
ert Zemeckis's *Who Framed Roger Rabbit* (1988), Brian De Palma's *Casu-
alties of War* (1989), Elem Klimov's *Agony* (1975), Fernando Solanas's
Tangos, the Exile of Gardel (1985), João Botelho's *A Portuguese Farewell*
(1985), Wim Wenders's *Wings of Desire* (1987), as well as experimental
cinema by Chantal Akerman, Michael Snow, Thierry Kuntzel, Werner
Nekes, and Hollis Frampton, and French TV drama and documentary,
such as *Les cinq dernières minutes* and *Alain Decaux raconte*. Even this
list gives only a light impression of the cinephilia on display.

Impersonal Enunciation therefore reads very unlike Metz's earlier,
heavily theoretical style, where quite frequently no specific film would
be mentioned for pages on end. The extensive use of examples in this
book suggests that Metz is listening to his own dictum, that "a film is
difficult to explain because it is easy to understand" (*Film Language* 69),
and letting the examples do much of the conceptual work. The longest

part of the book, part 2 (itself eleven chapters long), is a series of analyses of dozens upon dozens of films, from all genres, eras, and regions. The most readable part of the book, and probably the best place to start reading, part 2 offers a guide through a set of tropes, devices, and tendencies in filmmaking practice that suggest the operation of some kind of enunciating—that is, statement-making, animating force. From fairly focused analyses in the early sections there is a gradual shift to wider, more totalizing categories that arguably include the whole of cinema. In order of presentation, the subjects tackled in these chapters are looks to camera, words spoken by narrators, onscreen writing, frames inside the frame, mirrors and mirroring devices, displays of the apparatus of filmmaking, embedded narratives, subjective images and sounds, voices that speak in the first person, objective images and sounds that are nevertheless consciously oriented in some way, and supposedly neutral images.

The way that these themes broaden gives us some clue about the direction that Metz's argument takes: while enunciation is at first glance something that is connected to specific, deliberate strategies that have a generally reflexive tenor, on closer examination it comes to pervade all that we see and hear in every screen experience. Thus, as he nears his conclusion, Metz asserts, "There is *always* enunciation . . . in narrative film as well as in documentary or television talk-shows, because what is said never exhausts *the fact that it is spoken*" (**147**, original emphases). The theoretical question of who or what might be regarded as speaking is addressed in detail in the opening and closing parts of the book, which are far more "theoretical" than the long middle part. These sections indicate where the concept of enunciation, impersonal or otherwise, fits into the history of film theory and linguistics, and of critical theory more broadly.

Metz starts by adapting the concept of enunciation for analyzing film. In linguistics, enunciation refers to the *act* of saying something, as distinct from the thing that is said, which is known as the utterance or statement; the distinction is between *énonciation* and *énoncé*. Enunciation in language is frequently signaled by the use of deictics, a category of words that tie the utterance to the moment when it is uttered—for example, *I, here, yesterday*. When enunciation marks itself in cinema, says Metz, it does not do so by using deictic indicators but by using reflexive constructions. To use a figure that appears several times in this book, the film seems to fold in on itself, the act of enunciation and the thing that is enunciated coming into (sometimes uncanny) contact with one another. No fixed list of enunciative markers exists; rather, any aspect of sound or image can momentarily be employed in an enunciative way. In short,

"Enunciation is the semiological act by means of which certain parts of a text speak to us of that text as an act" (**23**).

Metz devotes a good deal of attention to Francesco Casetti's organization of cinema's enunciative apparatus into four categories in *Inside the Gaze*, but with a strong emphasis on where he diverges from Casetti. For Metz, Casetti's conception of enunciation is excessively attached to the idea of persons, an inheritance from language. Rather, enunciation should not be deictic, personal, or anthropomorphic. If any person is imagined to occupy the position of filmmaker, film spectator, sender, or receiver, Metz argues, it must be remembered that this person exists only in the imagination of the analyst. Any talk of real people in cinematic enunciation must be based on empirical research, and this is of no interest to him (or to Casetti) because it gives no access to generalizable rules. The text and the people who watch it are of two totally different orders, and it is impermissible to allow anything from outside the text into film analysis. It is therefore a mistake to look for humanoid "markers" of enunciation, traces of some kind of subject who is both inside and outside the film; instead, enunciation is "coextensive with film" (**23**), and it is always active, playing a part in every shot, even when it is not marked. In light of this, Metz adopts the terms *source* [*foyer*] and *target* [*cible*] to describe the parts of a film that the film emanates, respectively, from and toward. They are emphatically not roles but "*orientations*, vectors in a textual topography" (**20**).

All of the above is set out in part 1. What follows is part 2's wide-ranging, loose, playful, and even maverick tour of certain aspects of cinematic enunciation, the focus always on mechanisms that seem to alter the level at which a given scene or film is played, implicitly or explicitly altering the discursive solidity of the classical narrative setup. When Metz gets to part 3, in a methodological move familiar from his earlier theoretical writings, he sheds the very terms, *source* and *target*, that he formulated earlier once they have served their use: "the course of this book has gradually led me to define *enunciation* with an emphasis on the idea of a *process* or of a function, rather than an object. . . . The only term that I ultimately needed, from the point of view of production, is *enunciation* itself, which correctly describes a function" (**163**).

The main segment of part 3 provides counterarguments to objections that he anticipates will be made to his positing enunciation as key to understanding screen texts. First, he rejects the concept of a transparent narrative style, exemplified by Hollywood's so-called seamlessness, where a story seems to tell itself without any enunciative acts. Not only

is this a preposterous idea, but it is preposterous to suggest that anyone ever believed in it. In the 1970s, Metz points out, those who critiqued the transparency of mainstream cinema were making precisely the point that this style is replete with enunciative (and ideological) traces. The problem lies with the rather crude dichotomy developed between history and discourse by Émile Benveniste, the basis of whose analysis in the deictic system made it difficult to discern that the very presence of a statement is itself sufficient evidence for enunciation. Metz credits Casetti, Gérard Genette, and Catherine Kerbrat-Orecchioni, among others, with helping to extract from the debate some of the less useful aspects of linguistics, a discipline that is perpetually in the long shadow cast by subjectivity and tied thereby to a Romantic vision of the author.

He continues along similar lines in fending off accusations that the notion of enunciation is too deeply indebted to its roots in linguistics. He examines in detail the differences between literary and filmic narration, and between their respective senses of "beyond the text." Tracing the arguments of critics such as André Gaudreault and Käte Hamburger, he argues that literature is always trapped by its textuality, so that the same discursive material (i.e., language, words) is used to convey all levels of enunciation and narration, to the extent that the two terms are almost interchangeable. Not so onscreen, where certain kinds of nonnarrative enunciation, such as the scientific enunciation of documentary, cannot be described as narration.

The final justification for the use of enunciation, according to Metz, is that it makes it possible to think clearly about the "final I that is outside the text" (155). The location, apparently beyond the bounds of a film or written text, of a person or personification that is the ultimate source of that film or text, is not to be found inside any text at all. And if something is not in the text, and we are dealing with already-completed, noninteractive formats such as feature films and novels, then it does not exist at all. But this has not stopped an array of scholars from conceptualizing an ultimate, imperceptible source of meaning: meganarrator, extradiegetic narrator, homodiegetic narrator, narration *tout court,* "an author who is implied, implicit, imaginary; an enunciator, an implicit enunciator, a narrator, an implied narrator, a model author, an immanent author, and so on" (4).

The strenuous exclusion of any hint of personhood on the part of filmic enunciation is very important to Metz here (special mention goes to Marie-Claire Ropars-Wuilleumier, Gaudreault, and François Jost for their similar insights in this regard). This is because, as he emphasizes

near the end of the book, there is a fundamental asymmetry in the cinematic equation that obliges us to banish any sense of interaction based on linguistics. A screen experience does not involve an encounter between two counterparts, however they are described; rather, a film text must be completed, petrified, before its public can materialize. Only one pole, that of the spectator, is a person. "The characteristics of a film clearly influence its reception, but its reception belongs to another world that requires separate observation" (167). What's more, the mechanisms at work on each side of the equation are also very different; enunciation may be described as a set of very particular textual functions, while the spectator experiences a combination of moods and impressions that are on a different register altogether.

Taking the longer view, Metz's attempts to use concepts from linguistics to understand the meaning-making mechanisms of film, which date back to the start of his entire critical project, reach a kind of conclusion here. This may not be immediately apparent, because of the exploratory, tentative, and modest tone that pervades all of his writing, and I am careful here not to identify a concluding gesture in this publication that could tidily match Metz's own death, which followed soon afterward. The clue, however, is in the title: screen enunciation is *impersonal*, and that means that linguistic and communicative models in general, which are based on interactions between senders and receivers, do not quite work. There is no feedback: "film self-designates itself *because there is only itself*" (164). So now we can understand why Metz is interested in the devices that he examines throughout this book: screens within screens, first-person voice-overs, mirror devices, and the like seem to point us in two directions at once, either toward a metadiscursive presence imbued with some kind of subjectivity or (and this is what he favors in the end) an impersonal metadiscursive logic that is coded into the technology of the medium itself.

There is a strong sense of a growing awareness in the pages of this book that the great problematic that confronted screen theory in the transition from the 1980s to the 1990s was of the coming dominance of new screen technology and culture and therefore of a new culture per se. We should regard Metz in the context of others writing in French around this time who anticipate an era of hypermedia, hypertexts, and an end to Cold War–era certainties and dichotomies. For example, in "Postscript on Control Societies," first published in 1990, Gilles Deleuze attempts to update the Foucauldian account of the operation of power to take account of the increasing speed of technology. During the same

period, Bruno Latour's concept of Actor-Network-Theory proposed the network and nonhuman agency as central ways of understanding technological society. Jean-François Lyotard's reflections on the disappearance of the human in the face of advancing technology were a keynote of the 1980s, best represented perhaps by *The Inhuman* (1988). It was also during this period that some of the most incisive analysis by Jean Baudrillard and Paul Virilio of hypertechnology and power was being made; see, respectively, *The Transparency of Evil* (1990) and *Desert Screen* (1991). And then there is Jacques Derrida, whose grammatological works "already reflect an internalization of electronic media, thus marking what is really at stake in the debate surrounding . . . Western metaphysics," as Gregory Ulmer puts it (303).

Admittedly, the evidence here that Derrida, or indeed any of the above, played a part in Metz's thinking (from this group, only Deleuze gets a [passing] mention) is only circumstantial. However, it is necessary to insert Metz into the wider context of developments in critical theory in the largest sense because his intellectual modesty, and his meticulousness, limit his range of explicit reference to those authors whom he discusses in detail. This is not to understate the importance or scholarship of those whom he does cite frequently, a group that includes, in addition to those mentioned earlier, Edward Branigan, Raymond Bellour, Jean-Paul Simon, and Marc Vernet. Indeed, these critics themselves also operate/have operated in an intellectual milieu in which the broad-brush influence of Derrida, Deleuze, Latour, and, for that matter, Kristeva, Lacan, and Althusser may not always be plainly visible but is inarguably present.

Impersonal Enunciation needs to be placed in this intellectual context because what this book targets above all, particularly in the final chapter, are the transcendental claims of a cinema of presence. Metz asserts that every cinematic utterance is the result of an act of enunciation, just as every written text is the result of an act of writing. He makes clear that it has always been possible to read cinema's utterances in this way—hence the historical range of his references. But he also makes clear that there is something going on in the media environment of the period when he is analyzing enunciation that brings the issue to the fore. Anne Friedberg addresses precisely this situation, though she is writing in 2006, a full fifteen years after Metz:

There have been sporadic examples of multiple-frame images and multiple-screen display throughout the century-long history of cinematic and televisual media. And yet aside from some

notable historical anomalies, only in the last two decades—markedly with the advent of digital imaging technologies and new technologies of display—did the media "window" [begin] to include multiple perspectives within a single frame. And as a coincident development, the interface of computer display made this "new" multiple-"window"/multiple-screen format a daily lens, a vernacular system of visuality. This remade visual vernacular requires new descriptors for its fractured, multiple, simultaneous, time-shiftable sense of space and time. Philosophies and critical theories that address the subject as a nodal point in a communicational matrix have failed to consider this important paradigm shift in visual address. (Friedberg, 3)

The new conditions of possibility for enunciation that have been provided by (what we now refer to as) new media in the period in question manifest themselves both narratively and formally in, for example, puzzle films, one of the more popular trends in narrative structure of the past two decades—for example, *Groundhog Day* (Ramis, 1993), *Being John Malkovich* (Jonze, 1999), *Hidden* (Haneke, 2005), and *Inception* (Nolan, 2010). But there is a much broader field to which the ideas put forward here apply, and that is all screen narratives that feature prominently screens embedded inside one another. This includes action narratives based on struggles in control rooms full of computers, as in the television show *24* (Surnow and Cochran, 2001–14) or *Die Hard 4* (Wiseman, 2007). The hyperactive framing that is also found in television news, sports programming, and science drama (e.g., the *CSI* franchise [2000–present]) present us with screens as information-rich, ubiquitous, truth-revealing and yet always multiple and multiply enframed inside one another.

An implication of Friedberg's description above is that shifts in media technology and shifts in philosophy's conception of the subject run on parallel, and so separate, tracks. But *Impersonal Enunciation* describes cinema as a machine whose impersonal logic is more or less prominent at different times and places. So the possibility of reading cinema as being imbued with impersonal enunciation was always latent; it is only in the developments of the late 1980s and early 1990s that it becomes especially apparent. A deconstructive reading—for that is what Metz is performing here—may be made at any historical juncture, not just in the era of poststructuralism; indeed, the shared historicity of screen media, screen theory, and acts of screen reading is foregrounded. The

elegance of the concept of enunciation is that its perceptibility alters with each iteration, so we become aware of iteration per se, which in turn reveals cinema to be a series of acts, each situated in a particular time and space:

> Enunciation remains something simply assumed as long as we are not very attentive to how a film is made. As soon as we look and listen more carefully, we spot the traces of markers which, no matter how slight, prefigure a "true" orientation, which can then be imputed to the character or to the source [*foyer*]. The difference does not inhere in the object, but in the distance that we adopt in relation to it, in our more or less close or more or less inattentive reading, in every person's historical, semiological, and cinemagoing background, and in the various social circumstances in which a film is consumed. (3)

On reading this or many other of Metz's comments in *Impersonal Enunciation* about the practice of reading, we can also perceive traces of Derrida (who is also silently present when the talk is of the boundaries of the text, the outside of the text, and so on). More directly, though, we are reminded of Barthes on practices of reading. Indeed, it was under the direct influence of Barthes (and, less directly, of Jakobson and others) that Metz embarked on the unsuccessful project of identifying the code or codes that underlie cinema. The success of this failure, however, is in the way that Metz, finding code elusive, repeatedly winds his way back to the contingency, or specificity, of any given shot, cut, scene, or sequence. In other words, Metz ought to be counted as one of the thinkers, along with Barthes, who made the move from structuralism to poststructuralism not only possible but necessary, because he recognized that the systematizing tendency of information technology (of which cinema is a paramount instance) is more dreamt of than real. Instead, as structural analysis deepened, it discovered the complications of circuits of communication, of circuits of desire, of feedback loops, and of the undeniable situatedness of the sender of any message, leading to the realization that "everything said is said by someone," to cite one of the key aphorisms of *The Tree of Knowledge*, by Humberto Maturana and Francisco Varela (26).

Mention of Maturana and Varela, whose field of expertise is the feedback mechanisms of biological systems, may seem to lead us astray. But it is the cybernetic logic that they taxonomize that ought to interest us here, as it is precisely this, in this special form of paradoxical self-

reference, that Metz returns to again and again in *Impersonal Enunciation*. It follows from the statement that "everything said is said by someone," that that very statement is itself produced by a someone, and so on, and so on. A consequence of this kind of self-referential recursivity is that the individual and subjectivity become less tenable concepts, as it becomes clear that it is impossible to posit, or occupy, any neutral, external position from which any system can be described in totality. A Luhmann-influenced systems-theory approach such as this helps us understand Metz's categorical rejection of any anthropomorphizing of enunciation, his insistence that it is *impersonal*.

It also helps us to insert Metz into a narrative of the structuralist project as a component, even an epiphenomenon, of cybernetics. This is Friedrich Kittler's view: "Every theory has its historical a priori. And structuralist theory simply spells out what, since the turn of the [twentieth] century, has been coming over the information channels" (16). There may be a degree of reductionism in this assertion (note Kittler's "simply" [*nur*]), but it is by no means unreasonable to mention Metz and cybernetics in the same sentence. There are references to cybernetics and information theory throughout his writings, and we find him (in edited books, at conferences, in his own and others' footnotes, etc.) among practitioners of semiotics, cybernetics, and computational semiotics, such as Roman Jakobson, Roland Barthes, Julia Kristeva, Yuri Lotman, Ludwig von Bertalanffy, Thomas Sebeok, A. J. Greimas, and Umberto Eco. Selim Krichane (2013) traces this heritage in detail. As Bernard Dionysius Geoghegan tells it (124), the history of French semiotics starts when the early cybernetic structuralism of Jakobson and Claude Lévi-Strauss merged with Marxism in the journals *Communications* (where many of Metz's landmark articles of the 1960s and 1970s were to appear) and *Tel Quel*. What emerged was "an experimental . . . mode of writing that deployed cybernetic tropes and problematics to thematize the historical and political frameworks of communications and science" (124). Metz's attention throughout his writings, but particularly in this book, to the coevolution of material and mental life comes from this tradition and finds later expression in the more politically engaged concepts of Bernard Stiegler, such as *organology*.

Metz's deep interest in code can be understood in this context; in his monographs *Language and Cinema* (1971) and *The Imaginary Signifier* (1977), and in the 1968 volume of essays *Film Language* (*Essais sur la signification au cinéma* I), he is a true structuralist in the sense that he is attempting to see through or beyond any given film text toward its

deeper meaning, its organizing principles, its code. But, like many structuralists, he finds that the seeds of doubt about the project are there from the very start. In all of these works there is an acute awareness of cinema's incommensurability and of theory's incapacity to offer a list of codes and subcodes that operate behind the text. In fact, his writings trace a series of discoveries and realizations that culminate in this present book: cinema is a language, not a language system (*langage* vs *langue*, respectively), mainly because it does not permit bilateral communication; cinema is made of a multiplicity of codes; each film is a once-off instantiation of an unpredictable combination of cinematic and noncinematic codes; film viewing is therefore an event that depends on the spectator for meaning to happen; despite the seemingly mechanical and algorithmic logic of the camera, there is no corresponding algorithm that allows a code to be recognized; all of the tools of linguistic and literary analysis for identifying sameness and difference (e.g., analogy, metaphor, metonymy, representation, sign, signified, signifier, paradigm, syntagm) are inadequate when studying films.

By the time he gets to *Impersonal Enunciation*, it is clear to Metz that the "cinema-machine" operates according to its own self-realizing, feedback-looped enunciation *just as* these same aspects of screen media are thrown into unmissable relief in the digital revolution. One lesson to be drawn from this is that the cybernetic turn took place in theory, cinema, and media culture in general a good while before the digital era. This is not to say that Metz's categorizing impulse is absent here; for example, chapters 2 and 3 devote great energy to parsing the differences between what is diegetic, extradiegetic, homodiegetic, heterodiegetic, supradiegetic, juxtadiegetic, and peridiegetic. It is a reasonable problem, rationally presented, because it helps us to understand what is inside the system and what is outside. Metz is demonstrating a structuralizing instinct, and a cybernetic one, in the sense that it is an attempt to distinguish input from output and system from nonsystem. Ultimately, he is interested in the acts of stacking and coding that separate these various aspects of diegesis, in other words in the performative aspects of certain screen devices, hence his interest here in Benveniste's 1958 essay on doing verbs.

But there is also a degree of taxonomy fever in evidence here, to borrow a phrase from Mary-Ann Doane (2013). Metz's project in this book and elsewhere is dogged by the impossibility of fitting the right terms to the right concept. Just as images are imperfect copies of the things they represent/signify/refer to, so, too, are words imperfect stand-ins for

their referents. In other words, anxiety about fitting the right term to the right concept is fueled by cinema's own quasi-analogical relationship to the world. It is no longer enough to draw from this, as Metz does in earlier work, that instructive conclusions can be reached from the different ways that film and, say, language are imperfect. So much was clear, in a manner of speaking, from the very outset. The object of analysis in *Impersonal Enunciation* is not simply discourse at work but discourse-making itself at work, the *enunciation* not of special utterances but of potentially any utterances whatsoever.

NOTE ON THE TRANSLATION

Metz's taxonomy fever proved contagious in the process of translation, for which the best remedy has been to produce as free a translation as possible. Metz's style in this book is unlike anything else he wrote. Alongside the methodical interrogation of his own and others' terminology, and the assumptions that they contain, he ranges freely through his chapters, offering impressionistic asides, wry jokes, strange puns, and arch comments. The result is a very readable, if slightly weird, piece of scholarly writing.

A small number of original French terms have been supplied, usually in square brackets, where appropriate. The most common of these are *foyer, source, langue, langage, en-deça, dispositif,* and *appareil.* The most obscure of these is probably *foyer,* which Metz uses to describe the place or level from which the enunciations of a film emanate. Explicitly avoiding *enunciator* because of the implication of human agency, he uses *foyer,* which means home, hearth, focus, or source. I have opted for the last of these, acknowledging that *source* still has the flavor of a unitary, individual point—something that Metz is trying to avoid. Occasionally, Metz uses *source* in a similar way, so I have indicated where this takes place. The term *énoncé* also requires some explanation: it may be translated as *statement, utterance,* or *the enunciated.* I have used all three of these (principally the first two), depending on the context in each case. Similarly, *énoncer* is rendered variously as *to state, to make a statement, to utter,* or *to enunciate.* Unfortunately, the result is to break the common thread that runs through *énonciation, énoncé, énoncer,* and *énonciateur,* all of them crucial in Metz's vocabulary. Metz also uses a term from heraldry, *mise-en-abyme,* which may require a little explanation: *mise-en-abyme* is the name given to the effect achieved when an image contains itself,

which in turn contains itself, and so on infinitely into the abyss (*abîme*). Finally, I have retained unchanged the difficult-to-translate *en-deça* in chapter 9, where it is used to mean the unseen space *below* and *in front of* a camera. The related term *hors-champ*, often translated as "off-screen," has been rendered as "out of field" throughout this volume.

Where necessary, I have translated film titles into whatever title they were released under in English (when this is the case), and I have maintained the dates of release as Metz gives them, as these vary from territory to territory. Exceptions to this general rule, such as the backlog of American films that were released in Paris after World War II, are obvious when they appear.

All quoted extracts are translated by me, except where English translations of the relevant works have been cited in the notes. This latter category includes Metz's own works, Francesco Casetti's *Inside the Gaze*, Émile Benveniste's *Problems in General Linguistics*, and Michel Chion's *The Voice in Cinema*.

Chapter 5 appeared in slightly different form as "L'écran second, ou le rectangle au carré (Sur une figure réflexive du film)," in *Vertigo: Revue d'esthétique et d'histoire du cinéma* 4 (1989): 126–33. Chapter 6 also appeared in slightly different form as "Miroirs," in "Cinéma," a special edition of the journal *La Licorne* 17 (1990): 5–8. An early, shorter version of chapter 1 was published as "L'énonciation impersonnelle, ou le site du film (En marge de travaux récents sur l'énonciation au cinéma)," in *Vertigo* 1 (Nov. 1987): 13–34; and it was translated as "The Impersonal Enunciation, or, the Site of Film (In the Margin of Recent Works on Enunciation in Cinema)," by Béatrice Durand-Sendrail and Kristen Brookes in *New Literary History* 22, no. 3 (1991): 747–72. This translation also appeared in *The Film Spectator: From Sign to Mind*, edited by Warren Buckland. Because Metz extended the content of the original article, and in the interests of implementing a coherent voice and style throughout this volume, I have produced my own translation of chapter 1 in this volume. My translations of chapters 5 and 8, amended here slightly, appeared in the *New Review of Film and Television Studies* 8, no. 4 (2010): 348–71, and I am grateful to that journal for agreeing to their inclusion here.

FURTHER RESOURCES

An extraordinarily thorough bibliography of works by Metz, up to 2009, by Hans J. Wulff and Ludger Kaczmarek is available for free in the

Berichte/Papiere (ISSN 1613-7477) section of the website of the Medien-wissenschaft department of Universität Hamburg.

The best explications of Metz's critical project, in my opinion, are those by Warren Buckland in *Film Theory: Rational Reconstructions* (New York: Routledge, 2012), 73–92; and *The Cognitive Semiotics of Film* (Cambridge, UK: Cambridge University Press, 2000), 52–76. Thomas Elsaesser's introduction to the collected volume *The Film Spectator: From Sign to Mind*, edited by Warren Buckland (Amsterdam: Amsterdam University Press, 1996) is an impressively brief summation of the three great milestones of Metz's intellectual journey: semiotics, psychoanalysis, and enunciation. Finally, a neat précis of the concept of enunciation in film theory by Ruggero Eugeni can be found in *The Routledge Encyclopedia of Film Theory* (2014).

BIBLIOGRAPHY

Benveniste, Émile. "The Correlations of Tense in the French Verb." 1958. In *Problems in General Linguistics*. Coral Gables, FL: University of Miami Press, 1971.

Casetti, Francesco. *Inside the Gaze: The Fiction Film and Its Spectator*. Translated by Nell Andrew with Charles O'Brien. Bloomington: Indiana University Press, 1998.

Doane, Mary-Ann. "Christian Metz and the Psychoanalysis of Cinema." International Colloquium: The Semiological Paradigm and Christian Metz's "Cinematographic" Thought, University of Zurich, June 13, 2013.

Friedberg, Anne. *The Virtual Window: From Alberti to Microsoft*. Cambridge, MA: MIT Press, 2006.

Geoghegan, Bernard Dionysius. "From Information Theory to French Theory: Jakobson, Lévi-Strauss, and the Cybernetic Apparatus." *Critical Inquiry* 38 (Autumn 2011): 96–126.

Kittler, Friedrich. *Gramophone, Film, Typewriter*. Stanford: Stanford University Press, 1999.

Krichane, Selim. "Le code dans le paradigme sémiologique de Christian Metz: Filiations épistémologiques et transfert disciplinaire." International Colloquium: The Semiological Paradigm and Christian Metz's "Cinematographic" Thought, University of Zurich, June 14, 2013.

Maturana, Humberto, and Francisco Varela. *The Tree of Knowledge*. Boston: Shambhala, 1987.

Metz, Christian. *Film Language: A Semiotics of the Cinema*. New York: Oxford University Press, 1974.

Ulmer, Gregory L. *Applied Grammatology: Post(e)-Pedagogy from Jacques Derrida to Joseph Beuys*. Baltimore: Johns Hopkins University Press, 1985.

IMPERSONAL ENUNCIATION,

OR THE PLACE OF FILM

PART I

HUMANOID ENUNCIATION

1

HUMANOID ENUNCIATION

Not only has *enunciation* been defined in many different ways, but the concept also contains several distinct ideas. The latter fact no doubt contributes to the former. Two of these ideas have been well treated in the *Sémiotique* dictionary compiled by A. J. Greimas and Joseph Courtés: enunciation is a *production*, and it is a *transition*, a transition from a virtual instance (such as a code) to a real instance.[1] But there is a third idea, which is in fact the primary one for Émile Benveniste, Roman Jakobson, and, in the field of narratology, Gérard Genette.[2]

By *enunciation* we designate the presence, at both "ends" of a statement, of two human beings or, more exactly, of *subjects* (we should recall that for Benveniste the pairing I/You defines the "correlation of subjectivity"). Of course, narratology never tires of repeating that the enunciator and the addressee are abstract and structural phenomena, "positions"; that it would be clumsy to confuse them with the "empirical" sender and receiver (author, reader); that in theory and in practice *enunciation* is different from *communication*, and so on. Jean-Paul Simon, one of the first people in our field to have tackled these questions, is particularly concise on this point: enunciation does not summon up a "full" and "transcendental" subject but an "encoded and coded subject."[3] But we should not take these conventional formulations too literally, or at least we should not follow them in all their consequences. If there is no doubt that in general we can tell a narrator apart from an author, for example, the locations of enunciation itself—enunciation that we are told is purely textual—are nonetheless most often conceived of as people of some sort.

We have to admit that we cannot think of them otherwise; we cannot represent them to ourselves clearly, except as *instances of incarnation*. What is more, in the transmission process these instances are supposed to occupy the locations of enunciation. So, no matter how much somebody talks to me about the addressee, I will think of the spectator so that I can understand what is being said, and this spectator will (theoretically or miraculously) morph into the role of "addressee." Enunciation tends to take on a humanoid aspect.

For all that, we should not transfer onto the enunciative apparatus [*appareil*] the characteristics of its instance of incarnation, as do those narratologists who, having defined some Ideal (or Implied, Immanent, etc.) Reader, detail his reactions in the vocabulary of human and naive psychology. Moreover, words such as enuncia*tor* and address*ee*, with their suffixes, carry within themselves anthropomorphic connotations that are difficult to avoid and are quite bothersome in various fields, especially in film, where everything is based on machines. When what is at stake is the physical inscription of enunciation in the text, it would be better to have recourse to the names of things. I will propose, provisionally, as we will see, "source [*foyer (ou source)*] of enunciation" and "enunciative target (or destination)." (The human subject reappears when someone comes to *occupy* the source or the target.) Some time ago, Albert Laffay pointed out that at the heart of all films, with their "ultraphotographic interventions" and their various manipulations, one finds a "virtual linguistic source [*foyer*]," an "exhibitor of images," a "fictitious person" (we will return to the term *fictitious*), a "master of ceremonies," a "great artist," and as a result, finally, a "structure without images" (this last remark is exceptionally perceptive).[4]

Instances of incarnation do not map onto enunciative positions in a regular, homological way. So the spectator who is comically said to be real (also known as the spectator), whom we naturally expect to belong to the side of the target, also occupies the source [*foyer*] inasmuch as he is identified with the camera, while occupying the target, in that the film watches him. This second, reverse movement has been explored very well by Marc Vernet. The third fictive dimension of the screen creates a point of perspective that is directed toward us, "an anonymous look in the mirror that breaks and recasts the dual relation of the spectator to the image."[5] The spectator is, then, an *I* and a *YOU* at the same time. But as soon as it is put this way, it is clear that this idea does not really tell us very much. This is the first sign of the problems that come with using personal pronouns. These pronouns can only lead to a *deictic conception*

of enunciation in cinema, which I think is poorly suited to the realities of film. This theory is nevertheless the most common in the field. It often remains implicit, even more or less unconscious. We find it forcefully articulated and fully self-aware for the first time in the work of the best current analyst of cinematic enunciation, Francesco Casetti.[6] He lists his categories of the main enunciative configurations according to "executive hyperphrases," which, taken together, constitute a kind of *template for deictics*. So, for the look to camera: "HE (the character) and I (the enunciator), we watch you (the addressee)," and so on for all the important configurations that enunciation creates.

But is an *I* who cannot become a *YOU* still an *I*? The question could be asked of a psychoanalyst, whose answer we can predict, and of a linguist, for whom the reversibility of the first two persons is part of what defines them.

This reversibility is strongly present in *oral exchange*, which is the prototypical form of "discourse," as Benveniste distinguishes it from "story," and it provides him with the point of departure for all his theorizing about enunciation.[7] In a conversation, one has the feeling that one can *see*, or touch, the source [*foyer*] and the target of enunciation (whereas in fact they conceal themselves at this point of contact, taking as they do the form of grammatical pronouns). Once again, this is to confuse them with their instance of incarnation, with the two people who are talking. What we take to be the source [*foyer*] of enunciation is *another utterance*, which is simultaneous. It is the mimico-gestural utterance of the subject who speaks, which is to say of the same person (hence the confusion). The fact remains that the degree of reversibility of the enunciative poles is at a maximum in oral exchange. Instances of incarnation are real human bodies that combine two modes of presence in a remarkable way: presence between one another, and physical presence at the moment of their utterances (unlike written exchanges, messages on answering machines, etc., and most unlike literature, cinema, and painting). The reactions of the addressee are liable step-by-step to modify or reprogram what the enunciator says, by means of the parallel and logically anterior to-and-fro of listeners and speakers. On the whole, the theory of enunciation is largely constructed on situations that are exceptional in their structural characteristics but very common in everyday life.

The reversibility of characters is less prevalent in *written dialogue*, transcriptions, and other kinds of "reported speech" (we know that Benveniste was interested in this,[8] as was Genette).[9] Here there is no

longer any real feedback from the target back to the source [*source*]; rather there are (written) utterances that mimic other (oral) ones and also mimic this feedback effect. This mimicking is made possible by the identity of the global code (i.e., language) and above all of deictic terms that generally have the same form for the oral as for the written, so they seem to match up.

Pragmatics, to which nothing human is alien, has no doubt paid attention to the many intermediate cases. So, for example, the *I* in official discourse, whom nobody is supposed to answer even if the speaker is known by everyone, or again the *I* that signs off at the end of a leaflet, and so on. We come then by degrees to "story" [*histoire*], where the reversibility of characters disappears since in principle the third person alone is used. "Historical narration" [*énonciation historique*], to use another phrase from Benveniste,[10] is not indicated by any markers. Casetti will say that in certain cases enunciation is "presupposed," postulated by the simple presence of an utterance, or in the realm of fiction, it is "diegeticized." (But at the far end of the spectrum, enunciation may itself be *enunciated*).[11]

Before going any further, we should cover some elementary ground on true deictics that are found in articulated language. I will use examples from French and, seeing that the precise list of deictics varies according to different linguists, I will limit myself to the most common types: personal, possessive, and demonstrative pronouns;[12] adverbs of time and place; and verb tense. It should not be forgotten that there is a large overlap between the category of deictics and that of anaphoric reference. I will provisionally use the term *index* to cover the two, not forgetting that anaphoric and cataphoric reference in film have been discussed by Michel Colin,[13] by Jean-Paul Simon some time ago,[14] and later on by Paul Verstraten,[15] Lisa Block de Behar[16] and others.

For a start, a distinction must be made between twofold indices and those that are "simple." The former have one form reserved for discourse and another for story, as in "yesterday / the day before." "Yesterday" is deictic, while "the day before" is anaphoric, as the latter no longer refers back to the circumstances of enunciation but to some previous information contained in the utterance. By contrast, other indices have the same form for story and for discourse—this is the case with personal and possessive third-person pronouns and all demonstratives: *that* is what one physically points at, and it is also what the preceding sentence points at. The distinction between "twofold" and other examples is clearly irrelevant for terms that are used either solely in discourse (second-person

personal and possessive pronouns), or solely in "story," such as the simple past or the past anterior.* Twofold examples arise only for terms that have two functions.

The second major dividing factor is between deictics that *change signifier for the same referent* according to the circumstances of enunciation and deictics that remain as they are. In a conversation Mr. Durand calls himself "I" when he is the one who is speaking, but he is "YOU" when Mr. Dupont speaks to him. July 18 is "tomorrow" if one is speaking on July 17, but it is "yesterday" if it is now July 19, and so on. This category corresponds more or less to what philosophers of language call "token-reflexives," whereby the particular character of every enunciation (its "token") is reflected in the literal sense of the utterance. To know what is meant by *here*, we need to know where the word was uttered on a particular occasion. These are deictics par excellence (perhaps the only ones),[17] both because they appropriate a very particular mechanism of reference and because they include the key words *I* and *YOU* (which are also the ones that Casetti names). What is special about them is that they supply us with information about the enunciation *through the enunciation itself* and that they are in this way inseparable from actual changes in the real world, unlike in film or in books. This group contains the following: personal and possessive pronouns in the first and second persons; in verbs, the triad of present/past/future to designate the same date, depending on the moment of speaking; adverbs such as *yesterday/today/tomorrow*, or even *here/there* for the same location, according to how close or far away it is, *left/right*, and so on.[18] These terms, which are subject to change, contrast with those in which the signifier does not vary for a unique referent, even if the coordinates of the enunciation change—that is to say, even if the sentence is uttered later, elsewhere, or by another person. Examples include the timeless present ("The earth is round"), and all demonstratives, except those that are organized as "close/far" pairs, such as *this/that*.

This brief recap has aimed simply to underline the extreme precision of the deictic system, even when it is summed up in the simplest way. It comes as no surprise that one finds all of these mechanisms in the dialogue of a sound film, since the speech has been recorded en bloc. The same is true for dialogue in novels, as the mimicking transcription

*. Metz is contrasting the *passé simple* and the *passé antérieur*. In terms of the English tense system, the contrast he is making is, roughly, that between the simple past and its pluperfect counterpart.—Trans.

that I mentioned earlier is always possible. However, when it comes to this *I*—an *I* whose structural constraints I have partially described, *these constraints themselves determining its meaning*—what is the point in calling this *I* the source [*foyer*] of enunciation of an entire film or novel, or of any other noninteractive discourse that is completed before it is presented, if we do not allow enunciation or the reader-spectator any chance to intervene, even if only from the outside—for example, by closing the book or switching off the television? With some precision, Gianfranco Bettetini concisely names this kind of discourse, which includes most classical texts, "monodirectional," a term that I will retain.[19]

Among these discourses that are created and finalized in advance, we still have to distinguish between those that are linguistic, such as literary narrative, and those that are audiovisual. In the latter, speech, which can be quite faithful to everyday language, must work with the image. It is not the only bearer of meaning of the message, and the body of the text remains partially beyond it. In a novel, nothing is spoken—everything becomes writing—but the language is sovereign and the idiom unchanged (the text's idiom is also what is spoken by characters and readers). Discourse is strewn with "mimed" deictics as well as, particularly in passages of "story," anaphorics, but these are often expressed with the same word (such as *this*), with the result that a sense of unity persists. Any spontaneous perception of the gap between story and discourse is often fogged by these anaphoro-deictic terms, because if we did not move beyond them, discourse would transform itself into story without changing signifiers, so everything would shift mechanically by one notch, and the role of the situation would be replaced by the role of context. (In terms of pragmatics, we could say that the co-text becomes the exact substitute for the context.) Further, in writing, anaphora is less distant from deixis, as the latter operates on "situations" that themselves are pure products of the utterance. In discourse, in the dialogue of a novel, a character may speak of "this dog" if we know from the book that there is a dog in the room at that moment. In "story" the narrator of the same novel could say "this dog" if he is referring back to the previous sentence, where we learned that there was a dog in the room at that moment. In the former we have reconstituted deixis, in the latter ordinary anaphora.

To sum up: on the one hand story can take on the appearance of discourse or resemble some vaguely intermediate form. On the other hand the written text—because these things are connected but distinct—always gives, to varying degrees, the impression of an enunciative presence. This is because it preserves within itself something of deictic

enunciation, the one that works in a way that is most familiar to us. (It is no accident that the theory of enunciation in linguistics started as a theory of deictics.) The same applies to an even greater extent to "oral text," which is fully and solely oral, as is sometimes heard on radio and as has existed in bardic and other storytelling traditions for centuries.

"If there is speech, then somebody is speaking." This is the general feeling, even about books. But the film equivalent of this inner and immediate sentiment is far from certain: "If there are images to be seen, then somebody has arranged them." This will not ring true for many people. The spectator spontaneously attributes a film's dialogue to an embedded instance that is at one remove, and he attributes the spoken words of a narrator-off or of an anonymous, apparently independent, commentator to a position of enunciation that is still fluid and uncertain, a little submerged or at least veiled by the image (on this see André Gaudreault's excellent comments).[20] It can never pretend that the primary, true enunciation is not that of the "Great Image-Maker" [*Grand Imagier*] evoked by Albert Laffay, which is the figure who orders images and even voices (*and voices as images*), the figure whose broadly extralinguistic activity does not give a clear feeling of a personified enunciative presence. But usually this spectator is unaware of the Image-Maker. On the contrary, the spectator does not believe that things reveal themselves: he simply *sees images*. André Gardies, although he is an advocate (as am I) of a theory of enunciation in cinema, entertains significant doubt in this respect and declares that the notion of enunciation in film is perhaps only an anthropomorphic metaphor.[21] André Gaudreault observes that a linguistic utterance is automatically attributed to a particular person, identifiable or not, and that this certainty starts to wobble as soon as we are dealing with nonverbal utterances.[22] We should also remember that the verb "to enounce" [*énoncer*], which is common in French, is uniquely applied to the act of speaking or writing (cf. the wording of a problem [*l'énoncé du problème*]), thereby conveying the widely shared conviction that the only genuine language [*langage*] is a specific language system [*langue*]. Moreover, when David Bordwell condemns the very notion of enunciation in film studies, he advances a very similar argument about the nonlinguistic nature of the object.[23] And we could add a number of assertions by Gérard Genette to the effect that film can never know how to be a narrative properly speaking, because it is not a creature of a language system [*langue*].[24]

Those who think the concept "enunciation in cinema" has any meaning must not take this rather powerful argument too lightly. It forces us into an important restructuring—that is, to conceive of an apparatus

[*appareil*] of enunciation that is neither essentially deictic (and so anthropomorphic) nor *personal* (as in personal pronouns) nor too closely imitative of this or that linguistic configuration [*dispositif*], because linguistic inspiration is more successful when it comes from a distance. As Pierre Sorlin asserts, "Often a film effectively marks its relation with the public by underlining that it is a film (a manufactured object based on visual and sound recordings), but without employing the slightest indicator of subjectivity." He adds, "In many films, markers of enunciation do not refer back to any delegated subject."[25] When enunciation marks itself in the cinematic utterance, it is not, or at least not principally, by means of deictic indicators but by means of *reflexive* constructions. François Jost has already described a very similar idea in an article that I will return to at the end of this volume.[26] A film speaks to us about itself or about cinema or about the position of the spectator, and it is then that we witness this kind of splitting in two of the utterance [*énoncé*], which in all theories is the thing without which it would be impossible even to think about an act of enunciation.[27] Deictic splitting, which consists of being inside and outside at the same time (and fictionally, if needed), is not the only possibility. Metafilmic (metadiscursive) splitting, which is internal, can also support a complete instance of enunciation all by itself. This *double fold*, as I will attempt to show, can take many reflexive as well as commentative forms that are common in film and numerous enough to cover the current list of terms for enunciative positions: *film within a film, address off, address in, subjective image, shot-countershot, flashback,* etc. The example of cinema (and probably other discourses) invites us to expand our concept of enunciation with the result that, for once, film theory might (?) feed back into semiology and general linguistics. There is, moreover, nothing surprising in that the types of discourse that exist, which are so diverse, offer such a range of enunciative arrangements [*dispositifs*]. In fact, it would be barely worth mentioning if not for the fact that enunciation is so automatically associated with deixis by some people. After all, what is enunciation *fundamentally*? It is not necessarily, nor always, "I—HERE—NOW." Broadly speaking, it is the capacity that many utterances have of enfolding themselves, of appearing here or there as if in relief, and of shedding a fine layer of themselves on which the trace of *another nature* (or another level) is engraved; a trace that is concerned with the act of production and not the product, or better yet, if you like, is engaged with production from the far side. Enunciation is the semiological act by means of which certain parts of a text speak to us of that text as an act. It is not necessary to have recourse to the

mechanism of deixis, which is complicated and resistant to comparison. There is a great variety of possible markers of enunciation. In orchestral music, for example, one would be the characteristic timbre of the instruments. When the oboe comes in, it not only plays its piece; it makes itself recognizable as an oboe. The musical message splits into two layers, each with a different status. In a film, if characters view an event through a window, then they are reproducing my own situation as a spectator, reminding me both of the nature of what is going on—a film screening, an image inside a rectangle—and the part that I am playing. But the textual construction that does this reminding is metafilmic, not deictic. Or rather, in this example, it is metacinematographic, since the rectangle of the screen is reminiscent of cinema as such. In a more general way, as François Jost[28] and Jean-Paul Simon[29] put it, cinema does not have a fixed list of enunciative signs. Rather, it makes enunciative use out of any sign at all (as in my example of the window), any sign which can be removed from the diegesis and returned to it straightaway. It is the *construction* that, for an instant, takes on enunciative value.

Bettetini correctly points out that film, despite its spoken words, is always on the side of the written, never of the oral.[30] This is true in at least one, crucial respect: the enunciator and the addressee (of the entire work, not just of some embedded dialogues) do not swap labels along the way, and the reactions of the addressee do not modify either the intentions or the words of the enunciator. This remains the case even when (as happens) canonical markers of enunciation appear, such as extradiegetic comments directed toward "you," the public. This "you" can never answer back. (Conversely, this example reminds us that deictics, even when weakened in this way, do have some function in cinematic enunciation.) Dominique Chateau has observed that cinema instigates "discontinuous communication";[31] the two poles of enunciator and addressee can never swap places or even come into contact with each other. Transmission is split into two moments, recording and projection, and they are kept apart by various technological or commercial mediators. For his part, Vernet describes very well the look to camera as the symbol of the encounter between reality and the spectator, an encounter that is always desired, sometimes nearly achieved but never quite—an encounter that is at the very basis of cinema.[32]

Bettetini's position on these problems, in his remarkable book dedicated to the subject, *La conversazione audiovisiva*, is very rigorous and at the same time strongly paradoxical. He describes film as a "conversation" (hence the title) between a simulacrum of the sender and a simulacrum

of the receiver, both of them being inside the text, constituents of its apparatus [*appareil*] of enunciation and mimicking an exchange so as to prepare for the later possibility of real interaction. The first paradox is that he has chosen the metaphor of conversation for types of discourse that are radically separate from one another; the second paradox is that Bettetini's work, which does not lack subtlety, insists greatly on this separation. Film is not interactive; it does not receive feedback, so the conversation that this book discusses is imaginary and, as it were, fantasmatic. Although Bettetini's work has its attractions, I will not follow his lead here.

So film does not include the equivalent of deictics, not counting speech and written text of course. But there is another exception; a kind of global, permanent (and, truth be told, very atypical) deictic, which is a kind of actualizing "*Here is*" that is vaguely demonstrative, always unspoken and always present, and that moreover is an aspect of the image rather than of film.[33] (The image of an object *presents* us with that object, as it has an indefinable amount of designative force.) Otherwise, moving images and recorded sounds have nothing that resembles either verb tense, personal and possessive pronouns, or "over there" or "the day after tomorrow." It is easy to think that they do, because film can express these kinds of spatiotemporal relations, but only in an anaphoric manner, within itself and among its different elements, not between itself and another person or thing. An appropriate choice of images can convey "the next day" to us (by evoking the intervening night, by making it clear that there has been only one night, and so on), but it cannot say "Tomorrow," which is to say: one day after the day on which you are watching this film. In a more general way there will always be an important difference between textual arrangements that *evoke* the figure of an author or of a spectator and words such as *I* and *YOU*, which expressly *designate* the people who are talking in a conversation.

Casetti notes in passing that, contrary to the skepticism of most commentators (and I count myself a determined member of this group), film might in fact use a certain number of deictic constructions.[34] He mentions only two. First are the technical traces, intentional or not, that reveal to us the work of the image and of the sound and that survive in the final cut. These are indeed, I will grant, markers of enunciation, but they are typically metafilmic fragments of second-degree discourse that speak to us about discourse. There is nothing deictic about them, unless we regard as deictic everything that shows or indicates something to us. According to Casetti, film credits could also be deictic. My "meta-discursive" point could also be made even more forcefully in relation to

credit sequences. Besides, credits are entirely borne by language, which is written and sometimes spoken. It is true, however, that credits inform us, if not about the reality of the work of production, then at least about the names of the team that made the film, about the *auteur* (will this point cause confusion?), occasionally about the locations used, and usually about the approximate date of the film. But all this information does not come to us by means of deixis. If it is 1988 and I go to a new film, the credits don't tell me that it was "filmed this year." But if it specifies the year 1988, this can be understood by anyone without any particular information about the circumstances of enunciation. In this case deictic mechanisms are precisely what must be avoided because, taken in their purest form (a variable signifier for a unique referent), they would mean that the film would need to be updated constantly. I hope that the reader will forgive this crude example and rather trivial revision, but it is my aim to counter the figurative and overbroad usage of deixis.

On the subject of film credits, Casetti recalls the now-famous final sentence of *The Magnificent Ambersons*, "My name is Orson Welles," which is spoken by Welles himself.[35] The reflexivity is clear. It is mixed, on this occasion, with authentic deixis because if these same spoken credits had been narrated by a representative of RKO, we would have, "His name is Orson Welles" (I have plunged into absurdity by now). The signifier would have changed without any change of referent. The film admirably integrates this possessive into its overall construction: it is the voice of Welles that "takes on" the narrating voice of the story and authoritatively permeates the final minutes of the reel. But by its very nature this deictic construction is not cinematographic; rather, it is purely linguistic, and it is as such that it intervenes in the film, hence its power.

What Casetti proposes is a "system"—and one of considerable intellectual heft at that—which rests entirely on cardinal points that he considers to be the fundamental enunciative configurations of the cinema, or what he terms the "coordinates" of film enunciation. He is of course well aware that film presents us with many other enunciative positions, such as the various kinds of subjective framing that have been studied in great detail by Edward Branigan and that, in Casetti's account, would probably be treated as pertinent variants or derived instances.[36] Casetti's objective is different, as it is deliberately synoptic and general, like an aerial photograph. On more than one point he rehearses Bettetini's arguments, but he views himself as more "technical." He is the first to propose a set of formal elements for the whole set of film's enunciative

apparatus [*appareil*] along broad lines. In light of this it is no accident that my comments are directed toward his account of things.

Setting aside two constructions that Casetti studies elsewhere in the book[37]—the flashback and the film within a film (both of which I will return to presently)—he proposes the following four-part typology.[38]

1. *The objective view* (what the Anglo-Saxon tradition calls "nobody's shots"). They follow the formula: I (the enunciator) and YOU (the addressee), we watch IT/HIM (the utterance, character, film).
2. *Interpellation* (i.e., looks to camera and various modes of address): I and HE, we watch YOU, you who are then supposed to watch.
3. *The subjective view*: YOU and HE see what I am showing you.
4. *Impossible objective views* (i.e., unusual angles ascribed to the *auteur* that are impossible to attach to any character, and other similar constructions): "As if YOU were ME."

The second case, interpellation, includes a variant in which the enunciator does not slide into the HE of a character but into that of the entire scene, for instance when there are screens within the screen, mirrors, windows, folding screens, etc. (this is a rather loose grouping, in my opinion). It could be formulated as "THIS is for YOU, this is cinema; i.e., it is ME." We may remark that there is the idea of reflexivity ("this is cinema") in a general concept that is dominated by deictics, in fact far more so than Casetti states. He declares for a start that personal pronouns will be for him simple "equivalences with indicative force,"[39] but later on it is they and they alone that fit his formula and exemplify his distinctions, up until the moment when we realize that they are barely metaphorical and that their function has been much more than indicative. In fact, Casetti says toward the end, "[In enunciation] somebody appropriates a particular language [*langue*] . . . ; people articulate relations among themselves (the appropriation lets us distinguish between an I, a YOU and a HE/IT), etc."[40] So we are dealing with personal pronouns that are (almost) real. I will leave aside for now other aspects of the book. Casetti's range is a good deal broader, and he convincingly tackles more than one aspect of film, including the register of metadiscourse.[41]

Every concept of enunciation that is excessively marked by deixis entails, leaving spoken exchanges aside, three principal risks: anthropomorphism, an overemphasis on linguistics, and the slide of enunciation toward communication (i.e., toward "real," extratextual relations). Casetti himself rarely gives in to these temptations; in fact, he even warns us

against them, but in theory the risk remains (I say "risk" in the singular because the three are inseparable).

First of all, when a film is being shown, it is generally the case that there is (at least) one spectator. So the instance of incarnation of the target is present. But the instance of incarnation of the source—the film-maker or the production team—is usually absent. Bettetini attributes some importance to this dissymmetry, and so do I, because it is at the root of the mismatch between the interaction that takes place in cinema and the relation between persons that is supposed to exist in language.[42] A film does not take place between an enunciator and an addressee but between an enunciator and an utterance, between a spectator *and a film*, that is to say, between a YOU and a HE/IT. When we distinguish between them like this, their meaning becomes blurred, since the only human subject that is right there, and capable of saying "I," is precisely the YOU. It is moreover a common feeling, except of course in the spe-cialized company of filmmakers, that the "subject" is the spectator. This is certainly in evidence in works of psychoanalytic semiology that deal at length with the "spectator subject."

For Casetti enunciative poles are roles (the same term that Brani-gan uses)[43] that will subsequently be filled during the actual screening by bodies[44] (the same term that Bettetini uses).[45] This is a good way of putting it, and it touches on something essential. But where the enun-ciator is concerned, there is no body. And as it is true that the roles, or their equivalent in another theoretical framework, call forth an incarna-tion (the nature of this calling forth remaining somewhat enigmatic), the "enunciator" incarnates itself in the only body that is available, the body of the text, that is to say, a *thing*, which will never be an *I* and is not empowered to switch roles with some *YOU*, and which is and remains the source of images and sounds. *The enunciator is the film*, the film as source [*foyer*], acting as such, *oriented* as such, the film as activity. And this is just how people think: what the spectator has in front of him, this thing that he has to deal with, is the film. Casetti's notion that there must be a body for the addressee and for the enunciator is inspired by the first two persons of the verb in language.

Not being an *I*, the source [*foyer*] of enunciation does not produce a corresponding *YOU* or *HE/IT* on the screen. The utterance, the film itself, the character, does not have the characteristics of a *HE/IT*. *HE/IT* is what Benveniste calls the "nonperson," the one who is absent. But the film is not absent. *HE/IT* above all is the absent one insofar as it is spoken of by two who are present—that is, "I" and "YOU." Far from a

person who is absent squeezed between two who are present, the film is more reminiscent of somebody present squeezed between two who are absent—that is, the author, who disappears after the film is made, and the spectator, who is present but whose presence is not manifested in anything, as he knows all there is to know about having no role.

Another difficulty arises in relation to the action of "watching" or "seeing," which are obviously very important when talking about cinema. At times Casetti uses these verbs with "I" as a subject-enunciator. Thus, "You and I, we are watching it" is the formula for objective framing. For Casetti, "I" can designate only the body or the role of the filmmaker. If it is the filmmaker himself (his body), he does not watch; rather, he has watched (and even that is not precise—he has *filmed* and, in the process, watched: the "sender" [*émetteur*] does not watch his own film; he makes it). If this is the role of the enunciator, which is more probable, we cannot understand either how this ideal figure, who is, so to speak, upstream of the film, can watch anything. From the side of the source [*foyer*], nothing watches or sees; the source produces, radiates, *shows*. The apparent parallel between this enunciator (in the example of objective framing) and the addressee who sees is an artifact inherited from the symmetry of deixis. Drawing parallels with deixis can in various ways subtly falsify this authentically new system that has contributed so much to the field. So it seems to me that to conceive of the spectator as an *interlocutor*[46]— an idea that has existed for some time in textual semiotics—is pointlessly provocative once it is shorn of the very thing that defines it, which is the idea of possible immediate interaction. Also, if the cinematic spectator is an interlocutor, what shall we call the users of media that really are interactive, which exist already? Technical terms are not obliged to follow everyday usage, but at the very least they should not contradict it.

As for the reference points of the target and of the source [*foyer*], I have chosen the vague and cautious phrase "instances of incarnation." My reasoning is this: if it is the case that the source [*foyer*] and the target, which are basically just orientations of the text, call for *external* support, this does not render the support *real*. Or at least it is real only (and this is when we have the spectator or author who is, as they say, "empirical") in studies that are themselves empirical, based on surveys and questionnaires, organized test screenings, and the like. Research into enunciation does not avail of methods like these; rather, it is usually based on the analysis of film and remains "internal." This latter kind of research needs to *constantly conjure up a Figure of the Spectator*, and throughout we read that the camera is turned, for example, toward the spectator

(or toward the addressee, because the idealized status of the spectator sometimes makes it hard to distinguish which side of the alleged distinction is intended), or that the spectator is watching the left side of the image, or that he is associated with one particular character and not with another, and so on. In the end, while the two "real" poles of sender and receiver are imaginary, they are indispensable mental crutches for analyzing films; they are indispensable and can be very legitimately used on condition that one is well aware that this "real" is nothing but the imagination of the analyst. The analyst effectively succeeds in constructing the "spectator" and the "author" on the basis of two information flows: the unfolding of the film, and the reactions of the individual (as well as real) spectator that he himself is—a spectator who will also tell himself that a particularly sudden or unmotivated camera movement must correspond to an "intention of the author." This indeed is the case in film, or at least this is the only way we can construe it. But nobody knows the real intention of filmmaker X. As Branigan puts it very well, the work does not supply *any context*—no "frame," no "cadre," in this perspective—where the figure of the author can be placed.[47] To read a text, one is forced to fabricate an imaginary author as one goes along, in the same way that the author in the process of writing this text could do no other than construct an imaginary reader.[48] These remarks seem to me as essential as Bettetini's insistence on the fantasmatic character of the protagonists in the "audiovisual conversation,"[49] which I will return to.

In some excellent passages on the subject of visual "interpellation" Casetti declares that in the look to camera, the place of the addressee is an empty space in front of the screen, a space that is created by this blind look, the only out-of-field that can never enter the field of vision.[50] This is a keen analysis of a filmic configuration, but it cannot guarantee anything (in fact, it abstains from doing so) as far as real reactions of spectators are concerned, even though these spectators are supposedly represented by the addressee whose position is indicated to us. It is a safe bet that most members of the public have a much less subtle conception (or no conception at all) of the look to camera and that the public's "instinctive" responses themselves, both affective and visual, vary considerably according to who is in question and when. Certainly for any single image, there is no point on the screen (or even around the screen) that cannot become the "place" of one or several spectators. Hence the futility of certain empirical research projects that attempt to distinguish between interchangeable or wholly similar alternatives.

Even when it is about enunciation, textual analysis is still textual analysis. If you are interested in information about the viewing public and filmmakers, you have to go and gather it in situ, and you can't do without experiments or data collection. There is no point in discreetly letting on that getting to know the enunciator and the addressee would furnish us at least with probabilities or general frameworks for understanding the intentions of the author and the reactions of the spectator. These predictions are so general that no empirical study would accept them, and they could be proved false in relation to every individual spectator, even if they express a slight tendency that is common to many. This is because we are dealing with two orders of heterogeneous reality: a text (which is, I repeat, a thing) and people; that is, many different people and a single text. Pragmatics, at least when it sticks to the text, knows how to accept this limitation, which it resents even though it is nothing to be ashamed of. The spectator is subjected to multiple influences that the film obviously cannot predict; also, at the same time, it is not necessarily a contradiction to say that a film has "positioned" the addressee on the right of the screen and that such and such a spectator has directed his gaze toward the left (Bettetini's theory devotes a lot of space to discrepancies like this).[51] For all these reasons it seems to me that analyses of enunciation retain their usefulness and autonomy. What seem like vague "realist" tendencies turn out rather quickly to be temporary voluntary illusions. For instance, Casetti declares that the YOU assures the interface between the world of the screen and the world of which the screen is only a part[52] (i.e., apparently, then, enunciation *really* is one-to-one and really does have one foot in the world).[53] But a page earlier, Casetti reminded us that the empirical YOU is definitively outside the range of the film.[54] This is true, but is it also true for the interface-YOU? (Casetti is indeed acutely aware of the uncomfortable and "interstitial" character of the pragmatics project as a whole.)[55]

One final point, which may be superfluous: I am not pretending here that enunciative configurations are free of any influence on the observable behavior of spectators. This is a hypothesis that is as improbable as that which posits film's determining influence as undeniable. But to measure this influence, you have to go and observe it, which means leaving the text.

Film enunciation is always an enunciation about film. More metadiscursive than deictic, it does not inform us about the out-of-field but about the text that bears within itself its own source [*foyer*] and destination [*visée*]. For Branigan, narration in fiction film is in the position of a metalanguage in relation to that which is being narrated.[56] We will

see by and by that this "metalanguage" (which still needs inverted commas around it) is rather a *commentary* on, or a *reflection* of, the film, and sometimes it is both at the same time.

Two friends in conversation exchange *I* and *YOU* according to the physical reality of their turns to speak. A film "speaks" alone and without interruption; it does not allow me to speak, and it is enclosed inside itself (it is completed in advance, one size fits all). When the filmmaker appears in the image, as Hitchcock does in his films—in a figure that would seem to be reflexive and deictic at the same time—it is not, to use another remark by Branigan,[57] Hitchcock the film-er that we see, a filmmaker-auteur (an "external" instance), but a filmed Hitchcock, a character, a little piece of the film. Yet it is a metafilmic construction because we still recognize the filmmaker. There is always a moment, Branigan insists, when the film cannot reveal the conditions of its birth anymore and where we come up against an "apersonal component,"[58] which is a nice phrase, as it once again expresses the film as thing. Branigan also cites the famous opening credits of Godard's *Tout va bien*, where we see hands signing checks (the filmmaker wanted to demonstrate the role of money in film production, including his own films).[59] For the American analyst, who is pitiless and correct, unlike those who think films *really* can "show the apparatus [*dispositif*]," these images that are intended to be devastating in fact form one more ordinary scene of the film, since the act that shows us them is itself not shown. In a more general (and simplistic) way, we can say that the camera, without the aid of a mirror, can never film itself. It is like our eyes, which cannot see themselves. So we can also say that the supposed outside-the-text can only be part of the text, of the redoubled text, of the metatext. Bernard Leconte has shown convincingly that reflexive figures are even more prominent in television than in film, and he has already enumerated and defined a certain number of them.[60] The idea is that television does its utmost to multiply the number of opportunities and ways it can find to talk to us about television.

The textual enclosure of filmic enunciation is particularly clear in common and, so to speak, anonymous figures. So when we are told, as we often are, that in the "sonic first person" in voice-off, the enunciator has provisionally borrowed the voice of a protagonist, we are treated to a little to-and-fro in which all the terms are internal to the film: the enunciated marker of the enunciator (see Casetti), the "voice" of a character, the presence of explicit narration, etc. This is one example among many of the various types of metadiscursive fold that make up filmic enunciation

by folding the various components of the film into each other, just like folding a napkin.

The source [*foyer*] and the target [*cible*], considered in their literal sense, in their discursive identity, are not roles but *parts of text*, or aspects of the text, or configurations of the text (in this way, a shot-countershot stands out in the midst of a sequence of images). So source and target are, rather, *orientations*, vectors in a textual topography, instances that are more abstract than is generally admitted.

The source [*foyer*] is the entire text seen from upstream, in its ideally elapsed order. For Casetti, one attribute of film is that it "makes itself." The destination [*destination*] is the same text seen from downstream, going against the current, imaginatively unmaking and unloading itself. This is the moment that Casetti calls "giving oneself."[61]

On a couple of occasions, Casetti gives the example of the famous scene from *Gone with the Wind* where a strongly marked and spectacular backward traveling shot "loses" Scarlett in the midst of thousands of dead and injured soldiers lying on the ground, just after the Battle of Atlanta.[62] Casetti says that this camera movement simultaneously figures the way in which the scene is constructed (i.e., by the enunciator) and the way in which it demands to be read (i.e., by the addressee). One could say this of any sequence, and it is true. To move from one of the figurations to the other, all one has to do is *turn the text around* and look at it from the other end, even if this is to obtain two constructions that are completely parallel. (After all, in principle the reader only decodes what the writer produces, yet their respective activities move in opposite directions.)

Subjective images present another case in which, for Casetti, the role of the enunciator is effaced, while considerable value is placed, by contrast, on the addressee.[63] This is because he finds himself "syncretized" with a concrete character, that is, the person through whose eyes we see what we see and who is, therefore, like this addressee, someone who watches. This is not in doubt. But it is also the case that if you invert the text, the enunciator takes on his importance again insofar as the source [*foyer*] is "figured" in a character who is not only someone who watches (like the spectator) but someone who shows, like the filmmaker who stands behind him. This character has one eye looking forward and one eye looking behind, receiving images from two light sources. So the image can be interpreted in two different ways, like in drawings where the figure and the background switch back and forth.

Casetti is also for that matter very sensitive to the internal workings of the phenomena of reversion, even if he does not address them

separately. He emphasizes that "point of view" in cinema can be the place of the camera, and it can be the place of the spectator (they can coincide, but they remain distinct) to such an extent that enunciation, from the start, is split between *a showing* and *a looking*.[64] From the psychoanalytic perspective I would add that primary identification with the camera has the effect of transforming it into a retroactive delegate of the spectator to come (Gaudreault has written impressively on this idea).[65] I would also add that the projective-introjective qualities of this machine, a recording device that is also a pointed weapon, make it as ambivalent as the view itself, which it is difficult to characterize as active or passive because it receives and projects at the same time. Hence a symmetry, a *reversibility* of the source [*foyer*] and the target, which I have given some examples of and which is perhaps responsible for the theoretical recourse to deictics, which themselves are reversible in language. But these are two very different reversibilities, even if we call them both by the same name: in one case, the signifiers physically change their position and start to move for good; in the other, it is the spectator or the analyst who inverts his perspective without touching anything.

Another striking example is the look to camera, which I have discussed already. It is obviously a figure of the target. The destination point provisionally coincides with the position of the camera (because it is being looked at), and it is rare for the instance of reception of a film to be solicited in such an explicit way, that is to say, for the spectator to be directly intervened upon by the diegesis. But this construction also highlights the source [*foyer*], which is clearly depicted, for a moment, by the eyes of the character-viewer. The source [*foyer*] matches and redoubles the vector of this look. Observing this, Casetti suggests that the *I* has created an interlocutor for itself (hence the strong presence of the *YOU*), while profiting from it in order to affirm itself fully.[66] But this sounds like a novella in which the characters play tricks and mind games on each other. In fact, if the spectator, real or imagined, and the analyst (who is always deemed to be real) "turn" the text in the same direction as the viewer in the story, the story acts as the source [*foyer*] but also as the target because it is under fire (!) from the camera. And if we mentally turn the text in the same direction as the camera, the camera becomes the target of the viewer and even enables the existence of this same look, because it is a camera and so a source [*foyer*].

This is not to say that all figures of enunciation are reversible. If I have emphasized some of them that are, it is to draw attention to the abstract and yet (perceptive) textual character of the two "places" which

for the moment I am calling the source [*foyer*] and the target. These are not fictional characters, like the enunciator and the addressee, nor are they even things exactly; rather, they are directions that obey the geography of the film, orientations that are detected by the analyst. In a sense it is true that the action of a film plays out in its fullness between two poles, or two *plots*, as there always must be those who made it and those who are watching it, whatever name we attach to them. But when they mark themselves at a precise point of the film, it is important to describe the trace of this imprint that from this point on is depersonalized and has the status of a landscape. Even when the filmmaker addresses us using a person's voice-off, an anonymous and overseeing commentator, the result in the text is a unidirectional vocal crossing, whose source [*foyer*] is this profound organ that, lacking a "marker" of the target (if we assume there is no diegetic audience at all), disperses itself across the entire surface of the image, covering it like a coating.

Unlike the previous examples, this figure is not reversible; rather, it marks the source [*foyer*] and it alone. The "movement" of the voice makes sense only in one direction, and there are no means of turning the text for lack of a coherent construction in which the voice-off would be the target. Nonreversible figures are numerous and common. Among them, of course, are all types of film *address* (voice-off, voice-in, semidiegetic, intertitle, etc.). Equally, though this is not an exhaustive list, there is "impossible objective" framing, already mentioned, which is perceptibly deforming but impossible to attribute to a character and so corresponds to a direct intervention by the "author." A classic and often cited (notably, and with finesse, by Jost) example is Orson Welles's systematic use of low-angle shots.[67] In these the idea of orientation could be taken in its almost literal sense, since the marker of enunciation is the unusual coefficient of the shot angle. The "manner" of a work is a perpetual commentary on what the work is saying. This is not an undeveloped commentary but the opposite, one that is *enveloped* in the image. The factor of enunciative intervention cannot be reduced and, giving birth to the metatextual gesture, it is still half-stuck in the thing that will presently designate to us. It is also, taken together, foreshadowing a "style" (see pages **123–127**). But to return to the source [*foyer*] and the target, I would only like to say that they always consist of movements or perceptible (audiovisual) positions, or more exactly of reference points that make it possible to describe these movements and these positions.

The kind of validity we can attribute to textual analyses of enunciation can be compared, up to a point, to that which characterizes

semiological-psychoanalytic research. In each case, assuming the ana-
lyst has the necessary training (i.e., knowledge, methodology), the entire
value of the work depends on his personal qualities, because he is both
the researcher and (along with the film) the very *terrain* of research. He
can declare that the specific pleasure of the fiction film is derived from a
fetishistic process of splitting and a mix of belief and unbelief. He does
not need to survey people who might have great difficulty in respond-
ing on such an issue. It is a truth that is general or, more exactly, *generic.*
It concerns THE spectator. Everyone can find this truth in himself. It
does not tell us, for example, in the case of so-and-so that belief clearly
prevails over unbelief or that unbelief dominates in another case. There
is no contradiction here. The generic finding remains interesting and, in
my opinion, more so than findings that pay attention to its variations or
local modalities. But only empirical methods are adequate to describe the
curve of these fluctuations, which are inescapable once "real spectators"
enter the scene because the question to be answered is itself empirical.
And once we reach this point, the generic spectator, like the addressee
in pragmatics, has (or these two analyst figures have) little more to say.

So I will return to the terrain where they can speak, which is the anal-
ysis of enunciation that accepts itself as such and does not try to jump
out of the film to monitor the docility of the public—that is, *textual
enunciation* strictly defined, which sticks to the text and the text only.
We have seen that Casetti proposes a system of four precisely defined
terms, which has the merit of totally "covering" the field and which, it
seems to me, can barely be improved on for the time being within the
bounds of its own logic. I am tempted, however, toward a different, not
contradictory, approach that is unconcerned (initially) with the general
tendencies of enunciative positions but that aims to explore a number of
the most important of them in detail, in their singularity. Even so, this
number would fall very short of what films offer us because enuncia-
tion, we should not forget, cannot be reduced to localized and seemingly
disjointed "markers" (this is the humanoid concept: the footprints of the
semihuman Subject who is positioned both outside and inside). Rather,
we should not forget that enunciation is coextensive with film and that
it plays a part in the composition of every shot, so while it is not always
marked, it is active everywhere.

Once we have started to explore this shifting terrain, how can we not
try to distinguish between, for example, the classic "film within a film,"
which itself is susceptible to a great number of variations, some of which
we will try to pick out, and the presence in a film of a foreign profilmic

instance, such as a scene from another film in the process of being shot, which will then palpably modify the impact of the secondary film on the primary one? How could we not pay particular attention to sequences that display cinematographic equipment, being used to make a film *en abyme* or, more rarely, to make themselves? And how can we not ask ourselves which elements of the apparatus [*dispositif*] are on view: are we being shown the actual lamps on set, or (a very different gesture) is the motif that is filmed intended to remind us of the flatness of the screen? Does the film explicitly address the spectator, and if so, does it use voice-off, voice-in, or onscreen text? I will therefore make a survey of these and other figures of enunciation across the entire shifting landscape of modes of addressing the spectator, with a greater focus on describing them than on finding an organizing principle. I will limit myself, without attempting to exhaust the subject, to the most common constructions, that is, those that films often use or have used and that belong to a kind of collective, *rule-bound* heritage, as the names themselves testify ("out of field," "intertitle," etc.). These names reflect a whole tradition that at times needs to be redefined or defined more precisely but I have refrained from repudiating them at a stroke. The itinerary that I have chosen will bring me, at a considerable pace, through a hundred or so sites of enunciation that I have gathered together under ten headings, plus an eleventh fake heading (all will be explained). But for now, on to the first category!

PART II

SOME LANDSCAPES OF ENUNCIATION (A GUIDED TOUR)

2

THE VOICE OF ADDRESS
IN THE IMAGE
The Look to Camera

Cinematic narrative uses various methods that have been unevenly codi-
fied to address itself in more or less "direct" ways to the spectator. Quote
marks around this adjective are called for because it is obviously the entire
film that *targets* the person who will watch it; the film is trained on the
person who is trained on the film. But sometimes an unfolding narrative
(when there is one) likes to pretend to ignore this viewer and be surprised
by him, while on other occasions it seems to take him into account. These
then are different *modes of address*. I will say a few words about three of
them (there are others, classical and otherwise): address as voice-in, as
voice-off, and as writing (intertitles). This comprehensive grouping by
Francesco Casetti, plus the look to camera, is inspired by the term *interpel-
lation*, used in the Althusserian sense (i.e., the constitution of the subject,
in this case the viewer).[1] I am not going to deal separately with the look
to camera, which has been analyzed in depth, notably by Marc Vernet,[2] by
Casetti himself,[3] and in another, remarkable piece by Raymond Bellour in
relation to Fritz Lang.[4] There is no doubt this is one of the major aspects
of enunciation. To return to *interpellation*, it is a word that in current
usage too much evokes the idea of an obligatory or energetically solicited
response to fit the film (or novel), in other words a form of one-way "com-
munication" where the receiver (?) by definition never responds.

Unlike modes of address in spoken or written language, address by
the gaze is *reflexive*. It produces a particular type of mirror effect. Like a
rising tide meeting a river in an estuary, like a look that a mirror inter-
cepts and throws back at me, the beam that comes from the eyes of a

character *goes back against* (and stops in its own milieu) the flow that ordinarily issues from the projector, as well as from the eyes of the spectator that are trained on the screen. This suspense is rather similar to the precarious stasis of a weighing scale whose two sides hang half-way in midair. In this way the look to camera introduces a turning back that casts suspicion on the apparatus [*dispositif*] and heavily underlines it on its flip side. However, it "says" nothing explicit, whereas linguistic modes of address inevitably take on the force of *commentaries*, but there is nothing surprising in that difference.

Vernet, Casetti, and others have shown in detail that the look to camera often targets the real public via the spectators that belong to the plot, and it is true that the figure of the *diegetic public* hangs around every corner of cinema, as in one of the final sequences of *Sunset Boulevard* (Billy Wilder, 1950), where Gloria Swanson, who thinks she is a star again and is about to start filming, moves toward us with an intense look. Her image gets bigger, then dissolves, and we realize that she was looking at the public of the silent cinema, *her* public, which has also dissolved. I have borrowed this observation from Vernet.[5] In Alain Resnais's *Stavisky* (1974) every one of the partial narrators, each a witness to one of the various existences of the likable, exuberant, depressive crook, seems at first to look at and speak to the public in the cinema, before the camera pulls back to bring into view, with a slight delay, the members of the commission of enquiry whom each one is "really" speaking to. The gaze diegeticizes itself in a second step, as Casetti for his part has noted.[6]

In the history of cinema the look to camera has taken forms that might not occur to us. Noël Burch reminds us (among other things) that in *The Great Train Robbery*, by Edwin S. Porter (1903), the first image (or the last one, depending on the imagination of the cinema owner), which served as a kind of emblem for the film, shows the hero in a classic pose looking at the public and firing his revolver at them.[7] Much later, in the first James Bond films, the opening credits (once again) featured a very similar "innovation." But fortunately, most looks to camera do not include guns, and their "targeting" remains symbolic, and (in general) our safety is assured inside the cinema itself. In the introduction to his edited volume *Ce que je vois de mon ciné*, André Gaudreault convincingly points out that early cinema used the look to camera very often and as a "normal" device.[8] The actor acted like a person who knew he was being watched, and he himself readily looked at the camera. So it is a set-up [*dispositif*] that differs profoundly from what prevails today. The actor and the viewer were equals, each watching and being watched by

the other. Clearly the idea of the "look to camera" in its current sense (as a "marked" procedure, even if it is not as rare as we might think) does not apply to what Noël Burch calls the primitive mode of representation.[9]

Voice-in address, that is, the voice of address in the image, is now often combined (it is often said) with the look to camera. Nothing in fact prevents the person who is looking to camera from speaking to the public, and his voice is always *on*, because he has to give the spectator the spectacle of his opposing look. Groucho's "asides" solicit the complicity of those in the cinema against the object of his ridicule, and the stand-alone and come-all-you songs from musical comedies (Vernet and Casetti are both very good on this)[10] combine these two modes of address, through the body and through words. It is completely "natural," after all, to look at someone when speaking to them. A different but related construction is found at the start of Jacques Becker's last film, *Le trou* (1959–60). The person who will be the hero of the story, "Roland" in the plot (the actor Jean Kéraudy in real life), first appears to us elbow-deep in the engine of a 2CV, obscured by the open bonnet, partly visible from behind. After a brief moment he straightens up, turns, and says, looking at us straight on, "Hello. My friend Jacques Becker has told a true story in minute detail, and that story is mine." The *hello*, which reminds us of a friendly computer, is very rare in cinema, making this a strong mode of address.

This merging of two "channels" of address, speech and eyeshot, is also found where we would least expect it, outside of the credits, in genres that are less replete with markers than the musical or the burlesque, in the *mainstream* "realist drama" of narrative cinema. I am thinking, for example, of the famous scene in *La grande illusion*, which has featured in many essays, where the French prisoners stage a parody in front of their fellow prisoners, as well as their German guards, exploiting the language gap to make fun of the latter (whose incomprehension already makes a privileged receiver of the viewer-listener, making another, less examined, form of address). In the midst of the show, the news arrives that French troops have (provisionally) recaptured Douaumont. The makeshift troupe of actors suddenly turn serious and, still in their ridiculous costumes, stand to attention to sing the "Marseillaise." Without a hint of comedy they look straight into the eyes of the spectators who had been watching their clownish show and through them into the eyes of the French viewers of this French film of 1937, who heard the tones of their national anthem. This address is transferred via an intermediary inside the story—that is, the diegetic public once again. And above all,

I want to emphasize, it is effortlessly achieved in the midst of an "objective" sequence that is entirely contained in the fictional flow of the film.

With or without looks to camera, many songs in film are addressed to the public as much as to the character that hears them. We may recall in *Pépé le Moko* (Julien Duvivier, 1937) the fat old singer, whose success is long past, is now slumped in a corner of the casbah in Algiers, nostalgically playing the worn-out records of her Parisian youth. The gramophone is out of shot and the young voice with it, but onscreen the old woman "accompanies" herself and attempts to sing the song with what voice she has left, that is, with her voice-in (if we may put it like that), revealing the rather pathetic gap between her past voice and her present, fumbling efforts. The "play" between present and past is projected onto the discrepancy between the *voice that we see* and the one that remains invisible.

It was long believed, in a militant spirit of deconstructive avant-gardism and stout semi-ideological courage, that "markers" or open configurations of enunciation had the unavoidable effect, not to say the deserving definition, of breaching the ramparts of belief, of the imaginary and of the apparatus [*dispositif*]. It is still true that some do this. But others are no more than an aspect or moment (and this is no small thing) that is less *buried* than their neighbors within discourse, within the process of enunciation that conveys the fiction itself. So, enunciation that lets itself be "seen" is like a double agent: it denounces the cinematic illusion but is part of it. It has a role to play in the most conventional and inoffensive films. By dint of characterizing enunciation as an accusatory laying bare of the utterance, a revealer of shameful secrets, we almost forget that this utterance is what enunciation produces, and that its main function is not revelatory but constructive. I owe the Japanese researcher Takeda Kiyoshi for an excellent recent elaboration of this in French,[11] while Jean-Paul Simon has already described well the pitfalls of "unveiling."[12]

In *Nazarin* (1959) the Buñuelesque character of the dwarf, a tortured and mocked figure, entirely "Spanish," often turns his eyes to the viewer, as if inviting pity or simply consideration. When the woman with whom he is absurdly in love is led to prison, he remains standing in the middle of the village square (and in the middle of the screen), crying openly, always turned toward us, even uglier than he usually is. The image is quite insistent: he wants us to be able to witness his grief. The tears replace dialogue, which is another variant. The mode of address is here less "frank" than in Renoir's film, and if we had to, we could attribute all that we see and hear entirely to the diegesis. Thus, there are various degrees of "illocutionary force" in address and in other enunciative

devices, as has been well observed by pragmatists in relation to markers of subjectivity in language, encompassing the unavoidable deictic as much as the simple affective epithet, where yet another enunciative "presence" transpires (see Catherine Kerbrat-Orecchioni's excellent summary of these).[13] But to return to cinema, these hesitations, which we should not set aside too quickly, feed virtually into two opposed statements, one of which we tend to forget: if it is true that the signals that we want to be "pure" are sometimes engulfed in the diegesis, then a motif in the narrative can for the same reasons easily become laden with a trace of enunciative marking.

Sometimes it is asked whether such and such a construction, in itself, *is* or is not a marker of enunciation. We need the courage to discourage this kind of questioning straightaway. Even in language there are few terms that are by nature enunciative, apart from deictics, which are precisely missing in cinema. Cinema does, all the same, use extradiegetic optical effects, such as fades, wipes, and so on, which are more clearly discursive than other figures. But their relative specialization is not fully consistent, and even its own signposts can be submerged by the diegesis. On top of that, they make up only a small portion of all enunciative material. Whatever in a film (as in a novel) has the potential to be more or less a "marker" of enunciation is in fact more due to the overall once-off construction of a shot or of a sequence, a construction that often mobilizes conventions but changes their valence on every occasion. In the scene by Buñuel the twisted ugliness of the dwarf counts as much as the rest, yet nobody would dream of including a character's deformity among the usual or functional markers of enunciation.

The voice of an *explicit narrator* is another mode of address that is particularly evident in television, for instance in voice-over documentaries, reportage with commentary, television news reports, and so on. Eliseo Veron,[14] among others,[15] has already made great analyses of these. The *explicit narrator* (the notion is François Jost's)[16] is entirely engaged in speaking to us and is fully visible from in front or in slight profile, and his image only disappears to show us what he is talking about, in a paradoxical "alternating basis." (It is significant that cinematic documentaries, put under greater fictional pressure by their environment, generally use voice-off instead of this alternating style.) As for the voice-in, an example of this would be that of Alain Decaux in his historical television programs but also, in cinema, that of Anton Walbrook as the "presenter" in *La ronde* (Max Ophüls, 1950)[17] or of Werner Nekes in *Media Magica* (Werner Nekes, 1985), who is an auteur-demonstrator framed in

the midst of machines whose workings he is describing. Their status is "extradiegetic" in Gérard Genette's sense of the word,[18] which means they are speakers at the primary diegetic level and in the ordinary sense of the term. They are clearly separate from what they are narrating, describing, or explaining, which in Genette's terms makes them heterodiegetic, like the prisoner-actors in Renoir, who are neither narrators nor strangers to the story.[19]

The narrator-on-screen clearly addresses the spectator in a very direct way, combining once again the effect of the look with that of the voice, easily bringing a psychological aspect to the narration by his inflections and by the discreet seepage of affect.

We could analyze constructions of this type differently. When the image frames him, the narrator creates, or rather involuntarily constitutes, a secondary diegesis that "speaks" about his clothes, his body, and about the desk where he is sitting. The narration is not heterodiegetic; rather, it comprises two diegeses. The primary narration is "above" each of them as it ceases to coincide with the official narrator; this abstract function is quite similar to what has been very well described by Käte Hamburger.[20] It is a function that *brings together* the evocation of the period of the historical program and the views of the speaker at his little table. But for the time being it is the definitions of Genette, whose considerable heuristic richness is known, that will help me some day, at least so I hope, to leap into a rarely frequented little corner of cinema theory.

To sum up in broad terms: the extra-heterodiegetic regime is a common thing in addresses-in. Is this also true for the extra-homodiegetic regime? Here is the first example, which the popular television series *Les cinq dernières minutes* helpfully supplies: in the first season, where Inspector Bourrel—not to be confused with Cabrol*—was portrayed by the gracious, smiling face of Raymond Souplex. The established tradition was that, a few minutes before the end, the actor would turn to the public tapping his forehead ("But good lord, it's true . . .") and then set about the task of spelling out in a few words the workings of the mystery of the plot. He was an excellent raconteur (i.e., extradiegetically), but he was also a homodiegetic explicator involved since the start and, above all, in the whole unfolding of the investigation, that is to say, of the episode. The conjoining of these two functions only occurs for a few minutes

*. Bourrel was the detective in series 1, 1958–73, while Cabrol was in series 2, 1975–92.—Trans.

of the narration, but this is not important. Regimes of enunciation can vary, and they often do, in the course of a single "work." This is the case in film even more than in the novel because the variety of material gives license to multiple combinations and transformations.

Let me come back to the television historian Alain Decaux, whom I borrow from François Jost[21] as the innocent victim of my sampling, if for no other reason than his extra-heterodiegetic voice-in (nobody can do everything, not even members of the Académie française like Decaux). In the logic of enunciations, this combination has a high probability (hence its frequency on the screen), and there is something structurally "easy" about it. It is the image itself that undertakes the task of showing (always operating from "*in*," because it is the image) that the speaker is heterodiegetic. Decaux calmly sits in a hushed room, wearing a tasteful tie and glasses, a gentleness in his eye, while telling us a story about people exuberantly gutting one another, under the pretext of it being St Bartholomew's Day.[†] Conversely, the extra-homodiegetic regime, which is also easily enacted, *remains so only in voice-off*. This is a position of commonplace enunciation, notably in films that are "narrated" by one of their own characters.[22] The latter case splits into an off-screen narrator and a man onscreen who is also taking part in dialogues that we can see. This is a homodiegetic position because the individual from outside and the one from inside are supposed to be one and the same, and it is extradiegetic because one of them takes up the primary level of narration.

The process draws on conventions of psychological exploration, standard in the nineteenth-century novel. The speaker and the "person spoken about" may in fact be confused only in the shape of the *person*. But there is no person here, only characters, and as characters they are obviously not confused with one another (hence, for example, the idea of the agent [*actant*]). This happens even if they are separated by considerable perceptible differences, as in films where an adult recounts his childhood—for example, *How Green Was My Valley* (John Ford, 1941). This is only one manifestation of an instance of a concept of narrativity that can exist only by evoking a much greater split, and that is the *autobiographical lie*, which is triggered as soon as one starts speaking of oneself. "Objective" lies, not necessarily involving insincerity, are implicit in the act itself, which chops the actor in two (Lacan put it rather better), so that the two are no longer speaking about the

[†]. Massacre of August 24, 1572.—Trans.

same thing, since the speaker has his own interests, which are not necessarily in harmony with a candid personification of the person being spoken about.

In any event we have two enunciative "types" that are common in film or in television. These are, still using Genette's terms, the extradiegetic voice-in if it is heterodiegetic (e.g., narrators onscreen, external intermediaries in the fiction), and the extra-homodiegetic voice if it is *off* (i.e., self-narration on the primary level). All in all these make up two handles of a pair of pliers that places the voice-in that is my present concern in a manifestly more awkward position than at the start, as it is extra- and homodiegetic at the same time. It would effectively have to "belong" to a character who is more or less privileged, with the status of a primary narrator, but the leveling capacity of the visual rectangle—because I am assuming that it is "*in*"—makes it difficult to establish and maintain this marker of exception (offscreen speakers are powerful only because they are invisible, like God) unless it is isolated, like the iconic lecturer, by means of an inviolable change of level in the "reality" that is presented. But then, he becomes extradiegetic only by ceasing to be homodiegetic; he is no longer a character.

The pliers, however, afford a little bit of play and Inspector Bourrel's wink is not forgotten. The construction of every film, or at least of some films, can inflect the structural probabilities that abstraction supplies. In film narrations spoken by the hero, it can happen that the image loses interest for a moment in the events being recounted and moves to the figure of the narrator, who continues unperturbed (this is extra-homodiegetic) to speak to us about his life but for the moment with voice-in. Consider Arthur Penn's *Little Big Man* (1970): the character of the hundred-year-old man, the theoretical narrator of the entire story, sometimes appears in the image, framed in profile, or in half-profile from behind. In his cracked, rasping voice he makes various comments to the journalist who has come to interview him about the troubles of his tumultuous youth, which appear onscreen in other sequences, hiding the old man from our view and even depriving him, quite often, of speech. (This is a form of *Rahmenerzählung*, where the embedding narration and the embedded narration are drawn from the same imaginary substance, the focus at times being directed on the story and at other times on the conditions of its narration, which establish themselves in this way into a story mark II that is both distinct and identical.)

The same kind of voice-in, treated in a more flexible, inventive, and more ambiguous way, is to be found in Fellini's *E La nave va* (*And the*

Ship Sails On, 1983). The journalist character who has to "cover" the cruise of music lovers is seen at the end receding on the waves in his little boat with the rhinoceros and an amused smile. Most of the time the film treats him as a character like the others, but occasionally he turns to us in a resolutely extradiegetic manner and tells us a small part of the story of this unusual ship, where he himself is homodiegetically aboard. This lasts until another passenger, who requires his services in the plot, calls him or tugs him by the sleeve, causing him to abandon the screen and his address, depriving him of his intermittent prominence that is somewhat usurped from him by the overall narrator. (Although it may be difficult to settle the issue in many films, it seems that the entirety of the narration is not implicitly attributed to him.)

In *Urgences* by Raymond Depardon (1988), which is an amazing report on the psychiatric services in a hospital and on the misery of a big city and the benevolent inanity of a medical response that is largely underresourced, a very characteristic sequence shows us a doctor (a real one, who is being filmed at work) who, just after one of his patients has exited, turns toward the (future) viewer and speaks to him, to us, in the second person: "You see, this patient is a little better, sometimes we can get results." The "you see" fits the situation more than the doctor could have foreseen.

Let us imagine the same construction in its rawest form. For the whole length of a film a character who is constantly onscreen speaks to us. He never speaks to another character unless it is in a reported dialogue, which puts him in the position of being the only genuine speaker ("So I told him that . . ."). He is telling a story that he has played a part in and that he is relating to us while narrating everything else too. This would be, in sum, a spoken novel—or rather a *told* novel, as in [Jean-Marie] Straub—spoken by the photograph of the speaker, even if the image, as in some medieval illustrations, also shows some of what has happened to him or the frame which he is speaking in. The demands of audiovisual representation in standard narrative cinema make it unlikely that such a set-up [*dispositif*] would be fully deployed across an entire work. But aside from the fact that we have not seen every film and that we cannot consider them all, it succeeds in establishing itself on a smaller scale in sequences such as those I have just mentioned and in others. Some by Godard of course and above all by Straub, whose reflective temperament I love (I will come back to him). We find examples in some of the (sublime) recitatives in *Moïse et Aaron* (Straub and Danièle Huillet, 1974) or in *Mort d'Empédocle* (Straub and Huillet, 1987). I am also thinking of

the very moving narrations of the exiles in Chantal Akerman's *Histoires d'Amérique* (1989). In these very long steady shots of almost unbroken looks to camera, we see the images of Polish Jews who are telling their stories, while in the background is the undifferentiated, entrancing sense of New York, with its constant traffic, onscreen and off.

A difficulty of principle remains in the underlying contradiction to which I have already drawn attention. A character who is *visible and audible* (i.e., a "voice-in") can only be clearly and durably marked as extradiegetic (the first provider of the narrative) if he is heterodiegetic, exterior to the story. And if he is not exterior to it, if he is homodiegetic, he will have a hard time dominating it because he can be seen and heard inside it, physically "captured" in its substance. In the novel the extra-homodiegetic "voice" is nothing strange, and Proustian narration is emblematic of this. But books are made up only of written words; they have only metaphorical voices, and they are spared having to choose between *in* and *off*. Of these two, the one that is more strange to them—although there is some artifice in using these labels—is the "*in*" regime because it is defined by the presence of a rectangle of visual perception with sound included. "Off," which is pure voice, slightly separates film from the conditions of the novel, and it is not by accident that extra-homodiegetic narration, which is more difficult in cinema, ceases to be so in voice-off. Neither is it an accident that this "voiced first person" was immediately described as literary and novelistic by theorists who at the end of World War II, taking their cue from Jean-Pierre Chartier,[23] noted its great emergence in cinema, which had taken place a few years previously but had been "concealed" because of limited distribution during the war. As for the (relative) restrictions that the voice-in imposes on certain cinematic choices, they result as always from the *physis* of cinema. The inherent qualities of perception are less malleable than those of pure language.

In the rest of this volume I will no longer use *extradiegetic* in Genette's sense. It seems to me that expressions such as "primary narration," "primary enunciation," "first-level," and so on are fully capable of conveying the idea, and that there is an advantage—at least, as we have seen, for the study of film—to confine the term to its everyday, literal and "expressive" meaning—that is, *outside the diegesis*. Also, an explicit narrator is necessarily an *enunciated* narrator, who cannot coincide with the genuine source of the enunciation (I will come back to this point). For this, we will equally use the term "supradiegetic," proposed by Danielle Candelon, as it eliminates all risk of confusion.

So, the mode of address in voice-in can vary widely. It can be the lecturer showing a set of images; it can be the supposed provider of the primary narration when we see him speaking; it can be the ordinary character who at certain moments takes on a similar status (such as Fellini's journalist); or it can even—though this is difficult to distinguish from the previous example—remain largely enclosed inside the story, but leaving it enough intermittently to address the spectator in a clear-cut way (Groucho, Raymond Souplex). Equally, there are many secondary narrators, under the double condition that they are made visible and that they manage to pass through the quilt of diegesis in order to come into contact with us.[24] This can sometimes be very difficult to make out, and at other times it can be very obvious, as in the case of the unfortunate inmates of the hospital in Akira Kurosawa's *Akahige* (*Red Beard*, 1965), who recount the misery of their pathetic lives.

There are more unusual examples, such as diegetic characters in a film that, in one of its "moments," de-diegeticizes them to some extent. At the start and the end of Vincente Minnelli's *Designing Woman* (1957), each one of the character-narrators "presents" him- or herself (or takes leave) in a shot that was filmed for that purpose. Each one is dressed as in the story and sheds his or her diegetical status and name with brief light-hearted comments ("I'm the one who's the husband, so you see," etc.). Before the war, this procedure, which was no doubt distantly inspired by the "final bow" in theater, was common in French title sequences. Basically, each actor was identified most often by several images taken from the film itself and presented separately as on a poster, not by one image with a specially prepared speech.

Every mode of address has something to do with deixis. Because the film "addresses itself" to the spectator, the latter finds himself cast in the role of a kind of a grammatical second person. And as the (sound) film also uses language, this "you" can on occasion be uttered openly. But the affordances that are distinctive to cinema have nothing to do with this, and in addition—or consequently?—this "character" most often remains a little adrift. An onscreen speaker seems to address somebody who does not belong to the film, or even, if there is a listener within the film, the speaker seems to address himself also to somebody else who is somehow further away, beyond. A surfeit of voice seems both to build up and to elapse, and in this way it makes a *destination* of itself, uncertain yet lively, in a switching procedure that has been tried out in numerous films. The viewer-listener does not really think that *he* is being spoken to, but he is assured that one is speaking *for him*, and he does not confuse this

discourse with a dialogue that, in the same film, is restricted to its speaking participants. However, this dialogue is also ultimately destined for him, but the itinerary of the guided tour is no longer the same, as it now includes a demanding new stage.

The deictic function is obviously more marked in figures of film enunciation that take a linguistic form than otherwise. In a film, however, as in every recorded discourse, the grammatical second person, which is to say simply the second person, itself loses much of its deictic power. I will not revisit the impossibility of a response by the viewer and so of an exchange between the two people, an impossibility that means they are not fully people. We could speak of weakened deixis, as Käte Hamburger does in the case of the novel with her "faded" deictics.[25] This deixis may be weakened, but as I hope I have shown, it still works in its own way. Paul Verstraten is to be credited, as I mentioned earlier,[26] for his excellent analysis of this pseudodeixis (he borrows the expression from me) in the construction of a famous and moving film, *Letter from an Unknown Woman* (Max Ophüls, 1948). Verstraten convincingly combines deictic analysis with analysis by means of Greimasian shifting in [*embrayage*] and shifting out [*débrayage*].

Functioning like this, the address-in connects to a metadiscursive power that has been little discussed. It is clear that language often acts as a metalanguage for other means of expression, and "positioned" as it is in a mode of address in cinema, it continues to do this. If I may say so, it can be seen regularly taking a position of commentary and of linkage (e.g., *La ronde*), of explanation (the inspector on television), of proclamation (the prisoners singing "La Marseillaise"), of punctuation and adopting a distance (the journalist on the ship), of recapping or of mediation (songs in musicals), of officially endowing the image with meaning (Alain Decaux), etc. In sum, in all cases *a voice speaks to us from the film*, that is to say from the rest of the film, from the film that the voice itself encompasses. It can speak to us about the film a hundred ways, eighty of which I have had to omit. Its relation to the film can shift at any moment, but the fact of this doubling remains, through which the spectator, who is drawn by expressions *presupposing* what the same film gives him to see and to hear, finds himself obliged, if he is game, to suspend his consciousness that he is a spectator-listener, because *he is told so* as well. From this, it seems to me, comes the vague sense of a second person. This is in part because of the metalanguage, the folding of the film on itself, which gives the impression of deixis, blindly firing and hitting its target without knowing where it is, thereby creating a very particular YOU.

3

THE VOICE OF ADDRESS
OUTSIDE THE IMAGE
Related Sounds

In 1966 I tried to distinguish different stages in the evolution of cinema that leads to the gradual removal of voice from diegesis.[1] The degree zero is "realist," that is to say theatrical, dialogue, which is immersed in the image and the action, or which immerses them, which comes to the same thing. This is the most common setup. But the voice-in can also achieve a certain autonomy for itself, as in modes of address that I have just mentioned, and also when it slips into the solidly voiced chanting of a lyrical recitation (as in *Hiroshima, mon amour* [Alain Resnais, 1959]). But it is the placing *off* of voice that naturally enough provides the main contingent of extradiegetic voices. There are two main well-known types of voice-off: that of a character (the "speaking first person" of Jean-Pierre Chartier, the "I-voice" of Michel Chion),[2] and that of the narrator or external commentator, insofar as the former and the latter are absent from the image, as this is not always the case.

An example of the I-voice is when a character narrates an episode from his past in flashback. It establishes a position of enunciation that is, strictly speaking, *juxtadiegetic* (i.e., running closely alongside the plot). Its position at the edge of the story is due to the overlap—rather, the gap—established by the act of speech, but it is still the voice of a character, and it is a part of what it is narrating (this aspect becomes apparent with some distance). The gap is often itself made part of the story, never fully smoothed out, by some kind of psychological device, such as when the "the hero remembers" (as in *Brief Encounter* [David Lean, 1946]). I will deal with various I-voices at length on pages 107–16.

By contrast, some narrators' voices, like the one in *Paisà* [Roberto Rossellini, 1946] that relates successive tales of the difficult northward progress of Allied troops during the Italian campaign, do not have any basis in the story. If these voices do attach themselves to the story, it is from the opposite end, that is, because they recount the story, and so because they *are acquainted with* it.[3] But their position no longer matches that of some character, and he is himself impossible to situate more often than not. The film ends without our knowing who has been speaking. The place of the voice has been a nonplace. Hence its tendency to "make an address"; it is because a *supplementary voice* is involved that seems to hear itself in the film, and it is no doubt because it is there as a messenger and mediator and because it introduces the spectator via a level of access unavailable to the rest of the film. This is not to say, generally speaking, that the voice "speaks to it" in the ordinary meaning of the phrase but, once again, it speaks for it. This is weak deixis, connected to a commentative redoubling with the ever possible back-up of a true (linguistic/grammatical) second person.

Michel Chion has proposed a very useful typology for designating this voice:[4] voice from the pit, from the proscenium, from the speaker's lectern, "projected voice" when, despite its externality, it takes the form of a character and "encumbers" the scene with its "corpulence," as in the (semiexternal) voice of Sacha Guitry in *The Story of a Cheat* [Guitry, 1936], or of Jean Cocteau in *Les enfants terribles* [Jean-Pierre Melville, 1952]. This is also, for Chion,[5] a restrictive definition of the term *voice-off*, corresponding to the English term *voice-over* (not in the action or the image but a pure voice of commentary or narration), in contrast to the "out-of-field" voice—"voice-off" in English, inasmuch as the English terms themselves are fixed—whose visual anchoring is currently absent but has appeared onscreen and will return, "prowling" somehow among the images, captured in physical interaction with things that are seen, as when we "are" in the living room and we hear an invisible character humming a tune in the kitchen. This is a very important distinction, which could also be applied to sounds and to music and which gives rise, like all distinctions, to in-between and complex cases that Chion has addressed and which I will encounter in my turn.[6]

The voices of speakers who are constantly invisible are not necessarily, nor always, completely extradiegetic. Take once again *The Magnificent Ambersons*, with its commentary by the "hidden" voice of Orson Welles, who reveals his identity only in the end credits. This is not diegetic (obviously). But the text makes it clear, on several occasions,

that we should understand it to emanate from an inhabitant of the town, from a neighbor of some kind, and that his knowledge *is not simply that of a narrator*. This is the knowledge of an almost-friend, of a person walking by, of a person potentially playing a walk-on part in the story. The voice-off of the outsider-commentator thus allows a variant that is a little less outside, which we could call *peridiegetic*. It does not come from the diegesis but from what surrounds it, a zone that is both vague and close by. A similar (though more rare) instance is when an invisible voice addresses the hero as YOU (as in *La guerre est finie* [*The War Is Over* Alain Resnais, 1966]), which simultaneously distances him and keeps him within reach.[7]

Besides, an external commentator is not necessarily anonymous. The two are often confused. One from many examples (leaving Guitry, Cocteau, and Welles aside) is the voice-off of the actor Jean Servais in *Le plaisir* (Max Ophüls, 1952), an adaptation of stories by Maupassant. This voice is presented to us as if it is Maupassant's.[8] So it is in no sense anonymous, yet it is also external in relation to what we are shown, in the mode of the free-moving speaker of an old-fashioned documentary. So, a voice may be "named" as that of the filmmaker, as the author of the original novel, as a great moral character, and so on, without any of these figures encroaching on the story and its twists and turns.

It will come as no surprise that the address function makes itself felt with particular clarity in "supplementary" voices. This is an externalizing effect, a kind of refusal of diegesis whereby the voice is directed toward the ear from the outside, causing a rupture that is sometimes very marked, as at the end of *She Wore a Yellow Ribbon* (John Ford, 1949), where we suddenly hear an unknown, reassuring voice glorifying the famous US Cavalry. But the voice of a character can have the same kind of effect in certain circumstances, as we saw with some voices-in in the last chapter. It is yet more striking in the case of certain voices-off of characters or for "mixed" voices, which alternate in and off. The installation of the regime of address is based on what the speaker does not say in dialogue with the other characters, a trait which connects the external narrator to the "I" narrator, and it is based on how the voice is cast outward or at least a little bit off its own beaten track. The address function in cinema—as is also the case in language, which however uses deictics—has relatively fluid boundaries and allows for various degrees and modes that we must try to account for. A sentence such as "It is hot," which is clearly free of any specialist terms, evidently makes an address if, in uttering it, I am inviting my friend to open the window.

Coming back to the I-voice: it folds the story in on the narration and in this sense seems to close off the film and lock the Pandora's box. But at the same time, and contradictorily, the I-voice seeks to insinuate itself, like a linguistic pseudopod, into the foreground of the plot, into the position of a spokesperson that addresses in part the spectator-listener and in part God, the voice itself, or nobody (see Marc Vernet). We also need to consider the *coefficient of address*, which pertains to the I-voice itself but is more or less marked according to the film or sequence it is in. At times it is driven into a kind of silent paroxysm that tears the character in two. We may recall that the hero-narrator of *Little Big Man*, the man with the broken voice, is around 110 years old, while the narrated-hero, the "same" man, is followed in the narration only until the age of thirty-five or forty. The discrepancy between these two, in their physical appearance, speech, and so on is obviously great, and we barely get the impression that it is a man who is telling *his* life story. He speaks to us rather as if about another person, so that he who is speaking is also other, almost a stranger, much more narrator than protagonist. Yet it is him, because there is only one of him. But he speaks for us; furthermore, in the film itself the journalist who questions him, who *makes him speak*, is there to remind us of this because he (the journalist) represents us. The voice of a character, in sum, is also the voice of address. This is a common thing. In *Amadeus* (Miloš Forman, 1984) the wild old man fallen on hard times in the asylum no longer has much in common with the Salieri he once was, a hardworking and respected court musician who has been secretly ruined by his deep and jealous admiration for Mozart. The Salieri of the asylum is in fact a narrator, and he is speaking, once again, to a stand-in for the spectator, a priest who has come to hear his confession.

Elsewhere it is the very unwinding of the plot that "splits" the character and neutralizes one aspect of himself for the sake of the narrative function. Michel Chion and Edward Branigan have drawn attention to the structure of *Sunset Boulevard* (Billy Wilder, 1950), which is related entirely in flashback and in the first person by the dead hero (William Holden), who tells us his whole story and even the circumstances of his death.[9] His moving body and his voice-in are "living," whereas his voice-off, which "emanates" from the dead body that we see pitifully floating in the swimming pool, speaks to us from some other world, or from nowhere. And from Chion I will borrow the famous, magnificent example of *Anatahan* [Josef von Sternberg, 1953] and add my own interpretation.[10] The lost soldiers and the hero of the story speak their native Japanese in onscreen dialogue. But the film is accompanied throughout,

as if in a double exposure, by a *voice-over* in English, by von Sternberg himself, which speaks as "we" on behalf of this desperate remnant of the Japanese army. Chion notes that this voice is sometimes found somehow lacking by the image, so that the position it occupies is somewhat unclear. But it seems to me that this shortcoming is in fact very sensitive and very captivating, as it is based on the very characteristics of the voice. There is something diegetic about it, since its WE refers back to the unit of soldiers, to a genuine collective character, but one never knows *whom* it designates in that group, since it is anything but a united or homogenous group, and none of them speaks English. This evidence of von Sternberg's genius—the constant shifting of identity, the unusual resonance of the plural, the strange and deliberate mismatch of language—moves the English voice much closer to that of an external narrator, to a voice of address, and in the end to that which is "really" the voice of the auteur.[11]

So we may consider as voices-off of address, under different headings, at least three enunciative types (not including those that I am ignoring): the declared commentator, either extra- or peridiegetic (this is the strong type), while at the other extreme is the ordinary I-voice, with its inevitable *echo of address* (this is the weak type), and in the middle are certain specific constructions where the I-voice is more "extrovert" than usual (as in *Sunset Boulevard* and other films), less folded in on the plot and more turned toward the spectator. In truth it is always split between these two tendencies, but their relative sway can vary.

In all of these cases the mode of address is only rarely direct, and the public is not often interpellated in the second person. This is a perlocutory rather than an illocutory mode of address, to use the terms of pragmatism. But there are other modes. Near the start of *La bataille du rail* [*The Battle of the Rails*] (René Clément, 1946), a dry, didactic, very "1940s" voice tells us how German troop transports were organized on the French rail network. It then declares in conclusion: "I don't have anything else to explain to you." This voice will in fact intervene again (twice, briefly), but it is above all the YOU that is noteworthy, as it is an explicit and deictic mode of address. We can state once again that what makes comparison between cinema and language complicated is that the former uses the latter. We are comparing two terms, of which one is simultaneously alongside and "inside" the other.

Musical accompaniment also has an implicit effect on modes of address. Of all the elements that contribute to the materiality of the film text, it is music that is most often "normally" (if we can put it thus) extradiegetic. We will see later on (page **116 ff.**) that it can occasionally be

"juxtadiegetic" rather than genuinely external. But very often its relation to the action, aside from certain experimental pieces that are both well-known and rare[12] (Eisenstein, Michel Fano, the 1930s avant-garde, etc.), is of the order of simple convenience, rather general and loose, and when it acts upon us, it does so by lending more or less weight to the plot but also, for the greater part, by passing over its head (if we can imagine that plots have heads). This excess is inscribed, moreover, in the very notion of the extradiegetic. To paraphrase André Gardies for my own ends: music is "a singular form of commentary," but it does "not have the same power of suggestion as the verbal."[13]

Music produces affect; it is, as they say, "symbolic," etc. This has often been asserted if not analyzed. One would need to be a musician[14] to analyze offscreen musical address against the background of an image, which is obviously a very specific mode of address. Since the 1980s and the reign of the *nouvelle image*, music videos, in-your-face advertising, and music television, a new kind of connection has established itself at the lowest level, namely a totally new connivance between booming music that interpellates openly and even crudely, and a visual promised land that is sparkling, smooth, and fissured. Musical modes of address are more brutal than they used to be; they are more aggressive (higher decibel counts), more extravagant (synthetic-torturous sounds), more seductive (Dolby stereo), and even fastened to the image as if by some new kind of clamp. Now these shock-montages of images *cut* in sync with offscreen screams. A new sound cinema has been born, convulsive, bloated, and combining the attractions of hysteria with those of obesity.

Noises can also make an address in their own way. For this to happen, it is not enough that the spectator fails to locate noises "in" the frame, because many offscreen noises are clearly diegetical, nor is it enough, conversely, for a puzzling noise that is "internal" to the image to direct our attention to what is outside the image. What is important is that the noise is difficult to locate in relation to the narration, as in unidentifiable, extravagant, and unfindable noises. We are reminded here of the "free sound events" that are defined in the interesting typology proposed by Chateau and Jost, one of the first contributions to the analysis of sonic enunciation in cinema.[15] Not being part of the narrative, or being so against all logic, these noises spare themselves the detour through the story and go directly (or more directly) from the film to the spectator, who in turn perceives in them an "intention" to be interpreted, a variation of one of these famous "interventions of the author" that literary theorists eat for breakfast. Jost speaks of "punctuation-occurrences"[16]

for certain musical sounds that are treated as noises and that open an extradiegetic "gap" that designates the enunciator, while Roger Odin discusses a shot from *Zazie in the Metro* (Louis Malle, 1960), which did not make the final cut, where the character, while flushing a toilet (onscreen) activates the noise of a foghorn.[17] So the sound is both "in" (the flushing) and "off" (the foghorn). This is because the distinction, as I have already said elsewhere (rather briefly),[18] is actually aimed at the source of the sound rather than the sound. In Chion's work we find precise analyses of several other examples of this type, of which some are classics, such as the sound-evocation of the rugby match in *Le million* [René Clair, 1931] that accompanies the pursuit of the winning lottery ticket.[19] This was even more widely talked about at the time (around 1930), when the famous quarrel between "asynchronism" and "counterpoint" was raging.[20]

Noise and music, whose possibilities I have wanted simply to mention in this book, are obviously of lesser importance, at least as vectors of address and in normal films, than spoken or even written language, as I will explore in the next chapter. However, every sound element that is "off" or cannot be located tends more or less to detach itself from the story, which our reading habits construct according to the image that is augmented by *included sounds* (sounds that fill it out, that "are part" of it). A free agent by its very nature, the sound-off aspires toward the enunciative target that may be more or less close to the spectator-listener. In this way an autonomous layer of meaning, explicit or confused, is formed, which comes to *double* the story from time to time, to comment on it, to punctuate, contradict, and explain it, as well as to muddle it. As a result, this marginal layer of sound obliges the spectator who wants access to the diegesis to make an always somewhat surprising stop at the *semantic tollbooth*.

4

WRITTEN MODES OF ADDRESS

I hope I will be forgiven for my rather broad and completely provisional usage of the word *title* [*carton*] to designate intertitles and sub- or surtitles, when they are used other than for translating foreign languages. (By the by, when an intertitle is inserted against the background of an image, it can be mistaken for a surtitle.) So what I have in mind is all of the written content that is *original* and yet *added to the image*, which excludes writing in the form of shop signs, signposts, and newspaper headlines. A filmmaker such as Godard often transgresses the dividing line that tradition has firmly established between these two kinds of written content (titles and instances of writing that appear on film).[1] As for the written content of the credits, see Gérard Blanchard, Roger Odin, André Gardies, Francesco Casetti, Nicole de Mourgues, David Wills, Michel Marie, and others. The credits have an obvious function of address and even, what is rare in cinema, an "official" function. I will not devote any further space to this, except to recall that, despite appearances, it owes little to the deictic system.[2] There is a greater difference between deixis and mode of address than is often allowed.

Titles that are within the film itself come in two main forms. When they report dialogue in silent films, they are diegetical, or, to be exact, they are diegeticized by the spectator by virtue of a *convention of metonymic attribution*. They are, in the full sense of the term, "put in the mouth" of characters appearing just before or just afterward (see Claire Dupré La Tour's analysis of this).[3] Explanatory titles, by contrast, are "posted up" phrases whose enunciator and receiver could not plausibly

be characters, and they do not appear to be compatible with a conversation, so the spectator is their most likely target. For example: "But shortly afterwards, the little shopkeeper fell ill . . ." (note the tense of the verb). This external status can even be explicit: "Joséphine *did not know* that the worst was yet to come." These sentences emanate from the source [*foyer*] of enunciation and, for the duration of one title, the narrative (or filmic-narrative) act is content to inform the spectator directly, provisionally withdrawing sustenance from the intervening and autonomous *nature* [*physis*] of a character. Just think, for example, of the naive, pompous, and emotive intertitles that Griffith uses to guide, emphasize, justify, and interrupt the actions of his characters!

Commentary titles weave a kind of "literary," punctuated narration, a *narration that is other and with open intervals* that obeys in more than one way the narratological consistencies of the novel. So, paying attention once again to the usage of tense: "Everything was fine . . . / But suddenly she became suspicious . . ." Here we have two very simple lines in the epic preterite that is dear to German poetry, rendered in French by the imperfect and the simple past, and which is suitable for longer passages in many novels.

The explanatory title can have a clearly metadiscursive function (i.e., a secondary discourse, commenting on the discourse that the images are conveying), which is grafted onto the images and endeavoring to decrypt them. This dynamic can be inverted in some very long-winded silent films, which inundate us with a flood of writing punctuated here and there with a few cinematic images. In any case the commentary title, differing in this way from the dialogue title, belongs more to the narration than to the story. It is a classic "type" in cinema with a noble lineage (e.g., "When he reached the other side of the bridge, the ghosts came to meet him"),[*] and it is one of those specific address-effects whose fragile identity film theory needs to preserve. There is a great variety of markers of enunciation, just as they are unvarying in having a basis in the concept of textual folding. Besides, there are cases where doubling is (apparently) fictive. There are titles that provisionally replace the image in its narrative function and independently supply certain elements of the story rather than comment on them: "Three days later . . . ," "London, 1890," "Not far away . . . ," and all the other intertitles of this large category. So

[*]. Here Metz is quoting one of the best known silent film intertitles in French, taken from F. W. Murnau's *Nosferatu* (1922).—Trans.

is it necessary to divide in two the category of explicatory titles, which have already been distinguished from written dialogue, along a line that follows the now famous Barthesian distinction between anchorage (redoubling) and relay (complementing)?

I do not think so, because "relay" titles themselves conserve the detached position, proper for all explanatory texts, in relation to the film and not just to an isolated element of the plot. They divest themselves of markers as much as the others, as much through the (written) material as through the (linguistic) code. They also establish themselves at the primary level of enunciation. In many instances the two functions become more or less completely intermingled. If the title tells me, "She was an unfortunate woman," in the context of some images of affliction, it certainly adds detail and confirmation (or advance notice, if it comes beforehand); but it also adds to the sequence the precise idea of *misfortune*, which is difficult to distinguish, on the evidence of the image alone, from despair, sadness, despondency, and so forth. Equally, the commentary is an addition. For the entire film, every nondialogue title, whether or not it brings new information in its literalness, takes on the status of metadiscourse. So while it always "doubles" the message, it doesn't necessarily multiply its force by two.

This is because the analogy of intertitles with the sentence in a novel, which I briskly mentioned just now, is in fact far from perfect. A writer's words neither complete nor "command" images; they have the whole textual surface to themselves and have nothing to intensify or to double. It is true that no book-reader is surprised to read information that falls from the sky without seeming to pass through any character's hands, that is, via the bare ("omniscient") act of narration, which is very common. Nobody would think of regarding this as a mode of address. But cinema has connections with the theater. In the most common cinematic setup it is rather from characters (and practically only from them) that we are used to getting our information (since in the end this is what it's all about), information that, when taken collectively, depicts, constructs, *is* the fiction. When information comes from elsewhere, even if only in part, the process "marks" itself, and the spectator feels that the plot is leading him down a less trodden path, even if it is (now) well cleared. The same goes for theater, where it is common to consider as addresses, and for similar reasons, the words of the classical chorus or the songs of Brecht, which, however, do not always interpellate the public in a direct way.

Like all other types of address, written address readily allows interventions by spectators within the diegesis. Written address is as a result

anchored, more firmly established; but contradictorily, it also acquires a more ambiguous, or better said, more *mixed* status. At the very end of *Alexander Nevsky* (Sergei Eisenstein, 1938) onscreen text spells out word by word exactly what Alexander has just said to his peasant-soldiers who are gathered after the victory: "He who comes to us sword in hand by the sword shall perish. On that our Russian land takes and will forever take its stand." This is something obviously addressed to every spectator and careful listener of the film, and we should bear the historical context in mind, where the government is demanding caution in particular about Germany. But this address is also made, via a retroactive metonymy that is simultaneously magical and easily understood, to the warriors who have just barely left the screen and have heard, an instant beforehand, the same words spoken in Nikolai Cherkasov's strong, proud voice.

So intertitles can "target" the spectator using a more or less frontal angle of approach and more or less close to the angle that would define true address. In *The End of St. Petersburg* (Vsevolod Pudovkin, 1927) a famous shot shows a soldier turning toward us in a look to camera with a title declaring, "What do I fight for?" The effect is achieved by the simultaneous face-on image, by the interrogative form (which always contains, as some pragmatists say, a nonvisible second person), and by the absence of any plausible interlocutor within the story.

Another *path of address* (I am dealing with only a few of the many others that exist) is when the title explicitly combines the name of the actor and the name of the character, in an unwitting and completely new variation of what linguists and logicians call "co-reference." This device was used in some silent movies. In *Orphans of the Storm* (D. W. Griffith, 1921), when each of the Gish sisters first appears (one is tempted to say "occurs"), she is immediately preceded by a title saying, respectively, "Henriette: Miss Dorothy Gish" and "Louise: Miss Lillian Gish." Here the rupture of the diegesis is clearly achieved because it is produced by the *corresponding profilmic object*. It is precisely this breach that, in the absence of any look to camera or second person, does or does not make an address explicit. This information that we are given *about* the film, and which interrupts it, can be directed at none other than the spectator. It is true that many credit sequences bring the name of the character and the actor together, but in this case we are not in the credit sequence. Rather, this demonstrates that the positioning of the credit sequence and its display on the textual surface are subject to conventions that are adjustable. In *Agony* (Elem Klimov, 1975) the director chooses to

present the spectator formally, in "novelistic" color sequences (which alternate with period documentary images), with each important character at the moment of the character's first appearance in the frame: "Count X, captain of the guard, etc." This is a rarer case, as it names the character and not the actor (at least, not at the same moment). The psychological narration itself wants to be close to History (Rasputin, the end of the Romanovs), and Klimov attempts to "documentarize" the fiction by putting surtitles on screen showing the names that belong to Russian historical memory.

And so we come to the strong mode of address, which is to say the expressed second person that can even be (at its extreme) combined with the imperative, as happens in the final images of *Strike* (Eisenstein, 1924). In an extreme close-up of eyes trained on us, the title proclaims "Remember, proletarians!"[†] On this one occasion the deixis sustains and defines the enunciation. Of course, it establishes itself by means of language but also by means of a cinematic device, which English-speaking theorists call *eyeline*. It is clear that the "look to camera," especially when one or more pairs of eyes fill the screen, conveys something of an optical second person. This is the origin of the concept proposed by Francesco Casetti[4] and by Jean-Paul Terrenoire[5] of a category of deictics in the broad sense that is conceived for cases of this type.

Political films and the imperative voice do not have a monopoly on the written second person. In a well-known film that I have already mentioned, *Le Trou*, the end credits are introduced by the sentence, "You have just seen a film by Jacques Becker . . . ," and then the usual information starts to roll by. The second person, when it is used in this way, only makes explicit the pragmatic status of film credits.[6] Every film title, the moment it appears on the screen, is embedded in a "deep" phrase, as in *You are about to see*, but of course the whole thing is not explicit. This is why Becker's mode of address is very strong and above all very "pure." It comes from the film *qua* film, and it targets the spectator *qua* spectator.

As for modes of address of the intermediate type, they are notably frequent in politically committed films, such as those of the great Soviet era (the device is found in Alexander Dovzhenko's *Arsenal* [1928], for example) and in more recent Latin American works, such as *The Hour of the Furnaces* (1968), codirected by the remarkable Argentinian filmmaker

[†]. That is, remember the suffering of the strikers.—Trans.

Fernando Solanas.[‡] In all of these we find intertitles not in the second person containing political proclamations that in many sequences can still be considered part of the diegesis if we attribute them to the speaker on screen who is haranguing the workers. Because of their emphasis, their content, and their final exclamatory calls to action, these proclamations refuse to be totally immersed in the story and insist on *sticking out*, in the long run creating a hybrid entity that sits astride both the cinema public and the public of the film. Despite its strangeness, this *expanding diegesis* is in the end the logical effect of a film that is concerned with convincing people politically and with spreading its own message. It is also one of the avatars, in this case slightly out of control, of the "diegetic public" that haunts all cinema and seems on this occasion to be about to leap off the screen. David Bordwell has pointed out that many titles containing sentences in inverted commas in films by the great Soviet directors cannot be attributed to any character.[7] This is a good observation and, pushed even further, an example of an unspecified enunciative status. Are these the silent thoughts of the hero? Of the auteur? A stock convention of the period? Or a dose of well-meaning ideology?

We should also take into account how some titles play with typography, font size, the arrangement of words inside the frame, and so on. These unexpected variations both reinforce and modulate the effect of the address insofar as they pointedly attract the gaze and present themselves as enunciative intrusions. This occurs, to take a celebrated example, with the word STRIKE that appears several times in succession, the letters growing in size every time, as if trying to jump into the viewer's eyes. In the history of cinema it is above all Godard (not forgetting Solanas and a few others) who, after Eisenstein and with varying success, took on, experimented with, and enriched the work of the *written screen* in the credits and in the film itself.

[‡]. And Octavio Getino.—Trans.

5

SECONDARY SCREENS, OR SQUARING THE RECTANGLE

We are concerned here with the moments when a film presents us with a spectacle that is inside some kind of frame, door, window, etc. that itself is enframed inside the rectangle of the screen. What happens here is that the source [*foyer*] of the film *doubles* the scopic mediation that is normally required to reach us. This is another simple instance of what *enunciative gestures* can be.

The frame within the frame is a familiar device in cinema. It can play a central role in the plot and in the content of certain films. It can even be used as an emblem, and some films get their titles from them: *Rear Window* (Alfred Hitchcock, 1954), *Secret Beyond the Door* (Fritz Lang, 1948), and *The Woman in the Window* (Fritz Lang, 1944), where the window in the title is itself doubled by the framing of a photograph. There are yet other films where the internal screen takes various forms, such as car windshields, windows with half-drawn curtains, and various other ways of dividing up the visual field. More rarely it manifests itself literally. For instance, in the final image of Renoir's *Les bas-fonds* (1936), Pépel and Natacha, seen from in front, are walking hand in hand toward freedom down a country road. Then the edges of the frame contract and a secondary, smaller screen detaches itself from the main one and shrinks more closely around the image, which is surrounded by a dark band that "connects" it to the main frame; it is on this small rectangle that the word "Fin" is written in the exact dimensions of the smaller screen, almost hiding the image.

In some of its investigations, experimental cinema plays with this same variable boundary with characteristic frankness, not by resorting to the pretext of plot but by modifying the dimensions and the shape of the usable screen while leaving the rest empty, up to the point of making us half-believe that it is the main screen, the "true" one, that varies all along. In Michael Snow's remarkable film *Presents* (1980), which, like a piece of music, consists of two distinct movements that answer one another, the first movement, which mixes the serious and the humorous, shows a young woman enframed in a rectangle that never stops moving, as in those rows of funfair mirrors that at first make you obese, then stick thin, then enormous, and suddenly tiny. We know from other sources that investigations into the size and the proportions of the cinematic screen, and even into the number of screens, were a major concern for filmmakers such as Abel Gance and have been of constant interest to the film industry (Cinemascope, Cinerama, etc.). These are additional aspects of the same phenomenon, but they are not central to what I want to discuss here.

The internal frame, the *second* frame, has the effect of drawing attention to the main frame, that is to say, to the site [*lieu*] of enunciation, of which it is, among other things, a frequent and recognizable "marker." *Rear Window* invites us to watch at length one person, James Stewart, who himself is very preoccupied with looking out his window; the film thereby mischievously shows us what we are doing at the same moment. What is more, James Stewart watches with the aid of optical apparatuses (binoculars, then a telescopic camera lens). We have here a double assertion of cinematographicity, performed by the viewing rectangle and by the instruments of vision. I will not linger on this voyeuristic mimeticism, which I have already discussed at length[*] and which has become a classic theme of cinematographic theory, in relation precisely to films such as this one and *Peeping Tom* (1960) by the Englishman Michael Powell.

The interior frame obeys a principle of doubling—one screen on top of another—or a metadiscursive principle, but this is not the same thing as commentary, as in the various modes of address I have looked at up

[*]. Voyeurism is an important theme throughout Metz's *The Imaginary Signifier: Psychoanalysis and the Cinema* (Bloomington: Indiana University Press, 1982); he is perhaps referring here to the section "Story/Discourse (A Note on Two Kinds of Voyeurism)," 91–97.—Trans.

to this point. (I am using *commentary* in the common sense of the term, not as it is used by Harald Weinrich).[1] A commentary defines itself in always doubling what it is commenting on, but when it is done by means of language, as in voice-over, this doubling inevitably takes a more or less explicit form. For its part, the second screen is a spatial limitation, a visual restriction, a marking of the visual field, a picture of the image, and as such, it always has something mute about it. It effects the doubling without speaking it and accomplishes it without openly declaring it. As for the "commentative," we are then dealing with the *reflexive* (here I am in agreement with what Jacques Aumont says concerning the *sur-cadre* in relation to the opening of Max Ophüls's *The Earrings of Madame De* (1953);[2] we may also consider all those films that open with a theatrical curtain, or with the rectangle of the page of a book, and so on). The commentative and the reflexive are the two main registers of enunciation in film, or more precisely, registers of the perceptible traces that enunciation can leave in film—markers, pictures, etc.—because it may also, as we have seen, leave no traces or only very discreet ones. Roger Odin has proposed the notion "autoreflexive" to designate a mode of reading (not an aspect of film) that is focused on the functioning of the text, on the "work" that it does.[3] Evidently I have something else in mind, but we are thinking along the same lines.

Aumont has also reminded us that the process of the cinematographic *sur-cadre* (I will use his felicitous phrase) is an echo of a very old pictorial practice exemplified notably by the *veduta*, which is a view through the gap of a window, through the pillars of a colonnade, from behind the curve of an arch, etc.[4] When it is sufficiently separate, the *veduta* can split the tableau in two. The cinema has witnessed a similar evolution: the "film within the film" (as distinct from the secondary screen, which I will deal with separately), appearing as an extrapolation of itself, as the means to achieving its own full capacity.

Silent redoubling, redoubling in actuality, redoubling by means of spatial inclusion: the secondary screen (and, even more so, the film within the film) insistently evokes the "mise-en-abyme" of heraldry and the well-known commentary it inspired in André Gide: "I quite like when one finds, within a work of art, transposed on the scale of the characters, the very subject of the work itself" (*Journal*, 1899–1939). Need we remind ourselves that his novel *Paludes* is the story of a novelist who is in the process of writing *Paludes*?

In Gide's thought, and in certain examples of films within films, the first instance, that which reproduces itself and "reduces" itself by means of

of the mise-en-abyme, is the unusual work, once again as is *Paludes* ("the very subject of the work itself," as Gide puts it). But in ordinary cases, where the interior frame is nothing more than itself, we have the semi-involuntary witnessing of the cinematic mechanism, as if the gaze has been shunted onto another track. It is not the work that grows new shoots as it shrinks, recreating itself at its very core; rather, it is the means of expression itself, the cinema as such (as if, in a coat of arms, some other coat of arms were reproduced). Very often, the second rectangle does not provide anything that condenses or symbolizes the contents of the main one; a door may open, but it opens only in the pursuit of a plot point. All that we experience is the act of "opening" itself, understood as a gesture of the screen. In all cases the process is therefore metacinematographic, but it is not necessarily metafilmic. However, the metaphor of the coat of arms is quite suitable for the game of interlocking, downsized rectangles with which films so willingly provide us. It is to be found, for example, throughout almost the entire oeuvre of Yasujirō Ozu.

While he does not refer particularly to secondary screens, Marc Vernet has proposed what seems to me an important if more abstract notion, which I will keep returning to: that of the *diegeticization of the apparatus* [*dispositif*].[5] Occasionally films reproduce more or less faithfully, in the stories that they relate, certain elements or characteristics of the cinema or of its equipment, which as a result find themselves to be part of the diegesis. Consider the visual narration of American film noir, which Vernet analyzes in particular, where more than usual emphasis is laid on the contrasting play of black and white (shadows on a brightly lit pavement, etc.). This much-discussed contrast also consists in exploiting, in *putting into the story*, the technical "definition" (i.e., high or low) of the black-and-white film stock used in making these movies.

The interior screen is also a diegeticized element of the apparatus, insofar as the second frame, in contrast to the first one, is "motivated" by the plot and is supposed to be part of it. And, once again with the exception of the film within a film, this is why it does not take the form of the cinema screen but of an everyday object, such as an attic skylight or binoculars or the telescopic lens of a rifle, the latter two being particularly common in gangster films.

Therefore, the play of second screens may equally be counted among the many processes (we will return to others later) that enable one to pay attention to the "apparatus" of cinema—to *expose the apparatus* [*montrer le dispositif*], to use the fetishized phrase of the 1970s. If I have treated

it separately, it is because, while this famous apparatus consists of elements that could not be more varied—from electrical cabling to actors, from cameras to audio amplifiers, and from film emulsions to the seats in the cinema theater—within this complex of synergetic yet disparate elements the screen occupies an absolutely singular place. It is the frame and the veil of representation (Bazin, Mitry), that which opens and that which closes the gaze (Aumont)[6] and the thing that displays and that conceals (as Michel Chion puts it, the "place of not-seeing-everything [*pas-tout-voir*]").[7] It is, in other words, inside everyone's imagination and up to a certain point in reality, the *place of the film*, its emplacement, the place where it happens. It is not by chance that there are so many expressions such as "to adapt a book for the screen," where the word *screen* can designate the entirety of the cinema-machine. Everything takes place, for us, "on" (as we comically say) the screen; thus, sounds, even those that we call "in," however much the evidence all around us tells us that they resound from outside the screen (from all around, inside the theater); the illusion of depth, however much it repels the diegesis beyond the screen away from itself; and, in the other direction, sudden close-ups or zooming that propel the diegesis into our path, ahead of itself. Within the apparatus the screen is a strange conduit that governs the reception of the film during projection, like a narrow pass that gives access to a vast plain or like a misty corridor that leads to reverie. Other characteristics of the machinery are equally perceptible when the film is being shown, such as the texture of recorded voices, the choice of focal length, or changes made in the final stages of image correction. But the screen is more than perceptible, it is—it has become, historically and socially—the condition of and the receptacle for perception. It is also for that reason that it authorizes a strict transmission of visual mise-en-abyme; we can see a screen within a screen, but we cannot see—another cog of the machine—a key light inside a key light. The "abyss" can even become vertiginous, as when every frame frames a frame, for example as in the famous image in *Citizen Kane* when Susan is leaving. Multiple doors are arranged in a row along a long corridor, and they open one after the other in a paradoxical effect of reframing that is emphatic and static at the same time. Or, for example, in the sequence in *The Scarlet Empress*[8] in which the three monumental gates of the czars' palace open in succession in front of the future Catherine the Great. In Gustav Machatý's *Ecstasy*, a surrealist-influenced film of 1933 that is barely remembered today, the opening of a series of doors is used as a rather naive symbol for the erotic liberation of a character.

Sometimes the secondary screen almost manages to recreate, as if to the power of two, the strange and contradictory capacities of the real screen, capacities that are definitively uncertain, real and magic at the same time. In *The Golem* (the second version of 1920, by Paul Wegener, Carl Boese, and Henrik Galeen) Rabbi Loew "evokes" for his astonished guests the history of the Jewish people, creating an inexplicable apparition with a sweeping, powerful gesture of his arm. As if by tearing the ordinary screen, there appears some kind of ill-defined, frayed canvas at the top of the frame featuring a moving image of the flight into the desert and, "closer" to us, the image of the Wandering Jew. And all the while at the bottom of the frame the "real" participants of the ceremony continue to be visible and to watch, as do we, the really real viewers of *The Golem*.

There is a rather similar construction in *Wooden Crosses* (1931), directed by Raymond Bernard, based on a novel by Roland Dorgelès. A regiment marches by proudly, music in their heads, but in the upper part of the frame a second frame comes forward, or rather limps along painfully, superimposed on the sky, in which we see a pitiful cortege of huddled cripples on their crutches, living examples of the near-death that awaits their unwitting, intrepid counterparts in the same rectangle.

To return to the diegeticization of the apparatus. The progressive opening or closing of a door or of a curtain, actions internal to the plot, give the spectator the same point of view on the diegetic space as could have been achieved, for example, by a "shutter," which is an extradiegetic and explicitly enunciative process but which, by a fitting circularity, takes its name from window-shutters. In the same vein, filming through a semitransparent curtain (Sternberg, Ophüls) is equivalent, in terms of its sensory effect, to a blur. In Malraux's *Days of Hope* (André Malraux and Boris Peskine, 1945) we are treated to a spectacular forward-moving tracking shot when the car of the partisans rams the Francoist cannon, sacrificing itself in order to destroy its target. In Ridley Scott's *Alien* (1979) the doors and the airlocks of the spaceship are treated like diegeticized irises or shutters (I owe this to an observation by Reda Bensmaia during a seminar discussion). There is in sum a correspondence, both imperfect and precise, between certain optical effects and certain motifs or diegetic movements or, rather, perhaps between two *symbolic movements*, contrary and complementary, opposing and entangled accomplices who express themselves by means of one another. The same applies to technical processes. Even though they modify, modulate, and even model our perception of the diegesis, they are interpreted most often as natural and

preexisting characteristics of the story being told; just as—or inversely—certain elements of the diegesis can "unglue" themselves from it without deserting it, they can imitate the discursive intervention, and they can mold our point of view of the other motifs of the story. This surreptitious fusing designates a fundamental characteristic of narrative cinema, which distinguishes poorly between the enunciation and the enunciated, and at times confuses them for its own or for our pleasure. In 1971, before the subject became a commonplace for deconstructionism, I identified this as a type of permanent *trucage*.[9]

Roger Odin has shown that the opening credits of a film, normally considered to be extradiegetic and purely informative as they are shown at a transitional moment, also (or especially) have the function of facilitating the entry of the spectator into the plot and the temporary rupture with reality.[10] We have seen how Jost and Simon oppose language, which has special enunciative signs (deictics), and cinema, which does not have any and which effects an enunciative usage with whatever sign it can;[11] as a result, there are many aspects to this particularly fluid *exchange* between enunciation and what is enunciated.

Supplementary screens offer a privileged example of this permanent interchange. They take many forms that require further discussion. For instance, inlaying video images, which is becoming common, as is the *split screen*,[†] where the screen is divided into several vignettes. The latter is held in high regard in experimental cinema, and avant-garde video installations push it to its limit by playing with several separate monitors (there are nine in Thierry Kuntzel's admirable *Nostos II* [1984]). In narrative film, screens are most commonly split into two, with the line of demarcation at times solid (as in telephone scenes) or at times invisible, as during the opening credits of *Magnet of Doom* (*L'aîné des Ferchaux*), by Jean-Pierre Melville, where two versions of Jean-Paul Belmondo appear in a boxing match, the right and the left sides of the screen corresponding with a disconcerting similarity. (Here, as elsewhere in Kuntzel's work, it is not only the screen that splits into two but also the action). Elsewhere, the *split screen* frames two portions of a complicated space where a man is being pursued, creating a space for real topographic virtuosity. Consider, for example, the scene of the corridor and the staircase in Brian De Palma's *Sisters* (1973) when the doctor-husband comes down from Danielle's room while the police go up or, once again, the simultaneous

[†]. Metz uses the English term.—Trans.

presentation, in the same film, of shot and reverse-shot when the dark-skinned TV game-show player is dying in agony: we can see from inside the room as he tries to make a sign out the window, while in the other screen the neighbor opposite can see the pitifully weak movements of his barely visible hand on the windowpane. We should also consider double exposure, which in principle condenses two screens. But Marc Vernet has convincingly shown that, on the contrary, it consists of suppressing the frame of one of the two images and of diffusing one image across the whole of the other image.[12] In this way a face may be read as an emblem of an entire landscape, and the landscape in turn endows the face with something of its inanimate majesty. So double exposure is the extreme evolution of second screens, while at the same time their negation.

But let us get back to second screens. They may take many forms, yet they all share a certain something. Enunciation, like a high tide, brings them to us and then deposits them on the beach. But then they drift back and forth with the ebb and the flow of the tide, the ebb and flow of story and adventure. They manage nonetheless, from wherever they are, to mimic the very thing that gives them the capacity to be seen and to transmit a half-lie to us—that it is they that make us see. In Robert Altman's *Secret Honor* (1985), an impressive piece of political intrigue about Watergate, the deposed president, played with great skill by Philip Baker Hall, is shut up in his office, feverishly preparing his defense. He points the cameras of the building's surveillance system at himself, and it is on the system's monitors, on these multiple, small rectangles, that his rage and distress are diffracted and offered to the spectator to contemplate . . .

6

MIRRORS

We have known since Cocteau, or even well before him, that the mirror is a privileged filmic object. I will not revisit here[1] the psychoanalytic rationales for this affinity, which does not consist—contrary to words once put in my mouth—of a pure and simple identity between the screen and the mirror or even in a significant empirical analogy between them. The idea would be absurd, as the screen does not reflect the viewer's own body. We can only posit a similarity that runs deep and that exists at the moment of creation of the psyche.

Rather, for now we are concerned with mirrors that appear in films. We could regard them as variants of the secondary screen, as they isolate a "view" inside the view, but their mode of action is different: they do not intercept the gaze or let it pass through, in the manner of a door or a blind, but they return it to the sender; they recast it. Once again this is a case of reflexivity (literally, on this occasion) as the spring of enunciation. Branigan demonstrates very well that mirrors in films sometimes operate on the principle of "subjective" shots of a particular kind: everything takes place as if the character, instead of projecting his gaze into a given space, in fact projects his body.[2] As he regards himself in the mirror—as Humphrey Bogart does in an admirable image in *Dark Passage* (Delmer Daves, 1947), where he discovers for the first time, as do we, his new postsurgery face—we are almost obliged to imagine ourselves at the receiving end of the gaze and, from there, to flow back to its source, identifying ourselves in the process with the character, or at least with his position in space.[3] At the same time, Branigan goes on to point out,

the mirror also carves out, just as in more "ordinary" secondary screens, a frame within a frame.

This second function, which the seductions of the first make us sometimes forget, is the only one that occurs when the character watches something other than himself in the mirror, be it a person or an object (in detective movies), or even when the mirror belongs to the set and nobody is looking at it. In a film that I often bring up, *Le trou*, some ingenious prisoners planning an escape construct, using a shard of a broken mirror and the handle of a toothbrush, a kind of horizontal periscope that they pass through the keyhole of their cell door, enabling them to see the corridor to the left and to the right. Jacques Becker achieved some beautiful images in this film, such as the one, near the end, of the bunched pack of silent prison guards poised to attack, waiting for the signal. It is a good example of a *nonreflective mirror*, if by that one means that it reflects something other than the person who looks at it and acts simply as a secondary screen.

As far as the cartography of enunciation is concerned, the mirror can give rise to a wide variety of constructions. What follows are short descriptions of five of these, though this list is by no means exhaustive.

Mirrors are sometimes content to augment the interplay of gazes that in the normal course of events meet, avoid, or conflict with one another in filmic space—to a very great extent, they *make up* that space—while adding some supplementary and less common traces to this mesh of looks. Thus in a sequence of *La peau douce / The Soft Skin* (François Truffaut, 1964), Jean Desailly is able to perceive his secretary, who is in another room, thanks to a play of mirrors. The mirror performs here one of the functions that is its job in everyday life, in that it expands the film by "revealing" a space that is *simultaneously close yet separate*.

Elsewhere, this revelation brings with it the added element of intrigue, suspense, surprise, fear, danger, etc. This is the case above all in detective and adventure movies—for example, the scene in *Last Train from Gun Hill* (John Sturges, 1959) when the sheriff (Kirk Douglas) takes refuge on the first floor of the hotel and handcuffs the young killer to the metal bedpost. The prisoner's father (Anthony Quinn) comes up to join them under the pretense of trying to strike some kind of deal, but in fact he has three armed men coming behind him; it is thanks to a mirror that the sheriff can see the three henchmen coming up the stairs, so he can see through their treachery and foresee the coming gunfight. In sum, the film (in this case, a western) offers us for an instant the secondary screen as a *second screen*, so that, because we "are" in the room, we also—also

and elsewhere—may see the important event of the moment. This could be, for this sequence, the "formula" of the enunciatory configuration. (We see again that it is not necessarily reducible to a particular "marker").

It can also happen that the mirror, far from giving access to a neighboring location, enables a mental recollection, revealing on the contrary a completely different place that has no direct contact with that of the film. It opens onto something else, something whose presence *here* is impossible. Certain fantasy films exploit the strangeness that comes with this *false reflection*. In a collective film directed by Alberto Cavalcanti, *Dead of Night* (1945), one episode revolves entirely around a character who, in a very ordinary and unthreatening room, when he looks into a mirror on the wall on a few occasions, sees a totally different location. This type of case, where the mirror is like *a screen from another film*, a film that we will never see and that does not exist anywhere else, is not uncommon.

In *Figures de l'absence* Vernet identifies another figure, a kind of grafted double exposure that works on the principle of the mirror, which enables cinema to magically escape the constraints of *strict reflection* that define everyday perception, that is to say, to escape the limitation of the reflected surface by means of the reflecting surface.[4] We do not see any further than the edge of the mirror, or what we see there is something else; it is simply a wall. Vernet notably mentions an image from *Johnny Angel* (Edwin Marin, 1945), where a taxi driver, cruising through the night, framed from in front, sees behind him (and lets us see at the same time) the panorama of the city as it is reflected on the windshield, which thus acts like a kind of symbolic retro-vision on a huge scale.

Finally, the mirror can *itself be reflected*, whether by other mirrors or by its own facets, in such a way that the image is infinitely diffracted. Rather like the drop shadow or the invisible voice, this image haunts all of cinema as one of its most intimate symbols. It forms the famous ending of *The Lady from Shanghai* (Orson Welles, 1947) and of *A Chorus Line* (Richard Attenborough, 1985), where the play of mirrors dizzily multiplies the numbers of dancers, who are already dazzling in their golden-yellow costumes and hats. The young protagonist of *All About Eve* (Joseph Mankiewicz, 1950), who at the end attempts to do to Eve what Eve had done to Margo Channing, is shown to us (but not to Eve) complacently admiring herself in a mirror with several panes that break up and magnify her reflection. This is by no means a recent invention either. In *Wonder Bar*, a 1934 musical comedy, Busby Berkeley constructed an octagon of mirrors eight meters tall, each side five meters across, for the famous number "Don't Say Good Night!" Reflected on all sides, the circle

of dancers performs at the center of this apparatus [*dispositif*] in a good example of the scopic cannibalism that is made possible and desirable by the cinema-machine. It may also restrain itself and be content with a restricted degree of dissemination, but even then its mastery of the image and of the enunciative mark of the camera is affirmed. So we see in Truffaut's famous shot of Jean-Pierre Léaud,* where the young boy appears in four versions; the "real" one, with his reflection in the small mirror that he is looking at, and his image in two other, larger mirrors, which he is not looking at but that are looking at him, which "have" him in their sights and cannot do anything other than "take" him.[5]

Overall, the cinematic mirror, as in the title of André Cayatte's film, has two faces.† From the point of view of psychoanalysis the screen is a "mirror and non-mirror" (I am quoting myself here) that has a lot to do with scopic drive, specular identification, and narcissism.[6] Textual analysis makes the same findings from the opposite direction: an authentic, empirical mirror that is included within the rectangle of the screen. But the two aspects of the mirror are in harmony. Every mirror is a frame that delimits a portion of space. Every mirror is like a camera (or a projector) because it "'projects" the image a second time, because it offers it a second shot, because it has an *emissive* power. Indeed, it is because cinema itself is so rich in specular affinities that the imagery of films is so replete with mirrors and that these mirrors so often influence the path that enunciation takes.

*. In *The 400 Blows* (1959).—Trans.
†. *The Mirror Has Two Faces* (1958).—Trans.

7

"EXPOSING THE APPARATUS"

It might seem that the act of making the cinematographic appara-
tus [*dispositif*] obvious, the act of displaying it—"denunciating" and
"deconstructing" it, to use 1970s terms minus their militant subversive-
ness and ideology—might constitute the marker of enunciation par
excellence because, if we are to believe the credo of the times, in this
way a film lets us see or listen to the very thing that produces it. As early
as 1971, however, writers such as Pascal Bonitzer argued forcefully that
the theory-driven (or demagogic) exposure of the cinematographic
apparatus [*appareillage*] was not sufficient to emancipate discourse
and could even, in certain cases, encourage the spectator to indulge in
fetishism of the technology. What was important for Bonitzer was the
manner of "showing," that is to say, the work performed by the film.[1] In
addition, I think it is of primary importance that the camera (which
remains, despite everything, both actually and symbolically the cen-
tral component of the apparatus [*dispositif*]) cannot film itself by itself,
except by means of a mirror; and it is also important that the camera
that we are shown is not, or is only seldom, the camera that recorded
the film that is showing us the camera—Jean-Paul Simon identified
this small but frequent sleight of hand at an early stage.[2] When mark-
ers of enunciation are unmasked as we proceed toward an "unveiling,"
this is not in itself critical or really subversive, because these mark-
ers are only accessible in themselves in the statement [*énoncé*] and as
statements [*énoncés*]. A film, even when it is free of ideology, cannot
make the product and its mode of production coincide within itself,

rather only, in a mimetic gesture, the product and the mise-en-abyme of its process.[3]

Of course, this argument has to be modified for different films, which we will come to. There are cases such as Godard, even if he does take a scattergun approach at times. The fact remains that the filmic operation that has become baptized with what is by now a well-established phrase, "to expose the apparatus" [*montrer le dispositif*], only rarely shows THE apparatus, that is, its own apparatus, but is usually content to display AN apparatus that belongs to some other film, whether purely virtual or really within the diegesis. It is actually a simple procedure, and these days one of the most common across a range of films, including the most ideological ones. Optical instruments [*appareils*] are romantic and captivating objects that supply marvel in a story, lend an air of dreaminess, and haunt story lines in every genre. Also, the representation of a film's production can lead to a portrait of the "life of the actors" and from there to "the world of show-business," both of which are less corrosive than gossip magazines would with good reason lead us to believe. Even high quality films, which are endearing in other respects, such as Truffaut's *La nuit américaine* (1973), owe something to this sentimental alchemy that induces us to love cinema when we love the film, because the film is speaking of cinema in order to demystify it and to adore it all the more.

In *Jane B. par Agnès V.* (Agnès Varda, 1987) several times the camera insistently shows a standing camera turned toward us. I do not know what the intention of this is, but the result is that we are forced to be conscious that this instrument [*appareil*] is not the real one. (The apparatus [*dispositif*] does, however, contain elements that are less rebellious. One could very well, for example, deliberately let the boom being used in the shoot linger in a corner of the visual field, as happens in some intellectual-marginal films.)

A second major difficulty (connected to the previous one) is when the apparatus that is being "exposed" consists above all (with the principal exception of the rectangle of the screen) of objects and processes whose own apparatus is neither seen nor heard by the spectator in normal circumstances. The spectator is content to *know*, from an external and secondary source, that these things exist and that they intervene in the making of a film. That is why their "doubling," unlike that of the frame, is not always a true doubling. If you show a crane to a spectator, it is the first time that he sees it and not the second. It is to be found thus in the same shot as any other filmed object, and it is, like the spectator, permanently attracted by the gravitational force of the diegesis. Except

in special circumstances, the appearance of a camera somewhere in the frame does not convey anything more than the appearance of a gun. As far as the instant of enunciation is concerned, it is only a kind of allusion, a weakened and, as it were, automatic reminder: CAMERA certainly evokes CINEMA. But there must have been a *hidden camera*, another camera, the real one, which filmed both the gun *and* the camera that is paraded in front of us.

The "apparatus" operation leads to precise figures of enunciation only when the filmic text is "active" and is not content just to let the filming equipment be seen or, to put it more precisely, when it does *more* than "expose the apparatus" (I am in agreement here once again with Bonitzer). Constructions of this type can take many forms. I will now pick out several of them, while observing (as a slight aside to what I am proposing here) that they could also support arguments in favor of the "symbolic referent" that Vernet proposes to combine with my "imaginary referent."[4]

First, some aspects of the apparatus are "exposed" much more frequently than others (something we like to forget). Everybody films cameras or dolly tracks, but we seldom risk proposing an actual reflection on the two-dimensionality of the image (this is one example among others) in relation to the three-dimensionality that the imaginary of the story injects into it. On top of that, films that engage with this rarely "reflected" upon trait tend to have a much higher profile (if I may put it that way)— for example, Anglo-Saxon experimental films, *Berlin, Symphony of a Great City* (Walther Ruttmann, 1927), *Man with a Movie Camera* (Dziga Vertov, 1929), and so forth. With Ruttmann and with Vertov certain sequences are entirely conceived in order to underline visually, as if with a pen, the effect of a contradictory double reading of which the image could be the object, in depth or on the surface, for instance in images of the metro in the case of the German filmmaker, and of elevators in the case of the Russian (see analyses of these by Annette Michelson[5] and by Jacques Aumont).[6]

In other cases the perceptible presence of the apparatus is multiplied and diffused throughout the whole film and is engaged in complex games of "takes," of metaphors (Jacques Gerstenkorn),[7] and of inversions that engage with the motifs of the story. We see this, obviously, in Fellini's *Intervista* (1987) or in Bergman's *Persona* (1966), two films that I will come back to, or even—in a less obvious example that has been analyzed with great insight by Michel Marie[8]—in Godard's *Contempt* (1963), which is full of allusions to *Journey to Italy* (Roberto Rossellini, 1954)

and features a director in the plot who is a real director (Fritz Lang), a producer who is well known as an actor (Jack Palance), and a story (the *Odyssey*) to be filmed in the plot that is already a story outside the plot, etc. (The "apparatus" naturally also includes human beings, those who contribute to *making cinema*.)

Certain films, in the process of exposing the apparatus, offer a real analysis of it, enveloped in the folds of the fiction. I am thinking once again of *Persona*, and also, for example, of the remarkable "peep-show" sequence of *Paris, Texas* by Wim Wenders (1984), a subtle and incongruous allegory of the cinematographic spectacle that is achieved by means of a display that resembles it only obliquely and thereby illuminates it as much by contrast. The "filming" and the viewing take place at the same time, while the intercom-phone makes it possible to speak to the "actress," so this is not a real film . . .

Elsewhere the work of the film weaves selected strands between the aspect of the apparatus that is of interest and a character or a part of the diegesis. This kind of "strong" enunciative inscription may be superimposed on the preceding type. We know the famous image in *Persona* of the piece of film that is disintegrating. We can see the film destroy itself in front of us while the nurse Alma destroys herself, "burns" herself, by identifying with another woman, with an *actress*, thereby reproducing with somewhat more violence the rather all-consuming mechanism that quietly threatens us in every fiction film. I am indebted to Nick Browne[9] and to Christian Koch for their substantial discussions of this aspect of the film.[10] When the identification of the nurse with Elisabeth, the ailing celebrity, becomes entire and, so to speak, substantial, the apparatus [*dispositif*] physically confuses, almost with a shudder, the photographic portraits of the two women onscreen.

Finally, there is a smaller number of films that actually expose the much-promised apparatus to us, which is to say that they return in some sequence or another, to the act of *their own* filming or to their own equipment. In the last section of *And the Ship Sails On* (Federico Fellini, 1983), when the sweeping camera reaches the end of its wide trajectory, it reveals the underside of the enormous moving platform on which the on-set boat is supported and that mimics the swell of the sea. The image and its movement leave us in no doubt about the "identity" of this curious platform, which is, moreover, very Felliniesque. It is definitely the one that was used in the film and not, as is often the case, a stand-in that has been specially set up. There is another very similar construction with yet another false boat (or at least a real false boat, which was used

in filming, in this case a simple rowboat) in the exuberant and comical finale of the independent film *Naughty Boys* (1982), by Eric de Kuyper.

A rather unusual variant is *A Star Is Born* (George Cukor, 1954), a film that is replete with enunciative treasures and recounts, among other things, a film shoot in which the heroine is supposed to be taking part as an actress. The secondary film shows her standing at the window of a train in a station. She seems to be waving farewell, with her handkerchief in her hand, to somebody offscreen, while the steam of the puffing locomotive billows into her face. The whole thing takes place on a very snowy day. Cukor's mise-en-scène is based on the division of the screen into two areas, left and right, that are treated separately. A back-and-forth pan and a montage arranged in the same pattern show us, when the right side appears, the scene of the train and of this passenger. The illusion is perfect. But when the camera moves to the left, we see bizarre, cobbled-together bits of machinery, evoking a Hollywood where makeshift methods were still in use, which are busily manufacturing and pumping out smoke, fake snow, and so on. It is a mischievous final shot that shows us the two sides at once . . .

I should also point out that when the camera returns to the right, the viewer's readiness to believe is not diminished in the slightest by seeing these mechanisms on open display (this readiness is anchored in other, deeper places). What is interesting in this unveiling resides more in an emancipation of filmic intelligence, which is reserved for a minority of privileged viewers and makes of enunciation a real "game," than in some victory over the diegetic illusion itself. This latter, it is true, is tenacious and runs out of steam less quickly than its assailants, but it is not, after all, particularly bad: it is always partial and always partially with our consent, and occasionally a source of pleasure. (And then, when we want to do away with it for good, there are experimental films, which provide themselves with the means to do so and take the appropriate risks.) To go back to Cukor: in this sequence he has managed to reunite the filming and the "filmed," the special effects department and the special effect, the profilmic and the filmic realities *of the same film*, and it is worth noting that this is a film within the film.

There is also the *actor*, who is after all the most visible component of the apparatus. Theory prefers to speak of the character, which is a more noble abstract entity (the imaginary being more highly regarded than the real). Vernet[11] and, since 1980, Gardies (in a detailed analysis)[12] are to my knowledge the only people to have considered the actor from the point of view of enunciation.[13] It seems to me that there are in this regard

two main types of situation, with some in-between or mixed cases. An obscure actor functions to the benefit of the character because they are so closely connected and we do not associate the actor with other characters or with his private life as it is publicized in magazines and so forth. Better-known actors (all the way up to stars) force the public to consider the very reasons for the choices that are made, be they obvious (John Wayne as a cavalry officer) or often inscrutable (why is Candice Bergen cast in Ralph Nelson's *Soldier Blue* [1970]?). What is more, a well-known actor (which is to say, well-known in other films, let us be clear) will bring with him an echo of other films in which he has played, and he will inject a degree of contingency, multiplicity, and a sense of the virtual into his character. So the Jean Gabin in Jean Grémillon's *Remorques* (*Stormy Waters*, 1941) is not just the captain of a tugboat; he brings with him other tough-guy types (*Maria Chapdelaine, La bandera, La belle équipe, Les bas-fonds, La grande illusion*), as well as two or three handsome brooding types (*Gueule d'amour, Quai des brumes*), and, like it or not, a little of all of these is the captain of the *Cyclone*, resulting in the mixture of gentleness and brutality that the film attributes to Captain Laurent.

Some films are laden, in the true sense of the word, with *roles*, which is to say (human) entities that tend to blur the normal distinction between the actor, the character, the narrator, and sometimes even the declared author. One of the nicest examples, which is well-known in other contexts, is the composite and seductive treatment of Anton Walbrook in *La ronde* (1950), directed by Max Ophüls. In the film he is the only person with access to the apparatus, which is ostensibly symbolized by a merry-go-round that he operates by its handle. In the sequence of the count and the actress we see him using scissors to cut out a strip of film that corresponds to a passage that the film wryly adjudges too licentious. At the start, and then in between the film's episodes, he is an explicit narrator, present in the frame (i.e., there is little voice-off), speaking like somebody who does not belong to the story. Among many other statements, including "I am nobody," he tells us that he is the one who turns the carousel of love, which is the very subject of the film. So he is also an alleged author, a double one in this case, part Schnitzler,* part Ophüls. But he also represents the viewer: "I am you, any one of you." He also says that he is the "master of ceremonies" (i.e., subtracting from the alleged author). He is nothing other than a "passerby," an exact assertion, in

*. Arthur Schnitzler, author of the original play. —Trans.

alternative terminology, of the "peridiegetic" status that I discussed earlier[14] and that, as we can see, may be established by means of voice-in. Ultimately, he appears, on several occasions, as a character, seemingly fully diegetic but in reality a fake character (somewhat like Jean Vilar, who is the "incarnation" of Fate in Marcel Carné's *Les portes de la nuit* [*Gates of the Night*, 1946]) who declares himself as such on his first appearance. So, in "The husband and the prostitute," he is a hotel owner, but he speaks so enigmatically that Fernand Gravey (the husband) is astonished when he is told: "The truth is, I am not the hotel owner, sir . . ." The classics were the work of some great cineastes.

The willingness to put the apparatus on display proceeds in other cases from a naive and rather obscure desire to reconcile a pseudo-political superego with passionate adoration of cinema and its technics. But the examples just cited, which form a rather incomplete picture, would seem to suggest that there are real and substantial resources for enunciation, if *narcissism of the machine* is avoided, something which is the main cause of several gratuitous innovations.

I will conclude by returning to this narcissism, whose roots are undermined because the camera *does not exist* for the viewer. Branigan has perceived as much very clearly.[15] It does not exist as an object as it is the very thing that, in rendering all objects visible to us, necessarily remains in a place that is fundamentally beyond (Vernet). It is possible to deduce the position of the machine by the arrangement of these objects; the camera is a construction of the viewer. And, as Guy Gauthier has observed,[16] it does this so well that we imagine it is present where it has never intervened, as is the case with artificial images and animated vignettes. . . . This is why it is never *enough* to "expose the apparatus," but it is also why we can, in the process, expose many other things.

8

FILM(S) WITHIN FILM

Just as when we are allowed to see the inner workings of the cinema machine or its technical crew, the "film within the film" presents us with, to use the contemporary term, a reflexive figure. This is the case because the principle of doubling functions out in the open, as close as possible to what is evident, so that one film shows us another film as it is being projected. It is a process almost as old as cinema itself. In the short comic film *Uncle Josh at the Moving Picture Show* (Edwin S. Porter, 1902) we see the astonishment of the character Uncle Josh in front of a cinema screen, because he has never seen a film and does not know what one is.[1] (The conceit is clearly metacinematographic, and has many parallels with the theater, not only in Pirandello's conceits but as early as, for example, Corneille's *L'Illusion comique*, where the character of Pridamant cannot tell the real from the fictional). Much more recently, George Roy Hill's *Butch Cassidy and the Sundance Kid* (1969) offers us a delicately made yet archetypal instance of the film within a film: during the opening credits, in a small corner of the screen, a flickering western from the silent era insistently plays. Nestled there from the outset, it has the function of an epigraph that opens the "big" western that hosts it.

Different forms of the mise-en-abyme have been studied, in particular by Lucien Dällenbach in relation to literature and by Jean-Paul Simon in relation to film, in the journal *Vertigo* and by Jacques Gerstenkorn, Kiyoshi Takeda, Dominique Blüher, and others.[2] The approach I take here differs from these, however, insofar as, for me, the mise-en-abyme is only one of numerous manifestations of a principle of a more broadly defined

reflexivity. Ordinarily, reflexivity and the mise-en-abyme are considered, if not synonymous, then at least largely coincident. What interests me about the abyss is not the abyss, but enunciation. Here I will adopt an ad hoc classification system, starting straight off with the most simple, and without attempting to replace previous ways of classifying it.

The film within the film, or more precisely the relation between a film and its primary film, can lead to very diverse configurations that mark out the work of enunciation with varying degrees of clarity and complexity. This is the case even if the mere presence of the second film already stands as an automatic and minimal "marker." I will distinguish three types, which are in fact degrees, of enunciative force, or if you prefer, degrees of *exactitude* in the ways that a text can fold back on itself (there are of course intermediate cases). The strong variant, the third one, is in fact the only one where a true mise-en-abyme takes shape. In the first two cases the story of the film speaks to us about *other* films, which are quite distinct. It is as if the writer of *Paludes*[*] were to write poems instead of working on *Paludes*, or better—and I will come back to this—as if a coat of arms were broken into quarters by another coat of arms. In an old article, I opposed these "simple (metacinematographic) doublings" with "double doubling" (which is metafilmic and more fully reflexive), which is the proper meaning of *mise-en-abyme*.[3] This can be formulated in the following way: "the presence of a second film, which is the same film." It is this "same" that we will need to be more precise about, because it manifests itself in several ways, which are not all the same . . .

But I will start at the other end of the spectrum. The "simple" degree of mise-en-abyme, not unparadoxically, most deserves to be called the "film *within* the film" because the second film is *located* at one (or several) point(s) inside the enveloping, host film. What we have here is clearly delimited embedding, a well-marked-out interrelationship, as opposed to multifarious intricacy or complex hybridity. So in a detective film, a man is being followed. He hides in a nice dark cinema in an attempt to elude his pursuers. Acting on his fear in this way, just as instinctually as a screenwriter who has run out of ideas, he bunches up into a ball on his seat. We then see and hear through him indistinct snatches of some cheap, shoot-em-up western. Wouldn't the effect be vastly different if the unlucky man took refuge in the aisles of a convenience store, or between

[*]. André Gide.—Trans.

rubbish bins in a dark passageway, something that, incidentally, he will not fail to do in the course of the film?

The process of embedding can be less trivial, such as at the end of *Pee-wee's Big Adventure* (Tim Burton, 1986), where the executive from Warner Bros., which is in fact the real studio behind the film, buys from Pee-wee the rights to the story of all the adventures we have just seen him go through. We then see a small part of the entirely different film that they proceed to make. There, the hero is relegated to the insignificant role of a hotel bellhop. He is even deprived of his own voice, speaking instead in a smooth bass tone . . . Another variant: we are presented with what we have already seen as "real" (within the main film) as being in fact a film that a character is supposed to have made. This is the case in *It Should Happen to You* (George Cukor, 1954), when the unfortunate suitor, obliged to abandon his fiancée, who is intoxicated with her own ill-gotten fame, leaves her a small farewell film that melancholically replays several scenes based on their past meetings.

But that is not all. There is also the case of what should be called *quotations*—not to be confused with allusions, winks, pastiches, remakes, private jokes, etc.—which (often)[4] offer us very pure instances of simple embedding. The practice of quoting (I am speaking of quoting that the spectator recognizes, and cannot fail to recognize, as quoting) assumes simultaneously that the film being quoted is somewhat known and that the viewers are somewhat *au fait* with it (see, for example, the sequence from *Bicycle Thieves* [Vittorio De Sica, 1948] in Ettore Scola's 1974 film *We All Loved Each Other So Much*). To the metacinematographic dimension may be added the dimensions of history and of cinephilia, twin factors that give great force to the enunciative intrusion. Examples of true quotations are now very numerous, especially since the cinema has started contemplating itself as a lost object and feeds on its own interminably commented-upon bereavement, a process initiated by the Nouvelle Vague.[5]

In an elegant, emotional way *A Strange Love Affair*, an independent film by Paul Verstraten and Eric de Kuyper (1985), remakes the sequence from *Johnny Guitar* (Nicholas Ray, 1954) that deals with the question of affectionate relations that have been long interrupted and of whether they can be revived if and when circumstances allow. Ray's sequence is cited twice in *A Strange Love Affair*: first only the sound, during a class on cinema given by the hero of the story, and then the image and the sound together, which he plays when he gets home. We are already encroaching on the next categories in this classification because the contribution

of Ray adds complexity to the whole (later) film, which is without doubt the best that has been made on the subject of love between two men. But in terms of textual space, the location of the source of the quotation is clearly indicated.

In *On the Town* (Gene Kelly and Stanley Donen, 1949), a short comic stage musical (but filmed, of course), there is another film embedded at the heart of the main film, played by the same actors but against a backdrop of glowing, abstract scenery. This other film summarizes and symbolizes the "main" story in a schematic but, when all is said and done, complete fashion.[6] The secondary film is a metaphorical intensification of the main film.

Another classic case of overt embedding—but this is an immense subject—would be amateur films, with their shaky images and constant lurches in quality, accompanied by the thin-sounding, low-key whirr of the projector. We could say that the enveloping film, like an adult who amuses himself by evoking his childhood, attempts to revive inside itself the crackling of old films as they flicker and stutter, as if in search of the secret of some primordial sound (see Patrice Rollet[7] and Michel Chion),[8] in order to remind itself where it has came from, and to *say* so to itself.

The masterpiece of the genre, which brings much else of note to the genre, must be the Algerian film that is associated with the character Bernard in *Muriel* (Alain Resnais, 1963).[9] Some of its other features bring to mind categories such as frequent returns and narrow thematic parallels with the enveloping film. There is no shortage of "pure" (and more modest) examples: in the midst of *Les aventuriers* (1966) director Robert Enrico embeds a short Super-8 film, "previously" filmed by one of the characters, which represents with some evocative force (by means of brown-green tone and trembling twilit images, along with an atmosphere of panic and of end of empire) the hurried flight of a rich Belgian colonist, who has bought the protection of paratroopers just at the moment of the decolonization of the Congo.

It is possible to construct an intermediate category containing the various and numerous devices where the enveloping film intermingles more closely with the second film(s). Thus an alternating structure is sketched out, but in an overall context where the main film "summons" the included sequences and shots according to its own needs. In this way no kind of symbiosis or permanent connivance between the two filmic levels establishes itself, because these would be characteristic of fully reflexive configurations.

Pushed to its limit, this logic leads directly to montage. Even if the "secondary" images occupy the whole of the duration of the film, and even if the main film is reduced to acts of speaking (as happens frequently), it is still this commentary that enframes the whole thing and brings all the parts together. The commentary is indeed the thing that constitutes the main film, the thing that "*is*" the film.

Fiction films offer other generally less extreme examples of this structure, which has become common since "popular" cinema has itself become sophisticated and other cinema even more so. François Truffaut's *Love on the Run* (1978) tells its story in two ways at the same time—by unfurling in front of our eyes its proper ("main") plot and by copiously quoting, as the desire takes him, so to speak, from the four previous films (but that are "secondary" here) of Truffaut's Antoine Doinel cycle, which it feeds on and which for this film represent History: *The 400 Blows* (1959), *Love at Twenty* (1962), *Stolen Kisses* (1968), and *Bed & Board* (1970).

Biquefarre (Georges Rouquier, 1983) remakes several sequences from *Farrebique* (1947), which was filmed thirty-eight years before by the same director and in (almost) the same locations. But this is done in order to better show the "present" state of the countryside and the profound changes that have taken place in comparison to the older film. It is a one-way relation, once more—the narrative of today co-opts pieces that it takes as it pleases from that of yesterday, while the older film's construction and internal coherence remain other in 1983.

In *A Man and a Woman: 20 Years Later* (1986), Claude Lelouch organizes with great playfulness and finesse two distinct series of quotations, each with consequences for the plot. On the one hand we have of course his film from 1966, *A Man and a Woman*. We ought to study, by the way, from the point of view of enunciation, directors who get certain actors to make repeated comebacks because they echo former films, as in Léaud in Truffaut's work, Wayne in Ford, Ingrid Bergman in Rossellini, Marlene Dietrich in Sternberg, everybody in Bergman, blonde actresses in Hitchcock, and so on. On the other hand, to get back to *A Man and a Woman: 20 Years Later*, the images of Hitchcock's *Dial M for Murder* (1954) insistently appear within the narrative every time a television set is on, or as soon as someone switches one on. In a more general sense this film constantly intermingles, not without artifice, three different levels of reflexivity: (1) The "young" ones, Richard Berri and Evelyne Bouix, often repeat gestures or actions that were performed by Anouk Aimée and Jean-Louis Trintignant in *A Man and a Woman*; (2) the images from the older film are frequently interpolated into the new one; and (3) the

"older" heroes themselves reproduce in the second film the postures they struck in the first film, in particular Trintignant when he is behind the wheel of his car, seen from in front through the windshield, with lashing rain and the obligatory windshield wipers on.

In cases of perfect doubling, turning in on oneself, the "first" film weaves itself *through* another, which is not truly another and which is not truly "within" the other. Unfortunately, "film through a film" [*film à travers le film*] is an impossible expression. However, the relation between the two textual layers is indeed that of a crossroads, imbrication, braiding, or entanglement at the limit of symbiosis. There are multiple types, and every inventive work adds another. But in every case it is the duality even of the filmic levels that are shown that finds itself threatened, superseded, or brought into question.

At times, in experimental cinema, the main or first film (which is also the second one, as we will see) has been made using the film stock of a second film (in fact, the first film), which is "reshot" and transformed according to the desired goal. In 1969 Ken Jacobs created a film-demonstration of 118 minutes entitled *Tom, Tom, the Piper's Son*, which used as its starting point a 1905 ten-minute chase-farce of the same name attributed to one of D. W. Griffith's technicians, Wilhelm ("Billy") Bitzer. It extensively "quotes" the earlier film at the start and the end. The rest of the time Jacobs works on the body of the film, sometimes shot by shot, and sometimes distorting the image, reframing some details and inserting blank frames (see Dominique Noguez's analysis of this).[10]

Eureka, by Ernie Gehr (1974), seems at first sight to be an interminable forward-tracking shot, running at a surprisingly low speed, along the whole length of San Francisco's Market Street, gradually approaching a building that has not existed since the earthquake of 1906. But in reality, Gehr's work consists of essentially "expanding" a film made prior to the earthquake, which had been filmed in just such a traveling shot but which he runs at normal speed.[11] Once again, this is an intervention on the film stock itself, at the very core of the other film, in its most intimate aspect, which has transformed the other film at this point. In cases of this type the "first" film, that is, the film, is sewn into the body of its predecessor, in the way that a housewife will refashion a dress to create "another" one. In a modern figure of metempsychosis (transmigration of the soul) the first film is a second avatar of the second film.

This effect of transubstantiation may apply in completely other circumstances, as the (avowed) philological desire to reconstitute an old film (which thereby becomes the "second" film) in its supposed

historical textual integrity, an integrity that the first film realizes. It can happen, through a strange paradox, that this devotional return to an origin is accompanied by some voluntary renovations carried out on the body of the venerated ancestor. When compared to the previously available copies of Fritz Lang's *Metropolis* (1927), Giorgio Moroder's recent (1984) intervention involves several distinct changes that do not all have the same impact and are not entirely coherent. Some shots from the original that had been lost were rediscovered by Moroder (or by Enno Patalas at the Munich Film Museum). Others were more or less arranged, or fabricated, on the basis of the script by Lang and Thea von Harbou and on the basis of still photography. The typography of the intertitles was changed, while color and music were added with due consideration. The final result is somewhat ambiguous. Moroder's film, the "main" one, *encapsulates* that of Lang (the "second" one!) by means of a multiple process of addition and excess that simultaneously pulls it backward (= restoration, the spirit of history) and forward (= taking a modernist twist). But it is nevertheless *the same film*. Roger Odin has suggested a highly original interpretation of this metamorphosis: it is a question of adapting the film for a "new spectator," who is more concerned with visual and musical rhythm than with fictional knowledge.[12]

Another, more contemporary, case is when the main narration is built on a tissue of numerous inserted short films that themselves make up a significant portion of the length of the enveloping film. The prototype for this could be Woody Allen's *Stardust Memories* (1980). The subject lends itself to the technique—the hero, played by Allen, is a filmmaker, and the better part of the film plays out in the form of separate, successive scenes that once might have been called a stream of consciousness. These consist of parts of his own films that he is thinking about, his picture-memories, his fantasies, his regrets, and even a hallucination. (There are not only second films but also imaginary sequences, flashbacks, and so on; later I will discuss the kinship shared by every *diegetic repeating* and the film within a film). At the center of this mosaic, and making up part of it, are "real" scenes, which themselves are finely chopped up—as in *8½* (Federico Fellini, 1963), which seems to be the inspiration of this film—and offered in order to throw some brief, scattered light on the life of the hero in the present. He is spending a few days out of the city, staying at the Stardust Hotel, to attend a festival of his films. The professional interpreters of his work and his fans persecute him. "Reality" and various layers of his imagination interplay in an echo chamber, because they are all peopled by the same characters (and are subject to metamorphosis

when they switch from one psychic level to another). They form in themselves a complete and confused universe, just like the universe that each of us inhabits. The disparate multiplicity and the expanding number of episodes render in advance artificial any too-strict distinction between the main film and its secondary inclusions. On the contrary, the peculiarity of the enunciative structure here is due to the constant shifts of its source [*foyer*] and the "disordered" intermixing of the material that these shifts convey. It is also worth noting a strong variant of the mise-en-abyme, a variant that is no longer rare but is not yet common either: the short film that occupies the very start of the film in such a way that one is forced at first sight to take it as the "true" film. Here, it is the scene of two trains and is similar in this respect to the car race that opens the Lelouch film discussed earlier.

It can also happen that the main film is made *only* out of second films and contains nothing, or almost nothing, that "stands apart" or is exclusive to it. In a way, this is the case in *Citizen Kane*, which has been remarkably analyzed from a similar standpoint by Marie-Claire Ropars-Wuilleumier,[13] as well as by Seymour Chatman, Gianfranco Bettetini, Francesco Casetti, Michel Marie, and others.[14] We may note once again that a flashback—the form of every one of the narratives by the witnesses (the butler, Leland, and so on) in this film—may be regarded as a kind of film within a film. Also, the first section of the narrative, the newsreel, is actually a film. This has its desired effect, and Woody Allen imitates it. With Welles the included film, *News on the March*, is in theory fully distinct from the true film of which it is the opening section, but everything in what follows works to undermine this certainty. The rest of the narrative is simply a juxtaposition of several versions of *News on the March*, each episode being ONE film of the life of Charles Foster Kane. By contrast, the newsreel is retroactively transformed, because of its structural similarities, into a supplementary flashback. After (or rather before) we are given the point of view of all those who were close to him, we are given the point of view of Society, of America. This sequence then provides the thematic matrix for all of the others (see Michel Marie's examination of this), with the result that the film spends its time retracing its own steps. *Allusive intricacy* and *expansion* are thus the means that in this case enable the film within the film to haul itself up to the dimensions, or more precisely to the contours, of the entire film.

Rashomon (Akira Kurosawa, 1950), another illustrious and much-written-about film, belongs to the same (broadly defined) family. It consists of secondary yet strongly autonomous narratives instead of truly

included films. This is also true of Chris Marker's *Letter from Siberia* (1958) and many other films. If we let ourselves get carried away with progressively expanding and overgeneralizing our survey, we would do well to add numerous episodic films, such as *Un carnet de bal* (Julien Duvivier, 1937). In sum, all of these films "consist" of several films, in all senses of the verb. But that is going too far. In *Un carnet de bal* we reach, or rather we cross, the threshold that separates *films made out of films* (or at least out of multiple narratives) from *series of films* that are artificially assembled, whether this be for commercial reasons, for the illustration of some shared theme, or both. Reflexivity disappears, as we can see from the common kind of episodic film, and even more so when we advance one "notch" further to films that are authored by several directors (*Six in Paris* [1965], *Of Life and Love* [1953], *New York Stories* [1989]), even when these films pride themselves on having some kind of unifying theme.

Another very different construction, which diffracts the second film through the main film, is the *interactive* type, of which there are two incontestable classics: *Sherlock Jr.* (Buster Keaton, 1924) and *The Purple Rose of Cairo* (Woody Allen, 1985).[15] In both cases there is no longer a "mix" or surreptitious superimposition of the included film and the film-film. They remain properly separate, but the great novelty, and the thing that "stirs them up" in their own distinctive ways (or rather braids them together), is the way that they are interconnected in terms of cause and effect. In *The Purple Rose of Cairo*, for example, we may remember that the "real" young woman astonishes and seduces the actor in the secondary film, who finishes by (physically) abandoning the interior screen, while taking care to stay in focus, and by making a very conspicuous intrusion into the primary narrative, before the heroine, in an inverse trajectory, penetrates the screen. The narrative is made up of these back-and-forth movements. We can "move" from one film to the other in such a way that the relation between them seems to follow the famous political slogan "independence within interdependence."[†]

We know that *Man with a Movie Camera* (Dziga Vertov, 1929) introduced a large number of profoundly original forms, often differing from those that I have just described. I will choose one of them. In the

[†]. This phrase dates from a November 1955 speech at the French National Assembly, when Edgar Faure projected "l'indépendance dans l'interdépendance" for Tunisia, which was a French colony until the following year.—Trans.

sequences that interest me here, the included film, which is highly discontinuous and dispersed although omnipresent, consists of nothing but a segment of the enveloping film itself, provisionally extracted and, as it were, "downgraded," or transformed in front of our eyes into a second film. The inner film, in sum, *is* (in that moment) the main film, especially manipulated by enunciation, a film that includes itself. The most clearcut example is without doubt that of the cyclist. He is initially filmed "normally," in full flow and in the open air, and then just after that, the following shot shows him (it is indeed the same man) on the screen in a cinema with several rows of seats visible and a little bit of space around the screen. The *kinoks*[‡] have filmed him, and this reportage is now being projected in a cinema in Moscow, so the "current" reportage no longer shows us the cyclist himself but rather this projection. The main film has shed a little part of the film stock in order to give body to the internal film, and it has withdrawn itself a little in order to keep its distance and to maintain a marker of its precedence.

It would be vain to pretend to recount all the "strong" forms that the mise-en-abyme can take. But I hope I may be permitted to recall briefly what I have said about this before in relation to *8½*.[16] It is the story of the filmmaker Guido (played by Marcello Mastroianni, but there is no doubt that he is a stand-in for Fellini himself), who is in the process of preparing a film. This film, after all that we are *told* about it, ought to bear a family resemblance to *8½*. But we never see a single frame of it. What is narrated are the preparations for the (absent, but much discussed) secondary film, whose production will never be completed, leaving a gap that can be filled only by the main film. The sole, eminently enunciative, difference is that Fellini has made a film out of Guido's nonfilm. This major, constitutive discrepancy makes itself felt throughout, notably in the sumptuous final scene, where we see the enchanted merry-go-round of magical, grotesque characters who people the imagination of Guido-Fellini, who is represented as a small boy dressed entirely in white in the middle of the magical circle. The decisive moment comes when Mastroianni, the filmmaker in the story, himself enters the circle and finds his wife, La Saraghina, and the others, and in the process becomes one of Fellini's characters. The "main" film becomes unstuck, separating itself just at the moment when the two films are completed. *The film within the film is the film itself.* The mise-en-abyme structure reaches its full

‡. Dziga Vertov's circle of Soviet filmmakers.—Trans.

paradoxical force when there is no longer an included film, that is, when the two films, which are *avowedly* distinct, are physically totally confused. This is the symbiotic type.

It is quite rare, but we come across it (a little less perfectly achieved), for example, in the fine film *Tangos, the Exile of Gardel* (1985), by Fernando Solanas. The story concerns some enormously sympathetic Argentinians in exile in Paris. Tragic and comic, courageous and confused, in a permanent state of romantic, generous, and shabby self-derision, they undertake to compose a "tangedy," i.e., a tragedy-comedy-tango. We never see any of this work, only scraps and magnificent shots of rehearsals. But the entire film *is* this tangedy just as they describe it in their conversations within the story, they who have not managed to compose it but have managed to have it made, when all is said and done, by this film, which, with a unique flourish, both recounts and effaces their setbacks. In *Emergency Kisses / Les baisers de secours* (1989), Philippe Garrel plays the role of a filmmaker who is preparing a film. It is only a work in progress and will stay that way until the end. We will never see a single shot. The filmmaker tells us that in this film he will play the character of the filmmaker and that he will speak particularly about his relationship with his wife, a relationship that occupies a lot of space in the real film. The secondary film is only an echo projected through the main one, a carefully designed shadow. It does not distinguish itself in any way, except insofar as it asserts that it distinguishes itself.[17]

There exists a particular form of reflexivity where the redoubling is at the same time perfect and strictly circumscribed. I want to discuss famous people who "play themselves," such as Fellini and De Sica in *We All Loved Each Other So Much*, Brice Parain in *Vivre sa vie* (Jean-Luc Godard, 1962), etc. This is a common trend, or at least it has become so. It is clear that they are not *really* playing themselves (otherwise they would have no need of a director) and that they are shot as part of the fiction. But the effect of recognition is nonetheless inevitable for viewers who are familiar with them. In relation to *Pee-wee's Big Adventure* we saw how a movie studio (none other than Warner Bros.) could equally "play itself," showing that the exercise is not limited to people.

There are also intermediate cases, where someone plays a role that is not exactly him- or herself (or indeed, depending on the film, is not declared as such in the film), but who comes very close to it and is obviously conceived to be such. Fritz Lang in *Contempt* (Jean-Luc Godard, 1963) would be one of the best examples of this. Simple resemblances, even partial ones, can still be striking. So there is hardly any doubt that

some of the traits of the heroine of *A Star Is Born* (George Cukor, 1954), Vicki Lester, the singer in the "musical," are modeled on those of the person who acts her, Judy Garland, with the result that at times she plays a role that she greatly resembles.

In one sequence of *A Man and a Woman: 20 Years Later* the viewer finds himself with a jolt in the center of a vast Franco-Anglo-American military camp, evoking the 1940s as well as the 1980s, a place where soldiers and officers in various uniforms crisscross one another in all directions. We think at first that all of this is "real," that is, a diegesis at the primary level, and we do not yet know what this heterogeneous army will do in the story. But fairly quickly a change of framing reveals a camera (which is obviously not THE camera), as well as all of the equipment that goes with it. This camp scene was in the process (or on the point) of being shot by a crew of filmmakers, and the film (if we are to believe it) was showing us this scene because in the story the character Anne (Anouk Aimée) is by profession a producer.

We cannot say exactly, in relation to the images of the camp itself (before the revealing deframing), that the moment of enunciation "exposes the apparatus" to us. What we are shown here is supposed to be *filmed*, whereas the apparatus is on the side of the one who is "filming." Nor is it a film within a film anymore, because it is not presented to us as finished and preexisting, and it is not projected onto a screen. We are shown, if I may put it like this, an *alien profilmic [profilmique étranger]*—that is, the profilmic material[18] (i.e., that which is placed before the camera) of a film other than the main film. The process is quite common. It always achieves its effect, which is a simple one, seeing that the filmed profilmic object resembles by definition the filmic object. The viewer cannot fail to confuse, for a very short moment, the included profilmic object with the enveloping filmic object, something which authorizes various surprises and tricks in the screenplay. We even find false alien profilmics (!), as for example in Ettore Scola's film mentioned earlier, where we see the representation of Fellini's preparations for the scene at the Trevi Fountain in *La dolce vita*, but they are reconstructed by Scola in his own manner, despite the presence of Fellini in the image . . .

Fellini's *Intervista* (1987) is an almost unequaled source for enunciative moves and reflexive fireworks, and it invites us to marvel at its playfulness. It is a record of memories of a filmmaker, Fellini himself, as always, and it is also a ship's log of Cinecittà, the cinema-city. The richness of the constructions that redouble and point toward the source of the film is almost excessive. It can give us the feeling of a rather forced

investigation, of a ludic waywardness that has its origin in the self-indulgence that is peculiar to this auteur and that alienates some people (but not me). This is also the reason why *Intervista* is sometimes considered a minor film in Fellini's oeuvre, which no doubt has a little truth to it. It is still the case that the reflexive paths in this film cross one another according to a particularly complex, indeed overwrought, design. To start with the music: it is not by Nino Rota; rather, we owe it to Nicola Piovani, but Piovani reused long passages that Rota had composed for earlier Fellini films, music that Michel Chion has written about so well.[19] Thus the past of his oeuvre is present in the present.

The entire film is at the same time a *filmed film*—filmed by a Japanese television crew who have come to interview Fellini in the "here and now" of the narrative—and it is a *filming film*, that is, a film that films at length and at leisure many acts of filming. *Intervista* unfolds according to three degrees of filmicity [*filmicité*], which together form a stack of instantly interchangeable elements. There are secondary films within the film, but this film is itself the "secondary" film of another, virtually main, film—that is, the Japanese television show—which we will never see and the recording of which is secondary within the main film.

In *Intervista*, Film 1 shows us not only the apparatus of various Film 2s (as well as, frequently, its own) but also their shooting and their profilmic elements. This profilmic material becomes filmic (and consequently itself carries out a shoot in the film within the film) as soon as Camera 1 advances, leaving Apparatus 2 out of shot, and thereby becomes indistinguishable from Camera 2. We see the same thing in the fragment of filming Kafka's novel *America*, and for the Hindu film with the director on speed and the cardboard elephants, and so on.

This structure extends even to the auteur's own conception (screen-writerly or "real"?) of his own life. Now old and being interviewed (hence the title, *Intervista*), Fellini separates himself from his past through the device of a young journalist and interviewer who will, more than once, coexist visually with him, a "him" that is played by him. . . . At one stage he gives him a fake boil on the nose (under our noses) so that he comes across as more adolescent. Thus Fellini-the-actor, playing Fellini-the-character, who himself represents Fellini-the-filmmaker—and moreover, the auteur of the present film, as it will be made clear, but not immediately—gently teases another character of whom he suggests at a turning point in the dialogue that he "could be" the real young Fellini, all the while designating him (the person playing Fellini), by means of this boil, as an actor.

But as in *8½*, at the end the primary enunciation exercises a merciless *control* over all the figures to which it itself has granted a provisional and fake independence. After the night spent in the tent and the attack of the Indians armed with television aerials (justified in the main film by a second shoot on a neighboring set), Fellini-the-actor-character-auteur reappears in force and sends his crew off on their Christmas holidays (this is the end of the main film). He then takes care to remind us, by means of the second, real ending (featuring a clapper loader announcing "*Intervista*, 1, Take 1"), that he is the only director and that of all of the films of which we have seen parts, the only film that we have truly seen has been *Intervista*. Under less marked forms, this control, as Bernard Leconte has commented, is one of the functions guaranteed by all of the credits placed at the end of the film.[20]

I should add that the distinction between the moment of enunciation and the auteur—the auteur whom some comically insist on calling real, as if there were any that were unreal—that this distinction, which for its part is indeed real and needs to be maintained, does not interfere in any way with the *empirical* distance between the auteur and the source [*foyer*] of the film—a distance that is psychological, historical, and so forth and that is never zero, since the work exists in a separate state—nor does it prevent that distance from being highly variable and at times, as is the case here, from becoming very weak. It is enough that *Intervista* exists, that is to say, is projected at various times and in various places, so that we do not confuse the textual source [*source*] with the person of Fellini. However, the text itself is constructed as much as possible (and even a little more than that . . .) to foster this confusion. And this confusion is also a truth since the film, quite obviously, wants to be a "Fellini by Fellini."

As I alluded to earlier, the flashback shares something with the film within a film, at least insofar as it has the effect of making a "cut" at the heart of the narrative. It does not detach itself as frankly from the main narrative flow, seeing that it does not show us a part of itself as if it "were" another film. However, the basic rule for every narrative is to *move forward*, chronologically and causally (we may remember what Roland Barthes said on the subject), so that, when it "repeats," as if obeying the instruction *da capo*[§] in musical notation, when it restarts at a point situated *behind itself*, the thing that becomes established at that

[§]. "From the beginning."—Trans.

point is another separate narrative in the same story (this method has only a phenomenal value, seeing as in fact it is the narrative that creates the story and not the other way around). So I agree with Michel Chion, for whom the flashback starts at a moment when "time has suspended itself."[21] Leaving their obvious differences aside, it is thanks to its partial autonomy that the flashback is similar to the film within the film. Besides, the flashback does not always conserve this autonomy. It can become very long or even—in a classic move—it can become almost confused with the entire film, where the only thing that distinguishes it from the entire film is the "present" instance of an absolute limit, which the spectator is briefly reminded of from a distance. Structure and enframing can be made good use of to this effect, as for example in Henri Verneuil's *People of No Importance* (1956).[22] But localized flashbacks, equally common now, conserve the status of the embedded film and of the "included films" that I am considering here.

We have discussed flashbacks and films within films, but there are other similar, though varied, devices, such as consulting memoirs (cf. the Thatcher Archive in *Citizen Kane*), the novel within the film (everywhere in Truffaut's work), stage plays in the film (everywhere in Rivette), video in film (cf. the revelatory tape in Pierre Zucca's 1985 film *Rougegorge*), and so on. This is not to include hybrids and other composites. In a "second-rate flick" by Jean Dréville, *A Cage of Nightingales* (1944), the young hero, played by Noël-Noël, is supposed to have lived through tough times as a supervisor at a boarding school for difficult children. He has succeeded, not without difficulty, in transforming his charges by means of choir practice, and he has also saved them from a terrible fire, among other deeds. Later, he draws on all of these trials and tribulations to write an autobiographical novel. When it is published, his fiancée reads it to her mother, who until then had barely appreciated her future son-in-law. This voice-over reading occupies the central part of the film, and it is through this that the viewer learns about the exploits of this man who once worked with young tearaways. So we have a sort of flashback, which relates what the hero—the *I* of the read text—did before the "moment" of the film, a device that is used at the beginning and the end of the film. The construction is indeed that of the classical flashback: dialogues "played" by the actors, and purely narrative sections *spoken* by the voice-over ("That morning, the weather was good and I was happy . . ."), with the weirdness of a masculine *I* that is spoken by a female voice (she functions in the end as the narrator's female narrator, like a soloist). Apart from the foregrounded voice, this structure does not

contradict in any way that of a traditional novel narrated in the first person (and what is more, that is what it is, we are told). But this "novel" is directed at our perception; it gives us a lot to look at and listen to, so it is no longer a novel but strangely resembles a film within a film, although the main film clearly denies it the quality of the secondary film. In sum, then, it is at the same time an audiovisual novel, an illustrated recitation, a flashback and an embedded film.

We see an almost identical device in a markedly different film, *Another Woman* (1988), directed by Woody Allen. The heroine, Marion (Gena Rowlands), is deep into an autobiographical novel by her old suitor, where she is often the subject of the book (this reading is also a memory). The masculine *I* of the novel is given over to this woman who reads aloud and who, at the same time, "sees again" what she is reading, such as the lovers walking in Central Park, the sudden rain shower, the kiss in the little tunnel while taking shelter . . .

We come across constructions that are somewhat similar, on a smaller scale, every time in the cinema (and God knows it happens often enough!) that a letter is read aloud by its recipient, or by the sender as he or she is writing it, either with or without the appearance of the letter itself onscreen.[23]

We could use the term *inlaying* [*incrustation*] for a very particular case, which would be an approximate equivalent to the "*santon*" in literature.[**] In the cinema a perfectly representative sample is found in *Dead Men Don't Wear Plaid* (USA, Carl Reiner, 1982), elegantly translated into French as *Les cadavres ne portent pas de costard*.[††] It consists of a second-rate, artificial (it must be, given its date) film noir, a product of amalgamation that includes authentic fragments of film noirs of the past (*White Heat*, *The Killers*, *Double Indemnity*, *The Lost Weekend*, *The Big Sleep*, *Notorious*, etc.). But they are not presented as quotations, except in the credits in the form of warmhearted, nostalgic homages. They are integrated into the plot of a hyperfilm noir, concocted to fit the circumstances, imitating marvelously the grains and dust motes of the past greats. The film delights the viewer in the way that it finds elaborate methods of including sequences imported from other films as it goes along. Hence we have a play on the shot/countershot whereby it is possible to arrange a dialogue

[**]. Metz uses the term *santon*, but it is likely that he intends the identical-sounding *centon*, which is a piece of poetry or prose made up of borrowings from other authors.—Trans.

[††]. Literally, "Corpses Don't Wear Suits."—Trans.

between the "private eye" world of 1982 with a Humphrey Bogart who has become an unwitting character in this new film . . .

I will mention only in passing, as it deviates a little from my theme, what we could call films "about" films. Certain big-budget productions, such as in France *The Bear* (Jean-Jacques Annaud, 1988) and in Japan *Ran* (Akira Kurosawa, 1985), have provided occasions for a simultane-ously shot making-of, which is a special short film, half-documentary and half-advertisement, which in its own way tells the story of the shoot-ing of the "big," main film. There are also innumerable films in which the plot takes place in the world of film. And there are some more recent films that aim to recreate the history of a famous film-shoot or an epi-sode in the life of a great filmmaker (for example, John Huston in *White Hunter Black Heart* [Clint Eastwood, 1990] and Fritz Lang in *Artificial Paradise* [Karpo Acimovic-Godina, 1990]). In all these cases reflexiv-ity affects only the subject under treatment. It may also, in some places, mark the enunciation (the material invites it to), but it is not "included" in the device itself.

There may also be, "behind" the film and no longer "inside" it, *invis-ible* films, physically absent but very present in their own way. These are a special kind of memory game, less directly bound up with enunciation because they do not redouble it and because the film remains free of for-eign bodies. More study needs to be done on this; indeed, it has already been started by several young researchers.[24] The canonic type here would be the real *remake*, that which remains close to the original while packaging it differently; see, for example, *Breathless* (*À bout de souffle: Made in USA*, Jim McBride, 1983) and *The Bounty* (*Le Bounty*, Roger Donaldson, 1984). But the "lesser" film can also operate more freely in partial remakes, such as *The Shanghai Gesture*, by Sternberg (1941), which replays and replaces *Shanghai Express* (Sternberg, 1932). The film may also function by using parody or pastiche (spaghetti westerns, De Palma remaking Hitchcock), or it may inspire an attempt at recreating the orig-inal (Werner Herzog's *Nosferatu the Vampyre*, 1979). And there are also "encore-films" ["*films-bis*"]—not to be confused with what is known as *cinéma-bis* or low-budget genre cinema—which an auteur achieves by rearranging material from a previous work. For instance, Marguerite Duras's *Son nom de Venise dans Calcutta désert* (1976), which is based on her *India Song* (1975); or Alain Robbe-Grillet's *N. a pris les dés . . .* (1971), which is based on *Eden and After* (1970). In an extreme sense, all genre films—and they were once extremely common—contain within them-selves all the previous films of the same genre, so they share a very broad

lineage of "films within a film," which do not present themselves as such but whose traces may be found everywhere. We find here in this way all the problems of transtextuality, notably those of hypertext and architext, which Gérard Genette has defined with singular force.[25]

Equally at the edges of the concept of the film within a film, there is the immense field of the *allusion*—allusion to the cinema, allusion to a film. In Elem Klimov's *Agony: The Life and Death of Rasputin* (1981) the immense line of soldiers forming a large *S* in the snow irresistibly brings to mind a famous image from *Ivan the Terrible Part I* (Sergei Eisenstein, 1944). *Ashik Kerib*, directed by Sergei Parajanov (1988), ends with an image of a movie camera seen in three-quarter view, on which a dove lands, immediately followed by a written dedication to Andrei Tarkovsky. *El Dorado* (1967), directed by Howard Hawks, is often considered a self-remake of his famous *Rio Bravo* (1959), but in fact it is more of a systematic series of reenactments: the character of the deposed, alcoholic sheriff (Robert Mitchum, previously played by Dean Martin), the old man determined to help John Wayne, the likable but violent young man whose name is Mississippi (not Colorado, as in the earlier film), and so on.

To return finally to Dréville's *A Cage of Nightingales*: it demonstrates a complicated, rather than subtle, structure, but it illustrates in a striking way the necessity of not *closing off* the inventory of enunciative configurations. Although it may be limited to a certain number of fundamental devices, although it has its own "logic," and although it does not proceed from some pure and infinite freedom, it does make possible a great number of combinations. It is the physical nature of the filmic signifier that constrains it, but it is that very nature that *sustains* it by offering precise and varied possibilities. The mise-en-abyme, which is the most reflexive of all reflexive constructions, is not unique to cinema, but cinema has the means that enable it to enact it on highly varied objects and along very different *trajectories*.

9

SUBJECTIVE IMAGES,
SUBJECTIVE SOUNDS,
"POINT OF VIEW"

Let us consider a "pure" example of subjective framing in a famous image from André Malraux's *Espoir* (*Days of Hope*, codirected by Boris Peskine, 1945).[1] In the courtyard of a hotel two partisans are executing a traitor. He falls backward onto the ground, and the last thing he sees (which the viewer is also shown) is the sunflowers in the courtyard, viewed in a very striking low-angle shot. Of all enunciative constructions, the subjective image is without doubt the one that has been written about most often and to best effect. Of particular interest are recent, extended pieces on the subject by Elena Dagrada, Seymour Chatman, Francesco Casetti, Edward Branigan, François Jost, Michel Chion, Marc Vernet, André Gardies, and others, plus, notably among followers of Greimas, Jacques Fontanille.[2] The subjective image also occupies an important place in articles and introductory pieces on narratology, starting with *Récit écrit, récit filmique* by Francis Vanoye, which is the first and the classic of the genre.[3] As with the look to camera, and for similar reasons, I will generally leave aside any personal analysis of this motif, which remains one of the most important ones. In the history of theory, reflections and writings on the subjective image and then on subjective sound started very early on, unlike commentaries on the look to camera, which by and large are more recent. By a process of sedimentation they gradually became a veritable "dossier" that became well known but often poorly understood. It is my aim here to summarize this work and strip it down to its essentials, at least to its current state, as Noël Nel has already done in a different way.[4]

First of all is the old and perennially new question of seeing and knowing. When a character looks (or listens), he always *knows*, or at least he acquires a kind of knowledge that tallies with that looking or that listening, and with the likely pitfalls. But the inverse is not the case. A character who knows something has not necessarily seen it; he could have heard it; or, he has not necessarily heard something; he may have seen it. It is also possible that he has neither seen nor heard anything, but he has information about something from a letter, or from memory, and so on. It is this inaugural dissymmetry, which we don't very often bother making explicit, that accounts for the logic proper to the so-called subjective elements of cinematic storytelling.

As in a novel, a film may create a state of affairs that a character is aware of. But, thanks to the optical nature of the image, it can also show us what the character sees. This distinction is not present in literature, where "seeing" is itself a seeing that is *spoken*. Jost was the first to accord a central importance to this distinction,[5] and I think he was right to do so. He proposes the terms *ocularization* to describe visual subjectivity and *auricularization* when it is the character's hearing that is being solicited. *Focalization*, which refers to knowledge, despite its etymology, is maintained in parallel with the "perceptual" neologisms to describe purely mental subjectivations that are common to film and to the novel.[6] Thus for Jost the same word designates the same thing in both narratologies. Many so-called subjective flashbacks correspond in reality to simple focalizations, which is to say, according to the traditional definition in literature that is affirmed by Genette, they correspond to personifications of the source of information, without the optical orientation "following" and without any unusual framing. So, to take just one of many examples, in *Le jour se lève* (Marcel Carné, 1939), when Jean Gabin is cornered by the police in his house, the film of his life is evoked in sequences "guided" by his thoughts and memories but not by his gaze, because the angle of incidence does not correspond to his supposed position within the fiction, and his own image is often there on the screen. In *The Barefoot Contessa* (Joseph Mankiewicz, 1954) the count, Torlato-Favrini, evokes the memory of the evening when he slapped the rich South American who was coming on a bit too strongly with Maria. It is the count who informs us of this, but we do not see things through his eyes. On the contrary the camera is opposite him and takes care to show us this when he moves toward the person whom he is about to dress down.

I am not convinced that the terms Jost proposes are indispensable. It is the idea that is the thing. Maybe it would be simpler and in the

end clearer to contrast "mental" focalizations with "visual" and "auditory" ones? This would be my preference, for what it's worth.

Another aspect of the problem presents itself as the objectification of the subjectifier, as Rabelais's Limousin schoolboy might have put it.* Let me explain what I mean: It has been noted for some time that the so-called subjective image carried with it an underlying contradiction, which rendered it asymptotically impossible, so to speak. This observation was notably made in the course of the debate that greeted the French release of *Lady in the Lake* (Robert Montgomery, 1947) shortly after Liberation, a debate participated in by Jean Leirens, Barthélemy Amengual, Marcel Martin, Jean Masarès, Albert Laffay, Jean Mitry, and others. The idea is that, in order for the spectator to take in what a character is seeing, it is necessary for him to see that character himself, either just beforehand, just afterwards, or in some kind of accompanying shot. This is a case of suture achieved by the countershot, even though strictly speaking there might be no optical countershot. Alternatively, it is necessary that some kind of indicator, as long as it is clear, such as a fragment of dialogue, should inform him a little bit about the embodied viewer. In short, to slip into the gaze ("subjectively"), one must know the person ("objectively"). Montgomery's film was generally held to have failed because of its forgetting, or underestimating, this condition. We are not shown enough of the viewing character (I am rehearsing the criticism of the time), with the result that one perceived the images of the film rather as objective, so they came across as strange or unintelligible.[7]

In the second volume of his theoretical magnum opus, Jean Mitry concludes that the "true" subjective image (i.e., without a viewer in the frame) is only possible in small doses and in particular circumstances.[8] For his part, Merleau-Ponty said as much in his 1945 lecture on film[9], and it is the well-rehearsed theme of "art behaviorist" cinema, which is incapable of seeing things other than from the outside and incapable of showing *what a person sees*. Albert Laffay went even further when he declared that subjective vision of any kind is impossible onscreen.[10]

There was no doubt a certain amount of irritability in this noisily argued debate that bombarded me without warning when I innocently arrived in the Gare d'Austerlitz from my rustic, provincial cinema-club. The diegetic observer, in effect (I haven't forgotten this), precisely because he is diegetic is easily "shown" from the outside, either before or

*. The *écolier limousin* is a character in chapter 6 of Rabelais's *Pantagruel*, who inserts Latin words with French endings into everyday speech.—Trans.

after the subjective image. The lowliest third-rate film can conduct this back-and-forth easily and frequently. It is true that in the cinema the subjective is conditional upon the objective, but that condition is not entirely draconian. Thus in *Zéro de conduite* (Jean Vigo, 1932) a famous low-angle shot makes the small headmaster briefly appear to be a huge terrifying monster. But the very same scene "naturalistically" shows the child in the story who sees him like this when he is summoned to the office of the imperious shrimp who runs the school.

The issue has resurfaced recently. In "Le récit saisi par le film" Michèle Lagny, Marie-Claire Ropars-Wuilleumier, and Pierre Sorlin note that in French films of the 1930s a character who "subjectifies" a segment of the narrative can find himself objectified in another segment. For Edward Branigan,[11] when the narrator delegates his powers to a secondary narrator, to a character who bears the "point of view," this latter figure must first of all be situated, identified, and *cadré* (i.e., "framed" in the text, as in the theory of the same name). Taking the psychoanalytic perspective, I would suggest that to adopt a gaze, one must have seen the body of this gaze. Or it may be that secondary identification (with the character) presupposes primary identification (with the film, "with the camera"). It is for this very reason that in 1975 I named them "primary" and "secondary."

A few observations on the semisubjective image: The "difficulty" that I have just recalled has a consequence that, to my knowledge, Jean Mitry is the only person to have identified formally.[12] Seeing that the "subjectifier" is always objectified in some way or other, it comes as no surprise that this can take place in the subjective image itself. In Mitry's terms, this is a *semisubjective* image, or an *associated* image, by which he means it is wholly objective but is associated with one character's view. Thus in *Citizen Kane*, when Kane, in a fit of impotent rage, trashes the bedroom of his wife, who has just left him, he is observed by a group of shocked domestic staff standing silently at the doorway. The framing shows us the group that they form, and it shows us what they see, more or less at the same angle from which they watch him. The camera must have been positioned a little behind them and directed along an axis that more or less aligns with their point of view (this is an expanded variation of the subjective partial view but showing the viewers more fully).

In *L'acrobate* (*The Acrobat*) (1975), directed by Jean-Daniel Pollet, the tango scenes that are "played" by Claude Melki discreetly match, by means of the montage and above all camera movement, the changes that take place in the character of the victor of all these championships, even as he is constantly in the image. We see "as" he does, and we see him.

What is more, this is a common and almost anonymous image, such as every time characters are filmed from behind in a moving car, with a part of the road being swallowed up in front of them, or when the thoughts of the hero are visualized as an overlay on the features of his face.[13]

Semisubjective shots are as frequent as subjective framing and for the same reasons that put subjective framing in charge of making possible the identification of the viewer. Here the spectators can simultaneously "avail" themselves of the view of a character and the film's view of this character. The "associated" image is in fact an ordinary image, but it is oriented, inflected, made dynamic by a singular vision that is incorporated into the diegesis and into the shot itself, endowing the shot as if with a coming into the light. And if one thinks about it, it is also an uncertain, hybrid narrative regime, often with a fragile logic, clearly confirming, if there was any need, that the viewer is rather less concerned with coherence than with optimizing his relation to the diegesis, in other words, with his *narrative comfort.* (In this respect, Jost's notion of "spectatorial focalization" authorizes an interesting reinterpretation of traditional zero-focalization).[14] Considerations of the image as fully subjective at times underestimate the intermediary, outsider category of the semisubjective, which tends to parasitize the "point-of-view shot," as they call it in English, and which is common in filmmaking but goes unnoticed because the condition of access to subjectivity is instantaneously satisfied by it.

Is the subjective construction "primary" or "secondary"? Jost also raises this question.[15] Some subjective images establish themselves in some form on the spot, in the shot itself, "without the aid of context," by the direct play of the signifier and, notably, of the angle of incidence (it has to do, in my view, with *intrinsic* rather than primary ocularization). Others, which I call extrinsic (what Jost calls secondary ocularization), do not carry any visual or auditory trace of subjectivity within themselves and would be interpreted as objective (emanating directly from the principal source [*foyer*]) in the absence of some kind of indicator in the context. Thus a horizontal pan shot will be understood as subjective or neutral in accordance with whether it is or is not preceded or followed by *another* image that shows the character turning his or her head in a fully visible way. (Similarly, normal-looking shots can become "dreamlike" if they are persistently intercut with the image of someone sleeping.)

This is Jost's definition of primary ocularization: the scene is seen by someone, but that person is not shown. The narrator of the film slides

temporarily into the skin of a character who is designated by the image but does not feature in it. The camera "constructs a recessed view," as at the start of Fritz Lang's *M* (1931), when the murderer watches the girl in a high-angle shot and then in a tracking shot, until Peter Lorre's shadow is projected onto the advertising column.[16] Another form of intrinsic subjectification may be found in "deformed" images, which are supposed to convey the vision of a drunk or a character with poor eyesight or some such, in which the personalization of the shot remains attached to what the character actually sees. Genette has already insisted, in relation to the novel, on the fact that there is something of the paradoxical and of the logical at the same time in internal integral focalization, which makes us "see" everything *through* the hero but which in the end tells us nothing about him since to speak about him, one would have to be elsewhere, and so in an external or overhanging focalization.[17]

In relation to Jost's bipartite distinction, which I think has some currency, one would no doubt have to show oneself to be less restrictive regarding the differentiating role of context. It is the determining factor, it is true, for "secondary" ocularizations, but it also necessarily intervenes for every point-of-view image. It must be the case that the film, which in any case must be a classical film, lets us know which character, or at least which type of character, is the bearer of the recessed gaze, whether through a spoken cue, a previous sequence, the direction of its plot, or even its atmosphere and general style. In Lang's film we are given a hundred small details, which our attention correctly picks out from the context, that the person who is looking is a Villain. If *nothing* is actually suggested, not even a vaguely generic and recognizable situation, an unusually angled shot is no longer subjective but inscrutable and, we could even say, unintelligible. In a western, when the bottom of a deep, twisting ravine is viewed in an extreme high-angle shot, we know that it is the Indians who are watching, because we know we are watching a western. Of course, sometimes we only know one thing: that the image IS subjective, which is to say that it is someone other than ourselves who is watching it, but we cannot say who. It is the very definition of many suspense sequences. But once more, in these cases, in order to make us certain of this nameless presence, the context always intervenes in one way or another, whether by means of simultaneous soundtrack, earlier plot, an allusion in the dialogue, threatening music, or something else. In this I am in agreement with remarks by Jacques Aumont to the effect that subjective marking is inseparable from the narrative-diegetic complex and so is *always* contextual.[18]

Still, to get back to the point, there is a great difference between sub-jectivations that are established only by a play of approximations and barely impinge on the frame, and those that *establish themselves in the image*, even when effected by strong or weak indicators.

Some eyes are of the soul, and some are of the body. They are all "subjective," and cinema likes to mix them. In the course of an entire book, Edward Branigan has rigorously analyzed and counted the many types of image that are normally (and correctly, when all is said and done) classed as subjective but that are given this label for extremely different reasons.[19] An overarching account of enunciation can be achieved by putting them under just three headings. First are "normal" views attributed to a character—so subjectivity is expressed essentially by the angle of incidence, as in the scene of the watching domestic staff in *Citizen Kane*. Next are certain optical distortions that hold to the "real" vision of a character, when that character is a dizzy boxer or is drunk or mentally ill—think of Ray Milland in Billy Wilder's *The Lost Weekend* (1945). They use their eyes and they fix their gazes properly on the external world, but they see it in a deformed way. This is a mixture of optical data and imagination, or rather of *alteration*. Finally, non-optical images are mental images that do not pretend to give a sense of what the character sees but of what he imagines—reverie, dream, aspi-ration, fear, memory, regret accompanied by a wishful reconstruction of a different past, and so on. We know that sometimes optical distor-tions (such as blur) are used to convey these visions of the mind, but these are established by convention, whereas for the near-sighted char-acter who has lost his glasses, it has to do in principle with a realistic effort of depiction.

The case of memory is different, even though it is one of several kinds of imaginary vision. In film it is rendered as *flashback*, which is a surprising synthetic product, a kind of cultural version of frozen food. It is based for a start on the fiction that our memory precisely recon-structs the past for us, including the liveliness of events as they arise and the richness of detail that belongs only to the real present for the brief instant it is present. In an associated phenomenon, it often hap-pens (in contrast to other mental images) that a remembered sequence loses its feeling as memory in the course of the film and becomes transformed into a part of the plot like any other and is, so to speak, recaptured by the film as a whole, which more or less smooths out the "subjective" roughness and dampens the resonance of the past.[20] So the character-who-remembers can, by a process of usurpation, come to

occupy for a long or short period the source [*foyer*] of primary enunciation. He is "forgotten" as a character, and we hallucinate that he is THE narrator.

This process reaches its extreme with what is sometimes called *transvisualization*. The secondary story starts in a character's offscreen voice, and then the voice stops. Generally it is thought that what the voice is saying is "replaced," enacted, by the images and sounds. But in truth we cannot know what it says, because it has stopped speaking. So *what it could have said* is "transvisualized." The spectator forgets it thanks to it having spoken, thanks to it having presented the story as boxed off, and now it is simply "the film" that the spectator is watching. The source [*source*] has done away with the character. This (cinematographic) difference between memory and other mental evocations is not entirely without foundation. Memory is in effect the only vision of the mind (in Sartre's sense) that posits its object as *simultaneously* real and imaginary, that is, real in the past and imaginary in the present. In this respect, memory has only one technological counterpart, and it is not cinema; rather, as I have tried to show elsewhere, it is photography.[21]

Is there such a thing as external ocularization? This is not an enlightening question when put so bluntly, but first we should recall that the literary tradition, effectively reinvigorated by Genette,[22] distinguishes three types of focalization: "internal" (the character's point of view, as in the grammatical first person in Proust, or as in the occasional third person in Stendhal); "external" (a "behaviorist" narration, with the point of view placed outside the character, the view from the outside, as in some American novels); and zero focalization (God's-eye view, from everywhere and from nowhere, an "omniscient" narration in what is called the Balzacian style, *free of all restriction*).

The authors of "Le récit saisi par le film"[23] hold the "external" category to be useless in the case of cinema. However, this label might lend itself well (the three authors sort of acknowledge this), once transposed into optical and acoustic terms, to designating various kinds of markers that cannot be attributed to a character (because they would then be "internal") and that diverge nonetheless from the regime of filmmaking that is considered normal for its time or for its genre, which therefore constitute zero focalization (which we could also define as absence of focalization).[24] But the three authors prefer to bring together again that which is perceived by the character and that which refers to a strongly marked enunciation at the heart of the "internal" category (specifying, when

necessary, the "internal camera"), a category that from the outside is no longer opposed only to the zero position.

We may think of the comparisons often made between "subjective images of a character" and "subjective images of an author" in theoretical discussions of the 1920s and 1930s. The former were above all linked, from the start, to French impressionism, while the latter were linked to the German and Russian schools of the same period. I will return to the concept of "author's images" later, which for me are *objective oriented images*, or even stylistic markers, and sometimes both together. Emanating from an enunciative source [*foyer*] that, based on the basic convention well described by Robert Burgoyne,[25] is the place of objectivity, these images do not know how to be subjective, even though this is what they must be if one thinks of the *person* of the author. Or at least, they do not know how to be subjective, obviously, in the same sense as "images of a character." They need to be clearly distinguished from one another, as Aumont does in *L'œil interminable*.[26] "External" ocularization, as defined by Genette (i.e., the narrator viewing his world from the outside), gives us an adequate characterization of the enunciative choice that leads to, with no justification by the position of a character, a rapid forward-zoom onto a detail that is "objectively" judged to be important, as in the famous and very Hitchcockian rotating crane shot in *Notorious* (1946, scrupulously translated into French as *Les enchaînés*), which ends on Ingrid Bergman's hand holding the key, which is pivotal for the plot.

Jost also rejects the idea of external ocularization but in preference for the zero position. To this end, in *L'œil caméra*, he uses two main arguments, which do not seem to me to be decisive.[27] First, framings that are marked but are not subjective, rare "auteur" angles, as in Welles, would be irrelevant to a properly narrative analysis, despite their stylistic or rhetorical importance, so that ocularization that is in principle external would dissolve into the zero type—for instance, when the camera follows the steps of a character, keeping with the movements of the body and *without* another character viewing the scene. But by reasoning this way, Jost himself minimizes the impact of ocularization. It is a concept of interest for all aspects of the apparatus of enunciation, not just for the level usually considered (too strictly) narratological. Narration encompasses, as much as the plot, the position of the narrative source [*foyer*] in relation to what is being told, so inevitably it contains stylistic and rhetorical elements. In Jost's example, identification (which is elsewhere partial) of the camera with a character is a fully narratological fact. However, he continues, we tend too much to consider as (external) ocularization

what is in reality a position of knowledge, a focalization. It is this which would be external, an ocularization that is for all that neutral ("zero"). Jost's example: in *Strangers on a Train*[28] the camera frames the legs of a character without allowing the viewer to know who he is. For me this is precisely a striking example of external ocularization. Withholding *knowledge*, says Jost, is a stereotype of the "thriller" genre! But this is only half true, because this knowledge is incomplete only because of an erroneous look and because the framing of the legs alone is at an angle that is optically marked, which one would have had difficulty categorizing as some kind of zero case. Of course, Jost does not deny this. Simply, as in the previous example, he bizarrely underestimates the importance of the optical, perceptual factor that he had introduced earlier, and with good cause, as the very definition of ocularization.

But this (too brief) discussion has diverted me from my path. The same author admits elsewhere later on that his "zero ocularization" would cover several different cases, from the real "nobody's shot" to the marker of the primary narrator.[29] This is precisely why I think it is clearer to maintain *three* distinct positions: the intervention of the source [*foyer*] is not that of the character, and "neutral" filming, even if it only exists as a limit point (I will come back to this[30]), differs from the one as much as from the other. André Gardies, who prefers *monstration* to "ocularization,"[31] is correct to keep this trio, which is also the oldest and the simplest. For him the zero point becomes "panoptical" because it is the one that least restricts one's view and shows everything the most. In the same spirit Jost finally speaks of the shot of knowledge, and so of focalizations, of the "spectatorial" rather than "zero" position. The idea is adjacent, or rather parallel, and seems right to me. In the literary tradition, zero focalization is already that of omniscience, the omniscience of the author as it is always called, but also, as a direct consequence, the omniscience of the reader, as is sometimes forgotten. Gardies and Jost have undertaken, each in his own way, studies of combinations of different positions of knowing and positions of seeing.[32] More interesting work is to come from them, and I intend to return to it.

Michel Chion, who is the foremost critic in the area, has coined the phrase *point of audition*, which is an auditory homologue to point of view.[33] It corresponds to "auricularization," as coined by Jost, who is also very interested in the phenomenon. It refers to subjective sound, that is, when we hear what a character hears. We could say, inversely, that the enunciative source [*foyer*] delegates to a secondary, diegetic authority the power to let us hear what it hears.

I will borrow one of Chion's many simple and illustrative examples,[34] that of the telephone conversation where the image frames one of the callers in the room where he is (this is only one of several possible ways of filming a telephone call).[35] If we distinctly hear the voice at the other end of the line, the caller whom we can see becomes an auditory intermediary, and the film lets us hear "through" him, so the shot is acoustically subjective. If we do not hear the far speaker, or if his voice is reduced for us (i.e., reduced by the enunciation) to a low, indistinct sound, the point of audition belongs to a third-party observer who is some distance away in the same room, and it is through him that we now hear. The visible speaker no longer subjectivizes the auditory scene. The scene, and the speaker along with it, is "objective." Watching *Amadeus* (Miloš Forman, 1984), I am struck by the scene when Mozart, seen from in front as he feverishly composes, "hears" in advance his music but does not hear somebody knocking at the door. The viewer hears both. Then, when the composer is told that someone is calling, Mozart emerges from his dream. The sound of the knocking continues, but the music cuts off abruptly. So it was "subjective" and the viewer-listener could only gain access to it via the sound-imagination of the character of Mozart.

The authors of "Le récit saisi par le film" have observed that optical and acoustical orientation can differ and even diverge significantly in a single filmic instant.[36] There is a shot in a French film of the 1930s, *Le puritain* (directed by Jeff Musso), where the hero is shown in a very marked external ocularization (i.e., a rare angle *on* him), while at the same time the soundtrack uses mimicking music to retain the voices that he thinks he is hearing and that he is therefore the only one to "perceive" and the only person who can communicate it to the viewer-listener. In this shot the image is objective, and the sound is subjective.

Many film characters "hear" the voice of their own conscience, be it President Lincoln, the scolding of their absent mother, the carefree sweet nothings of the young wife who has since become a scowling nag, and so on. In spite of these, however, sound offers fewer possibilities than the image as far as enunciative orientation is concerned, except precisely when the sound is that of language. It seems to me that there are two fairly big reasons for this: the social habit, in film as elsewhere, of subordinating the sonic sphere (except speech) to the visual sphere, and the real inferiority of sound in its precision of spatial anchoring. I addressed these two points in 1975 in an article called "Le perçu et le nommé" in an attempt mainly to show that sound that is called off or out of frame is

in fact nothing of the kind since one hears it just as well as other sound (and in all parts of the room, also like other sound), but that it owes its name to the fact that its *visible source* is off or out of frame.[37] As I said, Dominique Chateau and François Jost have proposed a classification of sounds that is very interesting and avoids this bias.[38] But despite these various interventions, too often we keep classifying sounds according to criteria that in reality are visual.

Chion, who draws on his own experience in sound and music, has had a radical influence on my take on these matters in his three books, particularly the second.[39] He says that there is no sonic out-of-frame because there is no sonic frame. Sound is localized in relation to the image, or at least in relation to the story being told, whose essentials are transmitted by the image. In an image, seen in the rectangle of the screen, that is made up of a partial view of the world, narrative film uses disparate sounds on an ad hoc basis, sounds that are drawn from the "real," from the sound library, from music, etc. They are not placed singly in relation to each other, but each element is in relation to the frame and to the story. In this sense there is no such thing as the soundtrack. But even when it is disciplined, enframed, and monitored in this way, sound continues to "play," to bring something irreducible and threatening in its lurches and shifts (as in acousmatic sound, which is what one does not "see") and to vary its timbre to bring a mood that is happy, sad, or poignant. For Chion it is these aspects that make sound cinema valuable, not cerebral and tortuous investigations of asynchronism, of "noncoincidence," or of theorizing films. This is a spectacular historical return after decades of trying to attain a liberated sound.

Marc Vernet has recently revisited the problematic of "point of view," which he approaches via the notion of "in front" (*en-deça*).[40] Quite some time ago, Noël Burch distinguished six categories of beyond the frame.[41] It is the sixth of these that Vernet seized on in 1988 and recast as *en-deça*. He remarks that the other five (the four sides and the "rear") are extensions of the diegesis, while the *en-deça*, the "in front of" the screen, is a void, a nonplace. Casetti would say this is the only part of the out of field that will never become a field.[42] But this gaping hole can also be clearly designated (i.e., the look to camera), and it can even be densely populated when a character-viewer invests in it and gives it substance. So this is the *voyeuristic setup* [*composition voyeuriste*]. The film does not want to expose the viewer who lies low in front of the screen, but it presents the scene as being viewed, in the plot itself, by somebody other than those who are taking part in it. (This idea brings to mind Jost's "counter-relief

look" [regard en creux], which he says is "constructed" by primary ocularization.)[43] For Vernet the presence of the unseen voyeur is often marked by the placing of visual obstructions within the image. At the start of Citizen Kane the shots of the reclusive old man that are taken at Xanadu "tell" us, by the high angle, the distance, and the forbidding wire mesh fence in very close-up, that this is the view of a news cameraman on a stakeout. This construction is accepted only if the person watching is invisible to the viewer and to the character who is being watched. This then is secondary identification with the visible, "blind" character, which permits the primary identification (identification with the source [source] of enunciation) to slip temporarily into a delegated position of secondary identification with the invisible, viewing character.[44] I think there are some good examples at the start of Renoir's Swamp Water (1941),[45] where, in the image of the Okefenokee Swamp in the very first shot, the high grasses that are slightly swaying betray the presence of somebody (it is the fugitive, Tom Keefer), while at the same time the grasses block a proper view of the boat of the suspicious villagers who are advancing on the water.[†]

Marc Vernet's excellent contribution is confirmed in my opinion by the involuntary counterproof that some films provide for him, such as Wings of Desire (Der Himmel über Berlin, 1987), which features supernatural beings. Wim Wenders's two angels are supposed to be invisible to all characters, but by necessity—or rather because of the weakness of cinema, which is handicapped by its physicality, by this "solidness" that is not always advantageous—the film makes them visible to the viewer. So we see characters not seeing the things that we see, even though those things are under their noses. The arbitrarily decreed invisible remains perfectly visible to us: so there is a serious discrepancy between our position and that of the characters, which detracts from certain scenes, such as those set in the metro.

For Vernet, the voyeuristic setup can also be mobile if the viewer is himself in movement,[46] as in the classic figure of the forward dolly shot that is "attached" to an invisible character who is proceeding slowly through an unknown and probably hostile place (this is a "personalized" or even "subjugated" dolly shot). Any obstruction of the view is no longer due to the intervention of what we might call a third party, but it

[†]. There are some inaccuracies in Metz's recollection of this scene. In fact, we can see Keefer clearly, there are several boats, the grass barely moves, and this is not the very first shot.—Trans.

resides at the very heart of the instance of looking. The spectator who knows film well knows indeed that there will be no cutaway shot or sideways shift, that the film is looking directly in front of itself, and that the framing (even advancing in zigzags, if the bearer of the gaze so wishes) will always and only be frontal. So we cannot prepare ourselves for the danger by a mental anticipation materialized in the image. This danger will loom up *in our faces*, in an implosion that brutally succeeds the previous surfeit-of-nothing. Dolly shots of this type, despite the mobility that is supposed to be the definition of the procedure itself, "nail down" and immobilize the point of view. Their "blinker effect" results in a veritable "coercion of the look."

The notion of *en-deça* is based on a powerful idea—that of rethinking "point of view" (or certain points of view) starting from the theory of the out of frame. By bringing these two together, it emphasizes the global construction of film space and film narrative rather than merely the character-subject who watches. In a moment, I myself intend to propose the idea of subjectivity without a subject. With the *en-deça* the traditional view of things is inverted in a certain way since it is the field that "draws" us toward the out of field and *brings its viewer into existence*. But I find Vernet to be too categorical (and too hasty) when he condemns the concepts of the subjective camera, point of view, focalization, and ocularization,[47] because the *en-deça* is one more aspect, poorly identified before this book, of how a film's setup is arranged, according to a highly variable geometry, and how it is described using these briskly repudiated terms. Apart from the case of the look to camera, which it covers, too, the *en-deça* is still the film showing us what a character sees. Nothing has changed at this simple, and at the same time enigmatic, point of departure, only *after* which can there be divergence between different interpretations, to which I will now add my voice.

Vernet finds fault with the preceding notions of referring too much to supposed technical particularities. But, beyond my not seeing the problem that there might be with that, it seems to me that their initial technical connotation has greatly diminished as a result both of usage and of the uses they have been put to, notably for "point of view" (and even for "focalizing"). *Subjective*, Vernet continues, does not suit because framings that are called subjective can often pass for ordinary ones without the reverse shot, which, before or afterward, shows the person looking. But it is precisely Jost's secondary, "extrinsic" ocularization, and more generally the necessity of objectifying on the part of the subjectifier, which has been acknowledged for some time, as we have already seen,

by the same people who argue for the notion of point of view.[48] In the end the subjective image does not have much subjective about it because it does not tell us anything about the character who is looking. On the contrary, the subjective image reduces that character to pure gaze. This is something that is not in doubt; rather, it has already been pointed out by Genette even as part of the concept of focalization[49] and has been observed in relation to film by Jost[50] and Branigan.[51] On more than one occasion Branigan reminds us that the identification of the spectator with the viewing character is purely spatial and not psychological, affective, or "human," and he makes this claim in a work that is entirely centered on the notions of "subjectivity" and the "subject." To sum up, there is no necessary or systematic connection between notions that are anterior to the *en-deça* and some kind of ontological or crypto-Bazinian realism that confuses a character with a person. We can look *via* a character (which is precisely what Vernet shows so marvelously) without that character constituting a full or psychologically rounded subject, without our even knowing anything about him, *unless he is a character*, which is to say, unless he occupies a precise and predictable square on the complex chessboard of enunciation—a logical position of which one characteristic is the ability to provide when needed, or to seem to provide, by means of temporary and partial delegation, the capacity for real enunciative activity.

I hope that I may be forgiven for this rather long "literature review." But I cannot resist the desire to end by adding my own tuppence worth to this long-running debate, now seventy years old. It seems to me that it has not been sufficiently commented upon (with the exception of a very narrowly focused 1987 article by Marie-Claire Ropars-Wuilleumier)[52] that cinema has made abundant use of *subjective images without subjects*, images that incite us once again to dissociate the orientation of enunciation from any idea of a "person" or human being. To take a very common cinematic example: a truck or car is moving along, and the image shows only the rushing, bumping road, with or without our seeing a part of the bonnet or inside the vehicle. A nighttime variation is the shifting string of lights that we see in the sequence of the makeshift runway in Malraux's *Espoir*. Very often, we do not see either the driver or the passengers, and the "point of view" is that of the truck. There are many shots from a train in Renoir's *La bête humaine* (1938), where the rails slip by, and not a bit of Jean Gabin or even of the locomotive are to be seen— this is totally subjective. Cinema draws all machines into itself because it is itself one. These images could be regarded as objective, insofar as

their orientation proceeds directly from the camera (i.e., external focalization). But beyond these inevitable borderline cases these images resist definition as "objective orientation," which I will address later, because the "seeing" vehicle is always associated with some character or other, unless the narrative treats it as a symbolic character. It remains clearly in the realm of the "subjective," even in the absence of human beings.

At the start of *Peeping Tom* (Michael Powell, 1960) the protagonist slowly approaches a prostitute on the street and then, without using the viewfinder of the little camera hidden in his large overcoat, he films her undressing. There is then a dissolve to a fully subjective image (i.e., where the moment of seeing is not shown), which is in color, just like the rest of the film (even though the hidden camera records in black and white, something which we learn only afterward). But now we see the crosshairs of the secondary camera, two lines that cut the primary screen into equal quarters. It is clear that the protagonist could not have seen these lines, as he has seen what the image at that moment shows us (i.e., the prostitute, the bottom of a street and of a staircase, etc.). The portable camera has clearly "added" the crosshairs. Thus we have two separate views. When all is said and done, *nobody* has seen what is shown to us, the woman and the crossed lines together, yet it is obviously "subjective." A little later, Peeping Tom plays back the film that he has recorded on a small screen in black and white but without the lines. It is a classic film within a film, a film-lover's film.

Take an example from one of the many James Bond films, *Thunderball* (Terence Young, 1965). Agent 007 is listening to a recording that has been made in his absence by a concealed tape recorder. He hears the sounds of the footsteps of an enemy spy who has slipped inside his hotel room and searched every possible hiding place. The small variations in the sound indicate to Bond the path the intruder took inside the room, and the camera recreates this route as it "frames" the absent character (who was not always absent) by framing the empty space, an empty space that moves. What we see, this progress across the bare carpet, is subjective. It is the topographical reconstruction that 007 makes in his mind. But is it also, and above all phenomenally, an image *that follows sound*, a machine image that obeys injunctions that themselves are machinelike; it is a camera connected to a tape recorder. This sequence is quite similar to the well-known sequence in *Blow Out* (Brian De Palma, 1981) where a sound recordist (John Travolta) has a set of photographs that reveal an unsolved murder, but he does not know what order to put them in to reconstruct the events properly. He

finally manages to do this by "following" the sound recording that he unwittingly made at the moment of the crime, thinking he was simply "recording" nighttime sounds.

Experimental cinema develops these figures of *pure decentering* on a larger scale, without subsequent recentering, or where the centering can only be understood as being achieved mechanically. Some great classics, entire films that are wholly "subjective," start with the idea of making the camera itself, and the camera alone, the viewing subject. Strictly speaking, these are the only instances of a "subjective camera." I am thinking of the perpetual and fascinating spinning of *La région centrale* (1971) by Michael Snow, a film for which a camera-guiding robot was built. Also, Werner Nekes's 1974 film *Makimono*, whose moving fluidity is more or less a horizontal shot. Snow's <—>, a.k.a. *Back and Forth* (1969), which features an alternating horizontal-vertical pan in relentless repetition, also evokes (along with many others that we could list) a robot's view of the world, but one that moves back and forth rather than around. Patrice Rollet has remarked that some of the major technological innovations of recent years in cinema, such as Steadicam or handheld cameras, have the immediate effect of decoupling the camera from the human eye, thereby splitting up a very old cinematic pairing.[53]

Via video and via several practitioners such as Coppola, Lucas, and Spielberg, certain aspects of experimental cinema have been assimilated (and at the same time domesticated and profoundly "repurposed") since the 1970s by high-end production techniques. In New Hollywood films, "point of view" in its classic form tends to disappear. Shock cuts, the now obligatory and permanent virtuosity of the camera, deliberately senseless continuity, constantly over- or underexposed footage, the clouding over of what is effective and striking, every little self-regarding and barbaric act, all come together to give the viewer a general sense of vibration and of scenic railway.[‡] It has been done before, but properly, in the plots of *The Lady from Shanghai* and *City of Women* (Fellini, 1980). Point of view changes so often, in the midst of brutal flashes, distorted shapes, deliberate obscurity, frequently used "unusual" angles, and deafening blasts in the soundtrack, in such a way that we get a general impression of a machine for shaking up the world like at the funfair, or a gentler and vaguely cognitive variant of fireworks. I have already mentioned that Albert Laffay argues that cinematic point of view is deprived of anchorage; it is floating, *mechanical at times*, free of the "liberty of indifference."[54] These are

‡. Metz uses "scenic railway" in English.—Trans.

his terms, and they were excessive for many of the sequences of many films from his time and from our own, notably in Hollywood, which was an unrivaled place for creativity. His terms had a civilizing, *cleansing* feel, with articulations that always made it possible to locate the "angle," something that changed very often but never indifferently and remained identifiable at every moment. But Laffay's terms prophetically designated a certain tendency of contemporary cinema that doubtless is the shape of things to come, and that, fortunately, from time to time produces, in the hands of a Cimino or Scorsese on a good day, something more than fairground attractions or adolescent cartoon strips.

Overall, the subjective image has a deictic quality because it is defined by inserting a signal that refers, through the fiction, to *moments* of enunciation (as in the subjective flashback) and to *sites* of enunciation (such as the *en-deça*), and in all cases to enunciating entities, be they human or mechanical. We have seen how a notion such as "weakened deictic," which expresses little in linguistics, is indispensable for characterizing the process of orientation that is made by the economy of the properly deictic mechanism, while fulfilling a partially similar function, but condemning the viewer to never answering.

Nevertheless, the thing that the subjective image performs above all is a *double doubling* of the enunciative moment. It is not simply, as one resistant tradition has it, a target figure that is directed toward an addressee and is basically unilateral. Nor do I think, and here I differ from Casetti (or more precisely with one of the aspects of his position),[55] that the enunciator, when there is point-of-view framing, remains provisionally in the background. This is because the character-viewer "doubles" *at a stroke* the site [*foyer*] that shows via him, and the spectator, who sees via him (at this point I am with Casetti once again). He is positioned like a corner between the two: as exhibitor, it is the site mark II, and as viewer, it is the public mark II. If events unfold as sound, we hear via the character, and at the same time we hear him hearing. In the image it makes us see that we are seeing what we are seeing, and it shows us that the film is showing us what it is showing us: an intricate text is constructed from these murmurs and interleaved, crisscrossed and juxtaposed spectacles. It places itself at the heart of the film as a multiple *exchanger* of looks and acts of listening and, as Branigan says, as an "internalized distance" between real enunciation and alleged enunciation.[56] It bears repeating that the subjective image is *reflexive but not a mirror*. It does not reflect itself; rather, it reflects the source [*source*] and the spectator. And it is to this very particular reflecting that it owes the deictic echoes that it often brings to life.

10

THE I-VOICE AND
RELATED SOUNDS

I am adopting Michel Chion's term "I-voice" [*voix-Je*]¹ to designate the
voice-off of the character who is narrating (what they call *voice-over* in
English). Characters can use a different voice-off, which Chion prefers
to call out-of-frame,² which is when they can be heard while they are
located (in the story) outside the scene but within sonic range. The latter
belongs to what is being narrated, but it is the narrating voice that I want
to address here.

A character tells us what has happened or (more rarely) what is hap-
pening to him. This does not necessarily carry on throughout the film, as
the voice sometimes prefers to come in intermittently. Nor is it necessar-
ily the same voice from one end of the film to the other; Alain Resnais's
Stavisky (1974) is narrated by several successive voices, and each par-
tial account is clearly signposted. Elsewhere, in *All About Eve* (Joseph
Mankiewicz, 1950), for example, we switch from one voice to another
in a continuous account, and the viewer needs to pay attention to the
changes in the timbres of the voices or to the initial, subtle settling by
the camera on the character taking up the narrative. But the principle
is barely affected by these variations, and today it is well established in
cinematic rhetoric. We hear the character speaking, but we do not see
him. Or at least, we can see (and even hear) him in the process of doing
or saying what he says he is doing or saying, but we do not see him—
except sometimes at the start, to get the ball rolling, or punctuating the
film here and there—at the precise moment of the declarative act. It is a
common device, then, despite its genuine complexity and is, for starters,

difficult to name. In France the habit of saying "voice-off" [*voix-off*] has stuck. But we use the same term to refer to the diegetic speaker who is a little to the side of the image—we should call this out-of-frame—and at the other extreme for an external speaker who identifies himself as a non-character. So should we say "voice-off-character" or something similar to contrast with "voice-off-commentator"? Apart from the fact that these terms are awkward and ugly, they are not even precise, and certainly not consistent. I mentioned earlier[3] the voices of characters who can be assigned the value of address and of external narration (*Sunset Boulevard, Anatahan*), and I will presently consider the inverse case— that is, a voice from the outside that makes itself more or less (sometimes totally) complicit with the character. Should we speak of "diegetic" voice-off, again to contrast with those who intervene from the outside? This would suit only as an approximation because what is singular about the "voice-off-character" is precisely his obstinate tendency to exit the diegesis, even when he only half belongs to it. *I-voice* is the most suitable term, because of its simplicity and also because it foregrounds the only criterion that does not rely on inexact evaluations—that is, the usage of the grammatical first person, which is to say the film's use of an imported form of deixis, that of language.

Contrary to what we too often hear, the I-voice is not similar to the interior monologue of a novel. The latter completely occupies the whole narrative channel, while the former is accompanied by images, sounds, and dialogue. The I-voice attributes part of the narrating to a character but does not tell us that that character is in the process of delivering a monologue. There are some real interior monologues onscreen. For instance, in *Touchez pas au grisbi* (*Honour Among Thieves*, a.k.a. *Grisbi*) (Jacques Becker, 1954), when Max is furiously walking back and forth at home. *Visible in the frame, but with his mouth shut,* he lists all of the risks that he has already taken to save his friend Riton, then in the restaurant finally decides to risk his neck for him one more time. So the film really does let us know that Jean Gabin is delivering a "monologue."

Historically, the I-voice was "discovered" in France, or, rather, theorized for the first time there, by Jean-Pierre Chartier in his famous, remarkable article of January 1947, which I have often cited: "Les films à la première personne et l'illusion de réalité au cinéma."[4] The title[*] conveys the dominant feeling, which is that of a "subjectivity," an "I" of a

[*]. Which translates as "Films in the First Person and the Illusion of Reality in Cinema."—Trans.

character and so, it would seem, of some kind of sound equivalent to the subjective image. But it immediately becomes clear that this delegated site [*foyer*] is much closer to the real site [*foyer*] than it was in the subjective image. In that case the character looked, so I could do the same thing as him, and I drew him toward me. But here, this character speaks, and I listen; the roles are strongly differentiated, and this positions the character-narrator at a distance from the listener, on the side of enunciation, of which he is however only a misaligned emanation. This is no doubt why Albert Laffay, imprecisely for once (though only slightly), identified the resonance in this voice that he considered to be the bearer of the "*commentary*," the voice of primary enunciation (which he, let us remind ourselves, described with the phrases "Great Image-Maker," "master of ceremonies," "virtual linguistic source" [*foyer*], and "narrative intent").[5]) Jost, for his part, criticized Laffay for claiming that the Great Image-Maker could "borrow the voice of an actor."[6]

In fact, the I-voice can be applied to a surprising variety of situations. It can be used for a film that expresses itself through the I-voice, using the character as a simple pretext. If it is "really" the character who is speaking, there is nothing that can tell us—possibly the context but not the device itself—whether it is remembering things exactly, inventing or skewing them, and so on. Equally, the I-voice may be a compromise between its spoken words (or its thoughts, because this is not specified either) and their visual "illustration" as enacted by the film. Another issue: are the shots that we see the mental representations of the hero or simply the illustrations that are being offered to us? The status of the I-voice is surprisingly imprecise. Or rather, its precision lies elsewhere; it is rhetorical and not psychological. It has to do with *attributing* a section of the narrative to a character so that the narrative segments can be ordered properly. Everybody understands this. It can certainly be the case, especially in detective films, that the exact status of what has been spoken by a character—a faithful account, a deceptive invention, a delirious distortion—is of great importance, but the thing that has made this suspense possible is precisely the initially indeterminate status of the I-voice.

For starters, the I-voice presents us with constant ambiguity, whose principle is paradoxically quite simple: it is the voice of a character, but as long as it speaks and remains invisible, it blocks its absent body from accessing the Voice of the film; it substitutes itself for that Voice and mixes itself up with something that it is not—that is, the point of origin of the narration. It is this twofold, contradictory fact that, in 1945 and

for a while afterward, triggered and animated the numerous discussions that greeted the "appearance" of the device, which it was generally agreed was "novelistic essence" derived to some degree from interior monologue. These discussions centered ritually on four films, all of which were released in Paris after the war and, for us, were released at the same time: *Citizen Kane* (1941), *Laura* (1944), *Double Indemnity* (1944), and *How Green Was My Valley* (1941). Jean Pouillon's *Temps et roman* was published in 1946. It was popular to compare the I-voice to "vision with" (*la vision avec*), to the "point-of-view narrative," or to "narrative in the first person." But I must reiterate what Genette says: that internal focalization could be accommodated to the third person;[7] we will see filmic examples of this. In this kind of narration the narrator only says what the character says, which is of course limited to what the character is supposed to know and which also limits the knowledge of the reader or the viewer. So, as with the subjective image, and for the same reasons, this configuration establishes itself simultaneously at both poles of the narration, at the source [*source*] and at the target.

In strict logic, we could (we should) make the I-voice a variation of the point of listening, of subjective sound, because it is concerned with positioning a pseudo-subject by auditory means. But this move would in fact be a source of confusion for two separate reasons. First, the human voice, and so language, is a "noise" that is irreducible to all others; in an extreme sense, it embodies the very opposite of noise, as is evidenced by the meaning of the term in information theory, where it refers to everything that obstructs meaning. It follows that the I-voice per se is not tied to this or that perceptive aspect of filming, whether directed toward vision or hearing. It is not defined in terms of audiovisual focalization (ocularization and auricularization), which is liable to accompany it and indeed does so on occasion, but in terms of focalization of knowledge, which is seen as full and complete, even if, in some films, flashbacks present events that the narrator could not have known (no matter whether the screenplay has been botched or whether a doubling of the narrative source occurs, as Jost has subtly pointed out).[8] Whatever the case, it is normal for a focalization that is established through language to have a bearing on knowledge and not on perception.

Let me reiterate: the I-voice is more than *I*. While it is the voice of a character, it is also—owing to its invisibility—multiple, jumbled, and overarching. The notional place that it emanates from is subject to displacement and obfuscation, and sometimes it seems to be everywhere. As a diegetic voice it tends to jut out constantly in front of the diegesis,

to position itself half outside. Marc Vernet insists on its narrative function and on that which flows from it.[9] He adds that it is fundamentally always anonymous, that it looks over the shoulder of the image (this is reminiscent of Pouillon's "vision with"), a schoolteacherly voice. It is by definition distant and (like Chion's "acousmêtre") "interior" (I am thinking here of monologues in novels, which are also called interior). It is not, Vernet goes on to say, a mouth voice—for Chion the mouth is the practical and arbitrary criterion for defining the voice-in[10]—but a voice from the throat, from the chest. To wit, let us remember all of the terrifying voices-off, simultaneously human and dehumanized, which haunt the cinema, and horror films in particular of course, and remember the crazy screeching violence of the voices that give us the chills in *Psycho* (Alfred Hitchcock, 1960)! Vernet and Chion[11] have both, using a psychoanalytic perspective, accurately described the I-voice as simultaneously parental and monstrous. For Vernet it is also the voice of the spectator, whose *sense of absence is doubled* by the I-voice because, like the spectator, it can see everything but change nothing. It is no accident, I might add, that it most frequently accompanies a flashback, in other words, a *fait accompli*.[12] Finally, for Vernet, the offscreen narrator is God, the filmmaker, the spectator, and a real character all at the same time. (Yet another *place of speaking* with a floating "subject" and with a wandering deixis!) Chion similarly notes that the I-voice presents us with images (see *The Voice in Cinema*, 47).

I broadly subscribe to these two sets of analysis. The characteristics that they evoke are very pertinent to a simple fact that has barely been commented upon, even though it is commonly known—that is, the I-voice *never converses with other characters*, and they in turn do not talk to it. This remains the case, as Jane Crisp points out,[13] even if it is *intended* for another character, as in the confession by Fred MacMurray, which he records onto a Dictaphone for Edward G. Robinson in Wilder's *Double Indemnity* (1944). It is also the case in *A Letter to Three Wives*,[14] where the I-voice of Addie Ross playfully pretends, according to the film's internal rules, to be speaking to a third party as it ironically interjects itself into the conversation in the car between two women who cannot hear her. For all the differences that we would like to identify, the I-voice shares an essential quality with commentators and narrators: like them, it is shunted toward the outside by its lack of conversation within the film. It gives the impression of addressing the spectator and so of coming from the source of enunciation [*source énonciative*]. We cannot help attributing to it some kind of honorary control of the visible, whereas the

images are exactly what it controls least and what are most foreign to it (see Godard, or Duras, where this tension snaps), and they are, even as it speaks, what gives the lie to the permanence of genuinely primary enunciation, to which it itself owes its existence and its ability to be heard. You can lay your finger on it, while the voice-off is denied in the frame by the image or by the voice-in. Examples of this can be found even outside the avant-garde. In André Cayatte's *The Mirror Has Two Faces* (1958), at the moment when the husband, who is the intermittent narrator, affirms that his wife is happy with him, in the frame we see her (Michèle Morgan) harried by domestic work and mercilessly badgered by her odious, tyrannical mother-in-law. So the enunciation is not in the image, nor in the words of the actor Bourvil, but takes place in this abstract procedure that simultaneously brings them together and sets them against one another.

It remains for me to evaluate more precisely, in the perspective of a theory of enunciation, the degree to which the I-voice is diegetic. In what conditions do we see or not see the *body* of the speaker? Indeed, the visible body is obviously a major criterion of diegeticity [*diégéticité*], and it would seem to have been lacking from the start in the case of the I-voice, as the latter is one form of the voice-off. But closer examination reveals several types.

The body of the speaker can be visible before or after he narrates from off, and sometimes in the "holes" in the story, when the images that carry it forward are interrupted for a moment to show the narrator. A case in point is old Leland (Joseph Cotten) in *Citizen Kane*, who begs for cigars from his visitor because the nurses won't allow him any; this is the same Leland to whom we owe one of the subnarratives that make up the film, a tale in which he appears as a young man. In these brief scenes in the hospital, and in many other similar cases (I have already mentioned *Amadeus* and *Little Big Man*)[15] the body of the voice is carefully depicted as it is at the time when the voice is speaking, and not as it is at the time that is being spoken about.

Even as a story is being narrated off, we frequently see the character acting and speaking with a voice-in. When this happens, the body that can be seen certainly has its own voice, but *it is not the narrating voice*.

Lastly, sometimes (maybe even often) the visible body and the voice-off are theoretically supposed to belong to the same human entity, without this coinciding ever being able to be confirmed in an indisputable way through the vision or hearing of the listener-spectator. Thus in *The Lady from Shanghai*, by Orson Welles (1947), on several occasions the character of the sailor comments on his adventures from

off, referring to himself as "I." Parallel to this, we hear him speaking onscreen, where, of course, he also says "I." We recognize more or less the timbre of the voice (even though the off voice has been treated differently in the studio recording).[16] The film assures us that it is indeed O'Hara who is acting and speaking and O'Hara who is commenting on these actions and words. We rely on this kind of consistency, which is moreover necessary for the coherence of the narration, but in the final analysis, *we never see the body of the narrator;*[17] we only see the person he is speaking about, which is to say *the other him*, exactly as in *How Green Was My Valley*. What we have here is a case of the "hidden I."

Rather than three cases, really this has to do with three aspects of the same thing, all of them well-known and all a feature of their complexity, which familiarity makes us fail to appreciate. The first two are often combined in a single film, alternating or less often temporarily superimposed on one another (see Noël Burch).[18] Only the third of these, which is compatible with the second but not with the first, stands slightly apart because it supposes that the taking charge of the narrative by one of the characters will be pushed all the way to the point of imposing on the entire film the obligation of making him invisible *qua* narrator.

These three modes of drawing sonic lines show that the I-voice, even though by definition it emanates from a character, is not entirely diegetic. But this is not for the sole reason, already given, that it "pushes" itself in front of the spectator; rather, this is just a consequence, and there are more radical ones. The voice only becomes diegetic, or at least fully so, if the narrator is shown *in the act of narrating*; but then, it would no longer be off. Put differently, the *character* is diegetic, but the voice as voice is not quite. Hence the overhang effect that has struck many analysts. People often say "diegetic voice-off," which should be understood to be a conventional abbreviation of "voice-off of a diegetic character." This voice is precisely that which draws the magical and porous line that allows a character of the diegesis to step out of it while remaining within it. As I specified in anticipation earlier on, this is a *juxtadiegetic* voice, a voice from the edge. (This "juxta" echoes, for me at least, an idea of Genette's, whereby the narrator, when he is a character, is simultaneously extradiegetic as narrator and diegetic as character).[19] In cinema this intermediate status enables us to reconcile the novelistic, the visible, the multifarious (in other words, the diegetic side), with the compositional closure and sense of intimacy that is achieved only by using address, which is to say the extradiegetic modifier. As a result the

character-narrator never occupies the real source [*foyer*] of the film, which is an activity and not a person. O'Hara the sailor is not the main narrator of *The Lady from Shanghai*, but everything gives the impression that he is. Those are the rules of the game.

Certain I-voices can produce the same or very similar effect as external voices. To the examples given earlier (*Sunset Boulevard*, etc.), we could add the film by John Ford that I just mentioned: *How Green Was my Valley*. In that film the voice of an adult, whose body we never see, tells a story that, in an act of strange and absolute authority, it declares to be that of its own childhood, from the age of five to about fourteen, in a coal-mining region of Wales. The voice-in and the visible body are those of a child. We are asked to believe that this is the same person, but the adult voice, which we struggle to match with the frail body of the young hero, has the resonance of a commentary that is both affectionate and external, hanging over the film in an example of pure nostalgia that puts the entire story into the imperfect tense (a kind of transcendental imperfect) and makes of the story what it is—that is, a flashback but a flashback without any possible communication with the "present," a present that exists for us only through the eloquent remarks of an unknown person in his fifties.

Conversely, the voices of unknown commentators sometimes take on characteristics that bring them noticeably closer to I-voices. This is a kind of internal focalization in the grammatical third person (see Genette) because the voice refers to the hero using the pronoun *he* or *she*. I have already discussed, in relation to *The Magnificent Ambersons*, those "peridiegetic" voices that are simultaneously external and very close, and those *voices from next door*. For me, the best example of this is in *Two English Girls* (François Truffaut, 1971), which is mainly based on a novel by Henri-Pierre Roché.[20] Truffaut's adaptation, which is admirable for its inventive precision, was concerned in large part with the enunciative structure because the novel takes the form of a primary internal focalization (a person who is moreover always changing since it is essentially an epistolary narrative, with many instances of *I*). In the film, the adventures of Claude (Jean-Pierre Léaud) receive constant comment (in off) by the easily recognizable voice of Truffaut himself, in principle an outsider to the story, a beautiful voice that is at the same time monotone, toneless, friendly, and seemingly hurried, which speaks of the hero in the third person: "Claude left again . . . he wrote that . . . etc."

In literature the "subject" that utters this HE would be invisible, inaudible, and immaterial, as we find in all novels without an explicit

narrator (God knows if there is such a thing!). But here the *heard voice* lends it a captivating sense of reality—all the more so when one knows from outside the film the close relation that Truffaut had with the *other voice*—that is, Jean-Pierre Léaud. The heard voice transforms the subject into an extra character in the plot, who is both concealed and flagged. At the same time, in an apparent contradiction, this autonomized character flouts the barrier of the third person and becomes identified with the hero of the story. While "the voice" evokes the events that it is relating from the point of view of Claude, and him alone, the other characters, in particular the young Englishwomen Muriel and Ann, are almost always presented from the outside. This voice actually has an even more mixed status. In a single move it shows the world as Claude sees it, and it "shows" us Claude himself. It *observes* him throughout the whole film; it analyses his feelings; it *knows* how he feels and thus once again becomes a truly exterior voice of "omniscient" zero-focalization. But the contradiction is transformed in the final analysis and doubly so for the benefit of the spectator, who has the impression of access to absolute knowledge of Claude, from the outside and from the inside. The voice succeeds in creating an effect of "I" without losing the potential of "HE." This is an excellent example of the position that Jost calls spectatorial and André Gardies panoptic. Françoise Zamour and Patrice Rollet have commented on other aspects of this complex matter.[21] On the one hand, the Voice here admits alongside itself, at given moments, another I-voice that is more diegetic, which is that of Claude. On the other hand, it speaks in the past tense, thereby installing a distance and a kind of difference of age between the Truffaut of the period and "his" Claude, in what was probably an act of reparation for any offense caused to the author of *Jules et Jim*.

In experimental cinema we find *unlocatable* voices. Where there is no diegesis, or where it is reduced to disjointed fragments, the voice adopts a grounded and deconsecrated position that sometimes brings us great moments of humor. I am thinking in particular of *(nostalgia)*, by Hollis Frampton (1971) (the first part of his *Hapax Legomena*),[22] with its obscurely autobiographical commentaries (though performed by another voice, and not just any other voice, but Michael Snow's!). These commentaries are moreover always pronounced from on high, and they accompany (if that is the correct term . . .) each of a succession of photographs that we watch burning. Then there is also the priceless, heavily doctored monologue in *Side Seat Paintings Slides Sound Film* (Michael Snow, 1970–71), which oscillates from very serious to very shrill and

provides a burlesque accompaniment to the sequence of photographic slides. (The "slides" of the title mean both photographic slides and *glissandi*.) These are still I-voices, in a way.

Dominique Noguez has written on certain films "without images," such as Walther Ruttmann's famous *Wochenende* (1930).[23] It is clear in this film that the voices we hear (shouts, snatches of conversation, songs) cannot be categorized in terms of "off" and "in." They are always off because they are never visualized, but they belong to a realistic, descriptive evocation, where everything is recognizable and "shown." Other investigative films bring the voice much further astray and off-center, but the fact remains that the absence of images makes the idea of voice-off unworkable. One of many examples is the "black" sequence of *L'homme atlantique* (Marguerite Duras, 1981). (However, the blind rectangle is still a *place* that is capable of putting the spoken word "off"; the "off" is less flat and better rendered than the "in," and it conveys the emotion and the nostalgia of the book. All of Marie-Claire Ropars-Wuilleumier's work is testimony to this.)[24]

For standard films we could generalize by saying that the I-voice has a juxtadiegetic status and an indirect function of address, or of "semiaddress." This *semi*, which is hardly orthodox for a pragmatist, seems to me the best definition of the switching of the voice when it is that of a character who is relating his story outside the image. This exteriority directs the words toward us, the spectator-listeners, yet the words are not addressed to us, as they are a little more clearly in the case of anonymous speakers. Here, the person who is "outside" never really stops being inside. It is precisely this in-betweenness that defines the I-voice.

It occasionally has an equivalent in film music. It is "equivalent" at least in its indirect and juxtadiegetic address, because the *I* itself in music will obviously disappear except in the lyrics of songs, where we see it return with force.

Alongside music that can be described as accompanying, extradiegetic, and of "pure" address, which I have spoken of already, we also find musical interventions with a more complex status, sometimes difficult to recognize for sure or at first glance, primarily in musicals of course. Moreover, just as these feature a plot that often unfolds in the world of the *show*, notably of the musical stage comedy, and thereby install a permanent "second order," it is not always simple to determine which, in its content, is imputable to the action and which to the conventions of the genre. In *A Chorus Line* (Richard Attenborough, 1985), a film that builds on a hugely successful Broadway run, some young dancers who

(in the story) are auditioning for a Broadway musical (in a third-level mise-en-abyme), we see at the start of the film during a break back-stage complaining-singing of their dislike of the tyrannical choreographer. The "grumbling" words are clearly heard, so should we take it that the dancers have *said* them and that convention has put them to music, that they have "actually" sung them as we hear them, or even that they hummed them and that the musical demands of the genre have exalted their phrasing and voicing?

The final film of the late Jacques Demy, *Trois places pour le 26*, which was released in 1988, shows us Yves Montand declaring with assurance that "in a theater play" (the play whose preparation the film relates) all allusions to his personal life are precise. "Cinema is what is all around"— a nice play on words.[†] Yet in this play, or at least in the disjointed sections that we are shown in the usual way, there is a character, Maria, who was important to Montand in his early years in Marseilles. If we stick to the distinguishing characteristics of the singer-star, we would then have to admit that he "actually" loved a woman whom we christen *Maria* for these circumstances. But in another part of the film, in a scene set in the present that does not correspond to any part of the play and so is nothing more than "cinema," a character explains that Maria was "in reality" called *Milena*. All that remains, then, for the spectator is to ask what Milena was called in reality, since she exists, being in the play, though her real name must be fake seeing that it is given (in the film) outside of the play.

But to return to my point concerning juxtadiegetic music, about which Chion has also written about in very different and yet convergent terms.[25] Let us stay with "musicals," particularly in the classic rehearsal scenes, integrally *en abyme*, where we see in detail how a "musical" is prepared. One or other of the actors starts to sing his part in a section that is clearly diegetical, and the performer, who is a character in the story, really belongs onscreen. But the singing is weak, imperfect and hesitant, like a "real" song being born, and then, little by little, but rather quickly (this is one of the most common devices, whose origin is unknown), the character's confidence, body, and very substance consolidate, thanks to the invisible intervention of the orchestra and thanks to the enhancement of his voice, so that he ends magnificently

[†]. The original sentence reads "Le cinéma, c'est ce qui est autour"; Metz is presumably referring to the similarity between *autour*, meaning "around," and *auteur*.—Trans.

like the music *of the film*, all the time claiming by means of the persistence of the melody and of the singer the humility of its birth as music *in the film*, as music of a character. This transformation is made possible by the great flow of music that washes over the entire film and by the unmistakable similarity to other sequences in which the orchestra is made part of the diegesis, where the singer "actually" becomes more sure of himself, and so on.

Juxtadiegetic music can be produced in other ways in the musical comedy or in other genres. I am thinking in particular of that very popular form that we know as the "song from the film" (the term is already significant). Examples are myriad: "Son petit tra-la-la" and "Danse avec moi," in *Quai des Orfèvres* (H. G. Clouzot, 1947); "Les enfants qui s'aiment," in *Gates of the Night* (Marcel Carné, 1946); "Ich bin von Kopf bis Fuss auf Liebe eingestellt," in *The Blue Angel* (Josef von Sternberg, 1930); the collective farm songs of the *Cossacks of the Kuban* (a political musical by Ivan Pyryev, 1950); the unrestrained songs of *Jolly Fellows* (Grigori Aleksandrov, 1934); "Singin' in the Rain," in the film of the same name (Gene Kelly and Stanley Donen, 1952); "Two Little Girls from Little Rock" and "Diamonds Are a Girl's Best Friend," in *Gentlemen Prefer Blondes* (Howard Hawks, 1953); and so on and so on. Even though these pieces are almost always attributed to one character, and even though their very execution may be motivated by the diegesis, they "detach" themselves from the story and attach themselves to the film, from which they become inseparable in popular memory. This is so for two opposing but ultimately related reasons, in my opinion. First, they are precisely *pieces*, memorable units, musically powerful, self-sufficient, and as it were detachable and portable (sometimes they are conceived as such, composed with a musical release on record or cassette in mind). Second, their theme, or at least some of its components, is willfully replayed and scattered throughout the film as accompanying music, which helps us remember them while partially de-diegeticizing them, leaving them finally in an intermediary position that I am attempting to describe, in an unavowed mode of address half-contained within the story.

The dynamic between music and cinema can even be reversed when the song precedes the film. We are familiar with how a song comes to be "launched," sold, and exploited and how it helps give a "boost" to ITS film (this has been remarked upon by Pierre Lahorgue).[26] Bernard Leconte has drawn my attention to the historical example of Jean Vigo's *L'Atalante* (1934), which was once distributed under the title of a

popular song, "Le chaland qui passe,"‡ in the hope that it would attract any passing barges to this unusual film.[27]

Music that is not sung but instrumental presents a clearly different case. If the piece can stand alone and if it is noteworthy and, above all, if it is noticed, it can even take an exactly opposite trajectory. This is only normal since the music in this case is more often extradiegetic at the start. But it can become so strongly associated with the film that it can *lend* its impact to the images (which no visual form can equal)[28] so wholeheartedly that it is in the end perceived, against all reason, to be indispensable to the action and to be connected to the characters or settings.[29] It permeates and swallows up everything. Logically speaking, it remains extradiegetic, but in reality it affects and effects both reception and memory and so takes on something of the quasi diegetic. This is the case for the music of Richard Strauss in *2001: A Space Odyssey* (Stanley Kubrick, 1968); for that of Bruckner in *Senso* (Luchino Visconti, 1954); for so many pieces by Kosma, Maurice Jaubert, Maurice Jarre, or Georges Delerue; for the western melodies by Max Steiner and Ennio Morricone; for the famous zither of Anton Karas; and so on. In the case of *The Third Man* (Carol Reed, 1949) the music is almost totally identified with the story, whereas their real connection is very tenuous and consists of little more than a Viennese pastiche. This transferal also takes place in the opposite direction and for the same reasons: "Humoresque," which features in the superb 1946 film of the same name by Jean Negulesco, is an integral part of the plot because it is the musical piece that brings success to the hero violinist (John Garfield), but none of this prevents it from becoming the "theme music."

When it comes to "real" sounds, it is obviously more difficult to establish some kind of measurement of address. One runs the risk of attributing address to just any sound that is "outside the image" because it is always, for that very reason, directed toward the audience. Or one risks denying address to all sounds because their nonlinguistic nature prohibits them from explicitly aiming for the spectator-listener. All we can say is that there exist off or out-of-field sounds that are insistent or strange, rhythmic and condensed, or even interruptive and traumatic, and these can be distinguished from other sounds in a way that is not entirely clear. Anybody can tell the difference between a telephone ringing in the next room, the rumbling of a large truck on the back street, and the

‡. Literally, "the barge passing by."—Trans.

confused sound of running, whose own echo makes it reverberate and drop out. This latter, which we hear when Harry Lime is chased through the sewer tunnels of Vienna at the end of *The Third Man* achieves a simple and extravagant theatricality to woo the spectator-listener of this very "auditory" film. I am also reminded of the singular roll of the drum that closes Luis Buñuel's *Nazarín* (1959), when the hero is being walked to the prison by a soldier and an old woman they meet on the way offers him a piece of fruit. In these two cases it is clearly *the film* that is trying to say something, even if Nazarín has "heard" the tambourine, and as if the amplified sound effects of *The Third Man* are really perceived by the pursuers who were filmed in the acoustics of the place. With Reed the sound is diegetic but on display, whereas with Buñuel it is more extradiegetic. These examples show how fragile and productive is the dividing line between "subjective" sounds and those that manifest a direct intervention from the place of enunciation [*foyer d'énonciation*], a register that is entirely different and to which I will return presently. (As we will see, borderline cases do not consist solely of sounds.)

I have pointed out similarities between the I-voice and certain kinds of music and sounds by virtue of analogies that are both partial and real, but I am above all interested in how the I-voice itself defines enunciative orientation. It carries within itself a clearly deictic component, and it is because of its "I" (which for once is not metaphorical) that this or that character is *designated*. This is of course a weakened deixis because no reply or place-switching between people is possible. And it is deixis established by language and not by the film, even though the latter includes the former. But it is deixis all the same.

As for the metadiscursive dimension that is at the heart of the matter, it can be summed up in a movement of *threefold doubling*: doubling of the filmic enunciation to the benefit of the narrator-off, to whom it gives speech; doubling of the spectator-listener, inasmuch as the Voice is necessarily his own, even if it is not only that; and finally, doubling of the character himself, of the bearer of the Voice, to the benefit of a provisional and imperfect replica of a noncharacter, of a *reciter*.

This has a reflexive dimension in its play of uncouplings but at the same time a commentary function because the I-voice, whatever its ruses or subtleties, always "explains" images to us. It thereby brings into play in a single movement the two great features of metadiscourse: reflection and commentary.

11

THE ORIENTED OBJECTIVE SYSTEM

Enunciation and Style

There was a time when films were replete with "punctuation marks." This has long been something that interests me.[1] Fades to black, dissolves, wipes, and so on came to signal the articulation of the story, implicitly opposing themselves to the simple cut that marked the straightforward succession of shots within a coherent narrative unit. Moreover, it was this play of demarcations that to an extent created the narrative units themselves.

Optical effects of this kind are still sometimes used today, and Francis Vanoye has written on them briefly but with great clarity.[2] They are not attributed to a character who might "see" or "imagine" them. They are not subjective. They evidently come from the enunciative source [*foyer énonciative*] itself, and it is via them that "the film" speaks to the spectator (Béla Balázs remarked on this).[3] They speak *directly* because they are not diegetic either (see Soriau).[4] When an iris tremblingly recloses around the face of Lillian Gish, nobody doubts that the black halo belongs to a different register of representation than the heavenly and eternally astonished visage of the young girl. It does not belong to the story being told, which has nothing to do with the black circle, but in fact to the narration, which, located above the plot, is signaling the end of an episode to the spectator. This kind of notification becomes even more striking when the punctuation mark is fantastical or totally new. An example is in Jean Renoir's *Les bas-fonds* (1936), where several fades to black are brought in vertically, so the black "falls" from the top of the screen to the bottom, with the horizontal line between them slowly lowering itself.

(This fake fade is in reality a wipe but not a true wipe as it is not lateral, rather a pseudo-curtain . . .).

Punctuation marks are the purest examples of an enunciative system that we come across elsewhere: nonneutral images that clearly manifest an intrusion, or at least an *intervention*, but an intervention that, because it comes "from on high" and not from a character, is compatible with an objective status that paradoxically it can even reinforce. What we have here is a fiction that is foundational in fiction (and not just in cinema), whereby the primary level of enunciation does the job of reference point and so of an "objective" marker (Robert Burgoyne has made the same point in different terms).[5]

For Francesco Casetti images like this define one of the four cardinal positions of filmic enunciation, which he calls the "impossible objective" [*objectif irréel*] position.[6] It is a good expression, and it is fundamentally precise because everything that is separate from the diegesis separates itself by this means from the "real" that is established by the narrative pact. But the expression is also unsuitable because the word *impossible* (*irréel*) in everyday language suggests fantastical or extraordinary ideas, whereas the construction, as my first example already indicated, is in frequent and familiar usage. Instead I will use *oriented objective images* (i.e., involving the direct intervention of the source [*foyer*]). And I am interested not only in images but also in sounds and noises, optical manipulations or any elements whatsoever of a film as long as they hold this same enunciative position. They may be contrasted with objective, neutral views, which I will return to at the end and which themselves emanate from the source [*foyer*], but without bearing any perceptible marker of it.

I have already borrowed another characteristic example of this register from Casetti,[7] which is the powerful backward dolly shot in *Gone with the Wind*, which *purposely* progressively loses the silhouette of Scarlett among the thousands of dead and wounded lying on the bare ground in the immense aftermath of the Battle of Atlanta. The final shot of *Une si jolie petite plage* [*Riptide*], a 1948 film by Yves Allégret, consists of a never-ending, broadening backward dolly shot that works according to a fairly similar principle in a very different diegesis. It is moreover a very common device for the "the ends" of films and can also consist of a series of increasingly wide, separate shots. An example is in the final scene of King Vidor's *The Crowd* (1928), where the finally reconciled family goes to a variety show. The camera then deliberately loses them in the rows of the packed, laughing audience by means of successive

framings that progress backward, expanding the view with every step so that the shared optimism of the crowd manifests the innocence and power of the American spirit.[8]

Sequences such as these differ from punctuation marks in that the *photographed image* (i.e., the plot of the film, the set, etc.) continues to occupy the screen at the same time as the movement of the camera or the montage that is brought in either to "orient" it, to openly correct it, or to add to its meaning—all this whilst the punctuation marks are at times reduced to the optical effect itself, which is to say to the act of orientation, the act of editing, or to extradiegetic intrusion.[9] But the shared defining characteristics are the very occurrence of intervention and the boost that the narration gives to the story, overtly short-circuiting "translations" and other diegetic mediations that the narration ordinarily has to put up with.

This kind of enunciation is both objective and marked, and it is a localized and identifiable incursion by the "operator." It corresponds in its essential features to the "external" narrative system (i.e., external to the character), such as it is defined by the literary tradition and by Genette, and taken up again with careful adjustments in the field of cinema by François Jost, by André Gardies, and by the three authors of "Le récit saisi par le film." Indeed, it is opposed to the character's point of view (i.e., a system known as internal or subjective), as well as to the absence of point of view (enunciation that is "omniscient," "concealed," "transparent," etc.). The tripartite principle is very clear and difficult to improve upon. I have already mentioned that I find it regrettable that some authors have "annexed" the external system to one of the other two, with the result that what is distinctive about objective orientation becomes somewhat muddled.[10] But the disagreement is above all about form, because the enunciative system imposes itself on our attention in all classification systems, regardless of their differences. Thus, in "Le récit saisi par le film" it reappears under the heading of "internal-camera" (as opposed to "internal-character") focalization. In any event I prefer the old set of three.

Theorists of the 1920s and 1930s, who were barely concerned with enunciative autonomy, did write a lot (and I have echoed this work) about "subjective images *of the author*." The Author, not the Enunciator. So Ewald André Dupont's famous *Variété* (1925) provoked heated commentaries and discussion (particularly in Germany, of course), where they used the phrase "unchained camera" (*entfesselte Kamera*) to describe a spectacular freedom of point of view. This was achieved by filming from a flying trapeze, by a rapid 360-degree pan shot superimposed on the face of Emil

Jannings, etc. Jacques Aumont, whose discussion I am borrowing from here, shows that this freedom does not have its source in the supposed vision of a character.[11] This motivation does exist elsewhere, and I will return to this later. But what is important here is that the supposed vision *could be* lacking and that the orientation could proceed overtly from the film itself without a real or fake "alibi" from the character-who-sees.

The history of film and of film theory, in an episode such as the one under discussion (as well as others), raises an important question: is the "style" of film auteurs not a mark of enunciation? And is this also the case with "genres," insofar as they repeat (to some extent) collective styles? More radically, are images and sounds not *always* oriented, seeing that the camera and the microphone must be positioned in one place rather than another, and seeing that the dullest filmmaker, the assembly-line worker in the great dream factory, still has a "manner" that is more or less expressed, and seeing that the assembly line itself leaves its own recognizable "imprint," such as we see for instance in the historical epics of Cinecittà?

For an informed public it is certainly the case that styles act as trademarks and refer back instantly to a mode of production, which itself has a name or the name of a particular lineage. We can recognize a classic western or a real "turkey" just as we identify a hibiscus or a fox-terrier, and experienced people don't get them wrong. A certain type of tilted framing, of ceiling shots, of wide-angle shots, immediately means Orson Welles. When a link shot comes like a bolt from the blue, or we hear an atonal, neutral voice, we think "Bresson"; an empty scene at the start and at the end, and a multiplicity of rectangles: "Ozu"; refusal of the medium close-up and rarified, clean sparseness of sound: "Tati." This list could easily go on, and it shows that style can have effects that are somewhat analogous to the effects achieved by markers of enunciation.

Analogous, and yet quite different. We are told that style reflects back on the "auteur." Yes, but always and by definition to such and such an auteur (or such and such a school), while the source [*foyer*] of enunciation is an impersonal, anonymous category, in some way "the same" for all films, because it never says anything but "This is a film." Markers of enunciation do not designate anybody. They designate, as the name indicates, the activity that produces what is enunciated, *the filmic act as such*, always fundamentally identical to itself.

When an appropriate movement of the camera signals to us with a degree of insistence a detail that is useful for the comprehension of the plot, it does not (or not initially) have the value of a signature; rather, it is an intrusion of the act of narration into what is narrated. It is another

example, one of the most common, of the oriented objective image. Of course, this reframing can slide between images with a feigned ease and a false innocence that will immediately betray the hand of Hitchcock (or of De Palma if the same gesture is made with less finesse). Isn't the distinctive thing about style that it can be found in any part of a work, depending on each auteur's methods? But the movement of the camera itself, as distinct from the various possible ways it can be used, only tells us something (in the current example) about a method of production that aims to show the spectator something, and it calls to mind Hitchcock or De Palma only when such recall is needed. Thus style can strip itself of markers of enunciation just as it can strip itself of everything else; inversely, a play on these markers can at times become one of several stylistic traits. For instance, they are much more numerous and visible in Soviet cinema in its heyday than in Italian neorealism, and that difference is one indicator among many others of what separates the styles of these two schools.

What we call style, in cinema and elsewhere, is an omnipresent and more or less impossible-to-locate quality. It can be "pinned down" only for a given auteur but not in a general way. And quite often, even this is impossible, because it colors everything with a single gesture (Mizoguchi). Enunciative configurations, by contrast, occupy a fixed textual position that is easily predicted, and they appear in a discontinuous fashion. There are indeed "neutral" images (which we will come to)—neutrality is itself a posture of enunciation but an empty posture that is by definition purely negative (i.e., "invisible" narration). Consider Eisenstein's intertitles (which address the viewer), the unusual angles of Orson Welles's 1955 film *Mr. Arkadin* (i.e., objective oriented images),[12] the still shots that were so dear to the Nouvelle Vague (stopping on an image exhibits a strong enunciative disposition that brings cinema back to photography and exalts movement);[13] if, in figures such as these, which are numerous, stylistic markers coincide with markers of enunciation (which are plentiful and used willfully in Godard), they can equally and frequently leave their imprint on images that have been shorn of any explicit reminder of the source [*foyer*], on what we might call "transparent" images, and they can draw their power and distinctiveness from that very quality, as often happens in the films of Murnau, Dreyer, Renoir, Bresson, and Rossellini. And there are just as many cases where stylistic markers feature strongly in shots that remain "dull" as far as enunciation is concerned. This is the size of the gap that separates enunciative manifestation (which is distinct from enunciation itself and is therefore intermittent) from stylistic

manifestation, which is permanent or even hard to predict, and as a result can be found where the former is, and where it is not.

And there is more. What is particular about stylistic markers is that they can take any form, and they are sometimes very specific, impossible to anticipate, and tied to particular content (consider film noir, for example). But enunciation proceeds according to extensive systems of generalizable and to some degree abstract emblems, such as the mode of address, doubling the frame, and so on. So it is clear that the hieratic and decisive presentation of objects that are precious, strange, dazzling, and ethnographic (as in Parajanov), or of faces that are wrinkled, bearded, muddy, and sculptural (as in Eisenstein-Dovchenko), is expressed in the choice of a motif, of a culture, or of a theme rather than in the apparatus [*dispositif*] of enunciation, whilst by contrast such an act of presentation announces from afar the presence of the auteur and characterizes two styles that are particularly on display. Traits of this kind, such as faces and objects, can of course indirectly inflect enunciation (making it, for example, more "distant"), but every element of film can have such an effect, without for all that signaling by itself, unlike an I-voice or a film within a film, the adoption of such and such a recognized and identifiable register. (In some discussions the distinction is not made sufficiently clear between enunciative configurations or systems and everything that can give them color or "fill" them, which is, ultimately, the filmic material in its entirety.)

Even when they are "natural," enunciative markers *designate* discursive activity by means of a signal that is more or less identifiable, by a "gesture," and thus they *detach themselves from the gesture*. Once again this is "metadiscourse," reflexivity, or commentary. The markers of an auteur, *which in their precise details can be the same*, are indicators more than signals and they remain so in the works of theory-minded filmmakers (or more creative types), because they are the result of laborious forethought. This is so because this very artifice can be traced back to a temperament, and its deliberateness can only be undeliberate (Greenaway). In any case stylistic markers are not distinct from the discursive act; they do not "show" it; they are part of it, resonate with it, and are captured within it.

Enunciative figures have a feel of finitude, of "countability," while there seems to be an infinite number of possible stylistic markers. This is an obvious difference that I will not go into, but it is at any rate less absolute than it might seem because styles can be broadly conventional, as in the "Tarzan" films or the films of Carné-Prévert-Kosma, and because markers of enunciation are, conversely, too numerous and varied for a book as

short as this. It is no accident that constructions such as the I-voice started in the 1940s by being perceived as authorial markers belonging to a kind of "new American cinema" and by now are recognized, anonymous narrative forms, *instrument-figures* [*figures-instruments*]. The transformation of stylistic markers into markers of enunciation (or vice versa, such as when a modern film uses an iris that is knowingly allusive) is simple and constant. The combination of the two is also common. But their nature remains indistinct. *Intervista*, which I mentioned above,[14] is a film that illustrates this double relation of proximity and separation. Fellini uses signals of enunciation that are very codified (the film within the film, and so on) with narcissistic excessiveness and exuberance, which themselves are perfect markers of the auteur, but a film within a film does not have to have Fellini's stamp to remind us by its film-ness that the primary film is also a film. Similarly, "postmodern" cinema, cinema that has come after the "death of cinema," or commemorative, *posthumous* cinema, could be characterized in its entirety by the systematic reproduction of old tics of enunciation that are reconditioned for extra effect and transformed into tools of a style or markers of a manner. This evolution is even clearer in "trendy" advertising, which is to say, almost all advertising nowadays.[15]

On the whole, the relation between style and enunciation is close, and the exchanges between them are numerous and ongoing. There are four simple differences that separate them, however: (1) Style belongs to a given auteur or school, whereas enunciation anonymously signals the film or cinema as event; (2) Style can be found anywhere within a work, while enunciation follows one of a certain number of established paths, which are relatively varied but finite. In addition, style can make its mark at the point where enunciation shies away; (3) Style can be linked to concrete characteristics of the work or to its content, while figures of enunciation are always logical constructions; (4) The marker of enunciation signals discourse and for that reason remains distinct from it, while style is embodied within discourse and suffuses it into its mass.

Even in the (absurd) hypothetical situation where we would have two identical lists, one for markers of enunciation and the other for the markers of auteurs, the difference would persist because the theory would not designate the same aspect of a given figure. Francis Vanoye's suggested synopsis of the situation is as follows: enunciation is an operation, and style is a way of being.[16]

"Objective orientation" is one of the most common registers. It has several other forms that we could list: all optical or acoustical nonsubjective distortions, following dolly shots that keep us at every moment

at the right distance from the character while all the time clearly show-ing that he is moving, and the "ping-pong" style of shot/countershot in conversation scenes, where the narration takes good care to show each character up close at the moment when he speaks, and so on.

My next example is *A Portuguese Farewell* (João Botelho, 1985), set in the humid, sweltering jungle during a colonial war in Africa. The tough paratroopers in their combat gear hallucinate with fatigue as they are endlessly plagued by the unpredictable guerrillas, who disappear into the dense forest before they can be seen. These jungle sequences, where the drafted Son is killed, alternate regularly with those of the Father and the Mother, country people who have come to Lisbon for a few days a long time afterward to visit their now-widowed daughter-in-law. The images of the Metropolis are in color, as we would expect for a film made in 1985, but the images of the muddy, sodden jungle are presented in a sumptuous black and white—with shiny, almost golden, reflections—which opens in depth as we watch. This color, and even more this inter-ruption of color, is a direct choice of the narration, which conveys the entire history from the outside. The images of Africa are not subjective flashbacks, and no character is charged with "remembering" (the con-text is quite clear on this matter), but one part of the tale is affected *at its source* by a kind of peculiar indicator, in this case the change of film stock. Thus, we can see how "objective orientation," or more exactly its perceptible manifestation, can assume diverse forms in accordance with the cinematographer's range of materials.

It is also achieved by a slowing-down that is not motivated by the diegesis but stands out in the midst of "normal" images, as at the end of John Cassavetes's *Gloria* (1980), in the scene where Gena Rowlands and the child finally find each other again among the gravestones of a cem-etery, and the boy runs to jump into the arms of his "mother." The enun-ciative intrusion is emphasized by a sudden switch, at the same moment, from color to black and white.

Elsewhere, it is a *relation* between two elements of a film, a rela-tion that does not flow directly from the story but imposes itself on the attention as a "desired" effect. In *The Shanghai Gesture* (Sternberg, 1941), among many sumptuous images, there is an astonishing, highly detailed, baroque shot of the gaming establishment of Mother Gin-Sling; we see the enormous grand salon, ringed with lofts and mez-zanines that rise in expanding concentric circles, while down below, in the innermost circle is the main gaming table, presided over by Dalio. All around him are smaller tables, bars, high-class prostitutes, and men

in tailcoats; and crossing in all directions are Englishmen, Russians, Frenchmen, Hindus, and Malays. Just after the start of the film, this image appears in a forward-moving dolly, the camera progressively "slicing" through the middle. At the very end, we see the same image but this time in a backward-moving dolly, revealing the view bit by bit. It is by means of the relation between these two similar images and between these opposite movements that enunciation announces itself in the interior of the film.

The *absence* of an intervention that had been foreseen and expected can have the force of an intervention. There is a real gem of this type in *The Student Prince in Old Heidelberg* (Ernst Lubitsch, 1927). The young lovers, prince and servant, played by Ramon Novarro and Norma Shearer, are separated by social rank and cannot marry. The prince, who has studied at Heidelberg, marries whichever princess he is obliged to marry. The final sequence shows the wedding ceremony, with the royal horse-drawn carriage in procession through the streets of Karlsburg. The camera seems to be riveted to the unhappy, resigned face of the former prince (now the king), and we wait vainly for a long time for the shift that will show us the new queen, whose identity we do not know. We will never know her. The film refuses to show us; better to express the idea that this woman does not count and that the servant and the student prince were denied one another. A comparable refusal is one of the admirable subtleties of *Eyes Without a Face* (Georges Franju, 1960), where there is a *refusal of a countershot*, even while we are kept constantly in fear of seeing it, and this fear slowly becomes a maddening and terrifying desire. The surgeon, Pierre Brasseur, and his assistant, Alida Valli, frequently look at the horrible injury on the face of Edith Scob, and we are forced to join them as they look. Every time we tell ourselves that now is the moment, that *now* we are going to see what they are seeing. But we will not see it, or barely. There are only two blurry consecutive shots that correspond to the subjective vision of a young woman who is still partly under the influence of chloroform. The stroke of genius is to have combined for an extended period our identification with those looking with the refusal to show what is being looked at.

Some objective orientations are very striking and cheaply produce (in a manner of speaking) an effect that we must pay attention to. Thus we have the combination within a single work of two techniques that are normally separate, such as live action and animation in *Who Framed Roger Rabbit* (Robert Zemeckis, 1988), a film that goes to some lengths to forget that others preceded it in its main conceit.[17]

As often happens, definitional difficulties arise with borderline cases and are concerned with the *attribution* of certain examples rather than with the notions themselves. (The two are too often confused; it is the classificatory act itself that produces mixed or uncertain results, which are often the most interesting of all and the most revealing). Near the start of *The Grapes of Wrath* (John Ford, 1940), the Joad family's overladen, wheezing, rattling truck drives into a transient camp where refugees have been quartered, all victims of the Great Depression, in a jumbled, lamentable spectacle that unfortunately has become trivialized in the intervening years.* The sequence is partly subjective, with the angle of view nearly matching, at certain moments, the movements of the truck. We are discovering the camp at the same time that Tom Joad is. But it is also clear that *the film* fully adopts, in a deliberate way, this gaze on the world and that the Joads are here temporarily, as proxy narrators, provisional occupants of the source [*foyer*] of enunciation. Another well-known instance is the moment in *Le jour se lève* (Marcel Carné, 1939) when François is contemplating suicide, where two successive shots, the second closer up, are separated only by a framing of the hero that reveals his revolver. The effect, of course, is to quickly accentuate Jean Gabin's inner intentions and impulses, but the effect is also a foregrounding by the film for the benefit of the spectator of a motif that is important at that moment. As they appear to us, the two aspects are at the same time distinct and inseparable.

One should avoid trying to make things simpler than they really are. Sequences of this type—and they are not exceptional, on the contrary— are both subjective and objective-oriented but are closer to one pole than the other, depending on the details of the filmic treatment. This double affiliation passes under our notice in many films. The aspect of the camp that strikes the Joads is the same as what the film wants to bring to bear, for the very reason that it is what struck the Joads. Such ambiguity, such hesitation defines a register that one could justifiably call mixed. And this ambiguity is furthermore founded in theory, since enunciation can be entrusted to a character who for an instant fully "represents" it, whilst elsewhere it *withdraws* itself from subjective sequences that it itself advances, for instance directing our attention (to shift to the opposite extreme) toward the fact that a character is drunk, half deaf, etc. Subjective views or sounds can occupy all the degrees of a continuum

*. This scene is in fact one hour into the film.—Trans.

that is marked only by two conceptual positions. At one end the subjective gaze takes all its meaning from *not* being that of the film, as in all sequences of madness, or of hearing that is damaged after receiving a blow, and so on. At the other end the subjective gaze is that which the film adopts even though it is at one remove from itself (or because of this fact); so the film has provisionally chosen this subjective gaze to show us the world and to show *itself*. It is at this juncture that it may be congruent with objective orientation.

There is a more sophisticated example by George Cukor in *The Actress* (1953). There is a rapid sequence of three or four static shots at the start of the film with an offscreen commentary by the heroine of the story, about which we know nothing yet. First there is the photograph of a baby with the voice of Jean Simmons: "This is me at three months old" (I am recalling this from memory). Over the next photograph: "That's our house," and so on. The final static image is of the balcony of a theater with Jane Simmons among the audience, seen from in front: "That's where it all started." The image comes to life and the prologue gives way to the first "true" scene of the film, which is the "show" that will determine the career choice of the young girl who is entranced by what she sees onstage (from this point on, we no longer hear her in off). The effect of the prologue is clear: the narration itself is announcing itself and it opens by declaring that it has not yet started but that it will do so presently. The combination of static images, the placing of the voice "off," and the photograph of the baby that suggests a date that precedes the plot, clearly refer to the "objective" instance of enunciation, but the latter has chosen to express itself through images that the heroine introduces and comments on in the first person.

There are many examples of this kind of doubleness. One may recall the section of *Un carnet de bal* (Julien Duvivier, 1937) featuring the blacklisted doctor played by Pierre Blanchar, which was filmed in large measure in tilt shots (the device is very striking, but the sequence is quite mediocre). There is no doubt that this is an objective orientation, as it is the film that chooses to show us the world from that angle, and that choice is openly asserted. But it is also—and this is due to the cinema's particular capacity for supplying confusing subtexts—the evocation of an overwrought character, an alcoholic, a desperate, violent person on the brink of a breakdown. The unusual tilt of the image does not claim to translate the way in which the hero perceives the field of vision, since he figures in it himself—this is a typical example of what Jean Mitry defines as "semisubjective" framing—and furthermore it is an obvious

and deliberate allusion to the instability of the character and his precarious equilibrium; indeed, it is (rather heavy-handedly) a metaphor for these. The angular tilt functions indistinctly on behalf of the character and of the source [*foyer*] of enunciation. The film shows us events as the hero "sees them" but without going as far as focalization or internal ocularization, that is to say without the enunciation becoming formally "subjective."

In *Raging Bull* (Martin Scorsese, 1980), where the position of the narration most often remains objective, the image, the montage, and the link shots are constantly feverish and highly charged, like a rope stretched to breaking point. How can we not see in this the imprint of the hero, the boxer Jake La Motta (Robert De Niro), who is shown to us, even if from the outside, as perpetually nervous, full of anxious longing, and miserably obsessed with becoming the world middleweight champion?

These mixed enunciations, which bring an aspect of a character toward the source [*foyer*] and stop halfway, are not unrelated to the "free indirect style" of the novel, and of the modern novel in particular, as in Joyce and those who came after him. The parallel is striking, as much as the differences are obvious. This discursive system consists of expressing the thoughts of a character (or his words, because it is precisely the distinction between them that is suppressed), all the while referring to him in the third person, without the direct style's quotation marks or dashes, without a formal marker of interior monologue, and without the declarative verbs and *that*s of the plain indirect style, to such a degree that one no longer properly knows who is "speaking," the protagonist or the book: "She felt weary. Life was so demanding, and people were so harsh! Tomorrow, though, she would start again, she would take her little bag. . . . It was important to remember to close the door properly; she would not repeat what she had done the other day, etc." From a poetical-philosophical point of view, Pier Paolo Pasolini[18] (see Elena Dagrada's substantial work on this)[19] and later Gilles Deleuze[20] have connected certain filmic constructions to the free indirect style. The analogy can be extended to the area of enunciation, insofar as the free indirect style is an orientation that is both objective and subjective, or one that stands firmly between the two, or one that hesitates between them for a long time. And since the image is less explicit than language and less equipped with conventional signs, it finds it easier to hold this middle ground. And so we return in fact to the "semi-subjective" system defined by Jean Mitry, but for whole sections of films, and not for framings considered individually.

There is an interesting variant of the oriented objective regime that has been well analyzed by Dominique Chateau in another context, under the name "analogical modalisation."[21] It draws attention to the fact that in language it is possible to make what is enunciated modal without recourse to a modal verb but by simple intonation, such as an intonation of doubt. That is to say, it is done by means of an affective analogy between the marker and what it is marking, between the signifier and the signified. Chateau suggests that cinema allows constructions of the same type, notably to throw into relief certain elements of the image in relation to others. He takes the example of how to represent a man who is walking in a given space. A static shot of the setup will convey "Here is the SPACE where the man is walking" while an accompanying dolly shot will modify where the accent is to go: "Here is the MAN who is walking in this space." For me, this is an excellent example of the frequent combination of the objectivity of film and the continuous undermining of that objectivity for the sake of *inflecting* things. Put simply, in Chateau's example the relative degree of intervention is barely noticed, so that we approach from another borderline zone, one that separates (and draws together) the objective-oriented image and the neutral image.

Before coming to my last topic, first a few words on the metadiscursive status of the previous one. This is an aspect that is immediately apparent: when orientation becomes perceptible (whether or not combined with the semisubjective system), the film reminds us that it is a film, somewhat like the famous "authorial interventions" in a novel, that it is *constructed*, and, conversely (or consequently?), that it is the thing that is constructing the story. Basically, certain devices in filming, insofar as they shift attention to themselves, become a commentary on what is being filmed. They detach themselves, though only a little, from the story to orient our method of reading the story, while telling us how the instance of producing it sees the story. As Robert Burgoyne says in an article I have already cited, in a single gesture narration comments on what it is constructing while constructing it; we could say that narration acts itself out.[22]

Among the variety of metadiscursive forms, the commentative register is not reserved to processes that are based on language, such as the I-voice, most direct addresses, etc. This is in contrast to a reflexive system, which would be connected to the iconical and the sonic. In fact, these phenomena cut across each another. There are visual commentaries, such as shooting from a high angle, which shrinks the character and thereby overlays what is displayed with an aside. There is also so-called

accompanying music, which is overtly extradiegetic and which also "comments" on events as soon as it draws our attention a little but which on other occasions refrains from being obtrusive in such a way that it can be counted among the (considerable) number of weak modes of address or even, in other cases, of neutral elements. Objective-oriented information is not necessarily reflexive. It may be, as when the filming mimics what is being filmed (*Raging Bull*, etc.), and it may not, as, for example, punctuation marks or angular shots, which do not duplicate anything. But they still have the value of a commentary, and that is why I use *orientation* when referring to them, that is, orientation of the information according to this or that interpretation suggested to the spectator and presented as if coming from the source [*source*]. Even if they are brief or subtly employed, techniques such as optical effects, unusual framings, deliberate jumps of picture quality or of tone, conspicuous movements of the camera, striking repetitions, rapid cutting, paradoxical absences, and inserted punctuation marks all still disturb the realistic or fantastical purr of the diegesis and of the subjective views that are intertwined with it. They materialize for an instance that "intentionality" that belongs to the text itself, that "impersonal" intentionality that Paul de Man speaks of for the literary work. These are like complimentary wake-up calls for the spectator, jolts of the film, which all of a sudden designates itself, *comments directly on itself*, with visual or sonic signals, and which, in all senses of the word, *reprises* itself.

12

"NEUTRAL" (?) IMAGES AND SOUNDS

"The camera constantly sees, but most of the time we do not see what it sees." This is an excellent summation, borrowed from Lagny, Ropars-Wuilleumier, and Sorlin,[1] of an attitude to enunciation that is somehow negative yet very important, and it marks the final stage of my journey, along which I have made a few too many stops.

Many shots are free of any particular marker. I do not detect in them—or, rather, not easily—either a sign of attribution to a character (that is why I have called them objective) or even a trace of direct intervention by an enunciative agency. These are "ordinary" images (or sounds). Traditional theory treats this as a complete category, often under the name "objective images," without any further definition. This is an unfortunate, even inexact, term. We need to add "neutral" to avoid confusing these with elements that are objective but oriented, whose importance and frequency I hope I have already demonstrated. It would also be better to call them just *neutral images*. They are necessarily objective because attaching them to a character would immediately exclude them, according to all existing theories, from the neutral regime.

In Anglo-Saxon studios these are known as *nobody's shots*. For Francesco Casetti, as we have seen,[2] who calls them "objective" framings, which is to say statements [*énoncés*] that have no manifest enunciation, they constitute the first of his four big categories. Edward Branigan uses different categories: the objective position (i.e., so-called *Not From Point* images) is the inverse and mirror image of the subjective position (i.e., *From Point*), through the transparent intermediate layer of images that

are projective, reflected, metaphorically subjective, and so on.[3] But this distinction clashes with another, which is the presence or absence of a *condition*; that is, the orientation of the information by a kind of psychic color, by the "internal state" of the narrator as well as of the character. In this way the concepts objective and neutral are no longer confused, and this is to be welcomed. The "objective-non-conditioned" system corresponds to what I call neutral. But it does not appear enough as a limit; it is still (half) a "domain." The concepts of zero focalization, zero ocularization, absence of focalization, and so on are all sometimes taken to have the same meaning, despite legitimate objections from their piqued defenders, and they could lead one to believe that "zero" framings form a category in the same way as looks to camera or secondary screens.

We must turn our backs on this kind of looking, no matter how out of date or up to date it may be. *There are no neutral images.* Every visual or sonic element in film, even if it does not fit into the main categories such as voice-off, mise-en-abyme, and so on, even if it is really one of the most "ordinary" types, is built on multiple decisions implying an *activity*. Colors are like this or like that, the phrasing of dialogue is done one way rather than another, and so it goes for every one of numerous filmic parameters. Enunciation, not to be confused with its markers and configurations, which are localized, is omnipresent and answerable for every detail. The only difference between the oriented image, objective or subjective, and the neutral image (the difference between them can still be measured in degrees) is that in the former, enunciative intervention is conspicuous and, as it were, isolatable (i.e., interruptive music, rough reframing, highly emphatic arrangement of the set, and so on), while in the latter, it is everywhere and nowhere, an abstract postulate *in the background of the image,* "behind" the film as a whole. We deduce it from the very presence of the enunciated [*énoncé*]. This is the idea that I have already discussed of a "presupposed enunciation" as opposed to an "enunciated enunciation."[4]

Yet in sequences without markers this enunciation is not reestablished solely by a kind of reasoning that is both instantaneous and secondary. Casetti rightly observes that these sequences signal their enunciation "in [their] own formation," "by means of themselves in their entirety."[5] And therein lies the problem—in what the neutral image preserves of what is appreciable. There is no dividing line, at least for what we are examining here, between a discreet objective orientation that is gently proffered (for example, as in many shots by Jean Renoir) and one of these commonplace images in which, however, we can notice, if we are looking, the deft

positioning of the camera, the too-metallic sound of a closing door, or even, at the opposite end of the scale, the stereotypical banality of these noises, which is still a characteristic of the shot.

Enunciation remains something simply assumed as long as we are not very attentive to how a film is made. As soon as we look and listen more carefully, we spot the traces of markers that, no matter how slight, prefigure a "true" orientation, which can then be imputed to the character or to the source [*foyer*]. The difference does not inhere in the object but in the distance that we adopt in relation to it, in our more or less close or more or less inattentive reading, in every person's historical, semiological, and cinemagoing background, and in the various social circumstances in which a film is consumed. The more educated the public, the lower the number of neutral images and the greater the number of examples that will be identified as fitting into the specific categories that I have mentioned, as well as any other categories.

The idea of a neutral image, whether it is called this or by some other name (and sometimes by no name at all) has an initially practical value. What we call a marker of enunciation *in reality* (because it is not declared and is not always conscious), is only the marker that is easily perceived and is already fully "developed." We implicitly posit the contrasting if vaguely intuitive point of reference of a "neutral" state of filming, or at least neutral for a particular era or genre. And it is true that a regular viewer has no trouble bringing to life in his mind, for example, recurrent framings of interchangeable classic westerns: the lone horseman, seen in half-profile from behind, finally disappearing into the rocky horizon with a male voice singing off, the stagecoach at full speed in an accompanying dolly shot from right to left as the carriage becomes detached, the crossing of a canyon, from left to right, the horses going slowly in single file, in a high-angle side shot from the exit from a ravine, and so forth. But it is also true that the film fan, on seeing every one of these images in a given western, will quickly identify, even if only in trace quantity, some system of enunciation or other, starting with objective orientation, which is logically the first in the series and could encompass by rights all shots in all films unless one adopts the healthy habit that is now well established of citing it only when it manifests itself precisely and powerfully.

So the register of the "neutral" is a category that is both fictive (in theory) and endowed with a strong cultural reality as a quite accurate and fixed, intuitive, and reliable point of reference. Everyone who has addressed this question considers the image to be neutral—or,

incorrectly, "objective," or they do not even mention it—from the moment when the *distinct* visibility of the enunciation drops below a certain threshold. It cannot be any other way. But then, we have to accept the corollary, which is that neutral elements constitute a *limit*, not a category.

I repeat: not a category—so, not comparable to the enunciative forms that I have mentioned up to now. What is "neutral" is unclassifiable because every element that can be used to compose it could and must be classified differently if the analysis changes "scale" and takes into consideration traits that take longer to identify. We are dealing with an empty category, a logical fiction, rather like the empty set that mathematicians use. We are dealing with a dividing line that is needed for sorting and measuring, for putting "full" categories into perspective, categories that are *always* defined (though it is not said enough) by negative reference to a zero point. To posit the voice-off as a noteworthy system of enunciation (because one deems it worthy) is to admit for a moment that the voice-in is in some way more normal. To speak of the look to camera is provisionally to consider as nonmarkers all looks that are directed somewhere other than at the camera. To make the observation that a certain film "exposes the apparatus" [*dispositif*] is to imply one way or another that it is common or unremarkable not to show it. If I had to put a single neutral image in front of the reader, I would fail, because there is no such thing. But the body of work on images that are not neutral (that is, on *all* images) leans on this imaginary, indispensable crutch, about which we have to be clear. It is too often confused with an empirical reality, with a class of filmic elements. This is not because we say so but because we do not identify it sufficiently as an idea or because we regard them as belonging to the "list" of figures of enunciation.

Neutral enunciation is nothing more than an ever-receding finishing line where all "markers" exhaust themselves one by one to the point that they are less marking or less marked. Where is the limit, for example, of the subjective image? How can we make an absolute measurement of angular difference in relation to the gaze of the character? What is the limit of mode of address? At what linguistic distance from a specified second person? What is the limit of an objective low-angle shot? At how many degrees off the vertical? The neutral image or speech or sound is the sounding board for these questions. It does not provide an answer because it is the *positioning* of the threshold that is obviously undecidable, but it allows these questions to be posed. It is a category that does

not exist but that allows all the others to exist. We need to maintain it because we need its empty space.

What we have is a sounding board for something else: the provisional nature of theory itself. Many current works, and to some extent this one, set their variable rate of innovation according to a sort of "watered-down" (yet somewhat real) inventory of more or less official markers of enunciation. In fact, certain markers have been discussed very often (the prime example would be the subjective camera) and others not. The mostly fleeting history of research has created a situation in which everyone considers, as a rather obvious assertion, that the look to camera is strongly connected to enunciation, while there would definitely be hesitation and argument over whether the use of color or the setting of sound levels, to take two examples almost at random, ought to be interpreted in the same way. It is because enunciation *by* the cinema, as Takeda Kiyoshi has well noted, is inseparable from enunciation *about* the cinema.[6] Markers are to be found, in part, where theoretical discussion has put them, while the absence of certain others can be attributed to the silence that surrounds *them*. But as there is no point in artificially exaggerating their allure and because the progression of ideas requires time, the limit that designates the neutral image may also potentially "contain" figures that are qualitatively distinct from the signs that have already been catalogued, markers that have not yet been recognized as markers and that remain submerged for the moment in our overall understanding of the act of filming.

Neutral sounds and images, if they existed, would be those that give the spectator an instantaneous, vague feeling of being in the presence of a discursive event and the sense that this discourse does not have any specific anchoring points. Or, if I may put it this way, they supply an absence of this feeling. The spectator cannot lose sight of the fact, not entirely anyway, that what he is watching is a film. So he is always conscious of enunciation in one way or another. But, whereas he "sees" it (he *emplaces* it) at certain moments, the neutral image does not encourage him to locate it. It remains afloat; like a slightly loose envelope, it surrounds the film, or is behind it; it no longer has anything to do with the core content of a shot in any circumscribed way; it no longer imprints the film with one of these characteristic *wrinkles* whose traces I have tried to follow in the geography of this book.

Markers of enunciation are often spoken of as signs that might reveal something, and at the same time enunciation that shows itself is placed in opposition to what it is hiding. But in a certain sense it shows itself

always out of necessity because the "text" is open to viewing and listening and because the text never supplies a true illusion; that is to say, it never forgets its textuality. So the important, or rather the only, difference is between enunciation that is lodged somewhere particular and enunciation that is everywhere. In the latter the crucial folding that has been identified in various guises throughout this book is missing. The film comes to the spectator without commenting on itself or mimicking itself, without beforehand turning in on itself. It comes to us as a block, *without any one of its parts dedicated to telling us so.*

PART III

A WALK IN THE CLOUDS (TAKING THEORETICAL FLIGHT)

13

(TAKING THEORETICAL FLIGHT)

There are three big problems that threaten to compromise the very basis of the concept of enunciation that I have presented here. First, the idea of the "transparent" statement [*énoncé*], without enunciation, which enunciates itself; second, opposition to attempts to extrapolate concepts from linguistics, as the term *enunciation* comes to us from practitioners in that field, and for some that gives it the taint of cholera; third, the gap that we would sometimes like to traverse between enunciation and narration, which would have the consequence of emptying the former of most of its substance to the benefit of the latter. We need to be mindful that these concepts, which are normally distinct, can only be confused every time a discourse presents the double character of being a narrative; as it is deprived of a real, prior code that enables it to be autonomous, along the lines of what is idiomatic in the novel, the result is that its narrative consists entirely of a narration.

Let me start with a few words on the already old debate about the statement [*énoncé*] without enunciation, or the "story" [*histoire*] without discourse. We should not forget Benveniste's well-known phrase that unleashed a storm: "the events seem to narrate themselves" in the system of the story.[1] (Genette points out[2] that a very similar idea is found in the work of Percy Lubbock[3] but that the two authors did not influence one another.) We may ask what Benveniste himself ultimately meant by "seem." Genette reads this as the desire to temper somewhat the theoretical gesture that confers onto "story" a kind of automatism.[4] I think rather that this verb *seem* is due to a wise instinct, or simply to

a Benvenistean manner of saying things, and that the great linguist, "busy" at the time with deictics, in fact wanted to affirm that a discourse without them produces itself alone. *Alone* is to be understood in the symbolic sense. The point is obviously not to pretend that a narrative can materially construct itself, by itself. Whatever the case, this vision of "story" (I note with some surprise that it is necessary to repeat it) is now an idea that nobody believes in anymore, starting with the founder of narratology himself, who has regretted since 1983 not having "sprained his wrist" the day that he expressed (albeit with some reservations) his approbation of the famous dichotomy of "Story/Discourse" [*Histoire/Discours*].[5]

But there is more. *Nobody ever believed* this idea of a self-producing story, apart from its detractors. And this was even in the period where the big question of "transparent film" ("Hollywood style," etc.) was being asked in a spirit of ideological critique and scholarly subversion. This 1970s spirit wanted to unmask the lie of absent enunciation and to describe the mechanisms of the process of concealment. This is a central concern in the work of Stephen Heath, Jean-Pierre Oudart, Pascal Bonitzer, and Marie-Claire Ropars-Wuilleumier in relation to films "without writing," and it is to be found in the *Cahiers du cinéma* of the period, in *Screen* and *Camera Obscura*, in *Cinéthique*, and in Latin America, in Oscar Traversa's dynamic and succinct *Cine: El significante negado*, which was published in 1984, after some delay. Discussion of the transparency of dominant cinema was based entirely on a deep-seated suspicion and skepticism about this transparency, as can be clearly seen in the remarkable pedagogical writings of the period by Alain Bergala.[6] Certain filmic systems are very discreet when it comes to their apparatus [*dispositif*] of enunciation, while others "show" it to a greater or lesser extent (*Stagecoach* differs from *October*), and yet others draw attention to it, as in the case of Anglo-Saxon experimental cinema. This is to say that the notion of transparency retains all of its force *as a spectatorial impression*. But these days we put things differently: we would oppose, for example, as in Greimas or Casetti, diegeticized (and so "invisible") enunciation to enunciated enunciation, which signals itself in one way or another.

As always, deictics have skewed the issue. It cannot be repeated often enough (as Gaudreault does) that the distinction between Story and Discourse in Benveniste is based almost solely on the deictic system.[7] This boils down to saying (and it was often said) that deictics are the principal, or even the only, signals of enunciation. But research into

enunciation has developed and altered greatly since Benveniste and Jakobson, even if their interventions were influential. Since 1966, Genette has picked out markers of Discourse (which are more varied than deictics) in Balzac's *Gambara*, which is a Benvenistean example of Story.[8] In 1980, in her excellent update on enunciation, Catherine Kerbrat-Orecchioni noted that the simple presence of an evaluative adjective in the most neutral narrative ("The weather was unpleasant that day") is sufficient to reveal an enunciative presence.[9] Modern pragmatics, which we will come back to presently,[10] dissociates enunciation from subjectivity and conceives it as coextensive with the totality of the statement, because it is the sign itself that is "reflexive" and not at all "transparent" (these are the terms that are used, and the recurrence of the terms we are using is striking). The sign can only designate its referent while designating itself as a sign. So, the influence of "markers" has not stopped expanding and always in the direction of various schemas of metalanguage. Anyway, *the* marker of enunciation par excellence for Casetti and for Genette, the only one that is omnipresent and universal, is the very presence of the statement, a marker that by its nature is fundamentally reflexive, that a philosopher of language would call "opaque."[11] The text does not entirely efface itself in the face of its referent.

The definition of enunciation as "subjectivity in language," which is very common but a little dated, is manifestly inexact, or at least too restrictive.[12] In this sense my tour of some enunciative figures in film has only reinforced an obvious truth: what else could enunciation be, if not *the act of uttering*? The immediate sliding from that position toward the idea of a person-who-utters corresponds to a psychologizing ideology inherited from Romanticism (which still largely dominates the landscape), together with an obscure need to save the *author* at the moment when his disappearance is being proclaimed, something that is no longer to be wished for.

I myself was among those who spoke in the 1970s of the transparent film. Not coincidentally, I did so in homage to Benveniste, in an article entitled "Histoire/Discours: Note sur deux voyeurismes," which was a text full of personal opinions, lyrical in parts, a political critique of Hollywood cinema and at the same time a tirade somewhat in love with that very cinema that had been my bread and butter since adolescence.[13] This was a typical situation for a whole generation of French cinema-lovers (I was born in 1931). Indeed the idea of classical cinema, and even of American cinema, is a French invention (see Bazin, the *Cahiers du cinéma*, Raymond Bellour's two edited volumes on the subject, etc.).[14] So

in that text I distanced myself—by making a contrast with the apparatus [*dispositif*] of theater, truth be told—from the side of transparency. The article ends, "it is the 'story' which exhibits itself, the story which reigns supreme." But in another text from the same year, 1975, I described "transparency" as being itself an enunciative system, actively fabricated by the work of a signifier that is totally occupied with simulating absence.[15] And in 1971, writing about special effects, I had at some length distinguished between two kinds of spectatorial pleasure; one associated with the diegesis (i.e., camouflaged special effects) and the other with the workings of the cinema-machine, when special effects are created to be perceived and appreciated in their full virtuosity.[16] I have recounted all of this to underline that nobody ever took the phrase "statement without enunciation" at face value. *The concept of transparency is itself a fiction,* and it is as such that it puts theory to work. In order to critique the illusion of reality, it is necessary to have taken full measure of the reality of the illusion.

For Genette, Benveniste's "story" does not exist, or at least it is only a discursive form that is marked by exclusions and provisional, partial exceptions (notably deictics).[17] Rather, it seems to me, as I suggested in 1968, that Benveniste uses *discours*, judging by his treatment of the term, in two different ways: in opposition to *langue*, to designate language [*langage*] in action, in specific situations (and so not excluding narratives), and in opposition to "Story" in the sense that we all know (i.e., an exchange between people).[18] So Discourse Mark II and Story are the two forms of Discourse Mark I. Though they are different, my reading and that of Genette both reject Story in its absolute sense. David Bordwell, who has taken a strong interest in these issues, shows in a solid and convincing piece that the most "transparent" Hollywood films still contain visible markers of narration. He pointlessly criticizes this notion of transparency without realizing that he replaces it with a set of three characteristics that designate, in a way that is nevertheless interesting, exactly the same problem. On the whole, Hollywood narration, when we set aside variations of genre, epoch, and so on, would tend toward "omniscience" (i.e., it is extremely *knowledgeable*); it is also very "communicative" (i.e., it states a large part of what it knows, it does not hold back information); and it is less "self-conscious" than other narrative systems.[19] This would seem to be exactly right to me, and it reinforces in some ways a new typology of the notion of transparency.

It is perhaps time to *separate out* three issues that have for a long time remained "caught" inside one another:

1. There is *always* enunciation (call it "discourse" if you prefer) in narrative film as well as in documentary or television talk-shows, because what is said never exhausts *the fact that it is spoken.*

2. But the referential illusion, as well as the desire for fiction that brings us back to childhood, to our Mother's stories, to the Oedipal, all of these forces that rarely lose their strength (and even less so when in the presence of a story), tend to make us forget with a credulity that is broadly consensual, the troublesome awkwardness of this mediation. I will not return to this aspect of things that has long occupied my attention in the past. This is the *willing suspension of disbelief* that Coleridge speaks of, or Freud's concept of disavowal (*Verleugnung*), which is a mixture of belief and disbelief.

3. By a kind of corollary, the main characteristic of some films, particularly those complicit in 2, is that they help us more than others to forget 1. We could say, in this case, that discourse has again taken on (more or less completely) a form that is called story. But this pair of terms, which was so powerful in instigating this path of enquiry, is much less useful today. On top of that, it leaves the intervening levels blank. It is simpler to specify in every example which figures of enunciation appear and which do not appear.

Is it legitimate to speak of "enunciation" in the context of cinema, seeing that the term comes from linguistics? On this point we encounter objections from Bordwell,[20] who is irritated by "continental structuralism"[21] and the "Benveniste-Metz conception" (!).[22] I find myself criticized in flattering company: Marie-Claire Ropars-Wuilleumier, Raymond Bellour, Stephen Heath. Sometimes there is pleasure to be had in being found fault with. The criticism is that the concept of enunciation, when applied to cinema, fatally moves away from the Benvenistean definitions while still invoking them and thereby leads us into pointless contortions. Bordwell equally suggests that the pitiful Franco-English cohort considers every narration to be at base a linguistic process (I will not comment on this assertion, which the weight of the passing years has crushed).

Otherwise, one other thing is striking. It is actually the word *enunciation* that, because it comes from linguistics, provokes a range of reactions like a red rag to a bull. Throughout his book, in his title and even in the title of the chapter that I am citing,[23] Bordwell permits and constantly uses the term *narration*, and the study of narrative that he provides is on

the whole worthwhile. But the phenomena that are studied under this heading are the same that interest me (voice-off, text onscreen, looks to camera, etc.), even if the analysis presented is decidedly different. So the aim, at least on this point, is to flag a rupture (from Europe, semiology, etc.) rather than what is really a divergence.

Bordwell deals with narrative film, so it would seem to me quite normal to devote a lot of space to the concept of narration, narration that (here) can only be made with enunciation. However, I prefer *enunciation*, and for two reasons. First, the term is broader and remains useful, as we have seen in the course of this book, for experimental, non-narrative films, didactic/information films, television programs, etc. These matter a lot to me because, on the one hand, they draw on the same repertoire of figures of enunciation but use them differently. Just think, for instance, of the voice-in combined with the look to camera in television reporting and of the way that they alternate with voice-off in short embedded reports. On the other hand, as for the "continental" spirit with which I am afflicted, complications or distortions relating to their origin in Benveniste or in linguistics are far from being an obstacle. In fact, they offer a dreamed-of opportunity for some flexibility exercises that I recommend to everybody and that show the benefits of putting the concept to work, of enriching it and rendering it more "comprehensive" for its field. Kerbrat-Orecchioni, whom I have cited in another context, evaluates as a linguist the heterodox definitions that I have proposed in the past for concepts such as "connotation" and "metaphor," and she does so to good effect, even if she does not totally approve of my usages.[24] Because this is also where the problem lies: it must be clear that to borrow a notion, linguistic or otherwise, does not necessarily mean that one intends to *apply* it, or that one thinks that this is what must be done. This might be an obvious point, but it is often overlooked.

Then the hard-liners, sooner or later, find themselves outflanked by the more extreme hard-liners (it's the same with the leftists). So Bordwell deems "enunciation" to be inappropriate for "narration." But Genette, for his part, finds that "narration" is itself inappropriate every time that the story is *represented* (in theater, narrative painting, cinema, comic strips, etc.) and not *signified* by written or spoken language, whose intervention suggests the intervention of a mediator, because it consists of a transformation.[25] The entire "reality" is transformed into a sequence of words, with the exception of that which, in this "reality," already consisted of words—that is, the spoken words of characters. In sum, Genette goes on,

language never imitates, never represents and is never *mimesis*. The more it narrates (it transforms), it is *diegesis*, the more (in "spoken stories") it transcribes identically, or simply transposes by writing, it is *rhesis*.

The objection is serious but of varying gravity, depending on the mode of expression. It is valid perhaps for classical theater (or its successor, farce), for narrative painting, for certain photographic novels and comic strips. It is much less so for cinema. Genette says nothing about the considerable weight of elements and arrangements that film mixes into or adds to simple representation, of which *montage*, for the majority of theorists, is the symbolically totalizing expression. Half of the material of a film, sometimes more, is of a noniconic nature: optical effects (dissolves, etc.), spoken words, intertitles and other writing, and logical connectors of all types that convey causality, concession, succession, precession (i.e., flashbacks), and so on. *The coming together of two images is not an image*, and the visual sequence of the film, with its perpetual anaphora and cataphora, its unfolding of events, its causalities, its spaced-apart repetitions, its special-effects symmetries, bears more than a passing resemblance to a passage of writing. As early as 1946, Gilbert Cohen-Séat remarked on cinema's "logomorphism."[26] Laffay, as I have said, readily insisted on the "ultra-photographic interventions" that haunt film, and on the "structure without images" that it carries within itself.[27] André Gaudreault's entire theory is based on the idea of a "narration" that, in the film, manages to superimpose itself on what is on "display" and modifies it profoundly.[28] Käte Hamburger definitely went furthest in this respect, as she did not hesitate to consider narrative film as a branch of the literary arts, a mixture of the "epic" and the "dramatic."[29] A film uses images like a novel uses words. By combining them and putting them into sequences, film lightens what is iconic about images (we could be listening to Eisenstein at work). Film "replaces the *image-power* of the word with the *word-power* of the image."[30] Silent film was entirely epic, while sound films are more dramatic[31] (we may note, as with other authors, the seeming paradox that the most "novelistic" element of film is the image-track, not the dialogue). Hamburger again: the image has a "narrative function" (*Erzählfunktion*).[32] What the viewer sees may not be seen in the theater but may be read in a novel. That is why scenes without characters (landscapes, etc.), which are difficult in theater, are common in films and novels.[33]

Gaudreault mentions[34] a private letter that he received from Genette in which Genette accepts, or at least tolerates, a "broad" use of the concept of narration for stories that are represented and not signified.[35] Film

obviously benefits from this degree of tolerance, but it could demand more. Through its affinities with language, which are substantial, despite enormous and obvious differences, film has something in common with "narrow" narration, even if we maintain Genette's distinction. I find this distinction to be fundamentally correct, but it comes under parasitic attack by generic characteristics, which attach themselves to all narrative developments without worrying about what sustains them, with the result that broad and narrow distinctions cannot remain completely impermeable to one another.

The issue is that in certain cases, notably in narrative films, we no longer have a theoretical criterion to distinguish narration from enunciation. This aspect of the problem is generally not known about, and here I am wary of coming across as eccentric. It is in fact a common attitude, which on the contrary consists of keeping a permanent gap between the two notions, as if it had been proven that their binary status is necessary and that any instance of conjoining them should be peremptorily ruled out. Jean-Paul Simon has noted that the intervention of an explicit narrator in a film does not reveal the instance of enunciation to us, even if "it refers to it in a dismantled way."[36] So he is thinking of primary enunciation, but secondary (or tertiary, etc.) enunciation is fully part of the apparatus [*dispositif*] of enunciation. What else does an explicit narrator do, if not enunciate (enunciate, in this case, a linguistic narrative)? At the same time, of course, he narrates (hence "narrator"). So it would be necessary, in order to maintain two instances, to agree to set aside the label of enunciation for primary-level interventions. But this runs counter to a characteristic of enunciation, which is simultaneously evident and crucial—that is, its layered structure and its capacity to multiply itself, to *defer* itself infinitely, as we see in a simple sentence such as, "I'm telling you that he told me that nobody told him anything." For Gaudreault enunciation in novels corresponds to markers that connect to the "linguistic substrate," like *shifters* or the tense of verbs.[37] These markers "do not concern in the slightest" the activity of the narrator. But just after this, while still on the subject of explicit narrators (always the most troublesome ones), Gaudreault speaks of "the enunciator as narrator" without noting that he is cognizant, at a secondary level, of a coalescence that is just as characteristic of the primary one. This is because in the novel, markers of the Narrator (the inaugural, supradiegetic narrator) are for the most part (as Jost has noted, and as I am currently doing) drawn from the arsenal of language and its key turns of phrase, that is to say, from what we want to allocate to enunciation alone.[38] Genette's "modes" and "voices," points of

view, and everything like them establish themselves in many instances by means of grammar, verb tense, the paradigm of the three grammatical persons, adverbs of time and of place, and so on.

It is not absurd to connect enunciation to the substrate of language. But it should be known that enunciation will contain within itself, in advance, half of the tools of narration. It should also be known that it will become difficult to consider enunciation in film because what we call cinematographic language [*langage*], which is not a code, does not present the same degree of closure, or even of existence, as so-called natural language [*langue*]. The thing that, in the Story, shapes this "language" [*langage*] (very often including, indirectly and predominantly, nonnarrative films), is exactly the demands of narration, in particular in the era of the great pioneers, such as Smith and Williamson, Lumière and Méliès, Ince and Griffith, and the great Soviets. Thus, narrative film is not only the place where enunciation makes itself narration but the place where narration takes on board (incrementally) the totality of enunciation. This mutual interplay takes place in both directions simultaneously.

The critic who has most addressed this gap between narration and enunciation, Jost, is also the person who, occasionally and without admitting it, has made their points of similarity most clear. There is an apparent contradiction, of a type that is not at all rare nor particularly illogical, that by going far in one direction, we *touch* the opposite idea, that we provoke it into rising up. (This is also a familiar mechanism of the unconscious, whereby we feed ourselves arguments against a decision just as we are on the point of making it.) But I digress. So Jost tells us on the one hand that the narratological signification of a shot in a film is distinct from its "semiological signification," without taking due heed that this latter phrase is deeply enigmatic because semiology defines itself as the study of all acts of signification.[39] He comes back to his dissident theme in several passages,[40] such as this one: "That cinema is above all a look does not imply that every point of view has narratological pertinence. Certain camera positions refer back only to the apparatus [*dispositif*] of enunciation, while others have the value of diegetic authority."[41] This latter group, he goes on, are of interest to narration. But it is not clear how the first group, which he classes as enunciative, could be irrelevant in the eyes of a narratologist, at least for reducing the narrative to simple *plot*, and for removing from it modalizations, atmosphere, implicit commentary by the narration on what is being narrated, and so forth—in other words, in the final analysis, *the very way that narrating is done.* And elsewhere: the presence of a "Great Image-Maker cum narrator"

is implicit, and it reflects back on cinematic language.[42] This much is true, yet Jost himself, as we can see, calls it the narrator. Behind this insistence on duality, an alternative organization of things inscribes itself, and it is consolidated with reference to the novel.[43] He explains that the choices of narrative attitude often translate, without being reductionist, into variations of language [*langue*], the use of deictics, adverbs of time, and so on. (I have already indicated my agreement with this idea, and I repeat it here). Returning to Jost: he argues that when we move from the Great Image-Maker (i.e., invisible source [*foyer*]) to an explicit "storyteller," "*enunciation shifts from cinematographic language* [langage] *to a film's plot*" (the entire phrase is emphasized).[44] It can equally happen that the activity of this Great Image-Maker is "purely narrative," so we could call him an "implicit narrator."[45] In this way enunciation can become narration, and their combination is possible. It is at this point that I would like to intervene: the point is not (does this need to be specified?) to declare that the two terms are synonymous but to identify where the nature of a given film causes their respective spheres of meaning to intersect and designate the same thing.

I have already mentioned how Genette, when introducing the very notion of Narration as it relates to Narrative and Story, describes it as "*parallel*" to that of enunciation, thus displaying simultaneously the gap and the resemblance between them.[46] And it is liable to lead us from time to time, I dare say, quite far in the direction of what Genette also calls "that enunciatory instance that is narration,"[47] when the issue arises. For Branigan the plot is to narration what the spoken word is to speaking, or what the statement is to enunciation.[48] Once again we find the idea of parallelism. In general, then, we can recognize three broad tendencies of diverging attitudes toward the relation between enunciation and narration: there are those that insist on their separateness, those for whom they are at the same time distinct and related, and those who—in the double case of cinema that is narrative—unashamedly want to "fuse" them. This final position is my own, and it is where we also find Bettetini and Casetti with their constant citing of the "enunciator" and "addressee" in relation to film narrative. This enunciation, as we have seen, is also narration. But in pointing out the very fact of discourse, we encompass more, and we do it more radically, than by naming the type of discourse. (The issue is not, however, to proscribe "narration," which is irreplaceable for designating this type as such.)

The great extent of this problem has in my opinion been described well by Aumont.[49] He notes that film narration is not confined to one

or more *places* that can be assigned to the film; rather, it weaves in and out everywhere, in the montage, in framing, and in the represented object itself. Narratology examines storytelling *in* film, but it has difficulty in dealing with an entire film *as* storytelling. This is indeed the great "challenge" (to use the modern term) that I would like to pick up on and against which film-narrative studies are opposed. We are not yet rid of the explicitly factual framework, which corresponds to a kind of screenplay, or to a skeleton, rather than to the film itself. When a film is narrative, everything within it becomes narrative, even the grain of the film stock or the timbre of voices. Rather, we would need to say, "*insofar as a film is narrative,*" because we know that some films exist that are partly narrative in differing ways and degrees (consider Duras, Godard, Robbe-Grillet, and a hundred others). But this does not solve my problem; in a mode of expression that does not carry its own code within itself, narration, in the part of the terrain that it occupies, takes charge of all discursive fine-tuning and every enunciation. What is more, when we think of figures that everyone considers to be enunciative, we realize that most often they are also, inseparably, narrative: a diegetic speaker, a nondiegetic narrator, voice-off or voice-in, looks to camera, motivated or unmotivated music, beyond the frame, and so on.

Enunciation is the fact of uttering. (I am repeating myself; I must be getting old.) So in a science documentary it is scientific enunciation that is at work, while in a war film it is militaristic enunciation, and so on. These examples can be replaced by others if the reader decides that they do not correspond to specific kinds of enunciation. As for all the rest, for narrative enunciation, which has exceptional anthropological significance and has a broad social reach, we use a special word, *narration*, whose counterpart is, not accidentally, lacking everywhere else. Finding ourselves in this way faced with two nouns, we tend to look for two things, blithely forgetting that for all other kinds of discourse we do not even ask the same question. In the case of a geographical film we do not try to distinguish some kind of "geographization" from the enunciation. Though it would in this instance be the exact counterpart of the narration. But it does not have any social existence, of which, by contrast, narration has quite a bit, because it stands alone in our minds, and we no longer dream that it is anything other than a narrative enunciation.

The aim here is not to cut the connections between narrative films and other films. What they all have in common is precisely the fact of enunciation. In his remarkable recent book, *A Cinema of Nonfiction* (1990), William Guynn, on the basis of semiological analyses of several

documentaries, opposes the in-built ideology of the genre that believes it can attain the truth by means of brute "recitation" of the facts in their chronological order, and he convincingly deconstructs the apparatus [*dispositif*] of enunciation of these films. There is an effacement of any instance of a guiding hand, so that the spectator has the impression that he is himself the subject of the discourse, but there is also the intermittent presence of the voice-off of authority, which tries, however, to neutralize itself at the same time. The discourse of "reality" is as calculating and organized as that of fiction film. For that matter it lends it a good share of its figures of expression, the others coming from noncinematic media, such as journalism. Geneviève Jacquinot has made a detailed study of the play of enunciative patterns of organization, which are often borrowed from narration, in instructional films.[50] Several recent theses come to similar conclusions in relation to several more or less "nonfiction" genres: the instructional film (Rosemarie Meyer), advertising films (Françoise Minot, Margrit Tröhler), and television reporting (Thierry Mesny).[51] Hence the position of Roger Odin, whose pragmatic theory has from the start been interested in several film "genres."

There is a second factor that skews things: the terminology has become established principally with reference to linguistic narration, novels in particular. In these, narrative fine-tuning superimposes itself on a primary layer of strong coding, that of the idiom. So we could, if we liked, agree not to label them as enunciative and to speak of narration as that which appears as a distinct level. It is true that the distinction still remains quite difficult. Deictics, for example, will go into enunciation because they belong to language, but their *use* is very often decisive for a narration. Observations on this by Aumont and Jost are reinforced once again: when narration intervenes, it uses every tool that comes to hand, and this includes idiom, when there is idiom to be had. But in this latter case we have a criterion that somehow allows us to cut things in two, while narrative film, for its part, *is not based on anything*, and it itself constructs everything that, within itself, is of the order of "language" [*langage*] in the eyes of the analyst.

To sum up: enunciation is different from narration in two cases, and two only, each of which corresponds to a very large group of screen texts. In nonnarrative texts, which nevertheless have a discursive source, and in written or spoken narrations where it is conceivable, with difficulty, to distinguish between narrative mechanisms that stick to the idiom and those that are independent of it. In the first case it is enunciation without narration, and in the second it is enunciation *and* narration, but remaining in

principle separable. As for the syncretic case, it covers discourses that are at the same time narrative and extralinguistic. This is where we find, even in the primary (social) position, the storytelling of cinema or television.

Let us pause for a moment. All in all, the concept of film enunciation fends off quite well the three big charges of invalidation that can be or have been made against it. But this offers only negative assurance: the road is not impassable. What remains to be done is to show that this idea is the one to pursue. Why? For reasons that are local, particular, and connected to the various cinematic tropes that have been discussed in this book (and to all other tropes) but also for a more radical reason having to do with film just as much with other kinds of prefabricated discourse, such as the novel for instance. This can be summed up, for those who like things pithy, in the snappy phrase, "the final I is always outside the text." (But it must be added that it often leaves traces, and that its act *is* the text itself.)

Let us imagine a person who declares, "I'm leaving." If the analyst wants to reestablish the instance of enunciation, he notes, "I say that I am leaving." And so on and so forth. (I am borrowing this little instructive fable rather freely from Kerbrat-Orecchioni).[52] The final *I* can never be grasped; rather, it slips from your hands and withdraws into its nook. Trying to capture it is like chasing your own shadow. Let us consider the issue in other terms: at every stage of the analysis the metalinguistic aspect, once it is made explicit, becomes a linguistic aspect and in this way recreates the need for the metalinguistic approach. This exemplum is not simply plucked from thin air. These cascading regressive sentences are clearly visible (or at least the first links in the chain are) in certain formalizations found in generative semantics, which treat every sentence as having some completive aspect, embedded inside an underlying declarative statement such as "I say that . . ." (In an unexpected coincidence *speech act* theory reads the simple assertion as an illocutory act among others, a kind of implicit performative: so in the case of "I say that," this is the I SAY that is never said.)

This feeling of a *place of absence*, a paradoxical originary figure, yet more "absent" in fixed, noninteractive discourses, is one of the rare things that generate agreement among film theorists who are interested in narration or enunciation. This agreement does not appear immediately because every person has his own way of taking cognizance of this gap. So let us cast our eye over how this has been done. For Greimas the absence of the enunciative instance [*instance énonçante*] is axiomatic; it is affirmed with force, and these are closely related notions, starting with shifting in/shifting out, which presuppose it and are based on it.[53] For

Simon the "source" of a statement has as a primary characteristic that it never appears; only "traces" of it can do so.[54] In every discursive system the subject and the object are absent, and they reappear only if the social context of the system is taken into account.[55]

I have already cited Casetti's pleasing formulation, according to which enunciation is always "outside the frame" and can be perceived only in the statement [énoncé].[56] In a more general way, for Bettetini and Casetti, the very notion of the Enunciator, constantly used, has the function of designating an absence, or at least a "presence" that is purely textual. The enunciator is not a source [émetteur] (a physical person), nor is the addressee a receiver [récepteur], and it is in this very fact that enunciation differs from communication. We may recall that Bettetini goes as far as describing instances of enunciation as "fantasmatic" and that for Casetti and Bettetini they are roles without bodies.[57] The same can be said (as far as I am concerned) about Jost's *implicit* narrator, who owes his status to a particular mode of absence. Later I will discuss, from a neighboring perspective, the "impersonal narrator" proposed by Robert Burgoyne.

The idea is absolutely central for Branigan. Here are some aspects of it that will connect to those that have already arisen over the course of this study: the only "human" presence in a film is its textual intelligibility:[58] "The text is code, not psychology made manifest."[59] If we move up from "frame" to "frame," we end by falling into the final one, the entire film, which is always omniscient (even if it has "cast off" this knowledge onto a falsely primary narrator) and always unknowable because it is not named, it is not a character, and it is not situated anywhere, or at least not *elsewhere*. It knows everything, and we can know nothing about it.[60]

In Seymour Chatman's system[61] the notion of the implied author has (as in the work of Wayne Booth, from which Chatman borrows)[62] the main, or initial, function of clearly rejecting the other author from the text, an author who is precisely not implied by the discursive development (all of a sudden, he finds himself called "real," a term whose unwittingly funny side has not prevented it from getting spread around). Gaudreault proposes different terms ("Narrator," fundamental narrator, supradiegetic narrator, Mega-narrator)[63] to designate this ungraspable entity, which, he tells us,[64] is never figured, never visible in the film, always elsewhere, and never in human form: a point of origin that is always some distance away.[65] He adds that by virtue of these characteristics an instance such as this cannot in any instance assume the form of an "I."

Odin identifies, with great precision, different operations that are all necessary for the establishment of a fully fictional landscape.[66] He defines the last operation, "fictivization," as follows: the spectator attributes a particular status to the enunciator of the film; he is not, as people say these days, the real origin of the propositions that make up the story; rather, he is its fictive origin. Pragmatically speaking, he may enunciate these propositions without taking on the obligations that are described by Searle or Grice, as in a demand for sincerity, for verification produced on demand, and so forth and without being considered a liar for all that. By means of this artifice he can attain, and his spectator along with him, another kind of truth, which is perhaps more fundamental. I find the notion of a fictive origin unsatisfactory: it is clear that the enunciator, at the level of symbolism (where by definition this analysis is based), is really the one responsible for the text, its source at every moment. Every text has two origins, neither of which is fictive: empirically, the author who has constructed it, and symbolically, the enunciation that pronounces it (i.e., which *carries* it). What is fictional in fiction is not the origin but the mode of being of that which is said, and I would like to agree broadly with the point made by Genette on this question.[67] In contrast, it seems to me that nonfiction discourses, when they are set up in advance as autonomous and in a definitive way, spring up out of a place that is almost as empty as the place from which fictions arise. More precisely, there would be two "fictionalizations" to distinguish: one that belongs to the fiction alone, and one that is attached to the specific artifice of all prepackaged texts. But I would also point out, to return to my theme, that Odin tends to designate, in his own theoretical framework, the point of absence around which I am circling. Objections that cite conversational maxims as well as the social system of lying seem to me very illuminating, and the rapprochement between fiction and truth, insofar as it is carried out, is a nice reprise of an old, even timeless, idea of moralists and novelists.

This book has been influenced by Hamburger, who has concerned herself with fiction more closely than narration. She says it is defined by the absence of a real "I-Origin" and by the obligation of reconnecting the narrated story to those fictional I-Origins that are the characters.[68] (This fine point, which introduces the text into the situation, partly forestalls my objections.) When I read in a novel, "This evening, the weather was good,"*

*. Metz uses a present-tense adverb and a verb in the imperfect: "Ce soir, il faisait beau."—Trans.

the evening that I am being spoken to about is that of the character; it is not the evening when the sentence was written nor the evening when I am reading about it. As well as that, Hamburger goes on, the imperfect of the verb is compatible with an adverb of time in the present, and it itself expresses the present of the fiction.[69] As we can see, this is once again the topic of the final *I* outside-the-text, so here I will somewhat arbitrarily stop this perhaps overlong overview of the different evocations of the same empty space, which has paradoxically drawn everyone's attention.

Disagreements start when it becomes a matter of describing it and giving it a status in theory. Many writers feel the need to *personify* this point of origin, this hollowed out thing. In an analysis of painted portraits, Simon speaks about the spectator as a "You," and uses "I" to designate the character who is represented together with the painter who is behind him, so to speak.[70] Casetti, whom I have discussed at length,[71] gives a central place to personal pronouns in his map of enunciation. He upholds the opinion that film has deictics,[72] and that film constitutes a kind of language system [*langue*].[73] Bettetini posits the idea of "conversation," and so of active persons, at the center of his analysis, to the point of including it in the title of his work.[74] Jost, before his recent clarifications,[75] proposed an idea of the narrator, even the implicit narrator, that did not exclude every personal form. And of course there is also the implied author of Chatman and Booth. So this anthropomorphism takes many fairly diverse forms, which can only better illustrate how the vague feeling of a human presence offers a degree of reassurance.

In response to Genette, for whom there is only linguistic narration, Odin rightly insists on the importance of transformations that, in cinema, separate the initial datum from its representation.[76] So there really is, he goes on to say, a "narrator." For me this example is very typical, not only in its quality but because the writer, having invoked some *operations* (montage, editing, etc.) and having designated in this way the reality of a mediaTION, traverses rather too briskly for my liking the gap that separates mediation from mediaTOR. Odin is obviously trying to stand in clear opposition to Genette here, so his "responses" take on a particular rhetoric. But elsewhere it is difficult not to be struck in many cases by the suspicious and comical proliferation of "narratological instances"— an author who is implied, implicit, imaginary; an enunciator, an implicit enunciator, a narrator, an implied narrator, a model author, an immanent author, and so on. This vivid assortment of surrogates, cunning candidates for the twofold ousting of enunciation and of the real author, even have the nerve to present themselves to us as *both* nonempirical

(purely textual, etc.) *and* endowed with human attributes. How many times are *enunciator* and its alternatives used to speak about the author without saying so, and how many times is *addressee* used to unnecessarily prejudge the reactions of Vernet, who manages to say what he wants with two or three common words, such as *author, character,* and *spectator*? By multiplying the terms, one does not multiply reality, or more exactly the number of notions that the mind is capable of distinguishing from one another, which is to say, in the strict sense of the word, the number of *conceivable* instances. I myself have contributed, with "source" [*foyer*] and "target" [*cible*], to the terminological inflation that I am mocking, but we will soon see these minor additions obligingly disappear from the scene once their job is complete. I have absolutely no wish to add them to the Mound of Enunciation.

To return to the personification of the source of the text: We have already seen it in Genette, but only for written or oral storytelling: because language never represents, and because it performs a transformation (see above),[77] it engages the activity of a mediator, a speaker or a writer. Hence the term *narrator*, which is constantly used: extradiegetic narrator, homodiegetic narrator, etc. Hence, equally, the striking observation that the reader of a book always attributes the primary narration to the voice of a person, even when the text maintains absolute anonymity from him.[78] Also, every telling, whatever its focalization, is in the "deep" first person.[79] What is more, the narrator can be confused with the author (whether alleged, real, or a combination of the two).[80]

But it is also apparent (as Odin's reaction reminds us) that Genette objects to the idea of narrator and even of narration in film narratives and that Gardies, for his part, sometimes gives ground on this point in moments of doubt, where basically the same feeling is expressed.[81] The fact is that in this question of "personification" there is a certain number of intermediary, or hesitant, positions, or positions that are, as Genette has it, frankly split in two. No matter how freely Simon uses I and YOU, he does not notice any less that these pronouns differ profoundly from the real ones, in the sense that they cannot be *exchanged* for each other.[82] I myself have not in my turn been shy about hammering home this simple but decisive statement. In Robert Burgoyne's "Cinematic Narrator," an article that I have made great use of, Burgoyne posits in principle that the idea of narrator is a logical and pragmatic necessity of a piece of fiction, because inside the fictional-ludic contract of communication there hides a secondary pact, one of truth-in-imagination, of which only the narrator can be the guarantor;[83] it matters that the spectator should have

confidence in the diegetic veracity of what he is being told. This is why, according to Burgoyne, "unreliable narrations," which have been of great interest to American theorists, are possible only with secondary narrators. A typical example, and for sure a Hitchcockian one, is the famous initial flashback in *Stage Fright* (1950), intelligently translated as *Le grand alibi*.[†] This film's untrue narration that is attributed to the character of Jonathan has also been analyzed by Casetti,[84] Verstraten,[85] and others. In this way, says Burgoyne, secondary narrators, who are persons (I would add moreover that they are called characters), are able to lie, but not the primary narrator, whom he calls the "impersonal narrator," who cannot equivocate about anything without the fiction itself unraveling. This is a remarkable analysis, where the only thing that gives us pause is the almost contradictory expression "impersonal narrator." The entire article had referred to this as "impersonal narraTION." The author wanted no doubt to differentiate himself more clearly from Bordwell and Branigan. Anyway, in several passages, and even in the title, it is "Impersonal Narration" that is used (not without being preceded by "Cinematic Narrator"). This is a good example of an intermediary position.

In contrast, there are other authors (including myself) for whom any anthropomorphic account is formally rejected. Despite his personifying terminology (meganarrator, etc.), Gaudreault insists a lot, as I started to say, on the polyphonic, demiurgic, machinic, composite, and ultimately *barely human* quality of the narrative source in cinema.[86] It is the privilege of words and of words alone to be always attributed to a human being, even when we do not know which one.[87] (This assertion is made to some degree by all of the authors we are considering; I could have cited a remark to the same effect by Bordwell.[88] He asserts in effect that of all modes of expression, articulated language, which is to say language [*langage*] tout court, is the only one connected to the very definition of humans. But the conclusions that can be drawn from this for the analysis of enunciation are not obvious, a point I will address presently.) Gaudreault reminds us that the "narrator," early on, was a flesh-and-blood human being, a bard who spoke in the presence of his public.[89] With the book, this relationship becomes "prerecorded," but it would be a mistake to forget that it still is based on language. In cinema it takes place via electrical instruments and cables, and the illusion becomes impossible.

[†]. The crux of the film is the status of the fake alibi delivered by the villain in the form of a flashback, which itself is fake.—Trans.

The fundamental narrator is not a person, as film has an a-personal basis (Gaudreault uses a term from Branigan here).[90] Branigan's basic position is that the word *narrator* is in reality a conventional term that designates narration as an activity, an "activity without an actor."[91] Elsewhere, he powerfully (and correctly) declares that there are no people anywhere in a film, only text and code.[92] This position is what inspires his entire critical project. In the same spirit, Bordwell (in relation to film but not to the novel) rejects the very term *narrator*, and with it all terms for agents (enunciator, implied author, etc.) in preference for just "narration," which designates a process and covers all cases in his opinion.[93] I agree, and I am proceeding in the same vein, but with *enunciation*, for the reasons that I have given.[94] If a theory is "depersonified," it is clearer also to depersonify its terms, and so to drop *enunciator*. (Of course, this has to do only with the first level of enunciation or narration; secondary and further levels are anthropomorphic by definition, as it is the film itself that presents them to us as "characters" or "narrators," or both at once.)

In this, as in other matters, it is from Hamburger that I borrow my most hard-line position. Dealing with fiction and not with narration or enunciation, Hamburger opposes all anthropomorphizing of texts with a healthy, if at times rather harsh, vigor. Here are some samples on which she sets her sights: for a start, the notion of narrator signifies nothing (!) because there is nothing but the author and his or her narrations.[95] This narration is ever-changing and "impersonal" (the word appears several times); it is not a person but a *function*[96] and, to coin a phrase, a chameleon-function because it can slip at will into dialogue form (which supplies a part of the diegetical information) and back into anonymous discourse. It can survive the constraints of monologue, as well as the constraints of indirect discourse, for periods unless it opts for the relative liberties of the free indirect style.

So Hamburger rejects *Narrator* in favor of *Narration in the case of the novel*, which is an object of pure language. With this radical move she devalues "splitting" theories that separate out the case of film from that of the book while selectively personifying the latter. She also leads us to revisit an idea that has been invoked often (by Genette, Gaudreault, Bordwell, me, and others) of a fixed connection between the object of language and human presence, of a fundamental correlation that, on the contrary, is dismantled by machinic discourses. In effect, no matter how striking this contrast, it only opposes (as has been emphasized by Odile Bächler and Marie-Françoise Grange) impressions that we experience in reading a novel or watching a film, as the case may be.[97] For me these

impressions are of great importance and are not to be excluded from consideration, so I understand (but do not share) the anxiety that is at the heart of these splitting tendencies. Yet a book is as empty of all human presence as a film or any other work that has been composed and finished, something so evidently prefabricated and then *deserted*. Because what is it ultimately that we find in a written narrative? Sometimes there are secondary narrators, which are simply notional and are by definition at one remove. Sometimes the narrator who presents himself as the primary narrator cannot be because he is clearly a product of the text. And sometimes, finally, there is nobody: pure (unalloyed, for once) enunciation, which the two preceding narrators were indirectly aping. But rest assured that I have no intention of pursuing this foolhardy incursion any further, especially as some considerable heavyweights in the adjacent territory of Literature have done so already . . .

So what should we conclude from all of this? First, the level of enunciation (in the singular) that is commonly invoked corresponds in fact to two distinct types: textual (i.e., with markers) and personal (enunciator, narrator, and all their cousins). This is the level of *attribution*: a marker is attributed to somebody. On this second point it would be better not to be in too much of a hurry. A film spends its time in establishing Pierre or Paul as people, and sometimes the explicit enunciator pretends to be the primary one, but *he is completely incapable of establishing himself as a person*, and he remains what he is, which is a logical development, an utterance [*proferation*].

I can only reiterate, following Genette, the impossibility, without verbal gymnastics, of conceiving of something or somebody *between* the real production of the work (the author, who thus reassumes all of his importance) and its symbolic production (i.e., the narrator for Genette and enunciation for me).[98] The game of "examples" was over before it began because nobody will ever find, on the side of the production, anything but one of these two.

I have already just given a taste of this little-played game. Why, among certain authors, is there such a proliferation of hybrid, convoluted entities whose common characteristic, variously described, is to situate oneself both in the text and outside it, in discourse and in the world? I believe that to some extent (there are of course several factors) it is the joint effect of two sources of ideological pressure. On one hand there is the literary tradition, which continues to impose its interest in the author (fully legitimate in itself, not that this needs reiterating) in terms that evoke Law, Terror, and the Sacred. On the other hand the more recent

source of intoxication is linguistic pragmatics or, more precisely, its accompanying discourse, which volubly criticizes Saussure and "structuralism" for the sins of immanentism and ignorance of the Social but is careful to support its conclusions with purely textual analyses, linguistic intuition, or invented examples that are inserted into contexts that themselves are contrived. The results are remarkable by the way, and they ironically confirm that purely textual analysis, done authentically, has not lost its impact. But if we are looking for information about real and genuinely social contexts of speech, we have to look elsewhere, namely at research based on observation and experimental research (psychology, sociology, and so on). This is not to say that pragmatics pretends to be something that it is not or that it is playing a double game—I know this is not the case. What I am trying to identify is a generalized nostalgia for the social and for the author—that is, for the real, for what is around us—that does not affect the analyses themselves but that finds expression in comments and words (because it is these that I have in front of me), while being obstinately deaf to the fact that pieces of text *also* carry within them a mysterious, extratextual "x-factor." If they did not, then what could be the meaning of the notions that we have met at every step, such as "interlocutor," "dialogue," "implied author," and so on?

Early in this book, in a stance against anthropomorphic terminology, I chose to substitute the pairing "Enunciator/Addressee" with "Source/ Target" [*Foyer/Cible*]. (I also used *source* [not *foyer*], but this is a different case because it is not a technical term and is of the same type as "origin" [*origine*].) These are the terms that I settled on for these things. But the course of this book has gradually led me to define *enunciation* with an emphasis on the idea of a *process* or of a function rather than an object. (The "thing" is the text itself, not how its effects unfold.) Also, the only term that I ultimately needed, from the point of view of production, is *enunciation* itself, which correctly describes a function. (What is more, as Kerbrat-Orecchioni points out, despite edicts that broaden its meaning and despite the gracious entrance into the scene of "addressees," in real language this word only actually evokes production, not reception; hence it suits my purposes.)[99] From the point of view of reception I have contented myself with *spectator*. We will see why in a moment, and we will also see that the asymmetry between the two poles is even more marked than I have said, even if it is usually concealed by pairs of words ending in *-or* and *-ee*, which seem to match one another too tidily. Whatever the case, the time has come to bid adieu to my source and my target . . .

So we have an asymmetry between two poles. (These are traditional poles, even though they have been inherited from a different field, i.e., the theory of communication). This asymmetry has often been observed, but its consequences have not always been measured. And the consequences are considerable. On the side of "transmission" there is nobody, no person, only text; the enunciator, as I have just said, does not exist, or rather he is nothing but the personification of enunciation. As for "receiving," however, there is necessarily a person (or persons), and in every case at least one spectator—that is, the analyst (or simply the person watching the film)—because without him nobody would know anything about the text nor even that it exists, so much so that the pole of reception itself would disappear.

If a person is needed on this side, it is because there is no text (i.e., no text *there*), and if the pole of transmission can do without a symmetrical human presence, it is because the text makes up for it. We do not go to see a filmmaker; we go to see a film, but this WE that goes, is not another film; it must be somebody. Binary pairings such as those just mentioned, like "narrator/narratee" and all of their related forms, suggest that the work, be it film or novel, functions like a telephone or fax machine. They mask an inbuilt, fundamental imbalance. The author delivers the work to its place, while the spectator, who has nothing to deliver, displaces himself. *There is no exchange.* On the one hand we have an object in the absence of any person; on the other hand we have a person, deprived of an object, who presents himself. And of course he presents himself with all of his (cognitive, affective) capacities, and he presents himself in person, while at the other end, all corresponding operations have been mechanized.[100] This indicates that my observations do not chime with, nor are they dissonant with, normative research that aims to develop active, critical reception and to suppress possible manipulation, and so on.

Thus, positioned like a soliloquy, enunciation separates itself from interaction. Its deixis is simulated and its principal markers are foldings of the text back on itself. The film self-designates itself *because there is only itself.* It cannot, as conversation does, latch onto little bits of reality or use the immediate and multifarious influence of reality as a starting point. If film enunciation marks itself using metadiscursive figures, it is above all under the simple and obvious conditions of cinematographic transmission.

In a film, when subjective framing is attributed to the "enunciator," it is the analyst, who is in the position of the "addressee," who calls the

shots. And if the framing is attributed to the addressee, it is yet again the analyst who says so. This is another aspect of asymmetry. The entire film is apprehended from the side of the addressee, a fact that gives us reason to doubt the solidity of the pairing and brings us back to the extensive powers of the, or rather a, "real" spectator. And besides, it is only normal because it has to do with an act of seeing and not one of filming. In every domain, the position adopted by the analyst brings about this kind of imbalance. But all the same we should constantly bear this fact in mind, instead of hiding it from ourselves with words, and recognize the ongoing risk of various entanglements that, if possible, need to be undone by making an effort to be objective and, for starters, by frankly accepting the imbalance itself.

Bettetini calls our relation with film a "dialogue," while remarking that the sender is absent and only the receiver is present.[101] This dialogue unfolds between the receiver and the text.[102] Gaudreault notes the same thing but in relation to writing;[103] the reader is the only person who is "there." For Branigan everything takes place between a narration and a spectator,[104] whereas Odin's idea is of the relative independence of reading in relation to film (not in relation to the filmmaker or his intentions), and this idea is found throughout his semiopragmatic studies.[105] So I am not the first to note this asymmetry, even though I insist on it more than others do.

In my opinion it is Genette who most clearly sees beyond the issue of asymmetry and realizes what is at stake for theory here. He does not use binary terms. We have (in the final stage) the narrator on one side and the virtual reader on the other;[106] the narrative route is described as unilateral and "vectoral."[107] At one of the two poles, he tells us, we can at a pinch hesitate between several instances: a real author, an implied author, and so on.[108] But at the other extreme everything suddenly melts into a single entity. A book, it would seem, is made to be read. It has an aim, a destination. But the author (unlike the reader, who can infer or imagine only on the basis of what the text gives him) addresses himself to a reader who, at the moment of production, cannot be identified or regarded as existing—a virtual reader. "In contrast to the implied author," Genette writes, "who is in the head of the reader, the idea of a real author, the implied reader, in the head of the real author, is the idea of a POSSIBLE reader."[109] I would add that the word *spectator*, which is the filmic equivalent of *reader*, covers all cases, without even needing an adjective. In textual studies it obviously designates the virtual or generic spectator, the spectator embodied as the analyst. And in contrasting (empirical)

cases the context always lets us know, as in the statement "Cinemagoers in Toulouse did not like this film."

It has often been said that every film assigns a place (which might change along the way) for those who watch it. This is what is sometimes called "positioning," which is a horrible word for a good concept. The spectator finds himself identifying with one of the characters by the internal logic and construction of the film. Or rather he is placed, in such and such a sequence, above and to the left of what there is to see, and so on. All of this is precise and even crucial in the realm of texts, a realm with its own truth. But the average viewer, at a given moment, might "position" his gaze at the other side of the screen, or even to the ceiling or to the woman beside him, without the film being modified, or affected, or even knowing about it. This is almost the opposite of an interaction. Bettetini, whom I find is greatly overlooked, insists on this impassivity of the text, all the time maintaining the idea of a conversation.[110] So it develops in a way that is both paradoxical and appealing. I have also recalled how Casetti, in his talented and headstrong way, playfully (almost) grants us the "interface" role of the addressee, just after noting that the real YOU is outside the purview of the film.[111] I have also mentioned how he maintains in a single sentence that the look of the spectator is not external to the film and that it is a "necessary complement" of it (so this would be an internal complement . . .).[112] In fact, a film needs to be complete before the public can start to watch it. The emergence of the latter is conditional on the petrification of the former, as if they are in a fatal embrace. Everything takes place once again as if theory had a kind of aversion to fully accepting the difference in nature between the flesh-and-blood spectator and the one that is constructed by the film. We could say that the "true" spectator needs to offer a kind of endorsement so as to fully legitimate the other, and that the symbolic order cannot function all by itself.

Gardies has also addressed this problem in his study of francophone black African cinema. African films construct an "ideal" black spectator who differs significantly from the one who is envisaged by the declarations of filmmakers in the media.[113] This spectator is an "imaginary social subject" and is a kind of product of three forces: the camera-machine, the film-text, and the real culture of a particular African population.[114] The African spectator constantly oscillates between two positions; in Oswald Ducrot's terminology,[115] these are the *allocutaire* (i.e., the person to whom the enunciation is addressed and who takes on that role) and the listener (who is physically present and "perceiving").[116]

This seems a wise approach to me. We need to admit, looking at the examples that are repeated daily, that being acquainted with a given film tells us relatively little about the reactions that it will provoke in particular spectators. An explanation via internal analysis (and by examining the "place of the spectator"), however, is one of the elements that, combined with many others, will determine his reactions. But the weight of external factors makes all foresight based on the text difficult, in the same way that the text does not tell us much (directly) about its author. This situation is both strange and banal. The characteristics of a film clearly influence its reception, but its reception belongs to another world that requires separate observation. This is because the combination of known and unknown factors leads to an unknown result that must be discovered on-site. And the film also has its site, which is elsewhere. *It evolves in its own environment.*

When we speak about the spectator that is constructed by the film, or conversely about the discursive source located by the spectator, we still more or less have an idea of a certain *exactness* in our minds about these transactions. The spectator is not supposed to dream up an entirely other version of the film, nor do we consider that the thing he is watching is assigning him extravagant, inaccessible, or self-contradictory positions. This (generally little-understood) notion of minimal rationality has the effect of making room, alongside "examples," for the reactions of the imagination that I addressed (too briefly) at the start of this book.[117] When they are at work, the filmmaker and the production team necessarily have a certain idea of the public "for" whom they are making the film. This idea can be right or wrong, but it is certainly invented and belongs to the realm of fantasy: wishes, fears, desires, and so on. In the same way, the spectator cannot resist forging an idea of the filmmaker via various indicators contained in the film but which are reinterpreted, deformed, and transformed by his own fantasies. Cinephilia, which sets certain spectators apart, has the effect, according to a sharp observation by Bernard Leconte, of opening their eyes to certain aspects of cinema and closing their eyes to others.[118] It is commonly observed that reactions to a single film can diverge greatly, even violently, among a group of the same age, education, and social class, to the extent that an outsider could get the impression that the impassioned opponents in the discussion have not seen the same film. In fact, they have not seen the same film, because what every one of them sees is the result of an alchemy that alloys the film with his or her dreamworld. All of this is of course a result of film having a particular affinity with fantasy, enabling condensations

and confusions from one to the other, not to mention minor and real hallucinations. How many times have we seen an image in a film that is not there! (I will not revisit these questions, which I have already discussed long ago.) As Lacan put it brilliantly, the unconscious is not "behind" the conscious but between the external world and conscious perception. In short, the unconscious is like a pair of possibly faulty spectacles.

We have seen how Branigan proposes the notion of an imaginary author and an imaginary spectator.[119] For Wayne Booth[120] and, following him, Seymour Chatman[121] the implied author is in a rather similar vein but sometimes does not become confused with the narrator.[122] Chatman explicitly separates them.[123] (This is an example of the confusion that arises from anthropomorphism.) Umberto Eco's "model-author" is also a product of the spectatorial imagination,[124] and we cannot know exactly up to what point it also "covers" either over-the-top readings, which are not very rare, or the reader's own fantasy more generally.

And still we see reappearing, in this new field, the tenacious propensity to conceptualize what is not a person as a person. Here, it is a representation. Genette has said this with some force.[125] There is no imaginary author but an image of the author, no imaginary spectator but an image of the spectator (Genette would prefer "idea," but I think both terms work fine). Let us not fabricate an additional instance that we can add to the various implicit or subterranean authors that I have already dispatched, because it has nothing to do with the spectator himself but with what he thinks of the author. We have made such a habit of calling functions that are external to the text real, as in the comical phrase "real author," that it has come to the point that we consider "real" everything that is extratextual. Yet *there is an imaginary extratextual realm.* The "author" as fashioned by the spectator is defined as being the product of an act of imagination and as consisting of a mental image. It has no reality, either in its substance or in its attributes, and this greatly distances it from the real filmmaker. This image is not textual either; it willingly "hooks" itself on to indicators that appear in the film, but it itself does not appear in the film, because it is created by the spectator, who puts a lot of himself into it in the process. There is for that matter a fundamental difference between enunciation, a textual function, and what goes on in the minds of actual people. The former is precise and produces figures that can be situated on the rectangle of the screen and measured in time and space, while the "images" that the author or the spectator has forged for himself are conglomerations of moods, impressions, sympathies, and antipathies—extremely rich stories. They exist on another register, where

the asymmetry between the two poles that I discussed earlier is strongly felt. The spectator's fantasy can take its authority with more or less justification from a known object, the film, while not even a sketch of the impressions of the author about his future public can be put on show.

Some films present themselves to us as if they are being recounted by a person or even, if they are not narrative, as if they are commented upon by a person, as in old documentaries with voice-off. The person can remain invisible or appear more or less often. His discourse can be more or less transvisualized. In the case of stories this can be a character or an external narrator. There are also more complex arrangements that are intermediary or mixed. I have already devoted a few words to the subject of the voice-in, voice-off, I-voice, and so on. The point throughout, which I return to now, is that we see appearing, in the end, an enunciator (who is also a narrator, if he is narrating), in short *a person*, this time unchallengeable, because it is not theory that says so but the text itself. We have seen that Jost in his works insists more and more on these "explicit" or "profilmic" narrator figures (profilmic, I would add, due to the soundtrack, if they are speaking in off) or even "storytellers" when on the contrary they are visible.[126] Justifiably, he opposes them en bloc to an "implicit narrator" that is more permanent and profound (i.e., enunciation, in my terms). Casetti,[127] employing Greimasian terminology in his own way, speaks of the narrator and narratee as "figurativizations" (i.e., textually incarnated homologues, when they occur) of the enunciator and of the addressee.[128] The same basic proposal is made in the excellent general introduction to the analysis of film that Casetti has written in collaboration with Federico di Chio,[129] part of which is dedicated to these questions.[130]

When there is a real enunciator (i.e., a person), he can belong to the primary level, which is to say he is in charge of the entire film. Naive early documentaries would once again be the best example of this. In narrative film there is often a framing that takes the form of a (short) prologue or epilogue that exceeds the ambit of the storyteller. Thus, in Brian De Palma's *Casualties of War* (1989) the entire story is presented as the memory of war seen again in a dream (or nightmare) by Max Eriksson, a Vietnam veteran who is now back at home and has fallen asleep on a short tram journey. The images of the tram and the brief conversation he has with a young Asian woman when he disembarks are the only parcels of land that are not included in the narrative territory of the ex-conscript Eriksson. All the rest of the film comes to us through him, even if as integrated transvisualization. This is one of the most common

constructions. There are other cases where the enunciator changes iden-
tity along the way. Several characters in turn recount the story to us, but
the presence of a mediator is constant (as in *The Barefoot Contessa*); once
again, this is a primary-level enunciator, but one who is composite, col-
lective. Even more common are secondary enunciators, who are intro-
duced by the story and "support" the embedded stories (which Genette
regards as metadiegetic)—for example, characters who introduce and
sometimes accompany flashbacks that are, rightly in this case, labeled
subjective. We know there can be a third, fourth, or higher level, as in
the excellent thriller *The Enforcer* (1951), directed by Bretaigne Windust
and Raoul Walsh. In literature we might of course cite Jan Potocki's *The
Manuscript Found in Saragossa* (the film version of which, by Wojciech
Has, I have not seen).

To sum up: (1) An explicit narrator can (apparently) occupy any level
of enunciation. (2) The primary level of enunciation (apparently) may, or
may not, be occupied by an enunciator. Many films are presented to us
directly, as *unattributed* discourses. The same goes for literature.

But that is where the resemblance stops. Because in cinema the pri-
mary explicit narrator *is only the first of the explicit narrators* (hence my
"apparently"). He is never the primary one in an absolute sense in rela-
tion to the film, as Branigan[131] and, above all, Gaudreault[132] have noted,
adopting a position very close to my own. A novel is made only of
words, so we can say that in this sense it has only one "channel." When
the novel delegates, it delegates everything that it has, with the result
that the enunciator legitimately occupies the space of enunciation, the
source of discourse. (Put differently, we could say that the character
speaks the same language as the written work, whereas the film char-
acter does not shoot film.) In cinema the signifying material is more
diverse (images, sounds, dialogue, and so on), so there are many chan-
nels. The enunciator, even if he is the primary one of his kind, delegates
only one of these, dialogue. Yet the process of transvisualization that
is so common is there to withdraw that very channel from him, liter-
ally to cut his speech, so that his discourse, when it returns to the body
of the film, will be "reaccepted" by the film as a whole. Even when we
hear this voice, whatever it is saying, *it does not explain that there are
images*; it is responsible only for its own words, not for the whole appa-
ratus [*apparat*] that comes to our vision and hearing, and for the pro-
cession that is deployed at the same moment and cuts it short all the
more. The cinematic enunciator, in other words, is always embedded,
even when he does not admit it. But for these acts of delegation to be

generally illusory *as they are* does not entail that they remain without influence on the structure of the film text. It has often been remarked that they create levels, layers, a kind of depth in the unfolding of the narrative.[133] By means of transvisualization a theoretically secondary account can manage, even if it is "recuperated," to "block" all narrative paths momentarily.[134]

This difference between written and filmed material is more general, and we have come across several aspects of it already. Even though enunciation might be as impersonal in a book as in a film, a film does not convey the sensation so characteristic of a book that there is a thinking, unitary, and continuous intervention that imposes a homogenizing filter on everything; this filter imprints a unique and familiar code on everything, as old as the world, from which springs the ideal and illusory figure of the human storyteller. This impression *is* the (classical) novel. Gaudreault makes it clear that cinematic enunciation, perhaps paradoxically, is *less concrete*, because it borrows modes that are more complicated, more multiple, and less conventional.[135]

To return to my proposal, I identify three discursive levels in film: (1) the actually primary level, which is always impersonal, of enunciation; (2) the possible secondary level, which corresponds to the primary enunciator (diegetic or otherwise, in charge of a story or something else); and (3) the possible subsequent levels, which correspond to temporary enunciators (in charge of a story, or something else, but in principle always diegetic because, hypothetically, they preexist in the text).

The cinematographic theory of enunciation often leans, via a range of correspondences and differences, on its linguistic counterpart, and so also on pragmatics. It is a normal process, or at least would be if we consented to it, for pragmatics to move its attention beyond the classic duo that Benveniste and Jakobson have (necessarily) become with their "indicators" and *shifters*. The impetus that we owe to them is obviously considerable, but (for that very reason) their research has been succeeded by a lot of other research that has enriched and altered the field. Yet others came before or at the same time as them, but the success of pragmatics has guaranteed that their work has been widely disseminated. For Benveniste and Jakobson the study of enunciation corresponds to a general view of language that is not without genius, but from a technical point of view it essentially mobilizes deictics and is not overconcerned (pioneers can't get everything right) in the details of other aspects of enunciation. So the study of enunciation in cinema has been built on a foundation of stiletto heels.

It is true that one part of analytic philosophy is equally centered on deictics, as they play a significant role for *token-reflexive words* (as Hans Reichenbach calls them). But, without wanting to or being capable of entering the pragmatic debate proper, I note that the emphasis has moved from deixis (traditionally associated with subjectivity in language) toward *reflexivity*, in this particular case the reflection of enunciation at the heart of the statement, without which a sentence with deictics cannot even be interpreted. Furthermore, this idea of reflection plays a more general role in pragmatics, where currently it is opposed to a theory that is almost its inverse, according to which the sign is "transparent" and abolishes itself to the benefit of its referent, except in special usages that render it temporarily "opaque," as for example the *actual speaking* of a word (for example, the sentence "BOEUF [beef] has five letters" makes sense, but it does not make us think of meat).

Many pragmatists estimate, on the contrary, that language *in ordinary usage*, which maintains its referential value, constantly cites itself and exhibits what Gardiner calls its "sentence quality"—that is, its propensity to be made up of sentences. We are familiar with the classification established by Grice among various systems of signs: there are some that are "necessarily secret" (a bluff in poker) and some that are "not necessarily secret," and so on until finally the NN type, which are the necessarily not secret ones. This is where language positions itself, as it can ensure its referential function only if at the same time it designates itself as language. For example, a conversation can take place only if the participants have communicated to one another their intention to communicate, before they even know what their topic will be. Many examples show that a word can be used simultaneously in "use" and in "citation," as we used to say—that is, transparently and opaquely. So when we say "in brackets," or when we declare that so-and-so is best described with a *four-letter word*, the metalinguistic expression does not prevent us from making a vigorous assertion about the characteristics of the referent. The theory of speech acts, notably in Austin, while generalizing the illocutory on the ruins of the performative, has the effect of generalizing at a stroke the metadiscursive—every interrogative phrase also tells me (also "shows" me, according to the theory) that it is an interrogative; every jussive is a command; and so on. Language, in short, can only function by constantly turning back on itself.

The result, as Greimas predicted very early on, was that the very status of metalanguage is significantly undermined by this. It uniquely designates specialized statements, those that form, for example, books

about linguistics or their more familiar equivalents, as when I remind my friend that there is no circumflex in the word *gracieux*. Today the metalinguistic dimension is found *in the very heart of the linguistic* and no longer "on top" of it.

I will not pursue this subject any further, as it is leading me astray. There is only one thing to gain from it, something simple but important, which is the idea that enunciation is coextensive with the entire statement and not only with figures of the Subject.

We are now coming to the end. This book has tried to show that film enunciation is impersonal, textual, and metadiscursive and that it may comment or reflect on its own statement in a variety of ways. I have intended to *deploy* this view of things, but it crops up in previous writings and sometimes even reading through the work of authors for whom this position is otherwise quite alien.

I have already cited two characteristic remarks by Pierre Sorlin that would seem to dissociate enunciation from subjectivity and to reconnect it to the act by which a film reveals itself as film.[136] In the same issue of *Actes sémiotiques* Marie-Claire Ropars-Wuilleumier, who reaches (partially) different conclusions, nevertheless refuses any enunciative anthropomorphism: "Enunciation is different from any enunciator that it nonetheless summons."[137] The three authors of "Le récit saisi par le film" conceptualize enunciation as omnipresent in the unfolding of narrative and refuse to confine it to a particular location.[138] I have described the homology that Branigan notes (in passing) between the position of narration in relation to narrative, and that of metalanguage in relation to language.[139] I will leave aside Colin MacCabe's theory, even though it is explicitly based on the central notion of metalanguage, not because it is uninteresting—far from it—but because for him *metalanguage* is defined very differently from common usage and differently from my way of using it.[140]

As for the precise question that has guided my way—"Deixis or metadiscourse?"—to my knowledge only two authors have broached it: Jost and Gaudreault. Their interest in it predates my own. Since 1987, when I published an article that anticipates this book and has the same title, a mutual and almost simultaneous influence, which is sufficiently rare that it bears mentioning, has spontaneously established itself between their work and my own without our having any contact on the subject. Gaudreault, when he revisited his famous commentary on Benveniste in 1984, noted that deictics could not by themselves account for everything and that other markers betrayed "the authority responsible for the

organization of narrative signifiers."[141] On several occasions he expresses his skepticism about the existence of some kind of equivalent for *shifters* in film.[142] In one passage he "advances" the idea even further: because enunciation in cinema cannot be deictic, it must necessarily be much broader, and we should consider as a marker of enunciation every slight trace of the "manipulative activity" of cinema, such as an especially abrupt jump cut.[143] (This manipulative activity will take place of honor in issue 6/7 of the journal *Vertigo*, which will be devoted to rhetoric in film and is under preparation as I complete this book.)[‡] For Jost there are two particularly striking and clearly expressed passages, one (which I have already alluded to)[144] dating from 1980: when we speak of enunciation in cinema, we are really thinking about metalanguage, about the markers that say "This is cinema," and not about those that might anchor the discourse in the time-space of a subject and that are rightly lacking. In the other article by Jost, written eight years later, we find the following passage: "cinema can *signify* 'I am cinema,' but it cannot *say* so; and film does not relay back to a 'transmitter,' but to cinematographic language itself."[145] At the start of 1990 Jost and Gaudreault copublished an introductory work called *Le récit cinématographique*, a title that delivers exactly what it promises. Their positions, which I have commented on (and those of others, which do not concern me here), are restated there in a more didactic (less schematic) way. In the short time since then I have not noted any fundamental shift on their part, other than a more determined assimilation of the implicit narrator (Great Image-Maker, and so on), of the entity that "speaks cinema" at the moment of primary and impersonal enunciation (see in particular pages **34–36**). I can only welcome this, not only because of my wariness of anthropomorphism but also because the artificial gap between enunciation and narration is thereby reduced. At a conference in 1989[146] Jost demonstrated very well the ambiguity of the notion of the Great Image-Maker in the work of Laffay, who sometimes speaks of it as if it is a regulating principle and other times as if it is a real author, depending on what circumstances dictate: "For my part—and my understanding is inherited from Metz, or at least from what I have read by him—I consider the author to be a performed construction based on the film text."[147] (The inheritance that he generously mentions is recent, as it is only since 1986 that I have been concerned with these issues.) Jost finishes by saying that a certain degree

[‡]. See Gerstenkorn, ed., "Rhétoriques de cinéma" (1991) in bibliography.—Trans.

of anthropomorphism can be allowed if it is the kind that simply enables things to represent themselves, on condition that this principle of intelligibility is not confused with a real person. I would be quite prepared, on this basis, to put an end to our battles over distinctions, but I am still afraid (incorrigibly!) that every methodological anthropomorphism might too easily give rise to another. But to hell with pointless worrying!

Marie-Claire Ropars-Wuilleumier's highly elegant recent article "Christian Metz et le mirage de l'énonciation" addresses my 1987 article that has the same title as this book.[148] It is a rare thing to inspire such a high-quality response. If I may sum up her intentions (though the article must be read in the original, as I can only distort it here): while agreeing broadly with what I put forward, she aims to push me a little further, to push me toward a choice while expressing a fear. The fear is that, if we extract the mirage of enunciation from a film (enunciation that is consistent and personalized), then I will manage to redirect it to the out of the film, to put it simply. The corollary to this is the regret for my not being sensitive enough to what is at play in certain film *voices*, which provide the story and are made destitute by it, and of which they make up only a part. Thus they are bearers of a thwarted enunciation, of an asymmetrical deixis that would in fact be unique, even in language, if we were to reject an essentialist interpretation of Benveniste's famous analysis. I cannot give a counterargument in one go but in three maneuvers (like an old car turning around). First, some differences have diminished with the development of my work since 1987, so that I have moved closer on important points to what Ropars-Wuilleumier wishes for: film speech and sound have taken on great importance in my thoughts (along with particular forms of deixis, such as address). I have in the meantime become convinced that the enunciative status of the novel is at bottom identical with that of film, and so on.[149] In the second place Ropars-Wuilleumier puts forward analyses of voice-off such as dislocation/dislocution (especially on pages 110–11) that I find very persuasive, even though they do not resemble my argument (or rather for that very reason). These passages expand the field of discussion. Third, yes, it is the case that I still believe in the existence of a "genuine" exchange between an I and a YOU (in a single situation, i.e., conversation). Of course, it is still an exchange of discourse, but at least it is an *exchange*. The options offered by Ropars-Wuilleumier differ from my own in their theories of decentering and in their breadth of interest beyond both cinema and language. To sum up: I am in full agreement with this perceptive article, which identifies our differences and points of agreement equally well.

I cannot end this overview of the works that have influenced me most without saying a few words about an apparently rather different category of writing with which I have become very familiar as a reader. This category interests me greatly and gives me the sense that something important is at play. Writers in this category approach matters from the opposite direction in their film analyses, most notably (to my taste) Raymond Bellour, Thierry Kuntzel, Marc Vernet, and Anglo-Saxon feminists, where the question of enunciation is constantly open. This is particularly explicit in the first of these, Bellour, some of whose very titles foreground this same theme.[150] So these analyses of enunciation are never "deictic" or personifying, even though (too bad for the paradox) the historical, ideological, and psychoanalytical ramifications for the filmmaker, for society, or for History are given great weight in them. But these are the twists and turns of the text, its construction, its follow-ups, its symmetries, or the complexities of the character (a textual creature) that are interrogated and then, if there is space, positioned in relation to external data. Enunciation itself is never humanoid; it remains hitched to the text.

In short, everything happens as if the film can manifest the instance of proclamation that it bears within itself, and that bears it, only while speaking to us about the camera, the spectator, or while designating its own "filmitude," which is to say, in all cases, pointing its finger at itself. Thus, a delicately openable layer of film occasionally comes into being, unsticks itself from the rest, and, by means of this very folding that positions it as if in two parallel lines, settles into the distinctive and knowing register that we call enunciation.

April 1990

AFTERWORD

DANA POLAN

In 1979 I was in Paris on a dissertation fellowship and submitted by mail, as per procedure, a request to Christian Metz that I be allowed to sit in on his legendary seminar given under the auspices of the École des hautes études en sciences sociales but held at the film department of the Université de la Sorbonne nouvelle. Metz accepted me into the seminar, and an acquaintance began that eventually turned into friendship. Starting at the beginning of the 1980s and into the 1990s, I would go back every year to Paris with my wife, a Frenchwoman who passed away in 1996, and when we were there for a long enough time, I would return to Metz's seminar.

In the earliest years the sessions revolved around the book that Metz hoped to publish on the psychoanalysis of jokes, centered on Freud's classic *Wit and Its Relation to the Unconscious*. (Metz's book never appeared although a full draft of it exists in the archives.) Later, the topic of the seminar turned to the question of filmic enunciation, with special focus on a recently published theorization by Italian scholar Francesco Casetti, *Dentro lo sguardo: Il film e il suo spettatore* (*Inside the Gaze: The Fiction Film and Its Spectator*). First published in 1986, Casetti's book was translated into French in 1990, and this meant that the earliest sessions of the Paris seminar on his book revolved around Metz offering a virtually page-by-page analysis of a book in a language, Italian, he couldn't assume everyone in the class could read. I must say that although I loved Metz *and* loved his seminar as a social event—he would begin by inviting any participant who wanted to to announce new books, conferences,

interesting films, etc., and he would end with an invitation to go off with him to a local bistro for one of those legendarily long French lunches lubricated (arrosé, the French would say) with lots of red wine or ice-cold beer—I often found the careful working through of one book as exemplifying French obsessiveness around close reading at its seeming driest. The jokes seminar hadn't in fact been much different: the only easily available French translation of Freud's book on jokes was, to Metz's mind, woefully inadequate, and he devoted many long sessions to enumerating errors of translation as a preliminary to a deeper and more consequential study that seemed to keep being deferred.

What I want to evoke, then, in this essay is a certain surprise, as well as delight, but also a perplexity—maybe a delighted perplexity—that I felt when I rushed to read Metz's last book in the first days of its publication and that returns each time I return to it. I know I am not alone in this: most readers of the volume with whom I have conversed—especially those who were Metz's colleagues and/or took his seminar—have admitted to a similar reaction. I am not sure that those of us who were his students could have guessed what this volume would look like based on the way he presented some of its arguments in his famed seminar. Of course, that seminar and the prepublication of one evocative part of the book in the journal *Vertigo* might have given us some first indications, but it would seem that the final published volume easily provoked—and now, with this translation, finds new contexts in which to provoke—a sense of curiosity, a wonder at the essayistic openness of the book as a whole, and at the sometimes chatty or conversational or colloquial quality it bears. As Cormac Deane well pinpoints it in his smart, sharp introduction to the translation, "Metz's style in this book is unlike anything else he wrote. Alongside the methodological interrogation of his own and others' terminology, and the assumptions that they contain, he ranges freely through his chapters, offering impressionistic asides, wry jokes, strange puns, and arch comments. The result is a very readable, if slightly weird, piece of scholarly writing."

I am pleased to imagine how this eloquent, judicious translation of Christian Metz's last book may give English-language readers the occasion to discover Metz anew. In particular, I love thinking about how such readers will encounter Metz engaging in lively, even passionate, mode not just with cinema as a theoretical idea (the question of film language that so occupied him in earlier works) but with individual works of cinema—specific films, that is. Large portions of the book are indeed devoted to commentary on movies that is quite pointed, quite particular.

This is a book of filmic delights in a way that can seem quite surprising, especially if one has acquaintance with Metz's earlier theoretical works.

In his contemporaneous review of *Impersonal Enunciation*, Roger Odin, a friend of Metz's and his former student, sets out to invoke some sense of these surprises in the book—for example, the many moments in which the study offers direct, often expansive, expressions of Metz's personal tastes in film (for example, there are recurrent virulent jabs at the new music-video style of 1980s moving-image culture).[1] Complementing Odin's evocations and extending them, I'd insist on another striking element of *Impersonal Enunciation*: the sheer rush of references to specific films from across wide ranges of film history. It has been easy to imagine that cine-semiotics and its brand(s) of textual analysis traded breadth of film knowledge for an insistent and incessant concentration on a very few films (for instance, Raymond Bellour on *North by Northwest* or Stephen Heath on *Touch of Evil* or Metz himself on *Adieu Philippine* or 8½). But whatever the accuracy of that original assessment of film semiology's attitude toward broad knowledge (and I think this critique was often in fact misplaced, if not downright mistaken), Metz's last volume offers a capacious and quite capricious romp across vast reaches of film history. After a downright minimal mention of specific films in its first theoretical section (for example, Metz momentarily references *Gone with the Wind*, and here the citation comes only because of Francesco Casetti's prior citation of it in his own book and the need Metz felt, as noted above, to address in depth Casetti's studies of enunciation in cinema), *Impersonal Enunciation* gives itself over to a vast and admittedly eclectic cinephilia. Examples pour out from the book in exorbitant fashion and dazzle the reader with the author's erudition. Odin captures this:

> Never has a book by Christian Metz accorded so much place to examples: the ensemble is striking, both by the extreme precision of the analyses undertaken (something that won't surprise adepts of Metz) and by the diversity of audiovisual productions that are invoked (something that in contrast is newer): fiction films from a range of countries, from all epochs (from early cinema to the present) and from all genres (melodrama, Westerns, films noirs, musical comedies, burlesques, etc.), great classics or rare films, auteur cinema, investigative cinema, popular film, experimental film, militant films, documentaries, journalistic reports, and even television shows. (165–66)

And, again, as Odin has noted, these prolific citations often arrive accompanied by appreciative adjectives (twice, for instance, we're told that this or that cited film by Solanas is "remarquable") or serving as the occasion for even longer aesthetic estimations. For example, there is an extended footnote on the place of Zemeckis's *Who Framed Roger Rabbit* within the historical moment of Lucas-Spielberg-type cinema that is quite praise-filled:

> It would be a mistake to look down on films such as *Who Framed Roger Rabbit*, the Star Wars films, and their ilk. It is true that an entire, sizable, section of American film output is becoming indistinguishable from cinema for children. And these films can be marked by a fundamental shrill vulgarity, profound silliness, and a worrying predilection for violence. While another American cinema still does exist, these movies are evidence of an astonishing vitality of visual invention and technical ingenuity, as well as a spirited approach to reality, which is a genuine kind of intelligence, as Europeans tend to forget. French flops lack all of this.

Metz, we see here in a manner not always apparent in his other books, was drawn to film—and to films. Films serve as more than just convenient examples to test certain general linguistic or semiological principles out on, and the constant reference to individual movie titles had also to do with an affective investment in them on Metz's part. He seemed to recognize that, when used primarily for mere heuristic purposes, the reference, within a general theory of cinema, to individual films risked turning them into little more than cases or exemplars or vehicles of larger processes. In other words this was the risk that films would be used to make much bigger points rather than being studied in and of themselves. As one example of this heuristic approach we might note how, even as it mentioned specific examples from the history of cinema, Metz's earlier *Language and Cinema* also argued that individual films came to the spectator as so many concrete works, fixed in celluloid, whose specificity would have to be transcended for the broader needs of semiological analysis. Such analysis, as Metz imagined it here, had to go beyond the empirical reality of the films themselves to accede either to the textual systems that gave them their signifying potential or to the individual codes, abstract in their own fashion, that individual empirical films instantiated at this or that moment of their material unfolding. That is, this earlier book by Metz uses individual films as

cases in the construction of a broader, more abstract, theory. As Metz famously put it in *Language and Cinema*: "For the semiotician, the message is a point of departure, the code a point of arrival." The individual film can seem to matter not much at all: as Metz says soon after, "it would still be possible to directly speak of the *codes* without involving any of their particular manifestations."[2]

On the one hand, then, cinema exists to transcend itself in the articulation of theoretical questions. On the other hand there evidently was also clearly, simply, directly, an interest, present throughout Metz's work and emerging in full-fledged form in *Impersonal Enunciation*, in individual films in all their aesthetic specificity. If, in Metz's earlier texts, the individual film is only the materialized, manifested, or manifest message to be gone past to *arrive* (as in the quotation above) at analytical abstraction, *Impersonal Enunciation* frequently seems to linger at the surface of individual films themselves. Significantly, where *Language and Cinema* sees the individual filmic text as "a point of departure," *Impersonal Enunciation* strongly offers a converse journey metaphor: as the theoretical first section ends, Metz announces that he will now shift to a new terrain—or what he pointedly refers to as a "shifting landscape." The imagery here is spatial, but it is a spatiality embodied in a continuous journey, an ongoing process that moves onward to the films themselves, rather than a *departure* from the empirical reality of actual films into the generalities of theory: "The itinerary that I have chosen will make bring me, at a considerable pace, through a hundred or so sites of enunciation." And the itinerary itself will be termed a "guided tour" to "some landscapes of enunciation" (as the title of the long, central part of the volume describes its project).

In many instances in the long itinerary through the figures of enunciation that Metz offers as part 2 of his book, the citations of the films—or of sequences or moments from them, a qualification I'll return to—are detailed, evocative, poetic, even lyrical. Take, for instance, Metz's first discussion of a character's gaze at the camera in Buñuel's *Nazarin*: "In *Nazarin* (1959), the Buñuelesque character of the dwarf, a tortured and mocked figure, entirely 'Spanish,' often turns his eyes to the viewer, as if inviting pity or simply consideration. When the woman with whom he is absurdly in love is led to prison, he remains standing in the middle of the village square (and in the middle of the screen), crying openly, always turned toward us, even uglier than he usually is."

Yet what is initially a willful activity by a character within the diegetic universe reveals itself to be an intentional activity of the film overall—it is now the film itself that is insisting on this scene in all its visibility

to us. For Metz—and here I'm at risk of reducing his complex argument, demonstrated at length across so many examples—enunciation is *always* present in film insofar as any film exists as an intentional object whose very existence embodies that intentionality. But it is only in some cases that this intentionality of the film becomes manifest and visible (or audible, since Metz attends to sound as well as image) as such, rather than hiding behind the identification-garnering mechanisms of character and narrative fiction. In the case of *Nazarin* the dwarf is within the story world of the film but not as a main figure: from his relatively minor position within the narrative he begins to move outward from the fiction to its filmic enunciation. It is the film ultimately that focuses frontally on him, that has him cry, that renders him more pathetic than before, and this can render the film's operations tangible, expressive, manifest.

At moments *Impersonal Enunciation* appears to resemble not so much a guided tour (with the connotation of a set itinerary) as a random stroll, a stream of consciousness even, where one follows one's follies, one's *folies* and cinephilic *coups de foudre*, wherever they might lead. In this errancy films and filmic moments serve as momentary anchoring points to be enjoyed and then passed beyond to reach the next example: for instance, a discussion of subjective voice gives way at one point to a commentary on film musicals as per se self-reflexive (since they perform acts of performance), which then leads into an appreciative paragraph on *Trois Places pour le 26* by Jacques Demy (or, as Metz the cinephile puts it, the "regretté Jacques Demy"—again, a language of cinephilic appreciation). This is discussed in terms of its fictionalizing of Yves Montand's life and its factualizing of its fiction by the presence of Montand. This wandering discussion, not fully about subjective voice, it must be admitted, is then somewhat reanchored by a veritably explicit admission by Metz that he has gotten off topic and needs to reanchor the discussion: he asserts "But to return to my point concerning juxtadiegetic music" and launches into a discussion, replete with examples, of films where we see the rehearsal of a musical number (reflexive since such scenes speak of their own musical nature).

Where, as we've seen, *Language and Cinema* proposed the text as a point of departure, little more than starting place for the broadening journey into codes and textual systems, *Impersonal Enunciation* often insists on the irreducible particularity of individual film texts. As Metz declares a few pages after his *Nazarin* analysis: "The construction of every film, or at least of some films, can inflect the structural probabilities that abstraction supplies." Certainly, there are general principles

to the notion of enunciation; for instance, it relies on the assumption that texts are intentional acts whose intentionality can become manifest in privileged moments. These, however, can best be studied, and appreciated, *and admired* through the individual moments in films that embody them. Individual films put general theory to the test (rather than the other way around): as other attendees at Metz's seminar on enunciation might confirm, one thing that, in my recollection, took place insistently was the proposing of this or that general assertion about cinematic enunciation, sometimes by students, sometimes by Metz himself, and then, importantly, a search, sometimes by students, sometimes by Metz himself, for concrete filmic examples that could either confirm or contravene the general assertion and thereby force the theory to extend and develop.

Certainly, if we return to the point about *Nazarin's* ugly dwarf as an enunciation, and not just a character in the fiction, it's clear that Metz is using the one scene fancifully—and in this respect, it's in keeping with the frequent presence in *Impersonal Enunciation* of witty asides, whimsical and even invented figurations (this again echoes the seminar where one tried to imagine filmic procedures, however fanciful, that would contravene generality and abstract assertions). But it's also serious in its own way: it intends to reiterate that enunciation is not a structured code within cinema but a process that runs through and throughout cinema and is in many ways beyond structure, beyond code and codification. If Metz fancifully admits that dwarfish ugliness might not belong easily to an official taxonomy of enunciative marks, he still wants it to figure somewhere (if only in the film itself and in his own citation of it). Maybe no one would want to make dwarfish ugliness a received, recurrent category of enunciative marking, but Metz suggests that tears could well serve, *at least in this one case*, as an enunciative act. The dwarf doesn't verbalize his misery, doesn't offer it up in words; he simply and heartrendingly cries, and his tears speak no less than words: as Metz puts it: "The tears replace dialogue, which is another variant." In other words, as Metz shows in this chapter, part of whose title deals with "voice of address," there are certainly cases in cinema where a character's *words* detach from the fiction to comment on the film itself, but it can also be the case that something other than words—excessive amount of tears in the example of *Nazarin*— can also serve the commentative function. Indeed, the mention of a "variant" might well invoke for the reader the classificatory system in linguistics of the paradigm (one sobs or speaks, and each signifies in

its own way its difference from its converse). In other words Metz's own language allows us to see individual filmic moments as both unique and unclassifiable (no other film might use tears and ugliness as enunciation) and as unique and perhaps classifiable (the ugliness and the tears are a formal variant in relation to words). This emphasis on the singular case, as I've implied throughout this essay, certainly pushes *Impersonal Enunciation* toward a sort of empiricism: there are as many films to be cited as there are films that are interesting to cite. In Metz's words, "There are multiple types, and every inventive work adds another." Every film, in its own fashion, can offer useful instruction on the act of enunciation.

Enunciation comes to describe cinema's overall status as a *Voici* (a "here it is") intended manifestly to present worlds to viewers. *Enunciation* ends up as the term for the very act of cinema always speaking about its own conditions of existence (even as its fictions pretend directly to offer themselves as unenunciated diegetic universes). In other words there is no code to enunciation, since all of cinema is enunciative (even if not always manifestly so). Enunciation is, as Metz says on the last page of the book's theoretical introduction "coextensive with film and . . . plays a part in the composition of every shot, so while it is not always marked, it is active everywhere." Ultimately, Metz declares, enunciation is "the cinema as such."

But if this is the case, any and all films and film sequences are citable, including even (and markedly) those moments of film that might seem unmarked (what Metz refers to, in quotation marks, as "neutral" images and sounds) since the unmarked instance still is as produced, intended, and enunciated as are marked filmic moments. Indeed, in his chapter on neutral sounds and images, Metz suggests that cinephilia (of the very sort that runs through his own book, with its capacious engagement with myriad films) can turn the unmarked moment into a marked one: the cinephile notices the cinematicity of cinema and thereby makes manifest what a less critical spectatorial investment (of the sort incarnated by the ordinary viewer) in diegesis can occult. All films are always in every moment enunciative but not always manifestly so, but cinephilic knowledge focuses attention on those details and makes their enunciative qualities evident: "Enunciation remains something simply assumed as long as we are not very attentive to how a film is made. As soon as we look and listen more carefully, we spot the traces of markers. . . . The difference does not inhere in the object but in the distance that we adopt in relation to it, in our more or less close or more or

less inattentive reading. . . . The more educated the public, the lower the number of neutral images."

I've alluded to an undeniable empirical aspect of *Impersonal Enunciation*—the sometimes-random stream of citation of film titles, one after the other—but there are evident, necessary limits and limitations to this empiricism. Most immediately, the citation of films or of film fragments includes imaginary or hypothetical works (those contravening examples, for instance, that kept popping up in seminars as Metz or his students tried to imagine possibilities of cinema that wouldn't fit the theory), with the irony that later one can, from time to time, find concrete examples of precisely those imagined cases being produced: thus, to take one example, in analyzing diegetic narrators (that is, characters who adopt direct address), Metz asks us to "*imagine* the same construction in its rawest form. For the whole length of a film, a character who is constantly onscreen speaks to us" (my emphasis), and he needs to make that request to imagine such a film, he says, since the "demands of audiovisual representation, in standard narrative cinema, make it unlikely that such a setup [*dispositif*] would be fully deployed across an entire work." But notice already that this is an improbability, not an impossibility. As Metz immediately cautions, "No one has seen all films, thought about all of them," and in fact, certain films of Godard or Straub-Huillet approach this possibility of a cinema given over to characters who speak in direct address for excessively long periods (albeit not for the whole film, but again that's not an impossibility). Clearly, nothing necessarily would prevent such imagining from concretizing, from taking on empirical existence.

There can be no completion to the act of citation then, short of citing all of cinema. As Metz declares on the last page of the theoretical introduction to *Impersonal Enunciation*, his guided tour is driven by no "attempt to exhaust the subject." Earlier, *The Imaginary Signifier* had referred already to what it pointedly called a "problem" of research: namely, "the problem of the status and the list." If a "first temptation is to plunge immediately into 'extensive' work, to aspire to an exhaustive inventory—a list," Metz admits that "at the stage I have now reached in the writing of this text I have as yet no idea (I mean this literally, in all honesty) of the 'table' of cinematic figures I shall end up with, even assuming that I'm heading towards a table—which I am rather beginning to doubt."[3] In like fashion, the itinerary of *Impersonal Enunciation* offers no tabular finality, no taxonomic completion, no enumerative codification. Thus, Metz speaks at one point of "the necessity of not

closing off the inventory of enunciative configurations. Although it may be limited to a certain number of fundamental devices, although it has its own 'logic,' and although it does not proceed from some pure and infinite freedom, it does make possible a great number of combinations."

There was, as Roland Barthes noted, a gesture toward scientificity in Metz, but it is also one that doubled itself in dream, desire, fancy, and fantasy.[4] We might say that, certainly by the time of his later works such as *Impersonal Enunciation*, Metz was little inclined toward the type of statement that exhaustively enumerates the pertinent features of a concept in the form of an explicit, independent proposition. He was more interested in the phenomena than in the naming process, and his doctrinal apparatus was often only gradually put together, via a series of slips and slides (condensations/displacements), rather than being assembled all at once and once and for all, according to a directly conceptual procedure commonly seen as the only possible form that intellectual "rigor" can take. *Impersonal Enunciation* offers an odd regime of writing: obsessional and happy-go-lucky, meticulous and inexplicit, punctilious and wide-ranging.

I say "We might say that" but in fact Metz himself already pretty much did. A confession: my last sentences—from "We might say that Metz was little inclined toward the type of statement that exhaustively enumerates the pertinent features of a concept," etcetera, etcetera, on—are actually taken from Metz's own description in *The Imaginary Signifier* of Freud's writing enterprise and its complicated relationship to scientificity.[5] For me the borrowing works well, especially well for the strange, evocative text that is Metz's last book—a curious book and resonant for me because of that.

A longer version of this appreciation will appear as "Semiotics, Science and Cinephilia: Christian Metz's Last Book, *L'énonciation impersonnelle*," in Margrit Tröhler and Guido Kirsten, *Christian Metz and the Codes of Cinema: Film, Semiology, and Beyond* (Amsterdam: Amsterdam University Press, 2015).

NOTES

1. HUMANOID ENUNCIATION

1. Francesco Casetti makes this observation in his article "Les yeux dans les yeux," in "Énonciation et cinéma," ed. Jean-Paul Simon and Marc Vernet, special issue, *Communications* 38 (1983): 78–97; see also A. J. Greimas and Joseph Courtés, *Sémiotique: Dictionnaire raisonné de la théorie du langage* (Paris: Hachette, 1979), 125–26.

2. Gérard Genette, *Figures III* (Paris: Seuil, 1972), 226. As we will see, Genette reserves for narration a status that is "parallel" (his word) to that of linguistic enunciation. For him, the latter essentially arises from the trait of "subjectivity in language," as defined by Benveniste.

3. Jean-Paul Simon, *Le filmique et le comique* (Paris: Albatros, 1979), 96.

4. Albert Laffay, *Logique du cinéma: Création et spectacle* (Paris: Masson, 1964), 71, 80–83.

5. Marc Vernet, "Clignotements du noir-et-blanc," in *Théorie du Film*, ed. Jacques Aumont and Jean-Louis Leutrat (Paris: Albatros, 1980), 232.

6. See especially Casetti, "Les yeux dans les yeux"; and Francesco Casetti, *Inside the Gaze: The Fiction Film and Its Spectator* (Bloomington: Indiana University Press, 1998), originally published in Italian, which will be cited regularly here. See also Casetti and Federico di Chio's excellent didactic summary, *Analisi del film* (Milan: Bompiani, 1990).

7. Emile Benveniste, "The Correlations of Tense in the French Verb" (1959), repr. in *Problems in General Linguistics* (Coral Gables, FL: University of Miami Press, 1971), 205–15. On pages 206–9 Benveniste introduces *discourse* after

defining *story*; before anything else, he mentions spoken language and then written texts that reproduce or imitate it (dialogue in novels, correspondence, etc.). [The English translation of Benveniste renders *histoire* as "history," but I have opted for "story" in the present volume.—Trans.]

8. See the preceding note on writing which imitates conversation; in the same passage, Benveniste adds that a great proportion of written texts find themselves in this category.

9. Gérard Genette, *Figures* III (Paris: Seuil, 1972), 189–203 ("Récit de paroles"): transcribed dialogue is the only case where the literary text can proceed by *showing* rather than *telling*, to use the well-known Anglo-Saxon distinction. It is content to "write out" (Genette, 190), to put the actual words it wants to convey in writing. (This is why, in the logic of Genette's concepts, we can no longer really refer to these parts of a text as narrative [*récit*].)

10. Benveniste, *Problems in General Linguistics*, 207–8.

11. Casetti, *Inside the Gaze*, 21–23 ("enunciated enunciation"), 21–22, 24 (diegeticized enunciation), 21–22 (disguised enunciation in the "presuppositions" of a film, which "keeps a secret"). We can see that Casetti borrows some of these concepts from Greimas.

12. I will include the corresponding adjectives of course.

13. Colin specifically addresses the subject in a 1980 article, "La dislocation" (on John Sturges's *Last Train from Gun Hill*). He also devotes several passages to the theme in his books *Structures linguistiques/Structures filmiques* (Paris: Université de Paris III, 1982–83); *Langue, film, discours: Prolégomènes à une sémiologie générative du film* (Paris: Klincksieck, 1985); and *Cinéma, Télévision, Cognition* (Nancy: Presses universitaires de Nancy, 1992), published posthumously.

14. Jean-Paul Simon, "Remarque sur la temporalité cinématographique dans les films diégétiques" (1979), repr. in *Cinémas de la modernité: Films, théories*, ed. Dominique Château, André Gardies, and François Jost (Paris: Klincksieck, 1981), 57–74.

15. Paul Verstraten, "Raconter sa propre tragédie: *Lettre d'une inconnue*," in "Cinéma et narration 2," *Iris*, no. 8 (1988): 95–106, on Max Ophüls's 1948 film *Letter from an Unknown Woman*; see page 99 on "pseudodeixis." This excellent analysis draws on ideas from Greimas, from Michel Colin, and (more indirectly) from me.

16. Lisa Block de Behar, "Approches de l'imagination anaphorique au cinéma," in *Christian Metz et la théorie du cinéma*, ed. Michel Marie and Marc Vernet (Paris: Klincksieck, 1990), 235–49, which includes a very insightful analysis of Fellini's *Intervista* (1987).

17. So for Benveniste, to define which words are deictic is to organize spatiotemporal relations from the point of view of the *I*. This has to do with terms

whose signifiers will change according to the circumstances of speaking, though for an identical referent. See "Subjectivity in Language," in Benveniste, *Problems of General Linguistics*, 223–30.

18. This does not apply to all usages of these terms. Consider, for example, "I will sit to the right of the driver," where the point of reference (the driver) is a third party for whom "right" is not determined by the positions of YOU or I.

19. See Gianfranco Bettetini, *La conversazione audiovisiva: Problemi dell'enunciazione filmica e televisiva* (Milan: Bompiani, 1984), 98.

20. André Gaudreault, "Système du récit filmique," conference paper delivered at Université de Paris-III, March 25, 1987, 17–18.

21. See André Gardies, "Le su et le vu," in "Cinénarrable," ed. Michèle Lagny, Marie-Claire Ropars-Wuilleumier, and Pierre Sorlin, special issue, *Hors cadre* 2 (1984): 45–64.

22. See André Gaudreault, "Narration et monstration au cinéma," in "Cinénarrable," ed. Michèle Lagny, Marie-Claire Ropars-Wuilleumier, and Pierre Sorlin, special issue, *Hors cadre* 2 (1984): 87–98, 87.

23. See David Bordwell, *Narration in the Fiction Film* (Madison: University of Wisconsin Press, 1985), 16–26.

24. Gérard Genette, *Nouveau discours du récit* (Paris: Seuil, 1983), esp. 12, 29. I will come back to this later (pp. 148–50).

25. Pierre Sorlin, "A quel sujet?" in *Actes sémiotiques: Bulletin* 10, no. 41 (1987), ed. Jacques Fontanille. The two citations are on pages 43 and 49 respectively.

26. François Jost, "Discours cinématographique, narration: Deux façons d'envisager le problème de l'énonciation," in *Théorie du film*, ed. Jacques Aumont and Jean-Louis Leutrat (Paris: Albatros, 1980), 121–31.

27. Taking a broader perspective than the analysis of enunciation, in the technical sense of the term, the idea of "self-reflexivity in cinema" (where *self-* seems redundant to me) has already been very well analyzed by Reynold Humphries in relation to the American films of Fritz Lang; see his *Fritz Lang, cinéaste américain* (Paris: Albatros, 1982). On the same theme, see the work of a young Japanese researcher, Kiyoshi Takeda, on film theory of the 1920s and 1930s in his French doctoral thesis "Archéologie du discours sur l'autoréflexivité au cinéma" (École des hautes études and Paris-III, 1986).

28. See François Jost, *L'œil-caméra: Entre film et roman* (Lyon: Presses universitaires de Lyon, 1987), 36 (unless otherwise noted, all page citations refer to this edition); Jost, "Discours cinématographique," esp. 125–27; François Jost, "Mises au point sur le point de vue," *Protée* 16, no. 2 (Winter-Spring 1988): 147–55.

29. See Simon, *Le filmique et le comique*, 113. In this passage Simon takes up some of my earlier ideas (i.e., the tendency of "grammatical" markers to become part of the diegesis) and expands them in new ways. See also what Simon says in

Remarque sur la temporalité cinématographique dans les film diégétiques (Urbino: Centro Internazionale di Semiotica e di Linguistica, 1979), originally a pamphlet that reappeared in the edited volume *Cinémas de la modernité: Films, théories*, ed. Dominique Chateau, André Gardies, and François Jost (Paris: Klincksieck, 1981), 57–74: "cinema has no temporal deictics and can only construct them indirectly, for example by means of flashback" (63).

30. Bettetini, *La conversazione audiovisiva*, 106.

31. Dominique Chateau, "Vers un modèle génératif du discours filmique," *Humanisme et entreprise* 99 (1976): 2–4.

32. Marc Vernet, "Le regard à la caméra: Figure de l'absence," in "État de la théorie II / The Current State of Theory II," ed. Jacques Aumont, Jean-Paul Simon, and Marc Vernet, *Iris*, no. 2 (1983): 39–40; included in revised form in Marc Vernet, *Figures de l'absence: De l'invisible au cinéma* (Paris: Étoile / Cahiers du cinéma, 1988), 17–18.

33. I addressed this issue in 1964 in "The Cinema: Language or Language System?"—see Metz, *Film Language: A Semiotics of the Cinema* (New York: Oxford, 1974), 67—but without clearly connecting it to the question of enunciation. François Jost takes up the issue with more precision in his "Narration(s): en-deçà et au-delà," in "Énonciation et cinéma," ed. Jean-Paul Simon and Marc Vernet, special issue, *Communications* 38 (1983): 192–212.

34. See Casetti, "Les yeux dans les yeux," 82.

35. Casetti, *Inside the Gaze*, 33.

36. Edward Branigan, *Point of View in the Cinema: A Theory of Narration and Subjectivity in Classical Film* (New York: Mouton, 1984).

37. Casetti, *Inside the Gaze*, 88ff.

38. Casetti, "Les yeux dans les yeux," 89–91; Casetti, *Inside the Gaze*, 45–50 (section entitled "The Four Gazes").

39. Casetti, "Les yeux dans les yeux," 88.

40. Casetti, *Inside the Gaze*, 127: "It is in enunciation that a subject is unveiled (someone appropriates a language), and that individuals articulate relations among themselves (the appropriation of language introduces a distinction between an *I*, a *you*, a *he*, or a *she*)."

41. Ibid.; see, in particular, 121–23 on reflexivity.

42. Bettetini, *La conversazione audiovisiva*, 99–100.

43. See, e.g., Branigan, Point of View in the Cinema, 40.

44. Casetti, "Les yeux dans les yeux," 78, 84; Casetti, *Inside the Gaze*, 25.

45. Bettetini, however, expresses the idea from the other side and with greater prudence; see *La conversazione audiovisiva*, 110, where he addresses the "non-corporality" of the enunciator and the addressee insofar as they are reduced to textual positions.

46. Casetti, *Inside the Gaze*, 5–10.

47. Branigan, *Point of View in the Cinema*, 40.

48. Ibid., 39.

49. Bettetini, *La conversazione audiovisiva*, esp. 110 and 120.

50. Casetti, "Les yeux dans les yeux," 79; Casetti, *Inside the Gaze*, esp. 17, 52, 59–60.

51. Bettetini, *La conversazione audiovisiva*, 95ff. of chapter 4, "La conversazione testuale."

52. Casetti, *Inside the Gaze*, 129–33 (the final section of the book, entitled "An Interface").

53. Both insistently and implicitly, in one of the main themes that run through *Inside the Gaze*, Casetti suggests several times that the YOU is some kind of intermediary between the film and the world and that it is the site of constant toing-and-froing between the two. But elsewhere the book as a whole correctly puts the issue of the empirical spectator beyond the bounds of inquiry, with the result that we can no longer see what the status could be of this mediator who is simultaneously invoked and repudiated. Bettetini, by contrast, reminds us simply (and helpfully) that the reactions of the recipient cannot alter how the text develops, which is in direct contrast to the very principle of spoken exchanges (*La conversazione audiovisiva*, 109)

54. Casetti, *Inside the Gaze*, 128.

55. Ibid., 15.

56. Branigan, *Point of View in the Cinema*, 3.

57. Ibid., 40.

58. Ibid., 40; see 172 for a related idea.

59. Ibid., 172.

60. See particularly "La télévision regarde la télévision," *Revue du cinéma* 463 (1990): 62–69. Leconte introduces an entirely new distinction between reflexivity that is simply "televised" and a more profound effect, which he calls "televisual." On the one hand he is referring to the many programs whose subject is in part the medium itself (e.g., award ceremonies, telethons, invitations to phone in "live," and so on). On the other hand there is the display of electronic power, as when books take over the screen in the intellectual talk-show *Apostrophes* or when the image of a book is taken over by an expanding window through which we can see the author talking in the studio, etc.

61. Italian *farsi* "to make oneself" and *darsi* "to give oneself" (both notions are found throughout the book).

62. Casetti, *Inside the Gaze*, 56–57, where *Gone with the Wind* (1939) is discussed.

63. Ibid., 49.

64. Casetti, "Les yeux dans les yeux," 81–82.

65. Gaudreault, "Narration et monstration au cinéma," 93.

66. Casetti, *Inside the Gaze*, 127–28.

67. Jost, "Narration(s)," 198–99.

2. THE VOICE OF ADDRESS IN THE IMAGE

1. Francesco Casetti, *D'un regard l'autre: Le film et son spectateur*, trans. Jean Châteauvert and Martine Joly (Lyon: Presses universitaires de Lyons, 1990), esp. 17, 48–49.

2. See Marc Vernet, "Le regard à la caméra" (1983), repr. in *De l'invisible au cinéma: Figures de l'absence* (Paris: Étoile, 1988).

3. Besides Casetti's *D'un regard l'autre*, see his *Inside the Gaze*; and a large section of "Les yeux dans les yeux."

4. See also Raymond Bellour, "Le regard de Haghi," *Iris*, no. 7 (1987): 5–13; and Raymond Bellour, "Le malheur d'énoncer," in *Le mal au cinéma* (Paris-Dunkerque: Studio 43, 1989), 13–17.

5. See Vernet, "Le regard à la caméra," 17.

6. Casetti, "Les yeux dans les yeux," 85.

7. Noël Burch, "Un mode de représentation primitif?" in "Le cinéma avant 1907," ed. André Gaudreault, *Iris*, no. 3 (1984): 113–24.

8. André Gaudreault, ed., *Ce que je vois de mon ciné: La représentation du regard dans le cinéma des premiers temps* (Paris: Méridiens Klincksieck, 1988), 13–17 (not exactly an introduction but the first part of the "Études" section).

9. Burch, "Un mode de représentation primitive?"

10. See Casetti, "Les yeux dans les yeux," esp. 80, 87; and Vernet, "Le regard à la caméra," 13–16.

11. Kiyoshi Takeda, "Le cinéma autoréflexif: Quelques problèmes méthodologiques," *Iconics* 1 (Dec. 1987): 83–97.

12. I return to Simon on this theme on page 64.

13. Catherine Kerbrat-Orecchioni, *L'énonciation: De la subjectivité dans le langage* (Paris: Armand Colin, 1980).

14. Veron addresses this subject in many works, but see especially Eliseo Veron, "Il est là, je le vois, il me parle," in "Énonciation et cinéma," ed. Jean-Paul Simon and Marc Vernet, special issue, *Communications* 38 (1983): 98–120.

15. See Jean-Paul Terrenoire, "Les yeux dans les yeux: L'interpellation télévisuelle et l'implication du spectateur," in *Revue suisse de Sociologie / Schweizerische Zeitschrift für Soziologie* (1987), which has the same title as Casetti's already-cited article but differs in content and date of publication.

16. Jost granted a more and more central role to the opposition between the explicit and the implicit narrator. I will come back to this on pages 169 and 174–75. Regarding the notion of the "narrator" see Jost, "Narration(s)," esp. 202–3.

17. For more on this film see pages 91–92.

18. Gérard Genette, Figures III, 238–40.

19. Ibid., 251–54.

20. Käte Hamburger, *Logique des genres littéraires* (Paris: Seuil, 1986), chap. 2, esp. 128ff. and 156–58.

21. Jost, "Narration(s)," 203.

22. This excludes (while I am dealing with Genette's definitions) embedded narration that is attributed to another character or to a diegetic and no longer extradiegetic narrator—in other words, narration that leads us to a "metadiegesis."

23. Jean-Pierre Chartier, "Les 'films à la première personne' et l'illusion de réalité au cinéma," *Revue du cinéma* 4 (Jan. 1947): 32–41.

24. There is nothing in the definition of the voice-in address that says it is reserved for characters that dominate the diegesis. It is only one among many instances. If I have restricted myself to this type until now, it has been to avoid unnecessarily complicated confusion with Genette's definitions.

25. Hamburger, *Logique des genres littéraires*, 124. In a fictional system all deictics become "faded symbols."

26. See page 6, note 15.

3. THE VOICE OF ADDRESS OUTSIDE THE IMAGE

1. Christian Metz, "The Modern Cinema and Narrativity," in *Film Language: A Semiotics of the Cinema,* trans. Michael Taylor (Chicago: University of Chicago Press, 1991), 185–227, esp. 220.

2. Michel Chion, *The Voice in Cinema*, trans. Claudia Gorbman (New York: Columbia University Press, 1999), 47ff.

3. I recall a comment made by Gérard Genette, *Figures III*, 226: Balzac "invented" the Vauquer Guest House, but *Père Goriot's* narrator "got to know" it (the inverted commas are Genette's).

4. Chion, *The Voice in Cinema*, 3, 46.

5. Michel Chion, *Le son au cinéma* (Paris: Étoile / Cahiers du Cinéma, 1985), 32.

6. Ibid., 42.

7. Resnais's script was written by Jorge Semprún. We can take this "you" as the marker of a conversation that Diego, alias Carlos (played by Yves Montand),

has with himself. But it actually comes across as the film addressing the character. On this film see particularly André Gardies, "Fonctionnalité narrative du verbal dans le récit filmique: Esquisse pour une typologie," in *Le verbal et ses rapports avec le non-verbal dans la culture contemporaine*, ed. Jeanne-Marie Clerc (Montpelier: Université Paul Valéry, 1989), 127–41.

8. *Le plaisir* is without doubt one of the best examples of how complicated enunciation can get through the use of simple and commonplace techniques. The last part of the opening credits reads "and the voice of Guy de Maupassant: Jean Servais," and then the image closes in an iris. For the majority of the film it is effectively an extradiegetic and personalized voice that occasionally accompanies the images, with phrases taken more or less from the author. But in the third story Servais plays a character who is secondary elsewhere—the friend of the painter and the witness of the tale. So he appears in the image and occasionally speaks in voice-in, while continuing to intervene with comments in "off," as a storyteller, from the inside of the story, in the manner of the "I-voice." Before starting, he takes care to let us know that it is he (i.e., Maupassant) who is "lending his voice" to the character-narrator. Finally, during the relatively long black screen (which starts with the iris effect) that intervenes between the opening credits and the first tale, Servais's voice repeatedly and subtly changes "role." This is definitely Maupassant, but these are not quotations from his stories. This is the person Maupassant, as he is imagined by the film. He confides in us, while the screen is black: "I have always loved the night, darkness . . ." (here we get a kind of superimposition of Maupassant the man on top of Maupassant the writer) ". . . and I am delighted to speak to you in the dark, as if I was sitting next to you. And maybe I am." This time it is the metacinema that, still using the voice of some version of Maupassant, provides a definition of voice-off. Then, the voice tells us of its fear that these dated stories won't go down well with a public that is "terribly modern, as the living put it"—once again we have Maupassant the person, the haunting reminder of death, in pursuit of glory. It is also worth noting the usage throughout of the *YOU* of direct address, which is a true deictic.

9. See Chion, *The Voice in Cinema*, 46; and Branigan, *Point of View in the Cinema*, 76.

10. Chion, *The Voice in Cinema*, 55.

11. In his analysis of two great 1953 films, *I Vitelloni* (Fellini) and *Anatahan*, Vernet notes that a plural "we" voice-over recounts the story of a group in each film. See "Figures de l'absence 2: La voix off," in "La parole au cinéma / Speech in Film," ed. François Vanoye, special issue, *Iris* 3, no. 1 (1985): 47–56.

12. In a seminar discussion Dominique Blüher pointed out that these experimental pieces have a rather different aim in mind. They are focused on a homology or some kind of formal and structural correspondence between music and

image, while we are concerned here with multipurpose music, the most common type, which has a purely affective relation to the narrated *story* rather than to the *image* itself.

13. André Gardies, *Cinéma d'Afrique noire francophone: L'espace-miroir* (Paris: L'Harmattan, 1989), 167–68.

14. Hence my particular interest in the works of Michel Chion and my frequent references to them.

15. See several parts of their book *Nouveau cinéma, nouvelle sémiologie* (Paris: 10/18, 1979). See also Dominique Chateau, "Projet pour une sémiologie des relations audiovisuelles dans le film," *Musique en jeu* 23 (1976): 82–98; and chapter 5 of *Le cinéma comme langage* (Paris: Sorbonne, 1986), which is his 1975 thesis, "Problèmes de la théorie sémiologique de cinéma," etc. See also François Jost's "L'oreille interne: Propositions pour une analyse du point de vue sonore," in "La parole au cinéma / Speech in Film," ed. François Vanoye, special issue, *Iris* 3, no. 1 (1985): 21–34; "Pour une approche narratologique des combinaisons audiovisuelles," *Protée* 13, no. 2 (1985): 13–19; and pages 45–67 of the 1989 edition of *L'œil-caméra*, etc. Also worthy of mention are the writings on the semiology of sound by Michel Marie, Roger Odin, Daniel Percheron, and others.

16. Jost, *L'œil-caméra*, 64.

17. Roger Odin, "Quelques jalons pour une réflexion sur la notion de cohérence au cinéma," *Canadian Journal of Research in Semiotics* 6, no. 3 / 7, no. 1 (1979): 175–88.

18. Christian Metz, "Le perçu et le nommé," in *Essais sémiotiques* (Paris: Klincksieck, 1977), esp. 153–59.

19. See all of the first section ("Ce qui cherche son lieu") of Chion, *Le son au cinéma*.

20. Pudovkin, Kracauer, et al.—Trans.

4. WRITTEN MODES OF ADDRESS

1. See the following works by Michel Marie: "Intertitres et autres mentions graphiques dans le cinéma muet," *Revue de cinéma: Image et son* 316 (April 1977): 68–74; "Le film, la parole et la langue," in "Cinéma et littérature," edited by André Gardies, special issue, *Cahiers du XXe siècle* (May 1978): 67–75; "La séquence / Le film: *Citizen Kane* de Welles," in *Le cinéma américain: Analyses de films*, ed. Raymond Bellour (Paris: Flammarion, 1980), 27–44; and "Intertitres et sons au cinéma" (Thesis, Paris VIII, 1976).

2. See earlier in this volume (page 13) for analysis of this point.

3. Claire Dupré La Tour, "Intertitre et film narratif, 1895–1916," doctoral thesis in preparation. The phrase that is written in the title is like a completive, so it

is dependent (in generative terms) on an underlying declarative, as in "He says that . . ." The character's face with moving lips is the cognitive equivalent of the declarative.

4. See page 27 and notes 1 and 3 on that page.

5. Jean-Paul Terrenoire, "Sociologie et sémiologie: A propos de l'analyse scénologique de l'image télévisée," *Revue tunisienne de communication* 11 (Jan.–June 1987): 107–17, esp. 112–13; and Terrenoire, "Les yeux dans les yeux," 370.

6. See the authors cited on page 46. For the pragmatist view of things see Roger Odin, "L'entrée du spectateur dans la fiction," in *Théorie du film*, ed. Jacques Aumont and Jean-Louis Leutrat (Paris: Albatros, 1980), 198–213 (on Jean Renoir's *Partie de campagne*); Casetti's "Les yeux dans les yeux," 82, and his *Inside the Gaze*, 39ff.; an article on credit sequences by Nicole de Mourgues, to appear in a volume from the publisher Armand Colin; Gardies's "Genèse, générique, générateurs," *Revue d'esthétique* 4, 1976, and "La forme-générique: Histoire d'une figure révélatrice," *Annales de l'Université d'Abidjan* D, 14 (1981): 163–76; etc. This last article suggests an excellent definition of the credit sequence: it is beyond the text without being beyond the film; it tells *another* story, which is that of the production of the film and thereby obeys an extracinematographic code that is common to all of the spectacular arts.

7. Bordwell, *Narration in the Fiction Film*, 240.

5. SECONDARY SCREENS, OR SQUARING THE RECTANGLE

1. Harald Weinrich, *Le temps*, trans. Michèle Lacoste (Paris: Seuil, 1973); originally published as *Tempus: Besprochene und erzählte Welt* (Stuttgart: Kohlhammer, 1964). In this work, the "commentative" is opposed to the recited.

2. See Jacques Aumont, *L'œil interminable: Cinéma et peinture* (Paris: Séguier, 1989), 124. [Aumont's term *sur-cadre* literally means "over-frame" or "super-frame."—Trans.]

3. Roger Odin, "Mise en phase, déphasage et performativité dans *Le tempestaire* de Jean Epstein," in "Énonciation et cinéma," ed. Jean-Paul Simon and Marc Vernet, special issue, *Communications* 38 (1983): 213–38, esp. 232.

4. Aumont, *L'œil interminable*, 124.

5. See, in particular, Vernet, "Clignotements du noir-et-blanc," 226. But the idea recurs throughout Vernet's work. In fact, I will refer only to a single aspect of his work, because the idea refers in a more general way to various homologies that are set up between relations that are interior to a story and those of the viewer with the film, and it refers to the fear of the latter, the fear of knowing (of being surprised) set against an equal desire to know, etc.

6. Aumont, *L'œil interminable*, 107–10 ("frame-limit" and "frame-window").

7. See, in particular, the back cover of Chion, *La voix au cinéma*; and page 28 of Chion, *Le son au cinéma*; etc.

8. Josef von Sternberg, *L'impératrice rouge* (French title) (1934).

9. Christian Metz, "Trucage et cinéma" (1971), in *Essais sur la signification au cinéma*, (Paris: Klincksieck, 1972), 2:173–92. [This chapter was translated as "*Trucage* and the Film," by Françoise Meltzer in *Critical Inquiry* 3, no. 4 (1977), 657–75. She explains: "The word 'trucage' usually translates as 'trick photography' in the singular and 'special effects' in the plural. But Metz places many terms, including these, under the rubric of *trucage*, and I am therefore maintaining the French word" (657).—Trans.].

10. Odin, "L'entrée du spectateur dans la fiction."

11. See page 11 and notes 28 and 29.

12. Vernet, *Figures de l'absence*, all of the "Surimpressions" chapter, esp. 61.

6. MIRRORS

1. I have already spoken at length on this matter in "The Imaginary Signifier," *Screen* 16, no. 2 (1975): 14–76; reprised in the book of the same title (Bloomington: Indiana University Press, 1982), see 42–57 in particular.

2. See Branigan, *Point of View in the Cinema*, 127–29.

3. See the long analysis of this film in Vernet, *Figures de l'absence*, 35–41.

4. Ibid., 84.

5. The shot was reproduced in the first issue of the journal *Vertigo* (1987): 12.

6. See Christian Metz, *Le signifiant imaginaire* (Paris: Union Générale d'Éditions, 1977), 68–70, 120.

7. "EXPOSING THE APPARATUS"

1. See "Hors-champ (Un espace en défaut)" (1971), published as "Des hors-champs," in *Le regard et la voix* (Paris: 10/18, 1976). Bonitzer laid an emphasis on one aspect of this work done by the film: how the articulation of what is inside and what is outside the field contributes either to the maintenance or the suturing of the fundamental gap of cinematographic space.

2. See Jean-Paul Simon, *Le filmique et le comique: Essai sur le film comique* (Paris: Albatros, 1979), 125–31.

3. Ibid., 128.

4. See Marc Vernet, "Le figural et le figuratif, ou le référent symbolique: A propos de 'Métaphore/Métonymie, ou le référent imaginaire,'" in "Christian Metz et la théorie du cinéma," ed. Michel Marie and Marc Vernet, *Iris*, no. 10 (1990): 223–34.

5. Annette Michelson, "L'homme à la camera: De la magie à l'épistémologie," in "Cinéma: Théorie, lectures," ed. Dominique Noguez, special issue, *Revue d'esthétique* 26 (1973): 295–310.

6. Jacques Aumont, "Vertov et la vue," in *Cinémas et réalités*, ed. Roger Odin and Jean-Charles Lyant (Saint-Étienne: Université de Saint-Étienne, 1984), 23–44.

7. The relationship between enunciation and metaphor is one of the main issues Gerstenkorn tackles in his doctoral thesis, "Le métaphorique dans le film de fiction" (École des hautes études, 1990).

8. Michel Marie, "Un monde qui s'accorde à nos désirs (*Le mépris*, 1963)," in "Jean-Luc Godard: Les films," edited by Philippe Dubois, special issue, *Revue belge du cinéma* 16 (1986): 25–36. On the same film see also Marie-Claire Ropars-Wuilleumier, "Totalité et fragmentaire: La réécriture selon Godard," in "Contrebande," ed. Michèle Lagny, Pierre Sorlin, and Marie-Claire Ropars-Wuilleumier, special issue, *Hors cadre* 6 (1988): 193–207.

9. See Nick Browne, "*Persona* de Bergman: Dispositif/inconscient/spectateur," in *Cinémas de la modernité: Films, théories*, edited by Dominique Chateau, André Gardies, and François Jost (Paris: Klincksieck, 1981), 199–207.

10. Christian Koch, "Understanding Film as a Process of Change" (PhD diss., University of Iowa, 1970), which analyzes *Persona* and a film by Pakula.

11. See Marc Vernet, "Le personnage de film," in "Cinéma et narration 1," ed. Marc Vernet, *Iris*, no. 7 (1987): 81–110; see also Marie, "Un monde qui s'accorde à nos désirs."

12. André Gardies, "L'acteur dans le système textuel du film," in *Études littéraires* 13, no. 1 (1980): 71–107.

13. At the time of finishing this text, I received issue 4 of the journal *Admiranda* (1989), dedicated to actors' performance, which is of great interest. Some of the articles therein are written from the perspective of enunciation in film.

14. See page 41.

15. See Branigan, *Point of View in the Cinema*, 52–53. (What is called "the camera" is not a real profilmic object but a construction by the spectator that helps render intelligible the space that is represented and the representation of space.)

16. Gauthier made this observation in a seminar discussion.

8. FILM(S) WITHIN FILM

1. I am indebted for this information to my friend and former student Kiyoshi Takeda, who is currently a teacher and writer on cinema in Japan; see his

dissertation, "Archéologie du discours sur l'autoréflexivité au cinéma" (École des hautes études and Paris-III, 1986).

2. Lucien Dällenbach, *Le récit spéculaire: Essai sur la mise en abyme* (Paris: Seuil, 1977); Simon, *Le filmique et le comique*, 122ff.; all of the contents of "Le cinéma au miroir," special issue, *Vertigo* 1 (1987); Jacques Gerstenkorn, "A travers le miroir," introductory notes to *Vertigo* 1 (1987): 7–10; and numerous passages in his thesis, "Le métaphorique dans le film de fiction"; Takeda, "Le cinéma autoré-flexif"; Takeda, "Archéologie du discours sur l'autoréflexivité au cinéma"; Domi-nique Blüher, who proposes an excellent classification system in her predoctoral (D.E.A.) paper, "Première approche du cinéma dans le cinéma" (1988), 47–49.

3. See "Mirror-Construction in Fellini's 8½," in Metz, *Film Language*, 228–34.

4. This restriction is needed because it can also happen that a film is quoted several times in another film. We will shortly see almost a caricature of this, in Lelouch's remake of Hitchcock.

5. This has been excellently analyzed by Kiyoshi Takeda in "Archéologie du discours sur l'autoréflexivité au cinéma" and "Le cinéma autoréflexif" (see notes 1 and 2 above).

6. The embedding is clearly signposted. The stage play has its own title, vis-ible on a poster on the outside wall of the theater, which Gene Kelly leans against at the start of the sequence. The title is *One Day in New York*, which was used in a literal translation when it was released in France as *Un jour à New York*. But in the original version the main film differs from the inner one by its title, which is *On the Town*.

7. In a seminar discussion Rollet evoked "blown-up" Super-8 material, where the grain is visible, which functions as a lost metaphor of some originary film scene..

8. See Chion, *Le son au cinéma*, 113–14, on the "primordial sound of cinema," the sound of the heart of the engine, held in abeyance by the music and chatter of talkies, but which constantly threatens to return.

9. See Marie-Claire Ropars-Wuilleumier, Claude Bailblé, and Michel Marie, *Muriel*, research report (Paris: Galilée, 1975).

10. Dominique Noguez, *Une renaissance du cinéma: Le cinéma "under-ground" américain* (Paris: Klincksieck, 1984), 290–91.

11. This information comes from a conversation that I had with Gehr.

12. See Roger Odin, "Du spectateur fictionnalisant au nouveau spectateur: Approche sémio-pragmatique," in "Cinéma et narration 2," edited by Marc Vernet, *Iris*, no. 8 (1988): 121–30.

13. Marie-Claire Ropars-Wuilleumier, "Narration et signification: Un exem-ple filmique," *Poétique* 12 (1972): 518–30 (the example in the title is *Citizen Kane*).

14. Seymour Chatman, *Cinematic Discourse: The Semiotics of Narrative Voice and Point of View in "Citizen Kane"* (Urbino: Centro internazionale di semiotica e linguistica, 1977); Bettetini, *La conversazione audiovisiva*, 134–60; Casetti, *Inside the Gaze*, 84–94; and Marie, "La séquence / Le film." This film has been the object of much analysis, and my list here is far from complete.

15. For a less developed example see also the scene in *Stardust Memories* where, in the imagination of the filmmaker, he receives a posthumous award. To do so, he physically emerges from the secondary screen and accepts the plaque.

16. See Metz, "Mirror-Construction in Fellini's 8½," 228–34.

17. From another, extratextual, point of view, Garrel's film is an almost complete mise-en-abyme: the filmmaker is played by the filmmaker, the father by the father (Maurice Garrel), the son by the son (Louis Garrel, the little boy), and the famous actress by a famous actress, Anémone. There is one subtle twist, and that is that the wife is played by Brigitte Sy, Garrel's partner, whereas in the story he envisages actually entrusting the role of his wife, who is herself an actress, to a foreign actress. This might even be called the motor of all the "action," if that is the correct word.

18. On the notion of the profilmic, which is barely analyzed these days, see the excellent doctoral thesis by Tsun-Shing Cheng, "La 'scène' profilmique, ou le 'monde' perdu" (École des hautes études and Paris-III, 1985). Cheng currently researches film in Taiwan.

19. See Chion, *Le son au cinéma*, 125–26.

20. Leconte made this observation in a seminar discussion.

21. Chion, *The Voice in Cinema*, 48.

22. This naturalistic, populist and very "French" film was adapted from a novel by Serge Groussard. The film tells the story of the thwarted love of a lorry driver (Jean Gabin) and a restaurant waitress (Françoise Arnoul). She then dies as a result of a sordid, backstreet abortion, a real hard-luck story. All of this is "narrated" by Jean Gabin after the death of the young woman while he is staying at the roadside hotel where she worked and to where his journey "today" happens to have brought him. More precisely, he does not narrate at all (there is no speaking *I*); rather, the events are interior thoughts that are offered directly to the spectator and that "make," the film. So, like many other films, this is entirely set in the past, in such a way that this past becomes a little like the real present, and the "flashback-effect" is seriously mitigated.

23. See Patrice Rollet, ed., "Lettres de cinéma," special issue, *Vertigo* 2 (1988).

24. See, e.g., Jacques Gerstenkorn's thesis, "Le métaphorique dans le film de fiction."

25. Gérard Genette, *Palimpsestes: La littérature au second degré* (Paris: Seuil, 1982), 7–14. The thesis by Marc Cerisuelo (who has also written the excellent

Jean-Luc Godard) that was mentioned earlier is one of several that stress these notions as a contribution to a project that deals with the poetics of film.

9. SUBJECTIVE IMAGES, SUBJECTIVE SOUNDS, "POINT OF VIEW"

1. The film was made in 1939, with the working title *Sierra de Teruel*. It came out in 1945 with the new title, *Espoir* (no definite article).

2. See, e.g., Jacques Fontanille, "La subjectivité au cinéma," in "La subjectivité au cinéma," ed. Jacques Fontanille, special issue, *Actes sémiotiques: Bulletin* 10, no. 41 (1987): 5–23; Jacques Fontanille, "L'économie du savoir dans le film," in "L'école-cinéma," edited by Michèle Lagny, Marie-Claire Ropars-Wuilleumier, and Pierre Sorlin, special issue, *Hors cadre* 5 (1987): 245–56; and Jacques Fontanille, "Point de vue: Essai de définition discursive," in "Le point de vue fait signe," edited by Marie Carani, André Gaudreault, Pierre Ouellet, and Fernand Roy. Special issue, *Protée* 16, no. 1–2 (Winter-Spring 1988): 7–22.

3. François Vanoye, *Récit écrit, récit filmique* (Paris: CEDIC, 1979); rev. ed., ed. Henri Mitterand and Michel Marie (Paris: Nathan, 1989), chap. 10, "Points de vue, perspectives narratives, focalisations" (140–58). Unless otherwise indicated, pagination refers to the 1989 edition.

4. See Noël Nel, "Point de vue et théorie du film," an excellent sixteen-page broadsheet article that aims to encompass film enunciation.

5. See François Jost, "Du nouveau roman au nouveau romancier" (thesis, École des hautes études and Paris-III, 1983); Jost, *L'œil-caméra*; and various articles.

6. On focalization see Genette, *Figures III*, 206.

7. Let us remember all the same that, in keeping with the partial vision of the film, we see him when he sees himself (his own hands and forearms, his face in a mirror) but that we also see him at the start face-on when, as the narrator, he tells us that from this point on he will be the character in the story.

8. Jean Mitry, *Esthétique et psychologie du cinéma*, vol. 2, *Les formes* (Paris: Éditions universitaires, 1965), 61–79, 138–40.

9. Maurice Merleau-Ponty, "Le cinéma et la nouvelle psychologie," conference at l'Institut des hautes études cinématographiques, March 13, 1945; repr. in *Sens et non-sens* (Paris: Nagel, 1948).

10. Albert Laffay, *Logique du cinéma: Création et spectacle* (Paris: Masson, 1964), 73–77.

11. Branigan, *Point of View in the Cinema*, 42.

12. Mitry, *Esthétique et psychologie du cinéma*, 2:61–79, 138–40.

13. See Vernet, *Figures de l'absence*, 68–69.

14. Jost, *L'œil-caméra*, 76–79.

15. Ibid., 27–28.

16. For an impressive study of this sequence see Thierry Kuntzel, "Le travail du film," *Communications* 19 (1972): 25–39.

17. See Genette, *Figures III*, 209. Here, Genette echoes a comment made by Jean Pouillon in *Temps et roman* (Paris: Gallimard, 1946), 79.

18. Aumont, *L'œil interminable*, 67–68.

19. See Branigan, *Point of View in the Cinema*.

20. See André Gaudreault, "Système du récit filmique," text from a conference given at l'Université de Paris-III, March 25, 1987; and André Gaudreault, *Du littéraire au filmique* (Paris: Méridiens-Klincksieck, 1988), 180.

21. See Christian Metz, "Photography and Fetish," *October* 34 (Autumn 1985): 81–90. [French version: "L'image comme objet: Cinéma, photo, fétiche," in *Cinéma et psychanalyse*, ed. Alain Dhote (Courbevoie: CinémAction / Codé-sur-Noireau: Corlet, 1989), 168–75.]

22. Genette, *Figures III*, 203–24.

23. Lagny, Ropars-Wuilleumier, and Sorlin, "Le récit saisi par le film," 106–10

24. Ibid., 107.

25. Robert Burgoyne, "The Cinematic Narrator: Logic and Pragmatics of Impersonal Narration," *Journal of Film and Video* 42, no. 1 (1990): 3–16.

26. See Aumont, *L'œil interminable*, 61. Aumont does this with regard to the German film *Variety* (1925) and to some eccentric point-of-view shots that are related to the narration but not to the vision of a character. I will come back to this point.

27. See Jost, *L'œil-caméra*, 23, 26, 28, 73–77, 103, and 157n26. See also Jost's "Narration(s)." I am leaving aside another argument that he develops in less detail, particularly on page 196 of "Narration(s)." He suggests that the very opposition of "external" and "internal" is uncertain and unstable because it can be hard to distinguish between them, or they can lie on top of one another in a single image. If a photograph represents a person in profile looking into the distance, we may just as well invoke an external ocularization on the part of the person as an internal ocularization on the part of the photographer. But we can see that an orientation is not judged to be internal or external in relation to the *same* instance. This alone would threaten to close the gap that I am determined to maintain. Otherwise, every objective view of something is subjective for the camera.

There is another argument against the idea of external ocularization on page 112 of the revised edition of *L'œil-caméra*. It seems to be a contradiction in terms, as the word *external* seems to designate an "eye" that is located outside of any person. I am not of this opinion. In saying *external*, we are already referring

to something of a topographical order. We say that the object is not "seen" by the character and that the source of the gaze is somewhere around him. This is negative information, but it is significant nonetheless.

28. French title: *L'inconnu du nord-express* (Hitchcock, 1951).

29. Jost, "Mises au point sur le point de vue," 153; the publication dates do not reflect the chronology of the composition. See also Jost, *L'œil-caméra*, 40.

30. Pages 135–39.

31. André Gardies, "Le pouvoir ludique de la focalisation," in "Le point de vue fait signe," ed. Marie Carani, André Gaudreault, Pierre Ouellet, and Fernand Roy, special issue, *Protée* 16, no. 1–2 (Winter-Spring 1988): 139–45.

32. See ibid.; and numerous passages from Gardies, *Cinéma d'Afrique noire francophone*. See also Jost, *L'œil-caméra*, esp. chap. 3.

33. See Chion, *La voix au cinéma*; Chion, *Le son au cinéma*; and Michel Chion, *La parole au cinéma: La toile trouée* (Étoile / Cahiers du Cinéma, 1988).

34. Chion, *Le son au cinéma*, 53.

35. This very common cinematic "motif" and its various formal arrangements are analyzed in a doctoral thesis by Jacques Lemaître: "Téléphone et cinéma," DEA thesis, Paris-III, 1987. Certain simple gestures are remarkably frequent in film—e.g., lighting a cigarette, driving a car, loading a revolver. Making a phone call is one of these.

36. Lagny, Ropars-Wuilleumier, and Sorlin, "Le récit saisi par le film," 110.

37. Metz, "Le perçu et le nommé," penultimate section, "Les bruits: Les objets sonores."

38. See page 44 and note 15.

39. Chion, *Le son au cinéma*, esp. 29–31.

40. Vernet, *Figures de l'absence*, 29–58.

41. Burch, *Praxis du cinéma*, 30.

42. See page 17.

43. Jost, *L'œil-caméra*, 27.

44. Vernet, *Figures de l'absence*, 35.

45. *L'étang tragique* (1941).

46. Vernet, *Figures de l'absence*, 42ff.

47. Ibid., 30–32, 56–57.

48. Jost, *L'œil-caméra*, 27–28.

49. Genette, *Figures III*, 209. I touched on this idea on page 94.

50. Jost, *L'œil-caméra*, 79.

51. Branigan, *Point of View in the Cinema*, esp. 176: we call "point of view" the distance between enunciation and statement, and "subjectivity" is one of the forms frequently covered by that distance.

52. Marie-Claire Ropars-Wuilleumier, "Sujet ou subjectivité? L'intervalle du film," in "La subjectivité au cinéma," edited by Jacques Fontanille, special issue, *Actes sémiotiques: Bulletin* 10, no. 41 (1987): 30–39.

53. Rollet made this observation in a seminar discussion.

54. Laffay, *Logique du cinéma*, 73–77.

55. See page 20 with notes 63 and 64.

56. Branigan, *Point of View in the Cinema*, 183.

10. THE I-VOICE AND RELATED SOUNDS

1. Chion, *The Voice in Cinema*, 49–53.

2. Chion, *Le son au cinéma*, 32–44. It is with reference to sound in general and not just voice that Chion (strikingly) defines "off" and "out-of-frame" and the differences between them.

3. See pages 42–43.

4. See Chartier, "Les 'films à la première personne' et l'illusion de réalité au cinéma." The same volume of this journal also contained an article by Jacques Doniol-Valcroze on a similar theme and which also caused a stir: see Jacques Doniol-Valcroze, "Naissance du véritable ciné-œil," *Revue du cinéma*, 2nd ser., 4 (Jan. 1947): 25–29.

5. See Laffay, *Logique du cinéma*, 77, 80 ("commentary"), 94 ("narrative intent"), and 80–81 for the other cited terms.

6. François Jost, "La sémiologie du cinéma et ses modèles," in "Christian Metz et la théorie du cinéma / Christian Metz and Film Theory," ed. Michel Marie and Marc Vernet, *Iris*, no. 10 (1990): 133–41, 137.

7. See Genette, *Figures III*, 207, for example, on the subject of Stendhal or *Madame Bovary*. This is internal heterodiegetic focalization, as in *The Ambassadors*. See also chapter 17 of Gérard Genette, *Nouveau discours du récit* (Paris: Seuil, 1983), esp. 83.

8. François Jost, "Règles de Je," in "Cinéma et narration 2," ed. Marc Vernet, *Iris*, no. 8 (1988): 107–19, 107–8. When there is doubling of the "image source" at the heart of a single sequence of the I-voice, some views are "subordinated" to the spoken words, while others "infiltrate" them and are based on a distinct instance of enunciation, which manipulates the first instance as well as the film as a whole.

9. See Vernet, "Figures de l'absence 2."

10. See Chion, *La voix au cinéma*, 107.

11. Chion, *La voix au cinéma* (the entire book). For Vernet see note 9 above.

12. More rarely, the I-voice accompanies apparently current events live. A limited set of examples includes *Le silence de la mer* (*The Silence of the Sea*),

by Jean-Pierre Melville (1949), based on Vercors's novel of the same name. The I-voice belongs to the uncle, who is one of three characters that we see in action and one of two who is resolutely silent. It is just at the moment when he is silent in the face of the German character that he breaks his silence for us in order to explain things. The voice-off and the "silence-in" (what else can we call it?) are both positioned, fictively it should be said, in a *now* that is ceaselessly renewed.

13. Crisp made this observation in a seminar discussion.

14. Joseph Mankiewicz, 1949.

15. See pages 34 and 42.

16. Chion draws our attention to the technical conditions and sound production techniques that establish the I-voice (*La voix au cinéma*, 48–49). So it is not enough for the speaker to be invisible because this could just as easily be a character who is momentarily out of shot.

17. However, at the start and the end of the film we see the hero speak a few sentences that could strictly be attributed, through the "pure" character, to the character-narrator.

18. See Burch, *Praxis du cinéma*, 119–31, where he discusses Marcel Hanoun's *Une simple histoire* (1959). The narrator-heroine tells us what she said at this or that moment. In the frame, and so in voice-in, she actually speaks. But a sentence-off starts in the midst of a sentence-in and outlasts it by half.

19. Genette, *Figures III*, 239.

20. I say "mainly" because Truffaut also drew on Roché's notebooks, which sometimes overlap with his novels and are themselves more or less autobiographical. Truffaut even reprised some elements of *Jules et Jim* (the book, also by Roché) that do not occur in the film based on it that he made before this. In the end there are some additions of his own, such as the novel *Jérôme et Julien*, which the hero is supposed to have written. This gives a good sense of the complexity of the writing process that produced this film.

21. I refer to comments made in a seminar discussion.

22. Hollis Frampton, dir., *Hapax Legomena 1: (nostalgia)* (USA, 1971–72). In ancient Greek: "Things uttered only once." Thanks to Dominique Noguez, whom I badgered for the following: shot in 1971–72, this film consists of eight parts (I have not seen them all) that last 3 hours 22 minutes.

23. Dominique Noguez, "Mots/Sons/Images" (1989), in *Cinéma*, ed. Nicole de Mourgues, 137–41 (Rouen: CIREM, 1990).

24. See in particular Marie-Claire Ropars-Wuilleumier, *Écraniques: Le film du texte* (Lille: Presses universitaires de Lille, 1990).

25. See Chion, *Le son au cinéma*, 101–97.

26. Lahorgue made this observation in a seminar discussion.

27. Leconte mentioned this in the same seminar.

28. Music is beyond doubt the only art form that exists. All other forms are influenced by the concerns of narration, display, use (architecture), and so on. It is the only art that conjoins the immediacy of affect with the full mathematization of structure, which may suggest that the roots of feeling, insofar as they can be known, might in fact be relatively abstract. (In classical French the word *nombre* was used to mean rhythm and the poetic meter.) Music is also the only art that young people really like, the main one that is practiced by entire populations (Brazil, Africa, etc.), and the only one that is associated with the *body*, with dance.

29. Chion, *Le son au cinéma*, esp. 101–17.

11. THE ORIENTED OBJECTIVE SYSTEM

1. See "Trucage et cinéma" (1971) and "Ponctuations et démarcations dans le film de diégèse" (1971–72), both collected in Metz, *Essais sur la signification au cinéma*, 2:173–92 and 2:111–37, respectively; and "Métaphore/métonymie, ou le référent imaginaire," in *Le signifiant imaginaire*, 177–371, esp. 341–49.

2. Vanoye, *Récit écrit, récit filmique* (1989 edition), 73–76 (plus analysis of examples).

3. Béla Balázs, *Theory of the Film: Character and Growth of a New Art* (London: Dennis Dobson, 1952), 143–44. Balázs discusses the intervention of the filmmaker in the narrative, "'absolute' film effects" (185), and the "expressive technique of the camera" (143–51).

4. Étienne Souriau, "Les grands caractères de l'univers filmique," in *L'univers filmique*, ed. Étienne Souriau (Paris: Flammarion, 1953), 11–31, 19. Souriau says that "the visible material of transitions" is external to the imaginary universe of the film.

5. Primary narration has two separate functions: it "comments" on events as if they had an independent reality, and at the same time it is this narration that makes them exist and shapes them in their existential literalness (this is the "mimetic" function). See Burgoyne, "The Cinematic Narrator."

6. Casetti, "Les yeux dans les yeux," 90–91; and Casetti, *Inside the Gaze*, 49–50. Casetti adopts the term, with reservations and adaptations, from traditional grammar. [The English translation of Casetti opts for "impossible objective."—Trans.]

7. See page 20 above; see also Casetti, *Inside the Gaze*, 56–57.

8. In the same vein there are films that end with explicit moral, political, etc. *declarations*, in which objective orientation and mode of address come together. Limiting ourselves to examples from Pacific war films, we have

Merrill's Marauders (Samuel Fuller, 1962), where an unknown male voice tells us that the heroism of the famous Merrill unit is commemorated every year by an assault division who are the honor of the nation; we also have the final intertitle of *Objective, Burma!* (Raoul Walsh, 1945), which affirms the necessity of pursuing the war until the total destruction of Japan.

9. In "Trucage et cinéma" I suggested (particularly pages 175–77) a distinction between two types of optical effect: those that function as "exhibitors" that affect an image that is simultaneously visible, and those that replace and displace the image entirely, and so have the value of a "taxeme" in linguistics (i.e., the smallest unit of meaning in a given context). This distinction was taken up by Marc Vernet in parts of his *Figures de l'absence*.

10. See pages 96–98 above.

11. Aumont, *L'œil interminable*, 61.

12. To be more precise: *Mr. Arkadin*, or even *Confidential Report*, or *Dossier Secret* (Orson Welles, 1955).

13. This has recently become of great interest, following the "return" to photography. Consider the work of Michel Larouche in Quebec; Philippe Dubois at the *Revue belge du cinéma*; and, above all, Raymond Bellour's remarkable analyses of recent years, e.g., "L'interruption, l'instant," *La recherche photographique* (Dec. 1987): 50–61.

14. See pages 82–84 above.

15. See, e.g., the analysis by Catherine Kerbrat-Orecchioni, "Vive la vitalité Vittel: Une annonce publicitaire 'moderne,'" in "Le discours publicitaire: II," special issue, *Degrés* 14, no. 45 (1986): e1–e27. In a similar vein advertising "text" develops its mannerisms by systematically exploiting or transgressing the rules of language. See Blanche-Noëlle Grunig, *Les mots de la publicité* (Paris: CNRS, 1990).

16. Vanoye made this suggestion in a seminar discussion.

17. Before this, Jerry the mouse (from *Tom and Jerry*) danced with Gene Kelly in *Anchors Aweigh* (George Sidney, 1945) and with Esther Williams in *Dangerous When Wet* (Charles Walters, 1953). There was also Walt Disney's *The Reluctant Dragon* (Hamilton Luske and Alfred Werker, 1941) and the dance with the penguins in *Mary Poppins* (Robert Stevenson, 1964), and no doubt others that I haven't seen. But *Who Framed Roger Rabbit* does push things much further, so its achievements should be acknowledged. The film was directed by Robert Zemeckis in 1988 and is the result of a collaboration between three big factory systems: those of Steven Spielberg, George Lucas, and Walt Disney. It is true that they are canny businessmen, but we should also remember the other serious risks they have taken, such as *Howard the*

Duck (directed by Willard Huyck and produced by Lucas, 1986), which was a resounding financial failure.

The French title of Zemeckis's film, ingenious as always, was *Qui veut la peau de Roger Rabbit?* [Idiomatically, this means "Who wants Roger Rabbit dead?"; literally, it means "Who wants the pelt of Roger Rabbit?"—Trans.] Apparently they were unable to capture the play on words of the English verb "to frame," which means both "to plot against somebody" and "to put someone in a frame" and so, here, to create a person or bring him into existence.

It would be a mistake to look down on films such as *Who Framed Roger Rabbit*, the Star Wars films, and their ilk. It is true that an entire, sizable, section of American film output is becoming indistinguishable from cinema for children. And these films are notable for their profoundly shrill vulgarity, fundamental silliness, and worrying predilection for violence. While another American cinema still does exist, these movies are evidence of an astonishing vitality of visual invention and technical ingenuity, as well as a spirited approach to reality, which is a genuine kind of intelligence, as Europeans tend to forget. French flops lack all of this. What passes in the older cultures of Europe as stupid, when approached differently, calls forth a wealth of imaginative collaboration and manipulation of perception. What is more, these films are permanently engaged in absolute display of the signifier, so we have to recognize them as revolutionary . . .

18. Pier Paolo Pasolini, "Le cinéma de poésie," in *Cahiers du cinéma*, no. 171 (Oct. 1975): 55–64, esp. 59–60 (on the notion of "free indirect subjectivity").

19. Elena Dagrada, "Sulla soggettiva libera indiretta," *Cinema e cinema*, no. 43 (1985): 48–55.

20. Gilles Deleuze, *Cinéma 2: L'image-temps* (Paris: Minuit, 1985).

21. See Dominique Chateau, "Diégèse et énonciation," in "Énonciation et cinéma," ed. Jean-Paul Simon and Marc Vernet, special issue, *Communications* 38 (1983): 133–36.

22. See Burgoyne, "The Cinematic Narrator."

12. "NEUTRAL" (?) IMAGES AND SOUNDS

1. Lagny, Ropars-Wuilleumier, and Sorlin, "Le récit saisi par le film," 107.

2. See pages 13–14.

3. Branigan, *Point of View in the Cinema*, 99 (fig. 2).

4. See page 6, note 11.

5. Casetti, *Inside the Gaze*, 54–55. The Italian original, *Dentro lo sguardo*, is more precise on this point (page 68).

6. See Takeda, "Le cinéma autoréflexive."

13. (TAKING THEORETICAL FLIGHT)

1. Benveniste, *Problems in General Linguistics*, 208.

2. Genette, *Nouveau discours du récit*, 30, 66.

3. Percy Lubbock, *The Craft of Fiction* (London: Whittingham and Griggs, 1921).

4. Genette, *Nouveau discours du récit*, 66.

5. Ibid., 67.

6. See, in particular, Alain Bergala, *Pour une pédagogie de l'audiovisuel* (Paris: Editions de la Ligue française de l'Enseignement et de l'Éducation Permanente, 1975); and Alain Bergala, *Initiation à la sémiologie du récit en images* (Paris: Editions de la Ligue française de l'Enseignement et de l'Éducation Permanente, 1977).

7. See Gaudreault, "Système du récit filmique"; and Gaudreault, *Du littéraire au filmique*, 75–76.

8. Gérard Genette, "Frontières du récit" in *Communications 8*, edition on *L'analyse structurale du récit*, ed. Roland Barthes (1966), repr. in Gérard Genette, *Figures II* (Paris: Seuil, 1969).

9. Kerbrat-Orecchioni, *L'énonciation*.

10. Pages 171–73.

11. See Genette, *Nouveau discours du récit*, 67: ". . . because ultimately every statement [*énoncé*] is in itself a trace of enunciation. This, it seems to me, is one of the lessons we can draw from pragmatics."

12. For instance, this is the subtitle of the book by Catherine Kerbrat-Orecchioni that I have just cited. It is a somewhat paradoxical subtitle because the book presents a much more open conception of enunciative activity and does not reduce it to markers of "subjectivity."

13. See Michèle Lagny, *Langue, discours, société: Pour Émile Benveniste*, ed. Julia Kristeva, Nicolas Ruwet, and Jean-Claude Milner (Paris: Seuil, 1975), 301–6. For the English translation see Metz, *The Imaginary Signifier*, 91–98.

14. Raymond Bellour, *Le cinéma américain: Analyses de films*, 2 vols. (Paris: Flammarion, 1980).

15. Christian Metz, "Le signifiant imaginaire," in *Le signifiant imaginaire* (Paris: 10/18, 1977), 56: "what distinguishes fiction films is not the 'absence' of a special work of the signifier, but its presence in the mode of denegation, and it is well known that this type of presence is one of the strongest there are" [*The Imaginary Signifier*, 40].

16. See Metz, "Trucage et cinéma."

17. See Genette, "Frontières du récit"; and, more obviously, *Nouveau discours du récit*, 67.

18. Christian Metz, "Pour une phénoménologie du narratif"; see the lengthy note 5 on page 33 of the article as it was reissued in volume 1 of *Essais sur la signification au cinéma* [Christian Metz, *Film Language*, 25].

19. Bordwell, *Narration in the Fiction Film*; see pages 57–61 for definitions of these three concepts, which are borrowed from Meir Sternberg; see page 160 for their application to classical cinema.

20. Ibid., 21–26.

21. Ibid., 17.

22. Ibid., 22.

23. Ibid., 16–26.

24. See Catherine Kerbrat-Orecchioni, *La connotation* (Lyon: Presses universitaires de Lyon, 1977); and Catherine Kerbrat-Orecchioni, "L'image dans l'image," in "Rhétoriques, sémiotiques," ed. "Mu" group from Liège, special issue, *Revue d'esthétique* 1–2 (1979): 193–233.

25. See Genette, *Nouveau discours du récit*, esp. 12, 29.

26. Gilbert Cohen-Séat, *Essai sur les principes d'une philosophie du cinéma*, rev. ed. (Paris: Presses universitaires de France, 1958).

27. See page 4 above.

28. This is particularly clear in Gaudreault's 1988 book, *Du littéraire au filmique*; and, earlier, in his 1984 article "Narration et monstration au cinéma"; and, earlier still, in his doctoral thesis, "Récit scriptural, récit théâtral, récit filmique: Prolégomènes à une théorie narratologique du cinéma" (Paris-III, 1983), which introduces many of the concepts that he went on to develop later.

29. Hamburger, *Logique des genres littéraires*.

30. Käte Hamburger, "Zur Phänomenologie des Films," in *Texte zur Poetik des Films*, ed. Rudolf Denk (Stuttgart: Reclam, 1978), 121–32: film "ersetzt die *Bildkraft* des Wortes durch die *Wortkraft* des Bildes" (126, emphases in the original).

31. Ibid., 125.

32. Ibid., 126.

33. Hamburger, *Logique des genres littéraires*, 190.

34. Gaudreault, *Du littéraire au filmique*, 29n8. The letter is from February 1983.

35. "If we envisage (taking a broad definition) every kind of 'representation' of a story, then we obviously have theatrical narrative, film narrative . . . , etc. Personally, I am increasingly in favour of a narrow definition. . . . But it seems clear to me that in current usage the broader sense predominates, and so we need to live with this duality."

36. Jean-Paul Simon, "Énonciation et narration," in "Énonciation et cinéma," ed. Jean-Paul Simon and Marc Vernet, special issue, *Communications* 38 (1983): 155–91, 157.

37. Gaudreault, *Du littéraire au filmique*, 81.

38. See Jost, "Narration(s)," 192.

39. Jost, *L'œil-caméra*, 25–26; or even Jost, "Narration(s)," 193–94.

40. See, e.g., Jost, "Mises au point sur le point de vue," 147; Jost, *L'œil-caméra*, 81; and Jost, "Narration(s)," 198.

41. Jost, *L'œil-caméra*, 103n39.

42. See, e.g., ibid., 37.

43. Jost, "Narration(s)," 192.

44. Ibid., 202.

45. Jost, *L'œil-caméra*, 39n39.

46. Genette, *Figures III*, 226.

47. Genette, *Nouveau discours du récit*, 68.

48. Branigan, *Point of View in the Cinema*, 2, 176.

49. Jacques Aumont, "Le point de vue," in "Énonciation et cinéma," ed. Jean-Paul Simon and Marc Vernet, special issue, *Communications* 38 (1983): 3–29.

50. Geneviève Jacquinot, *Image et pédagogie* (Paris: PUF, 1977).

51. Rosemarie Meyer, "Contribution à l'analyse des apprentissages avec et par les médias audiovisuels" (EHES thesis, 1989); Françoise Minot, "Étude sémio-psychanalytique de quelques film publicitaires" (thesis, EHES and Paris-XIII, 1988); Margrit Tröhler, "La sexualisation du produit de consommation dans le film publicitaire français" (thesis forthcoming); Thierry Mesny, "Analyse du documentaire cinématographique et télévisuel dans sa construction interne et ses aspects structuraux" (thesis, Paris-III and EHES, 1987).

52. Kerbrat-Orecchioni, *L'énonciation*.

53. See, e.g., A. J. Greimas and Joseph Courtés, "Énonciateur/Énonciataire," in *Sémiotique: Dictionnaire raisonné de la théorie du langage* (Paris: Hachette, 1979), 125.

54. Simon, *Le filmique et le comique*, 121.

55. Ibid., 136.

56. Casetti, "Les yeux dans les yeux," 81.

57. This is the main idea in Bettetini's *La conversazione audiovisiva*.

58. Branigan, *Point of View in the Cinema*, 66.

59. Ibid., 123.

60. Ibid., 173, 184.

61. Seymour Chatman, *Story and Discourse: Narrative Structure in Fiction and Film* (Ithaca, NY: Cornell University Press, 1978).

62. Wayne C. Booth, *The Rhetoric of Fiction* (Chicago: University of Chicago Press, 1961; 2nd ed., 1983).

63. "Supradiegetic" is borrowed from Danielle Candelon.

64. See esp. André Gaudreault, "Narrator et Narrateur," in "Cinéma et narration," ed. Marc Vernet, *Iris*, no. 7 (1987): 29–36.

65. Gaudreault, *Du littéraire au filmique*, all of chap. 11.

66. Odin, "Du spectateur fictionnalisant au nouveau spectateur."

67. See Gérard Genette, "Le statut pragmatique de la fiction narrative," *Poétique* 78 (May 1989): 237–39. The elements of a fiction (its characters, temporal and physical settings, etc.) are clearly fictional, but their production is not. It is an act of authentically illocutory language that in reality creates a work.

68. Hamburger, *Logique des genres littéraires*, 82, 123–24.

69. Ibid., esp. 79–80.

70. Simon, *Le filmique et le comique*, esp. 121. (These pronouns, however, are in inverted commas; I will come back to this presently.)

71. Notably pages 13–15.

72. See pages 12–13 and notes to those pages.

73. See page 14, including note 40.

74. Bettetini, *La conversazione audiovisiva*.

75. See page 174 below. For Jost the notion of the implicit narrator is "depersonalized" en route but retains the name. Or at least the idea, which is already present, declares itself incrementally.

76. Odin, "Du spectateur fictionnalisant au nouveau spectateur."

77. Pages 148–49.

78. Genette, *Nouveau discours du récit*, 43.

79. Ibid., esp. 65.

80. Ibid., 92.

81. See Gardies, "Le su et le vu."

82. See, e.g., Simon, *Le filmique et le comique*, 106.

83. Burgoyne, "The Cinematic Narrator."

84. See, e.g., Casetti, *Inside the Gaze*, 106ff.

85. Paul Verstraten, "'Le film m'a menti': *Stagefright* d'Alfred Hitchcock," *Vertigo* 6/7 (1991), 67–70.

86. See Gaudreault, "Système du récit filmique."

87. Gaudreault, "Narration et monstration au cinéma," 87.

88. See Bordwell, *Narration in the Fiction Film*, 61–62.

89. Gaudreault, *Du littéraire au filmique*, 147.

90. This is true for books, too, despite appearances. More on this later. In *Du littéraire au filmique* this is Gaudreault on primary enunciation in written narrative: "A nameless instance, a nameless person . . . an instance of setting on the page, of setting in place . . . an IM-personal (or rather a-personal) instance . . ." (156).

91. Branigan, *Point of View in the Cinema*, 40, 48, 171.

92. Ibid., 17.

93. Bordwell, *Narration in the Fiction Film*, 61–62.

94. See page 148 above.

95. Hamburger, *Logique des genres littéraires*, 128. According to her, the term *narrator* can only be used to designate, according to convention, either the novelistic as opposed to other genres (128–29), first-person narrative (279), or the nondialogue sections of a written narrative (157).

96. Hamburger, *Logique des genres littéraires*, esp. 155, 158, 167.

97. Bächler and Grange urged this point in a seminar discussion.

98. See Genette, *Nouveau discours du récit*, esp. 96, 102.

99. Kerbrat-Orecchioni, *L'énonciation*, 30.

100. I am adding this note on comments made by Alan Singerman during a seminar discussion; I would like to clarify that my problem is not to do with the activity or passivity of the spectator. There is no doubting that the spectator is active. But it is the presence of the spectator that is important to me at this juncture, by contrast with what takes place on the other side.

101. Bettetini, *La conversazione audiovisiva*, 100.

102. Ibid., 99.

103. Gaudreault, *Du littéraire au filmique*, 151–52.

104. Branigan, *Point of View in the Cinema*, 17.

105. See, in particular, Roger Odin, "Pour une sémio-pragmatique du cinéma," in "État de la théorie I / The Current State of Theory I," ed. Jacques Aumont, Jean-Paul Simon, and Marc Vernet, special issue, *Iris*, no. 1 (1983): 67–82; and Odin, "Du spectateur fictionnalisant au nouveau spectateur."

106. Genette, *Nouveau discours du récit*, esp. 103–4.

107. Ibid., 103.

108. Ibid., 93–102.

109. Ibid., 103.

110. See Bettetini, *La conversazione audiovisiva*, esp. 109. Incidentally, Bettetini's "monodirectional" very much resembles Genette's "vectoral."

111. See above, page 18.

112. Casetti, "Les yeux dans les yeux," 78.

113. Gardies, *Cinéma d'Afrique noire francophone*, 142.

114. Ibid., 146.

115. Oswald Ducrot, "Illocutoire et performatif," *Linguistique et sémiologie* 4 (1977): 17–53, 31; Oswald Ducrot, "Analyses pragmatiques," *Communications* 32 (1980): 11–60, 15.

116. Gardies, *Cinéma d'Afrique noire francophone*, 139–40.

117. Pages 16–17.

118. Leconte made this observation in a seminar discussion.

119. Branigan, *Point of View in the Cinema*, 39. The current context prevents me from separating out these two concepts, whose proximity and possible crossovers create a real theoretical bind: on the one hand, the construction of the text, and on the other, constructions based on the text, whatever their level of individual fantasy. It is the latter that I am thinking of here. But we should not forget that the rigorous construction of the text (or even, for the author, the demanding anticipation of the public) is only ever true as an imaginary concept.

120. Booth, *The Rhetoric of Fiction*.

121. Chatman, *Story and Discourse*.

122. Genette, *Nouveau discours du récit*, 95–96.

123. In *Story and Discourse* Chatman distinguishes among the following, in this order: the real author, the implied author, "Discourse" or "Narrative Expression" (146–51). The narrator (and narratee) only come in in fourth place, and only when they are explicit, which is to say, when the act of communication is "mediatized."

124. Umberto Eco, *Lector in fabula: La cooperazione interpretativa nei testi narrativi* (Milan: Bompiani, 1979).

125. But he does so with reference to the implied author (see *Nouveau discours du récit*, 102). What they have in common is the idea that a narrative or enunciative *phenomenon* (here, a mental construction) is not necessarily an *instance*.

126. See Jost, "Narration(s)," 202–9; Jost, "Mises au point sur le point de vue," 152; and Jost, *L'œil-caméra*, 39.

127. Casetti, *D'un regard l'autre*, 33ff. (subsection titled "Narrators and Narratees").

128. Greimas also has "Interlocutor/Interlocutee," which Casetti does not take on. It offers an alternative to "enunciation/statement [*énoncé*]" and another possible result of "shifting out [*débrayage*]"; see, e.g., Greimas and Courtés, *Sémiotique*, 80. I don't find any of these terms suitable because an explicit enunciator (this term is sufficient) is not obliged to recount something or to converse with anyone; the authoritative speaker on television does neither of these things.

129. Casetti and di Chio, *Analisi del film*, 219–27.

130. The approach they take to the subject is of greatest interest to me from a didactic point of view. But, when dealing with multilayered narratives, it cannot dispense with specifying "Narrator 1," "Narrator 2," etc. And the fundamental problem resurfaces: these "narrators" are characters or commentators who make statements [*énoncent*], and inversely the "enunciator" is (often) somebody who narrates. Having said that, I don't think that a textbook can or ought to tackle this kind of question.

131. Branigan, *Point of View in the Cinema*, 42.

132. Gaudreault, *Du littéraire au filmique*, 178, 179, 181, 182. The point has already been clearly outlined in previous articles.

133. See, notably, Branigan, *Point of View in the Cinema*, 93–94.

134. See Gaudreault, *Du littéraire au filmique*, 183.

135. Gaudreault, "Système du récit filmique."

136. See page 9.

137. Marie-Claire Ropars-Wuilleumier, "Sujet ou subjectivité?" 31.

138. Lagny, Ropars-Wuilleumier, and Sorlin, "Récit saisi par le film," 117.

139. See pages 19 and 152 above.

140. See Colin MacCabe, "Realism and the Cinema: Notes on Some Brechtian Theses," *Screen* 15, no. 2 (1974): 7–24; and Colin MacCabe, "Theory and Film: Principles of Realism and Pleasure," *Screen* 17, no. 3 (1976): 7–27.

141. See André Gaudreault, "Histoire et discours au cinéma," *Dossiers de la cinémathèque* 12 (1984): 43–46. This article was republished four years later in Gaudreault's *Du littéraire au filmique*, where the citation can be found on page 77.

142. See, e.g., two pieces by Gaudreault, both titled "Système du récit filmique" and both dating from 1987: one [1] is a paper presented at a conference at the University of Paris-III on March 25, 1987; the other [2] is an article in "Texte et médialité," ed. Jürgen E. Müller, special issue, *Mana* 7 (1987): 267–77. See also *Du littéraire au filmique*, 177.

143. Gaudreault, "Système du récit filmique" [2].

144. See page 10.

145. Jost, "Mises au point sur le point de vue."

146. Jost, "La sémiologie du cinéma et ses modèles."

147. Ibid., 137–38.

148. Marie-Claire Ropars-Wuilleumier, "Christian Metz et le mirage de l'énonciation," in "Christian Metz et la théorie du cinéma," ed. Michel Marie and Marc Vernet, *Iris*, no. 10 (1990): 105–19.

149. See above, page 161.

150. See, e.g., Raymond Bellour, "Hitchcock, the Enunciator," *Camera Obscura* 2 (Autumn 1977): 67–92; and Raymond Bellour, "Le malheur d'énoncer," in *Le mal au cinéma* (Paris/Dunkerque: Studio 43, 1989), 13–17. See also Raymond Bellour, "To Analyze, to Segment," *Quarterly Review of Film Studies* 1, no. 3 (1976): 331–53; and Raymond Bellour, "Alterner/Raconter," in Bellour, *Le cinéma américain*, 1:69–88.

AFTERWORD

1. Roger Odin, "L'énonciation contre la pragmatique? A propos de *L'énonciation impersonnelle ou le site du film* de Christian Metz," *Iris*, no. 16 (Spring 1993): 165–76.

2. Christian Metz, *Language and Cinema* [1971], trans. Donna Jean Umiker-Sebeok (The Hague: Mouton, 1974), 49, 51.

3. Metz, *The Imaginary Signifier*, 171.

4. Roland Barthes, "Apprendre et enseigner," in *Le bruissement de la langue* (Paris: Seuil, 1984), 205–7. Originally published in *Ça cinéma*, nos. 7–8 (May 1975), special issue on Christian Metz.

5. Metz, *The Imaginary Signifier*, 231–32.

ON THE SHELF: WORKS CITED

Aumont, Jacques. "Le point de vue." In Simon and Vernet, "Énonciation et cinéma," 3–29.

——. *L'œil interminable: Cinéma et peinture*. Paris: Séguier, 1989.

——. "Vertov et la vue." In *Cinémas et réalités*, edited by Roger Odin and Jean-Charles Lyant, 23–44. Saint-Étienne: Université de Saint-Étienne, 1984.

Aumont, Jacques, and Jean-Louis Leutrat, eds. *Théorie du Film*. Paris: Albatros, 1980.

Bakonyi, Iván. Thesis, Paris-I, in progress.

Balázs, Béla: *Theory of the Film: Character and Growth of a New Art*. London: Dennis Dobson, 1952.

Bellour, Raymond. "Alterner/Raconter." In Bellour, *Le cinéma américain*, 1:69–88.

——. "Hitchcock, the Enunciator." *Camera Obscura* 2 (Autumn 1977): 67–92. For the French translation see Bellour, *L'analyse du film*, 271–91.

——. *L'analyse du film*. Paris: Albatros, 1980.

——, ed. *Le cinéma américain: Analyses de films*. 2 vols. Paris: Flammarion, 1980.

——. "Le malheur d'énoncer." In *Le mal au cinéma*, 13–17. Paris-Dunkerque: Studio 43, 1989.

——. "Le regard de Haghi." In Vernet, "Cinéma et narration 1," 5–13.

——. "L'interruption, l'instant." *La recherche photographique*, no. 3 (Dec. 1987): 50–61.

——. "To Analyze, to Segment." *Quarterly Review of Film Studies* 1, no. 3 (1976): 331–53. For the French translation see Bellour, *L'analyse du film*, 247–70.

Benveniste, Émile. "De la subjectivité dans le langage." *Journal de psychologie normale et pathologique* 3 (1958): 257–65. Reprinted in Émile Benveniste, *Problèmes de linguistique générale*, 1:258–66.

——. "The Correlations of Tense in the French Verb." In *Problems in General Linguistics*, 205–16. Coral Gables, FL: University of Miami Press, 1971. Originally published as "Les relations de temps dans le verbe français," *Bulletin de la Société de linguistique de Paris*, no. 54 (1959): 69–82. Reprinted in Émile Benveniste, *Problèmes de linguistique générale*, 1:237–50.

——. *Problèmes de linguistique générale.* 2 vols. Paris: Gallimard, 1966.

Bergala, Alain. *Initiation à la sémiologie du récit en images.* Paris: Éditions de la Ligue française de l'enseignement et de l'éducation permanente, 1977.

——. *Pour une pédagogie de l'audiovisuel.* Paris: Éditions de la Ligue française de l'enseignement et de l'éducation permanente, 1975.

Bettetini, Gianfranco. *La conversazione audiovisiva: Problemi dell'enunciazione filmica e televisiva.* Milan: Bompiani, 1984.

Block de Behar, Lisa. "Approches de l'imagination anaphorique au cinéma." In Marie and Vernet, "Christian Metz et la théorie du cinéma," 235–49.

Blüher, Dominique. *Le Cinéma dans le cinéma: Film(s) dans le film et mise en abyme.* Villeneuve d'Ascq: Presses Universitaires du Septentrion, 1997. —Trans.

——. "Première approche du cinéma dans le cinéma." D.E.A. thesis, Paris-III, 1988.

Bonitzer, Pascal. "Hors-champ (Un espace en défaut)." *Cahiers du cinéma*, no. 234–35 (Dec. 1971 / Jan.-Feb. 1972): 15–26. Reissued as "Des hors-champs," in Pascal Bonitzer, *Le regard et la voix: Essais sur la cinéma*, 9–24. Paris: 10/18, 1976.

Booth, Wayne C. *The Rhetoric of Fiction.* Chicago: University of Chicago Press, 1961; 2nd ed., 1983.

Bordwell, David. *Narration in the Fiction Film.* Madison: University of Wisconsin Press, 1985.

Branigan, Edward. *Point of View in the Cinema: A Theory of Narration and Subjectivity in Classical Film.* New York: Mouton, 1984.

Browne, Nick. "*Persona* de Bergman: Dispositif/inconscient/spectateur." In Chateau, Gardies, and Jost, *Cinémas de la modernité*, 199–207. Originally published as "The Filmic Apparatus in Bergman's *Persona*," *Psychocultural Review* 3 (Spring 1979): 111–15.

Burch, Noël. *Praxis du cinéma: Essai.* Paris: Gallimard, 1969.

——. "Un mode de représentation primitif?" In "Le cinéma avant 1907," edited by André Gaudreault, *Iris*, no. 3 (1984): 113–24.

Burgoyne, Robert. "The Cinematic Narrator: The Logic and Pragmatics of Impersonal Narration." *Journal of Film and Video* 42, no. 1 (1990): 3–16. This article also appeared in French: "Le narrateur au cinéma: Logique et pragmatique de la narration impersonnelle." *Poétique* 87 (Sept. 1991): 271–88.

Carani, Marie, André Gaudreault, Pierre Ouellet, and Fernand Roy, eds. "Le point de vue fait signe." Special issue, *Protée* 16, no. 1–2 (Winter-Spring 1988).

Casetti, Francesco. *Inside the Gaze: The Fiction Film and Its Spectator*. Translated by Nell Andrew with Charles O'Brien. Bloomington: Indiana University Press, 1998. Originally published in Italian as *Dentro lo sguardo: Il film e il suo spettatore* (Milan: Bompiani, 1986). English translation prepared from the French edition, *D'un regard l'autre: Le film et son spectateur*, translated by Jean Châteauvert and Martine Joly (Lyon: Presses universitaires de Lyons, 1990).

——. "Les yeux dans les yeux." In Simon and Vernet, "Énonciation et cinéma," 78–97.

Casetti, Francesco, and Federico di Chio. *Analisi del film*. Milan: Bompiani, 1990.

Cerisuelo, Marc. *Hollywood à l'écran: Essai de poétique historique des films; l'exemple des métafilms américains*. Paris: Presses de la Sorbonne nouvelle, 2000.

——. *Jean-Luc Godard*. Paris: Lherminier, 1989.

Chartier, Jean-Pierre. "Les films à la première personne et l'illusion de réalité au cinéma." *Revue du cinéma*, 2nd ser., 4 (Jan. 1947): 32–41.

Chateau, Dominique. "Diégèse et énonciation." In Simon and Vernet, "Énonciation et cinéma," 121–54.

——. *Le cinéma comme langage*. Paris: Publications de la Sorbonne, 1986.

——. "Problèmes de la théorie sémiologique du cinéma." Thesis, Paris-I, June 1975.

——. "Projet pour une sémiologie des relations audiovisuelles dans le film." *Musique en jeu* 23 (1976): 82–98.

——. "Vers un modèle génératif du discours filmique." *Humanisme et entreprise* 99 (1976): 1–10.

Chateau, Dominique, André Gardies, and François Jost, eds. *Cinémas de la modernité: Films, théories*. Paris: Klincksieck, 1981.

Chateau, Dominique, and François Jost. *Nouveau cinéma, nouvelle sémiologie: Essai d'analyse des films d'Alain Robbe-Grillet*. Paris: 10/18, 1979. Reprint, Paris: Minuit, 1983.

Chatman, Seymour. *Cinematic Discourse: The Semiotics of Narrative Voice and Point of View in "Citizen Kane."* Urbino: Centro internazionale di semiotica e di linguistica, 1977.

——. *Story and Discourse: Narrative Structure in Fiction and Film*. Ithaca, NY: Cornell University Press, 1978.

Cheng, Tsun-Shing. "La 'scène' profilmique, ou le 'monde' perdu." Thesis, École des hautes études and Paris-III, 1985.

Chion, Michel. *La parole au cinéma: La toile trouée*. Paris: Étoile/Cahiers du cinéma, 1988.

——. *Le son au cinéma*. Paris: Étoile / Cahiers du cinéma, 1985.

——. *The Voice in Cinema*. Translated by Claudia Gorbman. New York: Columbia University Press, 1999. Originally published as *La voix au cinéma* (Paris: Étoile / Cahiers du cinéma, 1982).

Cohen-Séat, Gilbert. *Essai sur les principes d'une philosophie du cinéma*. Paris: Presses universitaires de France, 1946. Reprint, 1958.

Colin, Michel. *Cinéma, Télévision, Cognition*. Nancy: Presses universitaires de Nancy, 1992.

——. "La dislocation." In Aumont and Leutrat, *Théorie du film*, 73–91.

——. *Langue, film, discours: Prolégomènes à une sémiologie générative du film*. Paris: Klincksieck, 1985.

——. *Structures linguistiques / Structures filmiques*. Mimeograph, University of Paris-III, 1982–83.

Dagrada, Elena. "The Diegetic Look: Pragmatics of the Point-of-View Shot." In Vernet, "Cinéma et narration 1," 111–24.

——. "Sulla soggettiva libera indiretta." *Cinema e cinema*, no. 43 (1985): 48–55.

Dällenbach, Lucien. *Le récit spéculaire: Essai sur la mise en abyme*. Paris: Seuil, 1977.

Deleuze, Gilles. *Cinéma 2: L'image-temps*. Paris: Minuit, 1985.

Doniol-Valcroze, Jacques. "Naissance du véritable ciné-œil." *Revue du cinéma*, 2nd ser., 4 (Jan. 1947): 25–29.

Ducrot, Oswald. "Analyses pragmatiques." *Communications* 32 (1980): 11–60.

——. "Illocutoire et performatif." *Linguistique et sémiologie*, no. 4 (1977): 17–53.

Dupré La Tour, Claire. "Intertitre et film narratif, 1895–1916." Thesis in preparation, University of Utrecht.

Eco, Umberto. *Lector in fabula: La cooperazione interpretativa nei testi narrativi*. Milan: Bompiani, 1979. Translated by Myriem Bouzaher as *Lector in fabula: Le rôle du lecteur ou la coopération interprétative dans les textes narratives* (Paris: Grasset, 1985).

Fontanille, Jacques, ed. "La subjectivité au cinéma." Special issue, *Actes sémiotiques: Bulletin* 10, no. 41 (1987).

——. "La subjectivité au cinéma." In Fontanille, "La subjectivité au cinéma," 5–23.

——. "L'économie du savoir dans le film." In "L'école-cinéma," edited by Michèle Lagny, Marie-Claire Ropars-Wuilleumier, and Pierre Sorlin. Special issue, *Hors cadre* 5 (1987): 245–56.

——. "Point de vue: Essai de définition discursive." In Carani et al. "Le point de vue fait signe," 7–22.

Frampton, Hollis, dir. *Hapax legomena 1: (nostalgia)*. USA, 1971.

Gardies, André. *Cinéma d'Afrique noire francophone: L'espace-miroir*. Paris: L'Harmattan, 1989.

———. "Fonctionnalité narrative du verbal dans le récit filmique: Esquisse pour une typologie." In *Le verbal et ses rapports avec le non-verbal dans la culture contemporaine*, edited by Jeanne-Marie Clerc, 127–41. Montpellier: Université Paul Valéry, 1989.

———. "Genèse, générique, générateurs." In "Voir, entendre." Special issue, *Revue d'esthétique* 4 (1976): 86–120.

———. "L'acteur dans le système textuel du film." *Cinéma et récit* 13, no. 1 of *Études littéraires*, edited by François Baby and André Gaudreault (Québec: April 1980): 71–107. Also published as a brochure by the Centre d'études et de recherches audiovisuelles de l'Université d'Abidjan, Côte D'Ivoire (no. 40 in the series, 1980), under the name "Esquisse pour un portrait sémiologique de l'acteur."

———. "La forme-générique: Histoire d'une figure révélatrice." *Annales de l'Université d'Abidjan*, series D, no. 14 (1981): 163–76.

———. "Le pouvoir ludique de la focalisation." In Carani et al., "Le point de vue fait signe," 139–45.

———. "Le su et le vu." In "Cinénarrable," edited by Michèle Lagny, Marie-Claire Ropars-Wuilleumier, and Pierre Sorlin. Special issue, *Hors cadre* 2 (1984): 45–64.

Gaudreault, André. *Du littéraire au filmique: Système au récit*. Paris: Méridiens-Klincksieck, 1988.

———. "Histoire et discours au cinéma." *Dossiers de la cinémathèque* 12 (1984): 43–46.

———. "Narrator et Narrateur." In Vernet, "Cinéma et narration 1," 29–36.

———. "Narration et monstration au cinéma." In "Cinénarrable," edited by Michèle Lagny, Marie-Claire Ropars-Wuilleumier, and Pierre Sorlin. Special issue, *Hors cadre* 2 (1984): 87–98.

———. "Récit scriptural, récit théâtral, récit filmique: Prolégomènes à une théorie narratologique du cinéma." PhD diss., Paris-III, 1983.

———. "Système du récit filmique" [1]. Paper presented at l'Université de Paris-III, March 25, 1987.

———. "Système du récit filmique" [2]. In "Texte et médialité," edited by Jürgen E. Müller. Special French-language issue, *Mana* 7 (1987): 267–77.

Genette, Gérard. *Figures III*. Paris: Seuil, 1972.

———. "Frontières du récit." In "L'analyse structurale du récit," edited by Roland Barthes. Special issue, *Communications* 8 (1966): 152–63. Reprinted in Gérard Genette, *Figures II*, 49–69. Paris: Seuil, 1969.

——. "Le statut pragmatique de la fiction narrative." *Poétique* 78 (May 1989): 237–39.

——. *Nouveau discours du récit.* Paris: Seuil, 1983.

——. *Palimpsestes: La littérature au second degré.* Paris: Seuil, 1982.

Gerstenkorn, Jacques. "À travers le miroir." Introductory note, *Vertigo* 1 (1987): 7–10.

——. "Le métaphorique dans le film de fiction." PhD diss., École des hautes études, 1990.

——, ed. "Rhétoriques de cinéma." Special issue, *Vertigo* 6/7 (1991).

Greimas, A. J., and Joseph Courtés. *Sémiotique: Dictionnaire raisonné de la théorie du langage.* Paris: Hachette, 1979.

Grunig, Blanche-Noëlle. *Les mots de la publicité.* Paris: CNRS, 1990.

Guynn, William. *A Cinema of Nonfiction.* London: Associated University Presses, 1990.

Hamburger, Käte. *Logique des genres littéraires.* Paris: Seuil, 1986. Originally published as *Die Logik der Dichtung* (Stuttgart: Klett, 1957; rev. ed. 1968).

——. "Zur Phänomenologie des Films." In *Texte zur Poetik des Films*, edited by Rudolf Denk, 121–32. Stuttgart: Reclam, 1978. Originally published in *Merkur* 9 (1956): 873–80.

Humphries, Reynold. *Fritz Lang, cinéaste américain.* Paris: Albatros, 1982.

Jacquinot, Geneviève. *Image et pédagogie.* Paris: P.U.F., 1977.

Jost, François. "Discours cinématographique, narration: Deux façons d'envisager le problème de l'énonciation." In Aumont and Leutrat, *Théorie du film*, 121–31.

——. "Du nouveau roman au nouveau romancier: Questions de narratologie." Thesis, École des hautes études and Paris-III, 1983.

——. "La sémiologie du cinéma et ses modèles." In Marie and Vernet, "Christian Metz et la théorie du cinéma," 133–41.

——. *L'œil-caméra: Entre film et roman.* Lyon: Presses universitaires de Lyon, 1987.

——. *L'œil-caméra: Entre film et roman.* Rev. ed. Lyon: Presses universitaires de Lyon, 1989.

——. "L'oreille interne: Propositions pour une analyse du point de vue sonore." In "La parole au cinéma / Speech in Film," edited by François Vanoye. Special issue, *Iris* 3, no. 1 (1985): 21–34.

——. "Mises au point sur le point de vue." In Carani et al., "Le point de vue fait signe," 147–55.

——. "Narration(s): en-deçà et au-delà." In Simon and Vernet, "Énonciation et cinéma," 192–212.

——. "Pour une approche narratologique des combinaisons audiovisuelles." *Protée* 13, no. 2 (1985): 13–19.

——. "Règles de Je." In Vernet, "Cinéma et narration 2," 107–19.

Jost, François, and André Gaudreault. *Le récit cinématographique*. Edited by Henri Mitterand and Michel Marie. Paris: Nathan, 1990.

Kerbrat-Orecchioni, Catherine. *La connotation*. Lyon: Presses universitaires de Lyon, 1977.

——. *L'énonciation: De la subjectivité dans le langage*. Paris: Armand Colin, 1980.

——. "L'image dans l'image." In "Rhétoriques, sémiotiques," edited by the "Mu" group from Liège. Special issue, *Revue d'esthétique* 1–2 (1979): 193–233.

——. "Vive la vitalité Vittel: Une annonce publicitaire 'modern.'" In "Le discours publicitaire: II." Special issue, *Degrés* 14, no. 45 (1986): e1–e27.

Koch, Christian. "Understanding Film as a Process of Change." PhD diss., University of Iowa, 1970.

Kuntzel, Thierry. "Le travail du film." *Communications* 19 (1972): 25–39.

Laffay, Albert. *Logique du cinéma: Création et spectacle*. Paris: Masson, 1964.

Lagny, Michèle. *Langue, discours, société: Pour Émile Benveniste*. Festschrift edited by Julia Kristeva, Jean-Claude Milner, and Nicholas Ruwet. Paris: Seuil, 1975.

Lagny, Michèle, Marie-Claire Ropars-Wuilleumier, and Pierre Sorlin, eds. "Ciné-narrable." Special issue, *Hors cadre* 2 (1984).

——. "Le récit saisi par le film." In Lagny, Ropars-Wuilleumier, and Sorlin, "Ciné-narrable," 99–121.

"Le cinéma au miroir." Special issue, *Vertigo* 1 (1987).

Leconte, Bernard. "La télévision regarde le télévision." *Revue du cinéma* 463 (1990): 62–69.

Lemaî tre, Jacques. "Téléphone et cinéma." DEA thesis, Paris-III, 1987.

Lubbock, Percy. *The Craft of Fiction*. London: Whittingham and Griggs, 1921.

MacCabe, Colin. "Realism and the Cinema: Notes on Some Brechtian Theses." *Screen* 15, no. 2 (1974): 7–24.

——. "Theory and Film: Principles of Realism and Pleasure." *Screen* 17, no. 3 (1976): 7–27. Reprinted in Phil Rosen, ed., *Narrative, Apparatus, Ideology*, 179–97. New York: Columbia University Press, 1986.

Marie, Michel. "Intertitres et autres mentions graphiques dans le cinéma muet." *Revue du cinéma: Image et son* 316 (April 1977): 68–74.

——. "Intertitres et sons au cinéma." Thesis, Paris-VIII, 1976.

——. "La séquence / Le film: *Citizen Kane* de Welles." In Bellour, *Le cinéma américain*, 2:27–44.

——. "Le film, la parole et la langue." In "Cinéma et littérature," edited by André Gardies. Special issue, *Cahiers du XXe siècle* (May 1978): 67–75.

——. "Un monde qui s'accorde à nos désirs (*Le mépris*, 1963)." In "Jean-Luc Godard: Les films," edited by Philippe Dubois. Special issue, *Revue belge*

du cinéma 16 (Summer 1986): 25–36. Revised and expanded in "Jean-Luc Godard: Le cinéma," edited by Philippe Dubois. Special issue, *Revue belge du Cinéma* 22–23 (1988): 25–40.

Marie, Michel, and Marc Vernet, eds. "Christian Metz et la théorie du cinéma / Christian Metz and Film Theory." *Iris*, no. 10 (1990).

Merleau-Ponty, Maurice. "Le cinéma et la nouvelle psychologie." Lecture delivered at l'Institut des hautes études cinématographiques, March 13, 1945. Reprinted in Maurice Merleau-Ponty, *Sens et non-sens*. Paris: Nagel, 1948.

Mesny, Thierry. "Étude du documentaire cinématographique et télévisuel dans sa construction interne et ses aspects structuraux." Thesis, Paris-III and École des hautes études, 1987.

Metz, Christian. *Essais sur la signification au cinéma*. 2 vols. Paris: Klincksieck, 1968–72.

——. *Film Language: A Semiotics of the Cinema*. Translated by Michael Taylor. Chicago: University of Chicago Press, 1991. First published 1974 by Oxford University Press.

——. "Histoire/Discours (Note sur deux voyeurismes)." In Metz, *Le signifiant imaginaire*, 113–20.

——. "The Imaginary Signifier." *Screen* 16, no. 2 (1975): 14–76.

——. *The Imaginary Signifier: Psychoanalysis and the Cinema*. Bloomington: Indiana University Press, 1982. Originally published as *Le signifiant imaginaire: Psychanalyse et cinéma* (Paris: Union Générale d'Editions, 1977).

——. "Le perçu et le nommé." In *Essais sémiotiques*, 129–61. Paris: Klincksieck, 1977.

——. "L'énonciation impersonnelle, ou le site du film: En marge de travaux récents sur l'énonciation au cinéma." *Vertigo* 1 (1987): 13–34.

——. "Le signifiant imaginaire." In Metz, *Le signifiant imaginaire*, 7–110.

——. "*L'image comme objet: Cinéma, photo, fétiche*." In *Cinéma et psychanalyse*, ed. Alain Dhote, 168–75. Courbevoie: CinémAction / Condé-sur-Noireau: Corlet, 1989.

——. "Métaphore/métonymie, ou le référent imaginaire." In Metz, *Le signifiant imaginaire*, 177–371.

——. "Mirror-Construction in Fellini's 8½." In Metz, *Film Language*, 228–34.

——. "The Modern Cinema and Narrativity." In Metz, *Film Language*, 185–227.

——. "Photography and Fetish." *October* 34 (Autumn 1985): 81–90.

——. "Ponctuations et démarcations dans le film de diégèse" (1971–72). In Metz, *Essais sur la signification au cinéma*, 2:111–37.

——. "Remarques pour une phénoménologie du narratif." In Metz, *Essais sur la signification au cinéma*, 1:25–35.

——. "Trucage et cinéma" (1971). In Metz, *Essais sur la signification au cinéma*, 2:173–92

Meyer, Rosemarie. *Contribution à l'analyse des apprentissages avec et par les media audiovisuels.* Thesis, École des hautes études, 1989.

Michelson, Annette. "L'homme à la camera: De la magie à l'épistémologie." In "Cinéma: Théorie, lectures," edited by Dominique Noguez. Special issue, *Revue d'esthétique* 26 (1973): 295–310.

Minot, François. "Étude sémio-psychanalytique de quelques films publicitaires." Thesis, Paris-XIII and École des hautes études, 1988.

Mitry, Jean. *Esthétique et psychologie du cinéma.* Vol. 2, *Les formes.* Paris: Éditions universitaires, 1965.

Mourgues, Nicole de. Publication on the status of credit sequences, forthcoming from Armand Colin, edited by Roger Odin.

Nel, Noël. "Point de vue et théorie du film." Broadsheet. 1989–90.

Noguez, Dominique. Comments on sound films without images at the Mots/Images/Sons Symposium, under the auspices of the journal *Cinéma*, organized by Nicole de Mourgues. Rouen University, March 14–17, 1989.

——. *Une renaissance du cinéma: Le cinéma "underground" américain.* Paris: Klincksieck, 1984.

Odin, Roger. "Du spectateur fictionnalisant au nouveau spectateur: Approche sémio-pragmatique." In Vernet, "Cinéma et narration 2," 121–39.

——. "L'entrée du spectateur dans la fiction." In Aumont and Leutrat, *Théorie du film*, 198–213.

——. "Mise en phase, déphase et performativité dans *Le tempestaire* de Jean Epstein." In Simon and Vernet, "Énonciation et cinéma," 213–38.

——. "Pour une sémio-pragmatique du cinéma." In "État de la théorie I / The Current State of Theory I," edited by Jacques Aumont, Jean-Paul Simon, and Marc Vernet. *Iris*, no. 1 (1983): 67–82.

——. "Quelques jalons pour une réflexion sur la notion de cohérence au cinéma." *Canadian Journal of Research in Semiotics* 6, no. 3 / 7, no. 1 (1979): 175–88.

Pasolini, Pier Paolo. "Le cinéma de poésie." *Cahiers du cinéma*, no. 171 (Oct. 1965): 55–64.

Pouillon, Jean. *Temps et roman.* Paris: Gallimard, 1946.

Rollet, Patrice, ed. "Lettres de cinéma." Special issue, *Vertigo* 2 (1988).

Ropars-Wuilleumier, Marie-Claire. "Christian Metz et le mirage de l'énonciation." In Marie and Vernet, "Christian Metz et la théorie du cinéma," 105–19.

——. *Écraniques: Le film du texte.* Lille: Presses universitaires de Lille, 1990.

——. "Narration et signification: Un exemple filmique." *Poétique* 12 (1972): 518–30. Reprinted in Bellour, *Le cinéma américain*, 2:9–26.

——. "Sujet ou subjectivité? L'intervalle du film." In Fontanille, "La subjectivité au cinéma," 30–39.

——. "Totalité et fragmentaire: La réécriture selon Godard." In "Contre-bande," edited by Michèle Lagny, Pierre Sorlin, and Marie-Claire Ropars-Wuilleumier. Special issue, *Hors cadre* 6 (1988): 193–207.

Ropars-Wuilleumier, Marie-Claire, Claude Bailblé, and Michel Marie. *Muriel.* Research report. Paris: Galilée, 1975.

Simon, Jean-Paul. "Énonciation et narration." In Simon and Vernet, "Énonciation et cinéma," 155–91.

——. *Le filmique et le comique: Essai sur le film comique.* Paris: Albatros, 1979.

——. "L'énoncé dans l'énonciation: L'objet filmique et la place du spectateur dans le signifiant cinématographique." Thesis, Paris-X and École des hautes études, 1975.

——. "Référence et désignation: Notes sur la deixis cinématographique." In *Regards sur le sémiologie contemporaine,* 53–62. Colloque Sémiologie-Sémiologies, Université de Saint-Étienne, Nov. 24–26, 1977. Saint-Étienne: Presses universitaires de Saint-Étienne, 1978.

——. *Remarque sur la temporalité cinématographique dans les films diégétiques.* Brochure (Urbino: Centro Internazionale di semiotica e di linguistica, 1979). Reprinted in Chateau, Gardies, and Jost, *Cinémas de la modernité,* 57–74.

Simon, Jean-Paul, and Marc Vernet, eds. "Énonciation et cinéma." Special issue, *Communications* 38 (1983).

Sorlin, Pierre. "A quel sujet?" In Fontanille, "La subjectivité au cinéma," 40–51.

Souriau, Étienne. "Les grands caractères de l'univers filmique." In *L'univers filmique,* edited by Étienne Souriau, 11–31. Paris: Flammarion, 1953.

Takeda, Kiyoshi. "Archéologie du discours sur l'autoréflexivité au cinéma." PhD diss., École des hautes études and Paris-III, 1986.

——. "Le cinéma autoréflexif: Quelques problèmes méthodologiques." *Iconics* 1 (Dec. 1987): 83–97.

Terrenoire, Jean-Paul. "Les yeux dans les yeux: L'interpellation télévisuelle et l'implication du spectateur." *Revue suisse de sociologie/Schweizerische Zeitschrift für Soziologie* (1987): 367–78.

——. "Sociologie et sémiologie: A propos de l'analyse scénologique de l'image télévisée." *Revue tunisienne de communication* 11 (Jan.–June 1987): 107–17.

Traversa, Oscar. *Ciné: El significante negado.* Buenos Aires: Hachette, 1984.

Tröhler, Margrit. Thesis, École des hautes études, in progress.

Vanoye, François. *Récit écrit, récit filmique.* Paris: CEDIC, 1979. Updated version edited by Henri Mitterand and Michel Marie (Paris: Nathan, 1989).

Vernet, Marc, ed. "Cinéma et narration 1." *Iris,* no. 7 (1987).

——, ed. "Cinéma et narration 2." *Iris,* no. 8 (1988).

——. "Clignotements du noir-et-blanc." In Aumont and Leutrat, *Théorie du film*, 222–23.

——. *Figures de l'absence: De l'invisible au cinéma*. Paris: Étoile/Cahiers du cinéma, 1988.

——. "Figures de l'absence 2: La voix off." In "La parole au cinéma/Speech in Film," edited by François Vanoye. Special issue, *Iris* 3, no. 1 (1985): 47–56.

——. "Le figural et le figuratif, ou le référent symbolique: À propos de 'Métaphorique/métonymie, ou le référent imaginaire.'" In Marie and Vernet, "Christian Metz et la théorie du cinéma," 223–34.

——. "Le personnage de film." In Vernet, "Cinéma et narration 1," 81–110.

——. "Le regard à la caméra: Figure de l'absence." In "État de la théorie II/The Current State of Theory II," edited by Jaques Aumont, Jean-Paul Simon, and Marc Vernet. Special issue, *Iris*, no. 2 (1983): 31–46. Revised and included in Vernet, *Figures de l'absence*, 9–28.

Vernon, Eliseo. "Il est là, je le vois, il me parle." In Simon and Vernet, "Énonciation et cinéma," 98–120.

Verstraten, Paul. "'Le film m'a menti': *Stagefright* d'Alfred Hitchcock," *Vertigo* 6/7 (1991), 67–70. The Dutch translation of this essay appeared in *Versus*, no. 3 (1989).

——. "Raconter sa propre tragédie: *Lettre d'une inconnue*." In Vernet, "Cinéma et narration 2," 95–106.

Weinrich, Harald. *Le temps*. Translated by Michèle Lacoste Paris: Seuil, 1973. Originally published as *Tempus: Besprochene und erzählte Welt* (Stuttgart: Kohlhammer, 1964).

Zamour, Françoise. Thesis, École des hautes études, not completed.

INDEX

Film and Culture

A series of Columbia University Press

EDITED BY JOHN BELTON

The Impossible David Lynch
TODD MCGOWAN

Sentimental Fabulations, Contemporary Chinese Films: Attachment in the Age of Global Visibility
REY CHOW

Hitchcock's Romantic Irony
RICHARD ALLEN

Intelligence Work: The Politics of American Documentary
JONATHAN KAHANA

Eye of the Century: Film, Experience, Modernity
FRANCESCO CASETTI

Shivers Down Your Spine: Cinema, Museums, and the Immersive View
ALISON GRIFFITHS

Weimar Cinema: An Essential Guide to Classic Films of the Era
EDITED BY NOAH ISENBERG

African Film and Literature: Adapting Violence to the Screen
LINDIWE DOVEY

Film, A Sound Art
MICHEL CHION

Film Studies: An Introduction
ED SIKOV

Hollywood Lighting from the Silent Era to Film Noir
PATRICK KEATING

Levinas and the Cinema of Redemption: Time, Ethics, and the Feminine
SAM B. GIRGUS

Counter-Archive: Film, the Everyday, and Albert Kahn's Archives de la Planète
PAULA AMAD

Indie: An American Film Culture
MICHAEL Z. NEWMAN

Pretty: Film and the Decorative Image
ROSALIND GALT

Film and Stereotype: A Challenge for Cinema and Theory
JÖRG SCHWEINITZ

Chinese Women's Cinema: Transnational Contexts
EDITED BY LINGZHEN WANG

Hideous Progeny: Disability, Eugenics, and Classic Horror Cinema
ANGELA M. SMITH

Hollywood's Copyright Wars: From Edison to the Internet
PETER DECHERNEY